MAP OF THE WORLD

FROM THE LIBRARY OF

Robert Newman

SIGNATURES OF THE VISIBLE

SIGNATURES OF THE VISIBLE

FREDRIC JAMESON

Routledge • New York & London

First published in 1990 by

Routledge
an imprint of
Routledge, Chapman & Hall, Inc.
29 West 35 Street
New York, NY 10001

Published in Great Britain by

Routledge
11 New Fetter Lane
London EC4P 4EE

Library of Congress Cataloging-in-Publication Data

Jameson, Fredric.
 Signatures of the visible / Fredric Jameson.
 p. cm.
 Includes bibliographical references.
 ISBN 0-415-90011-5
 1. Motion pictures. I. Title.
PN1995.J34 1990
791.43'015—dc20 90-33907

British Library Cataloguing in Publication Data

Jameson, Fredric
 Signatures of the visible.
 1. Cinema films. Theories
 I. Title
 791.4301

 ISBN 0-415-90011-5

for Peter Fitting

... signatures of all things I am here to read ...
Ulysses

Contents

Introduction

The visual is *essentially* pornographic, which is to say that it has its end in rapt, mindless fascination; thinking about its attributes becomes an adjunct to that, if it is unwilling to betray its object; while the most austere films necessarily draw their energy from the attempt to repress their own excess (rather than from the more thankless effort to discipline the viewer). Pornographic films are thus only the potentiation of films in general, which ask us to stare at the world as though it were a naked body. On the other hand, we know this today more clearly because our society has begun to offer us the world—now mostly a collection of products of our own making—as just such a body, that you can possess visually, and collect the images of. Were an ontology of this artificial, person-produced universe still possible, it would have to be an ontology of the visual, of being as the visible first and foremost, with the other senses draining off it; all the fights about power and desire have to take place here, between the mastery of the gaze and the illimitable richness of the visual object; it is ironic that the highest stage of civilization (thus far) has transformed human nature into this single protean sense, which even moralism can surely no longer wish to amputate. This book will argue the proposition that the only way to think the visual, to get a handle on increasing, tendential, all-pervasive visuality as such, is to grasp its historical coming into being. Other kinds of thought have to replace the act of seeing by something else; history alone, however, can mimic the sharpening or dissolution of the gaze.

All of which is to say that movies are a physical experience, and are remembered as such, stored up in bodily synapses that evade the thinking mind. Baudelaire and Proust showed us how memories are part of the body anyway, much closer to odor or the palate than to the combination of Kant's categories; or perhaps it would be better to say that memories are first and foremost memories of the senses,

and that it is the senses that remember, and not the "person" or personal identity. This can happen with books, if the words are sensory enough; but it always happens with films, if you have seen enough of them and unexpectedly see them again. I can remember nothing but conscious disappointment from a visit to a then current Soviet film at the Exeter Theater in Boston over twenty years ago; when I saw it again last week, vivid gestures reawakened that have accompanied me all that time without my knowing it; my first thought—how I could ever have forgotten them?—is followed by the Proustian conclusion that they had to have been ignored or forgotten to be remembered like this.

But the same thing may be observed in real time, in the seam between the day to day; the filmic images of the night before stain the morning and saturate it with half-conscious reminiscence, in a way calculated to reawaken moralizing alarm; like the visual of which it is a part, but also an essence and concentration, and an emblem and a whole program, film is an addiction that leaves its traces in the body itself. This makes it inconceivable that an activity occupying so large a proportion of our lives should be assigned to a specialized discipline, but also that we could ever hope to write about it without self-indulgence.

Barthes thought certain kinds of writing—perhaps we should say, certain kinds of *sentences*—to be *scriptible*, because they made you wish to write further yourself; they stimulated imitation, and promised a pleasure in combining language that had little enough to do with the notation of new ideas.[2] But I think that he thought this because he took an attitude towards those sentences which was not essentially linguistic, and had little to do with reading: what is scriptible indeed is the visual or the musical, what corresponds to the two outside senses that tug at language between themselves and dispute its peculiarly unphysical attention, its short circuit of the sentences for the mind itself that makes of the mysterious thing reading some superstitious and adult power, which the lowlier arts imagine uncomprehendingly, as animals might dream of the strangeness of human thinking. We do not in that sense read painting, nor do we hear music with any of the attention reserved for oral recitation; but this is why the more advanced and rationalized activity can also have its dream of the other, and regress to a longing for the more immediately sensory, wishing it could pass altogether over into the visual, or be sublimated into the spiritual body of pure sound.

Scriptible is not however the poetry that actually tries to do that (and which is then itself condemned to the technical mediation of a relationship to language not much more "poetic" than the doctrine of

the coloration of orchestral instruments and the specialized, painfully acquired knowledge of their technologies); it is the prose stimulated by the idea of sound, or the sentences that something visual—unfortunately, our only word for it is the *image*—calls into being by suggestion and by a kind of contamination. We don't write about these things, it is not a metaphorical representation that the sensory pretext summons but rather something related by affinity, that prolongs the content of the object in another, more tenuous form, as though to prolong a last touch with the very fingertips.

Out of nature, sound and the image will have to involve differentiation; it is only the single natural tone—the stone you hear through the peculiar dullness of a heavy drop of water, or the "green so delicious it hurts"—that has the power to hold the sensory attention for a time and at some length to fascinate. What is humanly produced must come in twos, by way of articulated contrast; but of course, that way you get two for one.

What is however pursued by writing in these other senses is somehow subjectivity itself, which seems to have something to do with the coloration of the instruments, and in particular the ways in which their sounds cross and oddly interfere, making each one separately audible in a piquant simultaneity that at some outside limit actually hurts the ear. Pain is the instrument of this aural pleasure, but it must be the articulated pain of at least two very different kinds of sounds at once. Yet the occasion to say something like this about music does not come very often, and is at best an impoverished pastime.

Images on the other hand can be thus endlessly collected, provided it is understood that here also color and coloration—even the degrees of black and white, especially the tonality of the monochrome, which offers something like a translation, and therefore something even closer to language, of the range of separate color—are the true object of the quest, and are what is always described, over and over again, in different words and by way of thoughts that do not look the same. Coloration is in that sense materialized subjectivity, so it is that still that we vainly search for across the plates and glossy prints.

Not only would an aesthetics of film be indistinguishable from the latter's ontology; it would be social and historical through and through by way of the very mediation of form itself, if you grant the historicity of perception (and of the apparatuses in which it is registered, and registers, all at once). Many of the essays collected here are occasional; one cannot always write about the things one admires; on the other hand, all of the occasions in question began in the senses, so to speak, and attempt to derive a historical, perhaps first of all a film-historical, dimension from that initial experience. I

may also say that this kind of analysis resembles Freud's mainly in the way in which, when successful, it liquidates the experiences in question and dissolves them without a trace; I find I have no desire to see again a movie about which I have written well.

It will be observed that the conception of film presupposed here is one in which the closest relative of the medium remains the novel as such (rather than such more obvious cousins as the theater play or video experimental or commercial). But the differences may be worth stressing, and they become more visible when one thinks of the social role criticism of the novel has so often played in any number of national traditions, and not only in the West. One thinks of the great 19th century Russian essays, in which Czarist censorship is surely not the only motive for the choice of the novel and its problems as a vehicle for social commentary; but one thinks also of Lu Xun's *Brief History of Chinese Fiction* (1923–24), and then from him back to De Sanctis, Brandes, Sainte-Beuve or Taine. To be sure, in talking about fictive characters, you can use the same language it might be more dangerous to use about real ones (it remaining for our own contemporaries to reverse the process and to argue—or to discover—that talking about real characters and historical situations is not much different from talking about fictive ones anyway). Meanwhile, in certain cultures, the existence of a foundational text (or the transformation of this or that novel into such a text, the systematic conferal on it of a kind of scriptural status) opens up the possibility of a different kind of intervention for the commentary form: as witness the innumerable Spanish meditations on the *Quijote* or Norinaga's allegorical use of *Genji*, not to speak of the diagnostic value of books like Jules de Gaultier's *Le Bovarysme*. Significantly, such commentaries have been notably absent from the Anglo-American tradition, with the signal exception of D. H. Lawrence's *Studies in Classic American Literature* (which bears on a different culture from his own and is thus, like so much of this writer's work, a kind of metaphysical travelogue. Elsewhere however, from René Girard's *Mensonge romantique et vérité romanesque* to Karatani Kojin's *Origins of Modern Japanese Literature*, the genre of the "theory of the novel" has been capable of a resonance that far transcends mere cultural critique. The fundamental work in the paradigm—Lukács' *Theory of the Novel*—posits the realization or determinate failures of achieved novelistic form as the surest symptom of the possibilities of individual and collective life in the capitalist period; while it is no accident that the most recent or belated (perhaps even posthumous) work in this genre—Franco Moretti's *Way of the World*—rehearses and interrogates for one last time those classics of political philosophy and sociology which have been all but excluded

from the positivism of their own specific disciplines, and rewrites Lukács in the secular tones that befit a postmodern age, taking the formal compromises of the *Bildungsroman* as indices of the specificity of a daily life unique to middle-class existence.

It is to be doubted whether any study of film can have this philosophical or historical value: Lukacs' standpoint turns on the structural possibilities of the novel to solve its "form-problem" (that it can never really do so is of course another matter, closely related to the structure of capitalism). The significance of that "form-problem" then lies in the fact that it is a place in which aesthetics can be seen as another form of ethics (or even, for a Lukacs that follows immediately on this one, another form of politics).

In film, however, it is my sense that none of the innumerable formal problems solved in the process of composing a film add up to the august metaphysical volume of the Lukacsean Form Problem itself. In film, the visual glues all these things back together in another way, and seals up the crevices in the form; it introduces a third thing alongside the classical Aristotelian question of Plot and the modern Benjaminian question of Experience. "Irony" as a grand philosophical issue does not take on film, even the Romantic kind, nor is it likely (despite Deleuze's pioneering attempt, in his books on cinema and on Francis Bacon) that the meditation on the visual will achieve even the symbolic value of the 19th century meditation on music.

But there are certainly other ways in which film has marked the life and work of writers in the twentieth century; and it is always worth remembering the degree to which going to the movies has been a very basic part of the weekly and even the daily life of modern intellectuals.

Sartre, a movie-goer since the age of three, tells us somewhere that the theory of contingency—the fundamental experience of *Nausea* and the cornerstone of Sartrean existentialism as such—was derived from the experience of film, and in particular from the mystery of the difference between the image and the world outside. Should that biographical fact not play a philosophical role in the rereading of this thinker? Is it conceivable that a properly cinematographic experience may thus similarly lie buried and unspoken, if not unconscious, in the texts of any number of otherwise respectable (which is to say, non-movie-going) poets and essayists? Did human nature change on or about December 28, 1895? Or was some cinematographic dimension of human reality always there somewhere in prehistoric life, waiting to find its actualization in a certain high-technical civilization? (and thereby now allowing us to reread and rewrite the past now filmically and as the philosophy of the visual)?

My long concluding reflections scarcely tries to answer, or even ask,

these questions, but it does offer the most sustained rehearsal of the dialectic of realism, modernism and postmodernism that I have so far attempted, and which I have hitherto misrepresented by staging one or the other in isolation. This dialectic seems to me to provide at least one formal mediation capable of including history within the sensory experience of the screen (there are obviously any number of others, as was indicated above): but it does so only on condition of remaining dialectical—indeed, the laws and accounts registered for each moment clearly remain absolutely asymmetrical and of distinct and different types, modernism turning out to be anything but an inverted realism, and postmodernism anything but a cancellation of modernism.

Two antithetical remarks occur to me in conclusion. The first is that all this has very little (or nothing) to do with television, which makes me wonder whether the entire discussion is not in the nature of a post mortem on a now historical form or medium, which finds its philosophy as well as its history posthumously. The second is that film itself has never been more alive than it is globally, where in the new world system a host of local voices have found the most sophisticated technical expression. A filmmaker in whom I have been interested was described in some local journal or other as "the Antonioni of Taiwan": at a moment when we in the West, for all kinds of socio-economic reasons, no longer have our own Antonionis any more, or our own Hitchcocks or Fords or Godards, it is good to know that elsewhere, outside the First World, we can look forward to their reinvention, along with the culturally unforeseeable itself (that had seemed to be a casualty of the end of modernism).

Durham
December, 1989

PART ONE

1.

Reification And Utopia in
Mass Culture

The theory of mass culture—or mass audience culture, commercial culture, "popular" culture, the culture industry, as it is variously known—has always tended to define its object against so-called high culture without reflecting on the objective status of this opposition. As so often, positions in this field reduce themselves to two mirror images, which are essentially staged in terms of value. Thus the familiar motif of *elitism* argues for the priority of mass culture on the grounds of the sheer numbers of people exposed to it; the pursuit of high or hermetic culture is then stigmatized as a status hobby of small groups of intellectuals. As its anti-intellectual thrust suggests, this essentially negative position has little theoretical content but clearly responds to a deeply rooted conviction in American populism and articulates a widely based sense that high culture is an establishment phenomenon, irredeemably tainted by its association with institutions, in particular with the university. The value invoked is therefore a social one: it would be preferable to deal with tv programs, *The Godfather*, or *Jaws*, rather than with Wallace Stevens or Henry James, because the former clearly speak a cultural language meaningful to far wider strata of the population that what is socially represented by intellectuals. Populist radicals are however also intellectuals, so that this position has suspicious overtones of the guilt trip; meanwhile it overlooks the anti-social and critical, negative (although generally not revolutionary) stance of much of the most important forms of modern art; finally, it offers no method for reading even those cultural objects it valorizes and has had little of interest to say about their content.

This position is then reversed in the theory of culture worked out by the Frankfurt School; as is appropriate for this exact antithesis of the populist position, the work of Adorno, Horkheimer, Marcuse, and others is an intensely theoretical one and provides a working method-

9

ology for the close analysis of precisely those products of the culture industry which it stigmatizes and which the radical view exalted. Briefly, this view can be characterized as the extension and application of Marxist theories of commodity reification to the works of mass culture. The theory of reification (here strongly overlaid with Max Weber's analysis of rationalization) describes the way in which, under capitalism, the older traditional forms of human activity are instrumentally reorganized and "taylorized," analytically fragmented and reconstructed according to various rational models of efficiency, and essentially restructured along the lines of a differentiation between means and ends. This is a paradoxical idea: it cannot be properly appreciated until it is understood to what degree the means/ends split effectively brackets or suspends ends themselves, hence the strategic value of the Frankfurt School term "instrumentalization" which usefully foregrounds the organization of the means themselves over against any particular end or value which is assigned to their practice. In traditional activity, in other words, the value of the activity is immanent to it, and qualitatively distinct from other ends or values articulated in other forms of human work or play. Socially, this meant that various kinds of work in such communities were properly incomparable; in ancient Greece, for instance, the familiar Aristotelian schema of the fourfold causes at work in handicraft or *poeisis* (material, formal, efficient, and final) were applicable only to artisanal labor, and not to agriculture or war which had a quite different "natural"—which is to say supernatural or divine—basis.[2] It is only with the universal commodification of labor power, which Marx's *Capital* designates as the fundamental precondition of capitalism, that all forms of human labor can be separated out from their unique qualitative differentiation as distinct types of activity (mining as opposed to farming, opera composition as distinct from textile manufacture), and all universally ranged under the common denominator of the quantitative, that is, under the universal exchange value of money.[3] At this point, then, the quality of the various forms of human activity, their unique and distinct "ends" or values, has effectively been bracketed or suspended by the market system, leaving all these activities free to be ruthlessly reorganized in efficiency terms, as sheer means or instrumentality.

The force of the application of this notion to works of art can be measured against the definition of art by traditional aesthetic philosophy (in particular by Kant) as a "finality without an end," that is, as a goal-oriented activity which nonetheless has no practical purpose or end in the "real world" of business or politics or concrete human praxis generally. This traditional definition surely holds for all art

that works as such: not for stories that fall flat or home movies or inept poetic scribblings, but rather for the successful works of mass and high culture alike. We suspend our real lives and our immediate practical preoccupations just as completely when we watch *The Godfather* as when we read *The Wings of the Dove* or hear a Beethoven sonata.

At this point, however, the concept of the commodity introduces the possibility of structural and historical differentiation into what was conceived as the universal description of the aesthetic experience as such and in whatever form. The concept of the commodity cuts across the phenomenon of reification—described above in terms of activity or production—from a different angle, that of consumption. In a world in which everything, including labor power, has become a commodity, ends remain no less undifferentiated than in the production schema—they are all rigorously quantified, and have become abstractly comparable through the medium of money, their respective price or wage—yet we can now formulate their instrumentalization, their reorganization along the means/ends split, in a new way by saying that, by its transformation into a commodity, a thing of whatever type has been reduced to a means for its own consumption. It no longer has any qualitative value in itself, but only insofar as it can be "used": the various forms of activity lose their immanent intrinsic satisfactions as activity and become means to an end.

The objects of the commodity world of capitalism also shed their independent "being" and intrinsic qualities and come to be so many instruments of commodity satisfaction: the familiar example is that of tourism—the American tourist no longer lets the landscape "be in its being" as Heidegger would have said, but takes a snapshot of it, thereby graphically transforming space into its own material image. The concrete activity of looking at a landscape—including, no doubt, the disquieting bewilderment with the activity itself, the anxiety that must arise when human beings, confronting the non-human, wonder what they are doing there and what the point or purpose of such a confrontation might be in the first place[4]—is thus comfortably replaced by the act of taking possession of it and converting it into a form of personal property. This is the meaning of the great scene in Godard's *Les Carabiniers* (1962–63) when the new world conquerors exhibit their spoils: unlike Alexander, "Michel-Ange" and "Ulysse" merely own images of everything, and triumphantly display their postcards of the Coliseum, the pyramids, Wall Street, Angkor Wat, like so many dirty pictures. This is also the sense of Guy Debord's assertion, in an important book, *The Society of The Spectacle*, that the ultimate form of commodity reification in contemporary consumer

society is precisely the image itself.[5] With this universal commodification of our object world, the familiar accounts of the other-directedness of contemporary conspicuous consumption and of the sexualization of our objects and activities are also given: the new model car is essentially an image for other people to have of us, and we consume, less the thing itself, than its abstract idea, open to all the libidinal investments ingeniously arrayed for us by advertising.

It is clear that such an account of commodification has immediate relevance to aesthetics, if only because it implies that everything in consumer society has taken on an aesthetic dimension. The force of the Adorno-Horkheimer analysis of the culture industry, however, lies in its demonstration of the unexpected and imperceptible introduction of commodity structure into the very form and content of the work of art itself. Yet this is something like the ultimate squaring of the circle, the triumph of instrumentalization over that "finality without an end" which is art itself, the steady conquest and colonization of the ultimate realm of non-practicality, of sheer play and anti-use, by the logic of the world of means and ends. But how can the sheer materiality of a poetic sentence be "used" in that sense? And while it is clear how we can buy the idea of an automobile or smoke for the sheer libidinal image of actors, writers, and models with cigarettes in their hands, it is much less clear how a narrative could be "consumed" for the benefit of its own idea.

In its simplest form, this view of instrumentalized culture—and it is implicit in the aesthetics of the *Tel Quel* group as well as in that of the Frankfurt School—suggests that the reading process is itself restructured along a means/ends differentiation. It is instructive here to juxtapose Auerbach's discussion of the *Odyssey* in *Mimesis*, and his description of the way in which at every point the poem is as it were vertical to itself, self-contained, each verse paragraph and tableau somehow timeless and immanent, bereft of any necessary or indispensible links with what precedes it and what follows; in this light it becomes possible to appreciate the strangeness, the historical unnaturality (in a Brechtian sense) of contemporary books which, like detective stories, you read "for the end"—the bulk of the pages becoming sheer devalued means to an end—in this case, the "solution" which is itself utterly insignificant insofar as we are not thereby in the real world and by the latter's practical standards the identity of an imaginary murderer is supremely trivial.

The detective story is to be sure an extremely specialized form: still, the essential commodification of which it may serve as an emblem can be detected everywhere in the sub-genres of contemporary com-

mercial art, in the way in which the materialization of this or that sector or zone of such forms comes to constitute an end and a consumption-satisfaction around which the rest of the work is then "degraded" to the status of sheer means. Thus, in the older adventure tale, not only does the *dénouement* (victory of hero or villains, discovery of the treasure, rescue of the heroine or the imprisoned comrades, foiling of a monstrous plot, or arrival in time to reveal an urgent message or a secret) stand as the reified end in view of which the rest of the narrative is consumed—this reifying structure also reaches down into the very page-by-page detail of the book's composition. Each chapter recapitulates a smaller consumption process in its own right, ending with the frozen image of a new and catastrophic reversal of the situation, constructing the smaller gratifications of a flat character who actualizes his single potentiality (the "choleric" Ned Land finally exploding in anger), organizing its sentences into paragraphs each of which is a sub-plot in its own right, or around the object-like stasis of the "fateful" sentence or the "dramatic" tableau, the whole tempo of such reading meanwhile overprogrammed by its intermittent illustrations which, either before or after the fact, reconfirm our readerly business, which is to transform the transparent flow of language as much as possible into material images and objects we can consume.[6]

Yet this is still a relatively primitive stage in the commodification of narrative. More subtle and more interesting is the way in which, since naturalism, the best-seller has tended to produce a quasi-material "feeling tone" which floats about the narrative but is only intermittently realized by it: the sense of destiny in family novels, for instance or the "epic" rhythms of the earth or of great movements of "history" in the various sagas can be seen as so many commodities towards whose consumption the narratives are little more than means, their essential materiality then being confirmed and embodied in the movie music that accompanies their screen versions.[7] This structural differentiation of narrative and consumable feeling tone is a broader and historically and formally more significant manifestation of the kind of "fetishism of hearing" which Adorno denounced when he spoke about the way the contemporary listener restructures a classical symphony so that the sonata form itself becomes an instrumental means toward the consumption of the isolatable tune or melody.

It will be clear, then, that I consider the Frankfurt's School analysis of the commodity structure of mass culture of the greatest interest; if, below, I propose a somewhat different way of looking at the same phenomena, it is not because I feel that their approach has been exhausted. On the contrary, we have scarcely begun to work out all

the consequences of such descriptions, let along to make an exhaustive inventory of variant models and of other features besides commodity reification in terms of which such artifacts might be analyzed.

What is unsatisfactory about the Frankfurt School's position is not its negative and critical apparatus, but rather the positive value on which the latter depends, namely the valorization of traditional modernist high art as the locus of some genuinely critical and subversive, "autonomous" aesthetic production. Here Adorno's later work (as well as Marcuse's *The Aesthetic Dimension*) mark a retreat over the former's dialectically ambivalent assessment, in *The Philosophy of Modern Music*, of Arnold Schoenberg's achievement: what has been omitted from the later judgments is precisely Adorno's fundamental discovery of the historicity, and in particular, the irreversible aging process, of the greatest modernist forms. But if this is so, then the great work of modern high culture—whether it be Schoenberg, Beckett, or even Brecht himself—cannot serve as a fixed point or eternal standard against which to measure the "degraded" status of mass culture: indeed, fragmentary and as yet undeveloped tendencies[8] in recent art production—hyper- or photo-realism in visual art; "new music" of the type of Lamonte Young, Terry Riley, or Philip Glass; post-modernist literary texts like those of Pynchon—suggest an increasing interpenetration of high and mass cultures.

For all these reasons, it seems to me that we must rethink the opposition high culture/mass culture in such a way that the emphasis on evaluation to which it has traditionally given rise—and which however the binary system of value operates (mass culture is popular and thus more authentic than high culture, high culture is autonomous and, therefore, utterly incomparable to a degraded mass culture) tends to function in some timeless realm of absolute aesthetic judgment—is replaced by a genuinely historical and dialectical approach to these phenomena. Such an approach demands that we read high and mass culture as objectively related and dialectically interdependent phenomena, as twin and inseparable forms of the fission of aesthetic production under capitalism. In this, capitalism's third or multinational stage, however, the dilemma of the double standard of high and mass culture remains, but it has become—not the subjective problem of our own standards of judgment—but rather an objective contradiction which has its own social grounding.

Indeed, this view of the emergence of mass culture obliges us historically to respecify the nature of the "high culture" to which it has conventionally been opposed: the older culture critics indeed tended loosely to raise comparative issues about the "popular culture" of the past. Thus, if you see Greek tragedy, Shakespeare, *Don Quijote*, still

widely read romantic lyrics of the type of Hugo, and best-selling realistic novels like those of Balzac or Dickens, as uniting a wide "popular" audience with high aesthetic quality, then you are fatally locked into such false problems as the relative value—weighed against Shakespeare or even Dickens—of such popular contemporary auteurs of high quality as Chaplin, John Ford, Hitchcock, or even Robert Frost, Andrew Wyeth, Simenon, or John O'Hara. The utter senselessness of this interesting subject of conversation becomes clear when it is understood that from a historical point of view the only form of "high culture" which can be said to constitute the dialectical opposite of mass culture is that high culture production contemporaneous with the latter, which is to say that artistic production generally designated as *modernism*. The other term would then be Wallace Stevens, or Joyce, or Schoenberg, or Jackson Pollock, but surely not cultural artifacts such as the novels of Balzac or the plays of Molière which essentially antedate the historical separation between high and mass culture.

But such specification clearly obliges us to rethink our definitions of mass culture as well: the commercial products of the latter can surely not without intellectual dishonesty be assimilated to so-called popular, let alone folk, art of the past, which reflected and were dependent for their production on quite different social realities, and were in fact the "organic" expression of so many distinct social communities or castes, such as the peasant village, the court, the medieval town, the polis, and even the classical bourgeoisie when it was still a unified social group with its own cultural specificity. The historically unique tendential effect of late capitalism on all such groups has been to dissolve and to fragment or atomize them into agglomerations (*Gesellschaften*) of isolated and equivalent private individuals, by way of the corrosive action of universal commodification and the market system. Thus, the "popular" as such no longer exists, except under very specific and marginalized conditions (internal and external pockets of so-called underdevelopment within the capitalist world system); the commodity production of contemporary or industrial mass culture has nothing whatsoever to do, and nothing in common, with older forms of popular or folk art.

Thus understood, the dialectical opposition and profound structural interrelatedness of modernism and contemporary mass culture opens up a whole new field for cultural study, which promises to be more intelligible historically and socially than research or disciplines which have strategically conceived their missions as a specialization in this or that branch (e.g., in the university, English departments vs. Popular Culture programs). Now the emphasis must lie squarely on the social

and aesthetic situation—the dilemma of form and of a public—shared and faced by both modernism and mass culture, but "solved" in antithetical ways. Modernism also can only be adequately understood in terms of that commodity production whose all-informing structural influence on mass culture I have described above: only for modernism, the omnipresence of the commodity form, *not* to be a commodity, to devise an aesthetic language incapable of offering commodity satisfaction, and resistant to instrumentalization. The difference between this position and the valorization of modernism by the Frankfurt School (or, later, by *Tel Quel*) lies in my designation of modernism as reactive, that is, as a symptom and as a result of cultural crises, rather than a new "solution" in its own right: not only is the commodity the prior form in terms of which alone modernism can be structurally grasped, but the very terms of its solution—the conception of the modernist text as the production and the protest of an isolated individual, and the logic of its sign systems as so many private languages ("styles") and private religions—are contradictory and made the social or collective realization of its aesthetic project (Mallarmé's ideal of *Le Livre* can be taken as the latter's fundamental formulation[9]) an impossible one (a judgment which, it ought not to be necessary to add, is not a judgment of value about the "greatness" of the modernist texts).

Yet there are other aspects of the situation of art under monopoly and late capitalism which have remained unexplored and offer equally rich perspectives in which to examine modernism and mass culture and their structural dependency. Another such issue, for example, is that of *materialization* in contemporary art—a phenomenon woefully misunderstood by much contemporary Marxist theory (for obvious reasons, it is not an issue that has attracted academic formalism). Here the misunderstanding is dramatized by the pejorative emphasis of the Hegelian tradition (Lukács as well as the Frankfurt School) on phenomena of aesthetic reification—which furnishes the term of a negative value judgment—in juxtaposition to the celebration of the "material signifier" and the "materiality of the text" or of "textual production" by the French tradition which appeals for its authority to Althusser and Lacan. If you are willing to entertain the possibility that "reification" and the emergence of increasingly materialized signifiers are one and the same phenomenon—both historically and culturally—then this ideological great debate turns out to be based on a fundamental misunderstanding. Once again, the confusion stems from the introduction of the false problem of value (which fatally programs every binary opposition into its good and bad, positive and negative, essential and inessential terms) into a more properly ambivalent dialectical and historical situation in which reification or

materialization is a key structural feature of both modernism and mass culture.

The task of defining this new area of study would then initially involve making an inventory of other such problematic themes or phenomena in terms of which the interrelationship of mass culture and modernism can usefully be explored, something it is too early to do here. At this point, I will merely note one further such theme, which has seemed to me to be of the greatest significance in specifying the antithetical formal reactions of modernism and mass culture to their common social situation, and that is the notion of *repetition*. This concepts, which in its modern form we owe to Kierkegaard, has known rich and interesting new elaborations in recent post-structuralism: for Jean Baudrillard, for example, the repetitive structure of what he calls the simulacrum (that is, the reproduction of "copies" which have no original) characterizes the commodity production of consumer capitalism and marks our object world with an unreality and a free-floating absence of "the referent" (e.g., the place hitherto taken by nature, by raw materials and primary production, or by the "originals" of artisanal production or handicraft) utterly unlike anything experienced in any earlier social formation.

If this is the case, then we would expect repetition to constitute yet another feature of the contradictory situation of contemporary aesthetic production to which both modernism and mass culture in one way or another cannot but react. This is in fact the case, and one need only invoke the traditional ideological stance of all modernizing theory and practice from the romantics to the *Tel Quel* group, and passing through the hegemonic formulations of classical Anglo-American modernism, to observe the strategic emphasis on innovation and novelty, the obligatory break with previous styles, the pressure— geometrically increasing with the ever swifter temporality of consumer society, with its yearly or quarterly style and fashion changes— to "make it new," to produce something which resists and breaks through the force of gravity of repetition as a universal feature of commodity equivalence. Such aesthetic ideologies have, to be sure, no critical or theoretical value—for one thing, they are purely formal, and by abstracting some empty concept of innovation from the concrete content of stylistic change in any given period end up flattening out even the history of forms, let alone social history, and projecting a kind of cyclical view of change—yet they are useful symptoms for detecting the ways in which the various modernisms have been forced, in spite of themselves, and in the very flesh and bone of their form, to respond to the objective reality of repetition itself. In our own time, the post-modernist conception of a "text" and the ideal of schizophrenic

writing openly demonstrate this vocation of the modernist aesthetic to produce sentences which are radically discontinuous, and which defy repetition not merely on the level of the break with older forms or older formal models but now within the microcosm of the text itself. Meanwhile, the kinds of repetition which, from Gertrude Stein to Robbe-Grillet, the modernist project has appropriated and made its own, can be seen as a kind of homeopathic strategy whereby the scandalous and intolerable external irritant is drawn into the aesthetic process itself and thereby systematically worked over, "acted out," and symbolically neutralized.

But it is clear that the influence of repetition on mass culture has been no less decisive. Indeed, it has frequently been observed that the older generic discourses—stigmatized by the various modernist revolutions, which have successively repudiated the older fixed forms of lyric, tragedy, and comedy, and at length even "the novel" itself, now replaced by the unclassifiable "livre" or "text"—retain a powerful afterlife in the realm of mass culture. Paperback drugstore or airport displays reinforce all of the now sub-generic distinctions between gothic, best-seller, mysteries, science fiction, biography, or pornography, as do the conventional classification of weekly tv series, and the production and marketing of Hollywood films (to be sure, the generic system at work in contemporary commercial film is utterly distinct from the traditional pattern of the 1930s and 1940s production, and has had to respond to television competition by devising new meta-generic or omnibus forms, which, however, at once become new "genres" in their own right, and fold back into the usual generic stereotyping and reproduction—as, recently, with disaster film or occult film).

But we must specify this development historically: the older pre-capitalist genres were signs of something like an aesthetic "contract" between a cultural producer and a certain homogeneous class or group public; they drew their vitality from the social and collective status (which to be sure, varied widely according to the mode of production in question) of the situation of aesthetic production and consumption—that is to say, from the fact that the relationship between artist and public was still in one way or another a social institution and a concrete social and interpersonal relationship with its own validation and specificity. With the coming of the market, this institutional status of artistic consumption and production vanishes: art becomes one more branch of commodity production, the artist loses all social status and faces the options of becoming a *poète maudit* or a journalist, the relationship to the public is problematized, and the latter becomes a virtual "public introuvable" (the appeals to posterity,

Stendhal's dedication "To the Happy Few," or Gertrude Stein's remark, "I write for myself and for strangers," are revealing testimony to this intolerable new state of affairs).

The survival of genre in emergent mass culture can thus in no way be taken as a return to the stability of the publics of pre-capitalist societies: on the contrary, the generic forms and signals of mass culture are very specifically to be understood as the historical reappropriation and displacement of older structures in the service of the qualitatively very different situation of repetition. The atomized or serial "public" of mass culture wants to see the same thing over and over again, hence the urgency of the generic structure and the generic signal: if you doubt this, think of your own consternation at finding that the paperback you selected from the mystery shelf turns out to be a romance or a science fiction novel; think of the exasperation of people in the row next to you who bought their tickets imagining that they were about to see a thriller or a political mystery instead of the horror or occult film actually underway. Think also of the much misunderstood "aesthetic bankruptcy" of television: the structural reason for the inability of the various television series to produce episodes which are either socially "realistic" or have an aesthetic and formal autonomy that transcends mere variation has little enough to do with the talent of the people involved (although it is certainly exacerbated by the increasing "exhaustion" of material and the ever-increasing tempo of the production of new episodes), but lies precisely in our "set" towards repetition. Even if you are a reader of Kafka or Dostoyevsky, when you watch a cop show or a detective series, you do so in expectation of the stereotyped format and would be annoyed to find the video narrative making "high cultural" demands on you. Much the same situation obtains for film, where it has however been institutionalized as the distinction between American (now multinational) film—determining the expection of generic repetition—and foreign films, which determine a shifting of gears of the "horizon of expectations" to the reception of high cultural discourse or so-called art films.

This situation has important consequences for the analysis of mass culture which have not yet been fully appreciated. The philosophical paradox of repetition—formulated by Kierkegaard, Freud, and others—can be grasped in this, that it can as it were only take place "a second time." The first-time event is by definition not a repetition of anything; it is then reconverted into repetition the second time round, by the peculiar action of what Freud called "retroactivity" [*Nachträglichkeit*]. But this means that, as with the simulacrum, there is no "first time" of repetition, no "original" of which succeeding repetitions

are mere copies; and here too, modernism furnishes a curious echo in its production of books which, like Hegel's *Phenomenology* or Proust or *Finnegans Wake*, you can only *reread*. Still, in modernism, the hermetic text remains, not only as an Everest to assault, but also as a book to whose stable reality you can return over and over again. In mass culture, repetition effectively volatilizes the original object— the "test," the "work of art"—so that the student of mass culture has no primary object of study.

The most striking demonstration of this process can be witnessed in our reception of contemporary pop music of whatever type—the various kinds of rock, blues, country western, or disco. I will argue that we never hear any of the singles produced in these genres "for the first time"; instead, we live a constant exposure to them in all kinds of different situations, from the steady beat of the car radio through the sounds at lunch, or in the work place, or in shopping centers, all the way to those apparently full-dress performances of the "work" in a nightclub or stadium concert or on the records you buy and take home to hear. This is a very different situation from the first bewildered audition of a complicated classical piece, which you hear again in the concert hall or listen to at home. The passionate attachment one can form to this or that pop single, the rich personal investment of all kinds of private associations and existential symbolism which is the feature of such attachment, are fully as much a function of our own familiarity as of the work itself: the pop single, by means of repetition, insensibly becomes part of the existential fabric of our own lives, so that what we listen to is ourselves, our own previous auditions.[10]

Under these circumstances, it would make no sense to try to recover a feeling for the "original" musical text, as it really was, or as it might have been heard "for the first time." Whatever the results of such a scholarly or analytical project, its object of study would be quite distinct, quite differently constituted, from the same "musical text" grasped as mass culture, or in other works, as sheer repetition. The dilemma of the student of mass culture therefore lies in the structural absence, or repetitive volatilization, of the "primary texts"; nor is anything to be gained by reconstituting a "corpus" of texts after the fashion of, say, the medievalists who work with pre-capitalist generic and repetitive structures only superficially similar to those of contemporary mass or commercial culture. Nor, to my mind, is anything explained by recourse to the currently fashionable term of "intertextuality," which seems to me at best to designate a problem rather than a solution. Mass culture presents us with a methodological dilemma

which the conventional habit of positing a stable object of commentary or exegesis in the form of a primary text or work is disturbingly unable to focus, let along to resolve; in this sense, also, a dialectical conception of this field of study in which modernism and mass culture are grasped as a single historical and aesthetic phenomenon has the advantage of positing the survival of the primary text at one of its poles, and thus providing a guide-rail for the bewildering exploration of the aesthetic universe which lies at the other, a message or semiotic bombardment from which the textual referent has disappeared.

The above reflections by no means raise, let alone address, all the most urgent issues which confront an approach to mass culture today. In particular, we have neglected a somewhat different judgment on mass culture, which also loosely derives from the Frankfurt School position on the subject, but whose adherents number "radicals" as well as "elitists" on the Left today. This is the conception of mass culture as sheer manipulation, sheer commercial brainwashing and empty distraction by the multinational corporations who obviously control every feature of the production and distribution of mass culture today. If this were the case, then it is clear that the study of mass culture would at best be assimilated to the anatomy of the techniques of ideological marketing and be subsumed under the analysis of advertising texts and materials. Roland Barthes's seminal investigation of the latter, however, in his *Mythologies*, opened them up to the whole realm of the operations and functions of culture in everyday life; but since the sociologists of manipulation (with the exception, of course, of the Frankfurt School itself) have, almost by definition, no interest in the hermetic or "high" art production whose dialectical interdependency with mass culture we have argued above, the general effect of their position is to suppress considerations of culture altogether, save as a kind of sandbox affair on the most epiphenomenal level of the superstructure.

The implication is thus to suggest that real social life—the only features of social life worth addressing or taking into consideration when political theory and strategy is at stake—are what the Marxian tradition designates as the political, the ideological, and the juridical levels of superstructural reality. Not only is this repression of the cultural moment determined by the university structure and by the ideologies of the various disciplines—thus, political science and sociology at best consign cultural issues to that ghettoizing rubric and marginalized field of specialization called the "sociology of culture"— it is also and in a more general way the unwitting perpetuation of the most fundamental ideological stance of American business society

itself, for which "culture"—reduced to plays and poems and high-brow concerts—is par excellence the most trivial and non-serious activity in the "real life" of the rat race of daily existence.

Yet even the vocation of the esthete (last sighted in the U.S. during the pre-political heyday of the 1950s) and of his successor, the university literature professor acknowledging uniquely high cultural "values," had a socially symbolic content and expressed (generally unconsciously) the anxiety aroused by market competition and the repudiation of the primacy of business pursuits and business values: these are then, to be sure, as thoroughly repressed from academic formalism as culture is from the work of the sociologists of manipulation, a repression which goes a long way towards accounting for the resistance and defensiveness of contemporary literary study towards anything which smacks of the painful reintroduction of just that "real life"—the socio-economic, the historical context—which it was the function of aesthetic vocation to deny or to mask out in the first place.

What we must ask the sociologists of manipulation, however, is whether culture, far from being an occasional matter of the reading of a monthly good book or a trip to the drive-in, is not the very element of consumer society itself. No society, indeed, has ever been saturated with signs and messages like this one. If we follow Debord's argument about the omnipresence and the omnipotence of the image in consumer capitalism today, then if anything the priorities of the real become reversed, and everything is mediated by culture, to the point where even the political and the ideological "levels" have initially to be disentangled from their primary mode of representation which is cultural. Howard Jarvis, Jimmy Carter, even Castro, the Red Brigade, B. J. Vorster, the Communist "penetration" of Africa, the war in Vietnam, strikes, inflation itself—all are images, all come before us with the immediacy of cultural representations about which one can be fairly certain that they are by a long shot not historical reality itself. If we want to go on believing in categories like social class, then we are going to have to dig for them in the insubstantial bottomless realm of cultural and collective fantasy. Even ideology has in our society lost its clarity as prejudice, false consciousness, readily identifiable opinion: our racism gets all mixed up with clean-cut black actors on tv and in commercials, our sexism has to make a detour through new stereotypes of the "women's libber" on the network series. After that, if one wants to stress the primacy of the political, so be it: until the omnipresence of culture in this society is even dimly sensed, realistic conceptions of the nature and function of political praxis today can scarcely be framed.

It is true that manipulation theory sometimes finds a special place

in its scheme for those rare cultural objects which can be said to have overt political and social content: sixties protest songs, *The Salt of the Earth*, (Biberman, 1954), Clancy Sigal's novels or Sol Yurick's, Chicano murals, the San Francisco Mime Troop. This is not the place to raise the complicated problem of political art today, except to say that our business as culture critics requires us to raise it, and to rethink what are still essentially thirties categories in some new and more satisfactory contemporary way. But the problem of political art—and we have nothing worth saying about it if we do not realize that it is a problem, rather than a choice or a ready-made option— suggests an important qualification to the scheme outlined in the first part of the present essay. The implied presupposition of those earlier remarks was that authentic cultural creation is dependent for its existence on authentic collective life, on the vitality of the "organic" social group in whatever form (and such groups can range from the classical polis to the peasant village, from the commonality of the ghetto to the shared values of an embattled pre-revolutionary bour- geoisie). Capitalism systematically dissolves the fabric of all cohesive social groups without exception, including its own ruling class, and thereby problematizes aesthetic production and linguistic invention which have their source in group life. The result, discussed above, is the dialectical fission of older aesthetic expression into two modes, modernism and mass culture, equally dissociated from group praxis. Both of these modes have attained an admirable level of technical virtuosity; but it is a daydream to expect that either of these semiotic structures could be retransformed, by fiat, miracle, or sheet talent, into what could be called, in its strong form, political art, or in a more general way, that living and authentic culture of which we have virtually lost the memory, so rare an experience it has become. This is to way that of the two most influential recent Left aesthetics—the Brecht-Benjamin position, which hoped for the transformation of the nascent mass-cultural techniques and channels of communication of the 1930s into an openly political art, and the *Tel Quel* position which reaffirms the "subversive" and revolutionary efficacy of language revo- lution and modernist and post-modernist formal innovation—we must reluctantly conclude that neither addresses the specific condi- tions of our own time.

The only authentic cultural production today has seemed to be that which can draw on the collective experience of marginal pockets of the social life of the world system: black literature and blues, British working-class rock, women's literature, gay literature, the *roman qué- bécois*, the literature of the Third World; and this production is possi- ble only to the degree to which these forms of collective life or collec-

tive solidarity have not yet been fully penetrated by the market and by the commodity system. This is not necessarily a negative prognosis, unless you believe in an increasingly windless and all-embracing total system; what shatters such a system—it has unquestionably been falling into place all around us since the development of industrial capitalism—is however very precisely collective praxis or, to pronounce its traditional unmentionable name, class struggle. Yet the relationship between class struggle and cultural production is not an immediate one; you do not reinvent an access onto political art and authentic cultural production by studding your individual artistic discourse with class and political signals. Rather, class struggle, and the slow and intermittent development of genuine class consciousness, are themselves the process whereby a new and organic group constitutes itself, whereby the collective breaks through the reified atomization (Sartre calls it the seriality) of capitalist social life. At that point, to say that the group exists and that it generates its own specific cultural life and expression, are one and the same. That is, if you like, the third term missing from my initial picture of the fate of the aesthetic and the cultural under capitalism; yet no useful purpose is served by speculation on the forms such a third and authentic type of cultural language might take in situations which do not yet exist. As for the artists, for them too "the owl of Minerva takes its flight at dusk," for them too, as with Lenin in April, the test of historical inevitability is always after the fact, and they cannot be told any more than the rest of us what is historically possible until after it has been tried.

This said, we can now return to the question of mass culture and manipulation. Brecht taught us that under the right circumstances you could remake anybody over into anything you liked (*Mann ist Mann*), only he insisted on the situation and the raw materials fully as much or more than on the techniques stressed by manipulation theory. Perhaps the key problem about the concept, or pseudo-concept, of manipulation can be dramatized by juxtaposing it to the Freudian notion of repression. The Freudian mechanism indeed, comes into play only after its object—trauma, charged memory, guilty or threatening desire, anxiety—has in some way been aroused, and risks emerging into the subject's consciousness. Freudian repression is therefore determinate, it has specific content, and may even be said to be something like a "recognition" of that content which expresses itself in the form of denial, forgetfulness, slip, *mauvaise foi*, displacement or substitution.

But of course the classical Freudian model of the work of art (as of the dream or the joke) was that of the symbolic fulfillment of the

repressed wish, of a complex structure of indirection whereby desire could elude the repressive censor and achieve some measure of a, to be sure, purely symbolic satisfaction. A more recent "revision" of the Freudian model, however—Norman Holland's *The Dynamics of Literary Response*—proposes a scheme more useful for our present problem, which is to conceive (how) (commercial) works of art can possibly be said to "manipulate" their publics. For Holland, the psychic function of the work of art must be described in such a way that these two inconsistent and even incompatible features of aesthetic gratification—on the one hand, its wish-fulfilling function, but on the other the necessity that its symbolic structure protect the psyche against the frightening and potentially damaging eruption of powerful archaic desires and wish-material—be somehow harmonized and assigned their place as twin drives of a single structure. Hence Holland's suggestive conception of the vocation of the work of art to *manage* this raw material of the drives and the archaic wish or fantasy material. To rewrite the concept of a management of desire in social terms now allows us to think repression and wish-fulfillment together within the unity of a single mechanism, which gives and takes alike in a kind of psychic compromise or horse-trading; which strategically arouses fantasy content within careful symbolic containment structures which defuse it, gratifying intolerable, unrealizable, properly imperishable desires only to the degree to which they can be momentarily stilled.

This model seems to me to permit a far more adequate account of the mechanisms of manipulation, diversion, and degradation, which are undeniably at work in mass culture and in the media. In particular it allows us to grasp mass culture not as empty distraction or "mere" false consciousness, but rather as a transformational work on social and political anxieties and fantasies which must then have some effective presence in the mass cultural text in order subsequently to be "managed" or repressed. Indeed, the initial reflections of the present essay suggest that such a thesis ought to be extended to modernism as well, even though I will not here be able to develop this part of the argument further.[11] I will therefore argue that both mass culture and modernism have as much content, in the loose sense of the word, as the older social realisms; but that this content is processed in all three in very different ways. Both modernism and mass culture entertain relations of repression with the fundamental social anxieties and concerns, hopes and blind spots, ideological antinomies and fantasies of disaster, which are their raw material; only where modernism tends to handle this material by producing compensatory structures of various kinds, mass culture represses them by the narrative construction

of imaginary resolutions and by the projection of an optical illusion of social harmony.

I will now demonstrate this proposition by a reading of three extremely successful recent commercial films: Steven Spielberg's *Jaws* (1975) and the two parts of Francis Ford Coppola's *The Godfather*, (1972, 1974). The readings I will propose are at least consistent with my earlier remarks about the volatilization of the primary text in mass culture by repetition, to the degree of which they are differential, "intertextually" comparative decodings of each of these filmic messages.

In the case of *Jaws*, however, the version or variant against which the film will be read is not the shoddy and disappointing sequels, but rather the best-selling novel by Peter Benchly from which the film— one of the most successful box office attractions in movie history— was adapted. As we will see, the adaptation involved significant changes from the original narrative; my attention to these strategic alterations may indeed arouse some initial suspicion of the official or "manifest" content preserved in both these texts, and on which most of the discussion of *Jaws* has tended to focus. Thus critics from Gore Vidal and *Pravda* all the way to Stephen Heath[12] have tended to emphasize the problem of the shark itself and what it "represents": such speculation ranges from the psychoanalytic to historic anxieties about the Other that menaces American society—whether it be the Communist conspiracy or the Third World—and even to internal fears about the unreality of daily life in America today, and in particular the haunting and unmentionable persistence of the organic—of birth, copulation, and death—which the cellophane society of consumer capitalism desperately recontains in hospitals and old age homes, and sanitizes by means of a whole strategy of linguistic euphemisms which enlarge the older, purely sexual ones: on this view, the Nantucket beaches "represent" consumer society itself, with its glossy and commodified images of gratification, and its scandalous and fragile, ever suppressed, sense of its own possible mortality.

Now none of these readings can be said to be wrong or aberrant, but their very multiplicity suggests that the vocation of the symbol— the killer shark—lies less in any single message or meaning that in its very capacity to absorb and organize all of these quite distinct anxieties together. As a symbolic vehicle, then, the shark must be understood in terms of its essentially polysemous function rather than any particular content attributable to it by this or that spectator. Yet it is precisely this polysemousness which is profoundly ideological, insofar as it allows essentially social and historical anxieties to be folded back

into apparently "natural" ones, both to express and to be recontained in what looks like a conflict with other forms of biological existence.

Interpretive emphasis on the shark, indeed, tends to drive all these quite varied readings in the direction of myth criticism, where the shark is naturally enough taken to be the most recent embodiment of Leviathan, so that the struggle with it effortlessly folds back into one of the fundamental paradigms or archetypes of Northrop Frye's storehouse of myth. To rewrite the film in terms of myth is thus to emphasize what I will shortly call its Utopian dimension, that is, its ritual celebration of the renewal of the social order and its salvation, not merely from divine wrath, but also from unworthy leadership.

But to put it this way is also to begin to shift our attention from the shark itself to the emergence of the hero—or heroes—whose mythic task it is to rid the civilized world of the archetypal monster. That is, however, precisely the issue—the nature and the specification of the "mythic" hero—about which the discrepancies between the film and the novel have something instructive to tell us. For the novel involves an undisguised expression of class conflict in the tension between the island cop, Brody (Roy Scheider), and the high-society oceanographer, Hooper (Richard Dreyfuss), who used to summer in Easthampton and ends up sleeping with Brody's wife: Hooper is indeed a much more important figure in the novel than in the film, while by the same token the novel assigns the shark-hunter, Quint (Robert Shaw), a very minor role in comparison to his crucial presence in the film. Yet the most dramatic surprise the novel holds in store for viewers of the film will evidently be the discovery that in the book Hooper dies, a virtual suicide and a sacrifice to his somber and romantic fascination with death in the person of the shark. Now while it is unclear to me how the American reading public can have responded to the rather alien and exotic resonance of this element of the fantasy—the aristocratic obsession with death would seem to be a more European motif—the social overtones of the novel's resolution—the triumph of the islander and the yankee over the decadent playboy challenger—are surely unmistakable, as is the systematic elimination and suppression of all such class overtones from the film itself.

The latter therefore provides us with a striking illustration of a whole work of displacement by which the written narrative of an essentially class fantasy has been transformed, in the Hollywood product, into something quite different, which it now remains to characterize. Gone is the whole decadent and aristocratic brooding over death, along with the erotic rivalry in which class antagonisms were dramatized; the Hooper of the film is nothing but a technocratic whiz-kid,

no tragic hero but instead a good-natured creature of grants and foundations and scientific know-how. But Brody has also undergone an important modification: he is no longer the small-town island boy married to a girl from a socially prominent summer family; rather, he has been transformed into a retired cop from New York City, relocating on Nantucket in an effort to flee the hassle of urban crime, race war, and ghettoization. The figure of Brody now therefore introduces overtones and connotations of law-and-order, rather than a yankee shrewdness, and functions as a tv police-show hero transposed into this apparently more sheltered but in reality equally contradictory milieu which is the great American summer vacation.

I will therefore suggest that in the film the socially resonant conflict between these two characters has, for some reason that remains to be formulated, been transformed into a vision of their ultimate partnership, and joint triumph over Leviathan. This is then clearly the moment to turn to Quint, whose enlarged role in the film thereby becomes strategic. The myth-critical option for reading this figure must at once be noted: it is indeed tempting to see Quint as the end term of the threefold figure of the ages of man into which the team of shark-hunters is so obviously articulated, Hooper and Brody then standing as youth and maturity over against Quint's authority as an elder. But such a reading leaves the basic interpretive problem intact: what can be the allegorical meaning of a ritual in which the older figure follows the intertextual paradigm of Melville's Ahab to destruction while the other two paddle back in triumph on the wreckage of his vessel? Or, to formulate it in a different way, why is the Ishmael survivor-figure split into the two survivors of the film (and credited with the triumphant destruction of the monster in the bargain)?

Quint's determinations in the film seem to be of two kinds: first, unlike the bureaucracies of law enforcement and science-and-technology (Brody and Hooper), but also in distinction to the corrupt island Major with his tourist investments and big business interests, Quint is defined as the locus of old-fashioned private enterprise, of the individual entrepreneurship not merely of small business, but also of local business—hence the insistence on his salty Down-East typicality. Meanwhile—but this feature is also a new addition to the very schematic treatment of the figure of Quint in the novel—he also strongly associates himself with a now distant American past by way of his otherwise gratuitous reminiscences about World War II and the campaign in the Pacific. We are thus authorized to read the death of Quint in the film as the twofold symbolic destruction of an older America— the America of small business and individual private enterprise of a now outmoded kind, but also the America of the New Deal and the

crusade against Nazism, the older America of the depression and the war and of the heyday of classical liberalism.

Now the content of the partnership between Hooper and Brody projected by the film may be specified socially and politically, as the allegory of an alliance between the forces of law-and-order and the new technocracy of the multinational corporations: an alliance which must be cemented, not merely by its fantasized triumph over the ill-defined menace of the shark itself, but above all by the indispensable precondition of the effacement of that more traditional image of an older America which must be eliminated from historical conscious-ness and social memory before the new power system takes its place. This operation may continue to be read in terms of mythic archetypes, if one likes, but then in that case it is a Utopian and ritual vision which is also a whole—very alarming—political and social program. It touches on present-day social contradictions and anxieties only to use them for its new task of ideological resolution, symbolically urging us to bury the older populisms and to respond to an image of political partnership which projects a whole new strategy of legitimation; and it effectively displaces the class antagonisms between rich and poor which persist in consumer society (and in the novel from which the film was adapted) by substituting for them a new and spurious kind of fraternity in which the viewer rejoices without understanding that he or she is excluded from it.

Jaws is therefore an excellent example, not merely of ideological manipulation, but also of the way in which genuine social and histori-cal content must be first tapped and given some initial expression if it is subsequently to be the object of successful manipulation and containment. In my second reading, I want to give this new model of manipulation an even more decisive and paradoxical turn: I will now indeed argue that we cannot fully do justice to the ideological function of works like these unless we are willing to concede the presence within them of a more positive function as well: of what I will call, following the Frankfurt School, their Utopian or transcendent poten-tial—that dimension of even the most degraded type of mass culture which remains implicitly, and no matter how faintly, negative and critical of the social order from which, as a product and a commodity, it springs. At this point in the argument, then, the hypothesis is that the works of mass culture cannot be ideological without at one and the same time being implicitly or explicitly Utopian as well: they cannot manipulate unless they offer some genuine shred of content as a fantasy bribe to the public about to be so manipulated. Even the "false consciousness" of so monstrous a phenomenon of Nazism was nourished by collective fantasies of a Utopian type, in "socialist" as

well as in nationalist guises. Our proposition about the drawing power of the works of mass culture has implied that such works cannot manage anxieties about the social order unless they have first revived them and given them some rudimentary expression; we will now suggest that anxiety and hope are two faces of the same collective consciousness, so that the works of mass culture, even if their function lies in the legitimation of the existing order—or some worse one— cannot do their job without deflecting in the latter's service the deepest and most fundamental hopes and fantasies of the collectivity, to which they can therefore, no matter in how distorted a fashion, be found to have given voice.

We therefore need a method capable of doing justice to both the ideological and the Utopian or transcendent functions of mass culture simultaneously. Nothing less will do, as the suppression of either of these terms may testify: we have already commented on the sterility of the older kind of ideological analysis, which, ignoring the Utopian components of mass culture, ends up with the empty denunciation of the latter's manipulatory function and degraded status. But it is equally obvious that the complementary extreme—a method that would celebrate Utopian impulses in the absence of any conception or mention of the ideological vocation of mass culture—simply reproduces the litanies of myth criticism at its most academic and aestheticizing and impoverishes these texts of their semantic content at the same time that it abstracts them from their concrete social and historical situation.

The two parts of the *The Godfather* have seemed to me to offer a virtual textbook illustration of these propositions; for one thing, recapitulating the whole generic tradition of the gangster film, it reinvents a certain "myth" of the Mafia in such a way as to allow us to see that ideology is not necessarily a matter of false consciousness, or of the incorrect or distorted representation of historical "fact," but can rather be quite consistent with a "realistic" faithfulness to the latter. To be sure, historical inaccuracy (as, e.g., when the fifties are telescoped into the sixties and seventies in the narrative of Jimmy Hoffa's career in the 1978 move, *F.I.S.T.*) can often provide a suggestive lead towards ideological function: not because there is any scientific virtue in the facts themselves, but rather as a symptom of a resistance of the "logic of the content," of the substance of historicity in question, to the narrative and ideological paradigm into which it has been thereby forcibly assimilated.[13]

The Godfather, however, obviously works in and is a permutation of a generic convention; one could write a history of the changing social and ideological functions of this convention, showing how analogous

motifs are called upon in distinct historical situations to emit strategically distinct yet symbolically intelligible messages. Thus the gangsters of the classical thirties films (Robinson, Cagney, etc.) were dramatized as psychopaths, sick loners striking out against a society essentially made up of wholesome people (the archetypal democratic "common man" of New Deal populism). The post-war gangsters of the Bogart era remain loners in this sense but have unexpectedly become invested with tragic pathos in such a way as to express the confusion of veterans returning from World War II, struggling with the unsympathetic rigidity of institutions, and ultimately crushed by a petty and vindictive social order. *westerns*

The Mafia material was drawn on and alluded to in these earlier versions of the gangster paradigm, but did not emerge as such until the late fifties and the early sixties. This very distinctive narrative content—a kind of saga or family material analogous to that of the medieval *chansons de geste*, with its recurrent episodes and legendary figures returning again and again in different perspectives and contexts—can at once be structurally differentiated from the older paradigms by its collective nature: in this, reflecting an evolution towards organizational themes and team narratives which studies like Will Wright's book on the western, *Sixguns* and *Society*, have shown to be significant developments in the other sub-genres of mass culture (the western, the caper film, etc.) during the 1960s.[14]

Such an evolution, however, suggests a global transformation of post-war American social life and a global transformation of the potential logic of its narrative content without yet specifying the ideological function of the mafia paradigm itself. Yet this is surely not very difficult to identify. When indeed we reflect on an organized conspiracy against the public, one which reaches into every corner of our daily lives and our political structures to exercise a wanton ecocidal and genocidal violence at the behest of distant decision-makers and in the name of an abstract conception of profit—surely it is not about the Mafia, but rather about American business itself that we are thinking, American capitalism in its most systematized and computerized, dehumanized, "multinational" and corporate form. What kind of crime, said Brecht, is the robbing of a bank, compared to the founding of a bank? Yet until recent years, American business has enjoyed a singular freedom from popular criticism and articulated collective resentment; since the depolitization of the New Deal, the McCarthy era and the beginning of the Cold War and of media or consumer society, it has known an inexplicable holiday from the kinds of populist antagonisms which have only recently (white collar crime, hostility to utility companies or to the medical profession) shown signs of

reemerging. Such freedom from blame is all the more remarkable when we observe the increasing squalor that daily life in the U.S. owes to big business and to its unenviable position as the purest form of commodity and market capitalism functioning anywhere in the world today.

This is the context in which the ideological function of the myth of the mafia can be understood, as the substitution of crime for big business, as the strategic displacement of all the rage generated by the American system onto this mirror image of big business provided by the movie screen and the various tv series, it being understood that the fascination with the Mafia remains ideological even if in reality organized crime has exactly the importance and influence in American life which such representations attribute to it. The function of the Mafia narrative is indeed to encourage the conviction that the deterioration of the daily life in the United States today is an ethical rather than economic matter, connected, not with profit, but rather "merely" with dishonesty, and with some omnipresent moral corruption whose ultimate mythic source lies in the pure Evil of the Mafiosi themselves. For genuinely political insights into the economic realities of late capitalism, the myth of the mafia strategically substitutes the vision of what is seen to be a criminal aberration from the norm, rather than the norm itself; indeed, the displacement of political and historical analysis by ethical judgments and considerations is generally the sign of an ideological maneuver and of the intent to mystify. Mafia movies thus project a "solution" to social contradictions—incorruptibility, honesty, crime fighting, and finally law-and-order itself—which is evidently a very different proposition from that diagnosis of the American misery whose prescription would be social revolution.

But if this is the ideological function of Mafia narratives like *The Godfather*, what can be said to be their transcendent or Utopian function? The latter is to be sought, it seems to me, in the fantasy message projected by the title of this film, that is, in the family itself, seen as a figure of collectivity and as the object of a Utopian longing, if not a Utopian envy. A narrative synthesis like *The Godfather* is possible only at the conjuncture in which ethnic content—the reference to an alien collectivity—comes to fill the older gangster schemas and to inflect them powerfully in the direction of the social; the superposition on conspiracy of fantasy material related to ethnic groups then triggers the Utopian function of this transformed narrative paradigm. In the United States, indeed, ethnic groups are not only the object of prejudice, they are also the object of envy; and these two impulses are deeply intermingled and reinforce each other mutually. The dominant

white middle-class groups—already given over to *anomie* and social fragmentation and atomization—find in the ethnic and racial groups which are the object of their social repression and status contempt at one and the same time the image of some older collective ghetto or ethnic neighborhood solidarity; they feel the envy and *ressentiment* of the *Gesellschaft* for the older *Gemeinschaft* which it is simultaneously exploiting and liquidating.

Thus, at a time when the disintegration of the dominant communities is persistently "explained" in the (profoundly ideological) terms of a deterioration of the family, the growth of permissiveness, and the loss of authority of the father, the ethnic group can seem to project an image of social reintegration by way of the patriarchal and authoritarian family of the past. Thus the tightly knit bonds of the Mafia family (in both senses), the protective security of the (god-)father with his omnipresent authority, offers a contemporary pretext for a Utopian fantasy which can no longer express itself through such outmoded paradigms and stereotypes as the image of the now extinct American small town.

The drawing power of a mass cultural artifact like *The Godfather* may thus be measured by its twin capacity to perform an urgent ideological function at the same time that it provides the vehicle for the investment of a desperate Utopian fantasy. Yet the film is doubly interesting from our present point of view in the way in which its sequel—released from the restrictions of Mario Puzo's best-selling novel on which Part I was based—tangibly betrays the momentum and the operation of an ideological and Utopian logic in something like a free or unbound State. *Godfather II*, indeed, offers a striking illustration of Pierre Macherey's thesis, in *Towards a Theory of Literary Production*, that the work of art does not so much *express* ideology as, by endowing the latter with aesthetic representation and figuration, it ends up enacting the latter's own virtual unmasking and self-criticism.

It is as though the unconscious ideological and Utopian impulses at work in *Godfather I* could in the sequel be observed to work themselves towards the light and towards thematic or reflexive foregrounding in their own right. The first film held the two dimensions of ideology and Utopia together within a single generic structure, whose conventions remained intact. With the second film, however, this structure falls as it were into history itself, which submits it to a patient deconstruction that will in the end leave its ideological content undisguised and its displacements visible to the naked eye. Thus the Mafia material, which in the first film served as a substitute for business, now slowly transforms itself into the overt thematics of business itself, just as "in

reality" the need for the cover of legitimate investments ends up turning the Mafiosi into real businessmen. The climactic end moment of the historical development is then reached (in the film, but also in real history) when American business, and with it American imperialism, meet that supreme ultimate obstacle to their internal dynamism and structurally necessary expansion which is the Cuban Revolution.

Meanwhile, the utopian strand of this filmic text, the material of the older patriarchal family, now slowly disengages itself from this first or ideological one, and, working its way back in time to its own historical origins, betrays its roots in the pre-capitalist social formation of a backward and feudal Sicily. Thus these two narrative impulses as it were reverse each other: the ideological myth of the Mafia ends up generating the authentically Utopian vision of revolutionary liberation; while the degraded Utopian content of the family paradigm ultimately unmasks itself as the survival of more archaic forms of repression and sexism and violence. Meanwhile, both of these narrative strands, freed to pursue their own inner logic to its limits, are thereby driven to the other reaches and historical boundaries of capitalism itself, the one as it touches the pre-capitalist societies of the past, the other at the beginnings of the future and the dawn of socialism.

These two parts of *The Godfather*—the second so much more demonstrably political than the first—may serve to dramatize our second basic proposition in the present essay, namely the thesis that all contemporary works of art—whether those of high culture and modernism or of mass culture and commercial culture—have as their underlying impulse—albeit in what is often distorted and repressed unconscious form—our deepest fantasies about the nature of social life, both as we live it now, and as we feel in our bones it ought rather to be lived. To reawaken, in the midst of a privatized and psychologizing society, obsessed with commodities and bombarded by the ideological slogans of big business, some sense of the ineradicable drive towards collectivity that can be detected, no matter how faintly and feebly, in the most degraded works of mass culture just as surely as in the classics of modernism—is surely an indispensable precondition for any meaningful Marxist intervention in contemporary culture.

(1979)

2.

Class and Allegory in Contemporary Mass Culture: *Dog Day Afternoon* as a Political Film

One of the most persistent leitmotivs in liberalism's ideological arsenal, one of the most effective anti-Marxist arguments developed by the rhetoric of liberalism and anticommunism, is the notion of the disappearance of class. The argument is generally conveyed in the form of an empirical observation, but can take a number of different forms, the most important ones for us being either the appeal to the unique development of social life in the United States (so called American exceptionalism), or the notion of a qualitative break, a quantum leap, between the older industrial systems and what now comes to be called "post-industrial," society. In the first version of the argument, we are told that the existence of the frontier (and, when the real frontier disappeared, the persistence of that "inner" frontier of a vast continental market unimaginable to Europeans) prevented the formation of the older, strictly European class antagonisms, while the absence from the United States of a classical aristocracy of the European type is said to account for the failure of a classical bourgeoisie to develop in this country—a bourgeoisie which would then, following the continental model, have generated a classical proletariat over against itself. This is what we may call the American mythic explanation, and seems to flourish primarily in those American Studies programs which have a vested interest in preserving the specificity of their object and in preserving the boundaries of their discipline.

The second version is a little less parochial and takes into account what used to be called the Americanization, not only of the older European societies, but also, in our time, that of the Third World as well. It reflects the realities of the transition of monopoly capitalism into a more purely consumer stage on what is for the first time a global scale; and it tries to take advantage of the emergence of this new stage of monopoly capitalism to suggest that classical Marxist economics is no longer applicable. According to this argument, a

social homogenization is taking place in which the older class differences are disappearing, and which can be described either as the embourgeoisement of the worker, or better still, the transformation of both bourgeois and worker into that new grey organization person known as the consumer. Meanwhile, although most of the ideologues of a post-industrial stage would hesitate to claim that value as such is no longer being produced in consumer society, they are at least anxious to suggest that ours is becoming a "service economy" in which production of the classical types occupies an ever dwindling percentage of the work force.

Now if it is so that the Marxian concept of social class is a category of nineteenth-century European conditions, and no longer relevant to our situation today, then it is clear that Marxism may be sent to the museum where it can be dissected by Marxologists (there are an increasing number of those at work all around us today) and can no longer interfere with the development of that streamlined and postmodern legitimation of American economic evolution in the seventies and beyond, which is clearly the most urgent business on the agenda now that the older rhetoric of a classical New Deal type liberalism has succumbed to unplanned obsolescence. On the left, meanwhile, the failure of a theory of class seemed less important practically and politically during the anti-war situation of the 1960s, in which attacks on authoritarianism, racism, and sexism had their own internal justification and logic, and were lent urgency by the existence of the war, and content by the collective practice of social groups, in particular students, blacks, browns, and women. What is becoming clearer today is that the demands for equality and justice projected by such groups are not (unlike the politics of social class) intrinsically subversive. Rather, the slogans of populism and the ideals of racial justice and sexual equality were already themselves part and parcel of the Enlightenment itself, inherent not only in a socialist denunciation of capitalism, but even and also in the bourgeois revolution against the ancien régime. The values of the civil rights movement and the women's movement and the anti-authoritarian egalitarianism of the student's movement are thus preeminently cooptable because they are already—as ideals—inscribed in the very ideology of capitalism itself; and we must take into account the possibility that these ideals are part of the internal logic of the system, which has a fundamental interest in social equality to the degree to which it needs to transform as many of its subjects or its citizens into identical consumers interchangeable with everybody else. The Marxian position—which includes the ideals of the Enlightenment but seeks to ground them in a materialist theory of social evolution—argues on the contrary that

the system is structurally unable to realize such ideals even where it has an economic interest in doing so.

This is the sense in which the categories of race and sex as well as the generational ones of the student movement are theoretically subordinate to the categories of social class, even where they may seem practically and politically a great deal more relevant. Yet it is not adequate to argue the importance of class on the basis of an underlying class reality beneath a relatively more classless appearance. There is, after all, a reality of the appearance just as much as a reality behind it; or, to put it more concretely, social class is not merely a structural fact but also very significantly a function of class consciousness, and the latter, indeed, ends up producing the former just as surely as it is produced by it. This is the point at which dialectical thinking becomes unavoidable, teaching us that we cannot speak of an underlying "essence" of things, of a fundamental class structure inherent in a system in which one group of people produces value for another group, unless we allow for the dialectical possibility that even this fundamental "reality," may be "realer" at some historical junctures than at others, and that the underlying object of our thoughts and representations—history and class structure—is itself as profoundly historical as our own capacity to grasp it. We may take as the motto for such a process the following still extremely Hegelian sentence of the early Marx: "It is not enough that thought should seek to realize itself; reality must also strive towards thought."

In the present context, the "thought" towards which reality strives is not only or even not yet class consciousness: it is rather the very preconditions for such class consciousness in social reality itself, that is to say, the requirement that, for people to become aware of the class, the classes be already in some sense perceptible as such. This fundamental requirement we will call, now borrowing a term from Freud rather than from Marx, the requirement of *figurability*, the need for social reality and everyday life to have developed to the point at which its underlying class structure becomes *representable* in tangible form. The point can be made in a different way by underscoring the unexpectedly vital role that culture would be called on to play in such a process, culture not only as an instrument of self-consciousness but even before that as a symptom and a sign of possible self-consciousness in the first place. The relationship between class consciousness and figurability, in other words, demands something more basic than abstract knowledge, and implies a mode of experience that is more visceral and existential than the abstract certainties of economics and Marxian social science: the latter merely continue to convince us of the information presence, behind daily life, of the logic of capitalist

production. To be sure, as Althusser tells us, the concept of sugar does not have to taste sweet. Nonetheless, in order for genuine class consciousness to be possible, we have to begin to sense the abstract truth of class through the tangible medium of daily life in vivid and experiential ways; and to say that class structure is becoming representable means that we have now gone beyond mere abstract understanding and entered that whole area of personal fantasy, collective storytelling, narrative figurability—which is the domain of culture and no longer that of abstract sociology or economic analysis. To become figurable—that is to say, visible in the first place, accessible to our imaginations—the classes have to be able to become in some sense characters in their own right: this is the sense in which the term allegory in our title is to be taken as a working hypothesis.

We will have thereby also already begun to justify an approach to commercial film, as that medium where, if at all, some change in the class character of social reality ought to be detectable, since social reality and the stereotypes of our experience of everyday social reality are the raw material with which commercial film and television are inevitably forced to work. This is my answer, in advance, to critics who object a priori that the immense costs of commercial films, which inevitably place their production under the control of multinational corporations, make any genuinely political content in them unlikely, and on the contrary ensure commercial film's vocation as a vehicle for ideological manipulation. No doubt this is so, if we remain on the level of the intention of the filmmaker who is bound to be limited consciously or unconsciously by the objective situation. But it is to fail to reckon with the political content of daily life, with the political logic which is already inherent in the raw material with which the filmmaker must work: such political logic will then not manifest itself as an overt political message, nor will it transform the film into an unambiguous political statement. But it will certainly make for the emergence of profound formal contradictions to which the public cannot not be sensitive, whether or not it yet possesses the conceptual instruments to understand what those contradictions mean.

In any case, *Dog Day Afternoon* (1975), would seem to have a great deal more overt political content than we would normally expect to find in a Hollywood production. In fact, we have only to think of the CIA-type espionage thriller, or the police show on television, to realize that overt political content of that kind is so omnipresent as to be inescapable in the entertainment industry. It is indeed as though the major legacy of the sixties was to furnish a whole new code, a whole new set of thematics—that of the political—with which, after that of sex, the entertainment industry could reinvest its tired paradigms

without any danger to itself or to the system; and we should take into account the possibility that is it the overtly political or contestatory parts of *Dog Day Afternoon* which will prove the least functional from a class point of view.

But before this becomes clear, we will want to start a little further back, with the anecdotal material in which the film takes its point of departure. The event itself is not so far removed in time that we cannot remember it for what it was; or more precisely, remember what the media found interesting about it, what made it worthwhile transforming into a feature story in its own right an otherwise banal bank robbery and siege with hostages, of the type with which countless newscasts and grade-B movies have familiarized us in the past. Three novelties distinguished the robbery on which *Dog Day Afternoon* was to be based: first, the crowd sympathized with the bank robber, booing at the police and evoking the then still very recent Attica massacre; second, the bank robber turned out to be a homosexual, or, more properly, to have gone through a homosexual marriage ceremony with a transsexual, and indeed later claimed to have committed the robbery in order to finance his partner's sex-change operation; finally, the television cameras and on the spot telephone interviews were so heavily involved in the day-long negotiations as to give a striking new twist to the concept of the "media-event": and to this feature, we should probably add the final sub-novelty that the robbery took place on the climactic day of the Nixon-Agnew nominating convention (August 22, 1972).[1]

A work of art that had been able to do justice to any one of these peculiarities by itself would have been assured of an unavoidably political resonance. The Sidney Lumet film, "faithfully" incorporating all three, ended up having very little—and it is probably too easy, although not incorrect, to say that they cancel each other out by projecting a set of circumstances too unique to have any generalizable meaning: literature, as Aristotle tells us, being more philosophical than history in that it shows us what can happen, where the latter only shows us what did happen. Indeed, I believe a case can be made for the ideological function of overexposure in commercial culture: the repeated stereotypical use of otherwise disturbing and alien phenomena in our present social conjuncture—political militancy, student revolt, drugs, resistance to and hatred of authority—has an effect of containment for the system as a whole. To name something is to domesticate it, to refer to it repeatedly is to persuade a fearful and beleaguered middle-class public that all of that is part of a known and catalogued world and thus somehow in order. Such a process would then be the equivalent, in the realm of everyday social life, of that

cooptation by the media, that exhaustion of novel raw material, which is one of our principal techniques for defusing threatening and subversive ideas. If something like this is the case, then clearly *Dog Day Afternoon*, with its wealth of anti-social detail, may be thought to work overtime in the reprocessing of alarming social materials for the reassurance of suburban moviegoers.

Turning to those raw materials themselves, it is worth taking a passing glance at what the film did not become. Ours is, after all, a period and a public with an appetite for the documentary fact, for the anecdotal, the *vécu*, the *fait divers*, the true story in all its sociological freshness and unpredictability. Not to go as far back as the abortive yet symptomatic "non-fiction novel," nor even the undoubted primacy of non-fiction over fiction on the best-seller lists, we find a particularly striking embodiment of this interest in a whole series of recent experiments on American television with the fictional documentary (or docudrama): narrative reports, played by actors, of sensational crimes, like the Manson murders or the Shepherd case or the trail of John Henry Faulk, or of otherwise curious *fait divers*—like a flying saucer sighting by a bi-racial couple, Truman's climactic confrontation with MacArthur, or an ostracism at West Point. We would have understood a great deal if we could explain why *Dog Day Afternoon* fails to have anything in common with these fictional documentaries, which are far and away among the best things achieved by American commercial television, their success at least in part attributable to the distance which such pseudo-documentaries maintain between the real-life fact and its representation. The more powerful of them preserve the existence of a secret in their historical content, and, at the same time that they purport to give us a version of the events, exacerbate our certainty that we will never know for sure what really did happen. (This structural disjunction between form and content clearly projects a very different aesthetic strategy from those of classical Griersonian documentary, of Italian neo-realism, or of Kino-pravda or ciné-verité, to name only three of the older attempts to solve the problem of the relationship between movies and fact or event, attempts which now seem closed to us).

While it is clear that *Dog Day Afternoon* has none of the strengths of any of these strategies and does not even try for them, the juxtaposition has the benefit of dramatizing and reinforcing all of the recent French critiques of representation as an ideological category. What sharply differentiates the Lumet film for any of the TV pseudo-documentaries just mentioned is precisely, if you will, its unity of form and content: we are made secure in the illusion that the camera is witnessing everything exactly as it happened and that what it sees is

all there is. The camera is absolute presence and absolute truth: thus, the aesthetic of representation collapses the density of the historical event, and flattens it back out into fiction. The older values of realism, living on in commercial film, empty the anecdotal raw material of its interest and vitality; while, paradoxically, the patently degraded techniques of television narrative, irremediably condemned by their application to and juxtaposition with advertising, end up preserving the truth of the event by underscoring their own distance from it. Meanwhile, it is the very splendor of Al Pacino's virtuoso performance which marks it off from any possibility of *verismo* and irreparably condemns it to remain a Hollywood product: the star system is fundamentally, structurally, irreconcilable with neo-realism.

This is indeed the basic paradox I want to argue and to deepen in the following remarks: that what is good about the film is what is bad about it, and what is bad about it is, on the contrary, rather good in many ways; that everything which makes it a first-rate piece of filmmaking, with bravura actors, must render it suspect from another point of view, while its historical originality is to be sought in places that must seem accidental with respect to its intrinsic qualities. Yet this is not a state of things that could have been remedied by careful planning: it is not a mismatch that could have been avoided had the producers divided up their material properly, and planned a neo-realist documentary on the one hand, and a glossy robbery film on the other. Rather, we have to do here with that unresolvable, profoundly symptomatic thing which is called a contradiction, and which we may expect, if properly managed and interrogated, to raise some basic issues about the direction of contemporary culture and contemporary social reality.

What is clear from the outset is that *Dog Day Afternoon* is an ambiguous product at the level of reception; more than that, that the film is so structured that it can be focused in two quite distinct ways which seem to yield two quite distinct narrative experiences. I've promised to show that one of these narratives suggests an evolution, or at least a transformation, in the figurable class articulation of everyday life. But this is certainly not the most obvious or the most accessible reading of the film, which initially seems to inscribe itself in a very different, and for us today surely much more regressive tradition. This is what we may loosely call the existential paradigm, in the non-technical sense of this term, using it in that middle-brow media acceptation in which in current American culture it has come to designate *Catch–22* or Mailer's novels. Existentialism here means neither Heidegger nor Sartre, but rather the anti-hero of the sad sack, Saul Bellow type, and a kind of self-pitying vision of alienation (also meant in its

media rather than its technical sense), frustration, and above all—
yesterday's all-American concept—the "inability to communicate."
Whether this particular narrative paradigm be the cause or the effect
of the systematic psychologization and privatization of the ideology
of the fifties and early sixties, it is clear that things change more
slowly in the cultural and narrative realm than they do in the more
purely ideological one, so that writers and filmmakers tend to fall
back on paradigms such as this who would otherwise have no trouble
recognizing a dated, no-longer-fashionable idea. Meanwhile, this "un-
equal development" of the narrative paradigms through which we
explain daily life to ourselves is then redoubled by another trend
in contemporary consumerism, namely the return to the fifties, the
nostalgia fad or what the French call "la mode rétro," in other words
the deliberate substitution of the pastiche and imitation of past styles
for the impossible invention of adequate contemporary or post-con-
temporary ones (as in a novel like *Ragtime*).

Thus, as if it were not enough that the political and collective
urgencies of the sixties consigned the anti-hero and the anti-novel to
the ash-can of history, we now find them being revived as a paradoxi-
cal sign of the good old days when all we had to worry about were
psychological problems, momism, and whether television would ruin
American culture. I would argue, for instance, not only that Miloš
Forman's 1975 *One Flew over the Cuckoo's Nest* (from the Kesey novel
of 1962) is a typical fifties nostalgia film, which revives all of the
stereotypical protests of that bygone individualistic era, but also that,
virtually a Czech film in disguise, it reduplicates that particular time
lag by another, more characteristically Central European form of
"unequal development."

Method acting was the working out of the ideology of the anti-
hero in that relatively more concrete realm of theatrical style, voice,
gesture, which borders on the behavioral stances and gestural idiom,
the interpersonal languages, of everyday life, where it is indeed the
stylization and effect of elements already present in the parts of the
American community, and also the cause and model of newer kinds
of behavior that adapt it to the street and to the real world. Here for
the first time perhaps we can understand concretely how what is best
about *Dog Day Afternoon* is also what is least good about it: for Al
Pacino's performance as Sonny by its very brilliance thrusts the film
further and further back into the antiquated paradigm of the anti-
hero and the method actor. Indeed, the internal contradiction of his
performance is even more striking than that: for the anti-hero, as we
suggested, was predicated on non-communication and inarticulacy,
from Frédéric Moreau and Kafka's K's all the way to Bellow, Mala-

mud, Roth, and the rest; and the agonies and exhalations of method acting were perfectly calculated to render this asphyxiation of the spirit that cannot complete its sentence. But in Pacino's second-generation reappropriation of this style something paradoxical happens, namely, that the inarticulate becomes the highest form of expressiveness, the wordless stammer proves voluble, and the agony over uncommunicability suddenly turns out to be everywhere fluently comprehensible.

At this point, then, something different begins to happen, and Sonny's story ceases to express the pathos of the isolated individual or the existential loner in much the same way that the raw material from which it is drawn—that of marginality or deviancy—has ceased to be thought of as anti-social and has rather become a new social category in its own right. The gesture of revolt and the cry of rage begin to lose their frustration—the expression "impotent rage" had been a stereotype of American storytelling from Faulkner, indeed, from Norris and Dreiser, on—and to take on another meaning. Not because of any new political content to be sure: for Sonny's robbery, the politics of marginality, is not much more than part of the wild-cat strikes of contemporary everyday life; but rather simply because the gesture "projects" and is understood. We mentioned the support of the crowd (both in real life and in the Lumet movie), but that is only the most conventional inscription of this tangible resonance of Sonny's gesture within the film. More significant, it seems to me, is the manifest sympathy of the suburban moviegoing audience itself, which from within the tract housing of the *société de consommation* clearly senses the relevance to its own daily life of the reenactment of this otherwise fairly predictable specimen of urban crime. Unlike the audience of the Bogart films, who had to stand by and watch the outcast mercilessly destroyed by the monolithic and omnipotent institution of Society, this one has witnessed the collapse of the system's legitimacy (and the sapping of the legitimations on which it was based): not only Vietnam, least of all Watergate, most significantly surely the experience of inflation itself, which is the privileged phenomenon through which a middle-class audience suddenly comes to an unpleasant consciousness of its own historicity—these are some of the historical reasons for that gradual crumbling of those older protestant-ethic-type values (respect for law and order, for property, and institutions) which allows a middle-class audience to root for Sonny. In the longer run, however, the explanation must be sought in the very logic of the commodity system itself, whose programing ends up liquidating even those ideological values (respect for authority, patriotism, the ideal of the family, obedience to the law) on which the social and political

order of the system rests. Thus ideal consumers—compared to their protestant-ethic ancestors, with their repressive ethics of thrift and work and self-denial—turn out to be a far more doubtful quantity than their predecessors were when it comes to fighting foreign wars or honoring your debts or cheating on your income taxes. For the citizens of some multinational stage of post-monopoly capitalism, the practical side of daily life is a test of ingenuity and a game of wits waged between the consumer and the giant faceless corporation.

These, then, are the people who understand Sonny's gesture, and whose sympathies are strangely intersected and at least arrested by the whole quite different countercultural theme of homosexuality. Yet such viewers have their counterpart within the film, not so much in the street crowd, which is only a chorus-like sign of this implicit public for Sonny's act, as rather in the hostages themselves, the women employees of the branch bank, whose changing attitudes towards Sonny thus become a significant part of what the film has to show us. Indeed, I would argue that on a second reading of the film, the relationship of form and background reverses itself, and the Sonny character—the hero, as we have seen, of a more conventional anti-hero plot—now becomes a simple pretext for the emergence and new visibility of something more fundamental in what might otherwise simply seem the background itself. This more fundamental thing is the sociological equivalent of that wholesale liquidation of older ideological values by consumer society on which we have already commented: but here it takes the more tangible form of the ghettoization of the older urban neighborhoods. The phenomenon is not an historically extremely recent one; nor is it unknown either to sociological journalism or to literature itself, where is one sense its representation may be said to go all the way back to Balzac's description of the corrosive and solvent effect of the money economy and the market system on the sleepy *Gemeinschaften* of the older provincial towns.

What is less well understood is the degree to which this process, which in the United States was significantly accelerated after the end of World War II, and thus contemporaneous with the introduction of television and the launching of the Cold War, was the result of deliberate political decisions that can be identified and dated. The post-war federal highway program and the momentum given to the construction of individual family dwellings by veterans' housing bills are essential components in the new corporate strategy:

> The 1949 Housing Act introduced the idea of federal assistance for private development of the center cities, an approach to urban renewal vigorously pushed by the General Electric Company, large

banks and insurance companies. The center cities were not to be
the site of housing development for working class people. . . . These
political and economic decisions effectively determined the pattern
of individual and residential development for the next generation.
The white working class was fated for dispersal; the center cities
were to be reserved for the very poor and the relatively affluent. In the
circumstances, durable goods purchases—cars, washing machines,
one-family houses—began to absorb an increasing proportion of
workers' incomes and had an enormous impact on work patterns.[2]

We may add that this vision of the future was first systematically
tried out on Newark, New Jersey, which may thus fairly lay claim to
something of the ominous and legendary quality which surrounds the
names of the targets of the World War II strategic bombing experi-
ments.

But there is a fundamental distortion in the way in which we have
traditionally tended to deplore such developments in contemporary
American society as the destruction of the inner city and the rise of
shopping center culture. On the whole I would think it would be fair
to say that we have thought of these developments as inevitable results
of a logic of consumer society which neither individuals nor politicians
could do very much to reverse; even radicals have been content to
stress the continuity between the present-day atomization of the older
communities and social groups and Marx's analysis of the destructive
effects of classical capitalism, from the enclosure stage all the way to
the emergence of the factory system. What is new today, what can be
sensed in the excerpt from Stanley Aronowitz's *False Promises* quoted
above just as much as in *Dog Day Afternoon* itself, is the dawning
realization that someone was responsible for all that, that such mo-
mentous social transformations were not merely part of the on-going
logic of the system—although they are certainly that too—but were
also, and above all, the consequences of the decisions of powerful and
strategically placed individuals and groups. Yet the reemergence of
these groups—the renewed possibility of once again catching sight of
what Lukács would have called the *subject* that history of which the
rest of us are still only just the *objects*—this is not to be understood as
the result of increased information on our part of so-called revisionist
historians; rather, our very possibility of rewriting history in this way
is itself to be understood as the function of a fundamental change in
the historical situation itself, and of the power and class relations that
underlie it.

Before we say what that change is, however, we want to remember
how vividly *Dog Day Afternoon* explores the space which is the result

of these historical changes, the ghettoized neighborhood with its de-
caying small businesses gradually being replaced by parking lots or
chain stores. It is no accident indeed that the principal circuit of
communications of the film passes between the mom-and-pop store
in which the police have set up their headquarters, and the branch
bank—the real-life original was appropriately enough a branch of
Chase Manhattan—in which Sonny is holding his hostages. Thus it is
possible for the truth of recent urban history to be expressed within
the framework of the bank scenes themselves; it is enough to note,
first, that everyone in the branch is nothing but a salaried employee
of an invisible multi-national empire, and then, as the film goes on,
that the work in this already peripheral and decentered, fundamen-
tally colonized, space is done by those doubly second-class and under-
payable beings who are women, and whose structurally marginal
situation is thus not without analogy to Sonny's own, or at least
reflects it in much the same way that a Third World proletariat might
reflect minority violence and crime in the First. One of the more
realistic things about recent American commercial culture, indeed,
has been its willingness to recognize and to represent at least in
passing the strange coexistence and superposition of the America of
today of social worlds as rigidly divided from each other as in a
caste system, a kind of post-Bowery and or permanent Third World
existence at the heart of the First World itself.

Yet this kind of perception does not in itself constitute that renewed
class consciousness we evoked at the beginning of this essay, but as
such merely provides the material for a rhetoric of marginality, for a
new and more virulent populism. The Marxian conception of class,
indeed, must be distinguished from the academic bourgeois sociologi-
cal one above all by its emphasis on relationality. For academic sociol-
ogy, the social classes are understood in isolation from each other,
on the order of sub-cultures or independent group "life styles": the
frequently used term "stratum" effectively conveys this view of inde-
pendent social units, which implies in turn that each can be studied
separately, without reference to one another, by some researcher who
goes out into the field. So we can have monographs on the ideology
of the professional stratus, on the political apathy of the secretarial
stratum, and so forth. For Marxism, however, these empirical observa-
tions do not yet penetrate to the structural reality of the class system
which it sees as being essentially dichotomous, at least in that latest
and last social formation of prehistory which is capitalism: "The
whole of society," a famous sentence of the *Communist Manifesto* tells
us, "is increasingly split into two great hostile camps, into two great
classes directly confronting one another: the bourgeoisie and the pro-
letariat." To which we must only add, 1) that this underlying starkly

dichotomous class antagonism only becomes fully visible empirically in times of absolute crises and polarization, that is to say, in particular, at the moment of social revolution itself; and 2) that in a henceforth worldwide class system the oppositions in question are evidently a good deal more complicated and difficult to reconstruct than they were within the more representational, or figurable, framework of the older nation state.

This said, it is evident that a Marxian theory of classes involves the restructuring of the fragmentary and unrelated data of empirical bourgeois sociology in a holistic way: in terms, Lukács would say, of the social totality, or, as his antagonist Althusser would have it, of a "pre-given complex hierarchical structure of dominant and subordinate elements." In either case, the random sub-groupings of academic sociology would find their place in determinate, although sometimes ambivalent, structural positions with respect to the dichotomous opposition of the two fundamental social classes themselves, about which innovative recent work—I'm thinking, for the bourgeoisie, of Sartre's Flaubert trilogy; for the proletariat, of the Aronowitz book already quoted from—has demonstrated the mechanisms by which each class defines itself in terms of the other and constitutes a virtual anti-class with respect to the other, and this, from overt ideological values all the way down to the most apparently non-political, "merely" cultural features of everyday life.

The difference between the Marxian view of structurally dichotomous classes and the academic sociological picture of independent strata is however more than a merely intellectual one: once again, consciousness of social reality, or on the other hand the repression of the awareness of such reality, is itself "determined by social being" in Marx's phrase and is therefore a function of the social and historical situation. A remarkable sociological investigation by Ralf Dahrendorf has indeed confirmed the view that these two approaches to the social classes—the academic and the Marxist—are themselves class-conditioned and reflect the structural perspectives of the two fundamental class positions themselves. Thus it is those on the higher rungs of the social ladder who tend to formulate their view of the social order, looking down at it, as separate strata; while those on the bottom looking up tend to map their social experience in terms of the stark opposition of "them" and "us."[3]

But if this is so, then the representation of victimized classes in isolation—whether in the person of Sonny himself as a marginal, or the bank's clerical workers as an exploited group—is not enough to constitute a class system, let alone to precipitate a beginning consciousness of class in its viewing public. Nor are the repeated references to the absent bank management sufficient to transform the

situation into a genuine class relationship, since this term does not find concrete representation—or *figuration*, to return to our earlier term—within the filmic narrative itself. Yet such representation is present in *Dog Day Afternoon*, and it is this unexpected appearance, in a part of the film where one would not normally look for it, that constitutes its greatest interest in the present context—our possibility of focusing it being as we have argued directly proportional to our ability to let go of the Sonny story and to relinquish those older narrative habits that program us to follow the individual experiences of a hero or an anti-hero, rather than the explosion of the text and the operation of meaning in other, random narrative fragments.

If we can do this—and we have begun to do so when we are willing to reverse the robbery itself, and read Sonny's role as that of a mere pretext for the revelation of that colonized space which is the branch bank, with its peripheralized or marginalized work force—then what slowly comes to occupy the film's center of gravity is the action outside the bank itself, and in particular the struggle for precedence between the local police and the FBI officials. Now there are various ways of explaining this shift of focus, none of them wrong: for one thing, we can observe that, once Sonny has been effectively barricaded inside the bank, he can no longer initiate events, the center of gravity of the narrative as such then passing to the outside. More pertinently still, since the operative paradox of the film—underscored by Al Pacino's acting—is the fundamental likeability of Sonny, this external displacement of the acting can be understood as the narrative attempt to generate an authority figure who can deal directly with him without succumbing to his charm. But this is not just a matter of narrative dynamics; it also involves an ideological answer to the fundamental question: how to imagine authority today, how to conceive imaginatively—that is in non-abstract, non-conceptual form—of a principle of authority that can express the essential impersonality and post-individualistic structure of the power structure of our society while still operating among real people, in the tangible necessities of daily life and individual situations of repression?

It is clear that the figure of the FBI agent (James Broderick) represents a narrative solution to this ideological contradiction, and the nature of the solution is underscored by the characterological styles of the FBI agents and the local police chief, Maretti (Charles Durning), whose impotent rages and passionate incompetence are there, not so much to humanize him, as rather to set off the cool and technocratic expertise of his rival. In one sense, of course, this contrast is what has nowadays come to be called an intertextual one: this is not really the encounter of two characters, who represent two "individuals," but rather the encounter of two narrative paradigms, indeed, of two narra-

tive stereotypes: the clean-cut Efrem Zimbalist-type FBI agents, with their fifties haircuts, and the earthy urban cop whose television embodiments are so multiple as to be embarrassing: FBI meets Kojak! Yet one of the most effective things in the film, and the most haunting impression left by *Dog Day Afternoon* in the area of performance, is surely not so much the febrile heroics of Al Pacino as rather their stylistic opposite, the starkly blank and emotionless, expressionless, coolness of the FBI man himself. This gazing face, behind which decision-making is reduced to (or developed into) pure technique, yet whose judgments and assessments are utterly inaccessible to spectators either within or without the filmic frame, is one of the most alarming achievements of recent American moviemaking, and may be said to embody something like the truth of a rather different but equally actual genre, the espionage thriller, where it has tended to remain obfuscated by the cumbersome theological apparatus of a dialectic of Good and Evil.

Meanwhile, the more existential and private-tragic visions of this kind of figure—I'm thinking of the lawman (Denver Pyle) in Arthur Penn's *Bonnie and Clyde* (1967)—project a nemesis which is still motivated by personal vindictiveness, so that the process of tracking the victim down retains a kind of passion of a still recognizable human type; Penn's more recent *The Missouri Breaks* (1976) tried to make an advance on this personalized dramatization of the implacability of social institutions by endowing its enforcer with a generalized paranoia (and, incidentally, furnishing Marlon Brando with the occasion of one of his supreme bravura performances); but it is not really much of an improvement and the vision remains locked in the pathos of a self-pitying and individualistic vision of history.

In *Dog Day Afternoon*, however, the organization man is neither vindictive nor paranoid; he is in the sense quite beyond the good and evil of conventional melodrama, and inaccessible to any of the psychologizing stereotypes that are indulged in most of the commercial representations of the power of institutions; his anonymous features mark a chilling and unexpected insertion of the real into the otherwise relatively predictable framework of the fiction film—and this, not, as we have pointed out earlier, by traditional documentary or montage techniques, but rather through a kind of dialectic of connotations on the level of the style of acting, a kind of silence or charged absence in a sign-system in which the other modes of performance have programmed us for a different kind of expressiveness.

Now the basic contrast, that between the police chief and the FBI agent, dramatizes a social and historical change which was once an important theme of our literature but to which we have today become so accustomed as to have lost our sensitivity to it: in their very differ-

ent ways, the novels of John O'Hara and the sociological investigations of C. Wright Mills documented a gradual but irreversible erosion of local and state-wide power structures and leadership or authority networks by national, and, in our own time, multinational ones. Think of the social hierarchy of Gibbsville coming into disillusioning contact with the new wealth and the new political hierarchies of the New Deal era; think—even more relevantly for our present purposes—of the crisis of figurability implied by this shift of power from the face-to-face small-town life situations of the older communities to the abstraction of nation-wide power (a crisis already suggested by the literary representation of "politics" as a specialized theme in itself).

The police lieutenant thus comes to incarnate the very helplessness and impotent agitation of the local power structure; and with this inflection of our reading, with this interpretive operation, the whole allegorical structure of *Dog Day Afternoon* suddenly emerges in the light of day. The FBI agent—now that we have succeeded in identifying what he supersedes—comes to occupy the place of that immense and decentralized power network which marks the present multinational stage of monopoly capitalism. The very absence in his features becomes a sign and an expression of the presence/absence of corporate power in our daily lives, all-shaping and omnipotent and yet rarely accessible in figurable terms, that is to say, in the representable form of individual actors or agents. The FBI man is thus the structural opposite of the secretarial staff of the branch bank: the latter present in all their existential individuality, but inessential and utterly marginalized, the former so depersonalized as to be little more than a marker—in the empirical world of everyday life, of *fait divers* and newspaper articles—of the place of ultimate power and control.

Yet with even this shadowy embodiment of the forces of those multinational corporate structures that are the subject of present-day world history, the possibility of genuine figuration, and with it, the possibility of a kind of beginning adequate class consciousness itself, is given. Now the class structure of the film becomes articulated in three tiers: the first, that newly atomized petty bourgeoisie of the cities whose "proletarianization" and marginalization is expressed both by the women employees on the one hand, and by the lumpens on the other (Sonny and his accomplice, Sal [John Cazale], but also the crowd itself, an embodiment of the logic of marginality that runs all the way from the "normal" deviancies of homosexuality and petty crime to the pathologies of Sal's paranoia and Ernie's [Chris Sarandon] transsexuality). A second level is constituted by the impotent power structures of the local neighborhoods, which represent something like the national bourgeoisies of the Third World, colonized and gutted of their older content, left with little more than the hollow

shells and external trappings of authority and decision making. Finally, of course, that multinational capitalism into which the older ruling classes of our world have evolved, and whose primacy is inscribed in the spatial trajectory of the film itself as it moves from the ghettoized squalor of the bank interior to that eerie and impersonal science fiction landscape of the airport finale: a corporate space without inhabitants, utterly technologized and functional, a place beyond city and country alike—collective, yet without people, automated and computerized, yet without any of that older utopian or dystopian clamor, without any of those still distinctive qualities that characterized the then still "modern" and streamlined futuristic vision of the corporate future in our own recent past. Here—as in the blank style of acting of the FBI agents—the film makes a powerful non-conceptual point by destroying its own intrinsic effects and cancelling an already powerful, yet conventional, filmic and performative language.

Two final observations about this work, the one about its ultimate aesthetic and political effects, the other about its historical conditions of possibility. Let us take the second problem first: we have here repeatedly stressed the dependence of a narrative figuration of class consciousness on the historical situation. We have stressed both the dichotomous nature of the class structure, and the dependence of class consciousness itself on the logic of the social and historical conjuncture. Marx's dictum, that consciousness is determined by social being, holds for class consciousness itself no less than for any other form. We must now therefore try to make good our claim, and say why, if some new and renewed possibility of class consciousness seems at least faintly detectable, this should be the case now and today rather than ten or twenty years ago.

But the answer to this question can be given concisely and decisively; it is implicit in the very expression, "multinational corporation," which—as great a misnomer as it may be (since all of them are in reality expressions of American capitalism)—would not have been invented had not something new suddenly emerged which seemed to demand a new name for itself. It seems to be a fact that after the failure of the Vietnam War, the so-called multinational corporations—what used to be called the "ruling classes" or later on the "power elite" of monopoly capitalism—have once again emerged in public from the wings of history to advance their own interests. The failure of the war "has meant that the advancement of world capitalist revolution now depends more on the initiative of corporations and less on governments. The increasingly political pretensions of the global corporation are thus unavoidable but they inevitably mean more public exposure, and exposure carries with it the risk of increased hostility."[4] But in our terms, the psychological language of the authors of *Global Reach*

may be translated as "class consciousness," and with this new histori-
cal visibility capitalism becomes objectified and dramatized as an
actor and as a subject of history with an allegorical intensity and
simplicity that had not been the case since the 1930s.

Now a final word about the political implications of the film itself
and the complexities of the kind of allegorical structure we have
imputed to it. Can *Dog Day Afternoon* be said to be a political film?
Surely not, since the class system we have been talking about is merely
implicit in it, and can just as easily be ignored or repressed by its
viewers as brought to consciousness. What we have been describing
is at best something pre-political, the gradual rearticulation of the
raw material of a film of this kind in terms and relationships which
are once again, after the anti-political and privatizing, "existential"
paradigms of the forties and fifties recognizably those of class.

Yet we should also understand that the use of such material is
much more complicated and problematical than the terminology of
representation would suggest. Indeed, in the process by which class
structure finds expression in the triangular relationship within the
film between Sonny, the police chief, and the FBI man, we have
left out an essential step. For the whole qualitative and dialectical
inequality of this relationship is mediated by the star system itself,
and in that sense—far more adequately than in its overt thematics of
the media exploitation of Sonny's hold-up—the film can be said to be
about itself. Indeed we reach each of the major actors in terms of his
distance from the star system: Sonny's relationship to Maretti is that
of superstar to character actor, and our reading of this particular
narrative is not a direct passage from one character or actant to
another, but passes through the mediation of our identification and
decoding of the actors' status as such. Even more interesting and
complex than this is our decoding of the FBI agent, whose anonymity
in the filmic narrative is expressed very precisely through his anonym-
ity within the framework of the Hollywood star system. The face is
blank and unreadable precisely because the actor is himself unidenti-
fiable.

In fact, of course, it is only within the coding of a Hollywood system
that he is unfamiliar, for the actor in question soon after became a
permanent feature of the durable and well-known television series,
Family (1976–80). But the point is precisely that in this respect televi-
sion and its system of references is another production, but even more,
that television comes itself to figure, with respect to Hollywood films,
that new and impersonal multinational system which is coming to
supersede the more individualistic one of an older national capitalism
and an older commodity culture. Thus, the external, extrinsic socio-
logical fact or system of realities finds itself inscribed within the

internal intrinsic experience of the film in what Sartre in a suggestive and too-little known concept in his *Psychology of Imagination* calls the analogon[5]: that structural nexus in our reading or viewing experience, in our operations of decoding or aesthetic reception, which can then do double duty and stand as the substitute and the representative within the aesthetic object of a phenomenon on the outside which cannot in the very nature of things be "rendered" directly. This complex of intra- and extra-aesthetic relationships might then be schematically represented as follows:

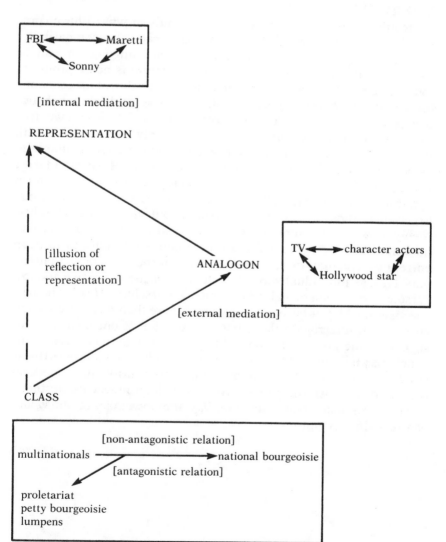

Here then we find an ultimate formal confirmation of our initial hypothesis, that what is bad about the film is what is best about it, and that the work is a paradoxical realization in which qualities and defects form an inextricable dialectical unity. For it is ultimately the star system itself—that commodity phenomenon most stubbornly irreconcilable with any documentary or ciné-verité type of exploration of the real—which is thus responsible for even that limited authenticity which *Dog Day Afternoon* is able to achieve.

AFTERWORD:
I would today say that this essay is a study in what I have come to call *cognitive mapping*[6]. It presupposes a radical incompatibility between the possibilities of an older national language or culture (which is still the framework in which literature is being produced today) and the transnational, worldwide organization of the economic infrastructure of contemporary capitalism. The result of this contradiction is a situation in which the truth of our social life as a whole—in Lukács's terms, as a totality—is increasingly irreconcilable with the possibilities of aesthetic expression or articulation available to us; a situation about which it can be asserted that if we can make a work of art from our experience, if we can give experience the form of a story that can be told, then it is no longer true, even as individual experience; and if we can grasp the truth about our world as a totality, then we may find it some purely conceptual expression but we will no longer be able to maintain an imaginative relationship to it. In current psychoanalytic terminology, we will thus be unable to insert ourselves, as individual subjects, into an ever more massive and impersonal or transpersonal reality outside ourselves. This is the perspective in which it becomes a matter of more than mere intellectual curiosity to interrogate the artistic production of our own time for signs of some new, so far only dimly conceivable, collective forms which may be expected to replace the older individualistic ones (those either of conventional realism or of a now conventionalized modernism); and it is also the perspective in which an indecisive aesthetic and cultural phenomenon like *Dog Day Afternoon* takes on the values of a revealing symptom.

(1977)

3.

Diva and
French Socialism

The first French postmodernist film enjoys an advantage denied its American equivalents (those of Brian De Palma): the privilege of a historical *conjuncture*. May 10, 1981, the date of the first left government in France for thirty-five years, draws a line beneath the disappointing neo-romantic and post-Godard French production of the 1970s, and allow *Diva* (1981), directed by Jean-Jacques Beneix, to emerge (rightly or wrongly) with all the prestige of a new thing, a break, a turn. As with Godard (but the comparison stops there), the novelty would seem to lie in the realm of the image; several generations of post-Hitchcock productions have taught us to ignore (or at best to tolerate) the thriller framework as a pretext for watching something else—although it would have been interesting to reread this brutal and perfunctory, amateurish plot in terms of the tradition of the French *policier* itself, so unfamiliar and so little known here.

Still, even in the plot something new can be detected on closer inspection: remarkably, it is that rare thing, the emergence of a new kind of *character*. Not the first glimpse, in the curious dialectic of camera-familiarity (the empiricism of the already-there, of the no-explanations-needed), of the zen millionaire, Godorosh (Richard Bohringer), meditating before his elaborate jigsaw puzzle of the ocean waves, or surly in his throne-isolated bathtub, digesting cigars and unfaithfulness: that is still predictable Sixties fallout—the mystico-marginal lifestyles gradually adopted, along with dope and love beads, by the idle rich. Curiously, however, this contemplative will stir into activity, bewildering the hero with unmotivated (yet vaguely ominous: we still think we are in a triangle-drama) tirades on the proper way to butter French bread. It is *this*—the principle of pure activity latent in the seer's contemplation—that will grow and expand before our eyes for the remaining duration of the film, as alarming as sheer physical expansion to gigantic or angelic stature: signified by

55

his appearance on the cross-beam of the abandoned hangar, far above the villain, voice magnified electronically and body augmented by technological prostheses that lower and raise objects in the void. The transformation of this minor character into the god in the machine, into the Cocteau-style guardian angel, the saviour figure whose supreme powers lie in *resourcefulness*, in know-how, in knowledge about this jungle (but is it really a jungle any longer, in spite of its stock villains and their violence?), in a mastery of postmodern urban space itself and its technological equipment—this formal transformation will determine an immense generic shift in the film's direction, and in the process open it up to the most random or heterogeneous uses, work effectively against any trivializing reunification into another well-made movie (of the Brian De Palma type).

The guardian angel never kills; he despatches villains by sheer optical, perceptual, "representational" trickery, so that it is their own traditional habits of space that destroy them. And he does it for *money:* along with the (properly post-industrial) glamorization of technological skill (see Daniel Bell), the acquisitive impulses of this new-rich yet marginal privileged elite—who seek their fortunes in the peculiar media and entertainment interstices of late capital—are not for an instant felt to be negative or destructive, let alone "alienated." In such an allegory, then, the Sixties have come to this—the unexpected emergence, not of the well-known "new subjects of history" (students, blacks, marginals, women), but of a hip new countercultural businessman, who wishes us well, who *loves* us (but is afraid it might blow our minds, like David Bowie's Starman).

The official "hero" of the film has nothing of this historical originality: Jules (Frédéric Andrei) is, on the contrary, very much a historicist allusion, the reinvention of a very traditional figure in French populist art: the *naif*, the innocent (not going back as far as Voltaire's *Candide* or as Parzifal, but certainly back to the Popular Front, to Raymond Queneau and to Renoir's "Monsieur Lange"), with all the good humor of the "people" in the older sense, the big-city kid whose urban formation is still the popular "quarter," the government functionary (he's a postman) whose instincts are not that of "bureaucracy" (in the forbidding post-contemporary sense) but of "service," in the sense of the favor or the good turn. Even his "mobilette" is a sign which vehiculates historical transformation (or recoding) within it: like blue jeans, the former emblem of post-war financial modesty—the scooter—on its way to the very different high-technology libidinal prestige of the motorcycle and the jet set. Jules's wide eyes are the space of perceptual receptivity, of the openness into which the diva's extraordinary sound will flow—the "endless melody" which consti-

tutes, better than any logic of the narrative sequence, the irreversible temporality of the film, sonata-form repetition rather than the Freudian kind, the grand "inevitability" of the climactic return.

Alongside the activity of his guardian angel, Jules can doubtless only seem to embody *passivity*, yet this now reevaluated in some unaccustomed way. Gorodish, after all, included meditation (and the countercultural *aesthetic*) within his occasional moments of accelerated yet economical praxis: symmetrically, Jules's passivity (which is rapt aesthetic reception) also includes something active within itself, yet something which cannot be thought or named but only shown. And shown it is: in the supreme moment in which, having stolen the diva's song, he brings the illicit, sacred tape home to his miraculous garage-loft—lifted, motor-bike and all, to this place beyond the world by a cumbersome archaic-mechanical freight hoist, all cables and the grating laborious passage of time (mythic-Wagnerian moments, these). The tape inserted, Jules then sprawls upon a water-sofa in the corner, abandoning his rapt body motionless for the camera to explore as for the first time it discovers the whole enormity of the place in which we find ourselves. Stricken beneath the world of sound, yet still glowing with pale colors, this is now a dead immobile landscape in which Jules's body has an unearthly pallor with few equivalents in other media: a blanched luminosity neither that of death, nor of plastic or wax, recalling only, perhaps, that ideal Barthes-Balzac hermaphrodite translucent in moonlight. It is the flesh tone of the more romantic French photorealism (as of Jacques Monory)—in contrast to the brutal polyester-and-fiber-glass sculptures of the Americans (as of Duane Hansen), at whose dumpy housewives or nude hippie lovers visitors to the Whitney embarrassingly stare or glance in passing. And it comes with the little inner jolt of the unexpected freeze-frame, the sudden deathly transformation into a still photograph, except that the camera *continues to move* and in so doing betrays the garish and *real* photorealist mural behind this staged pastiche: a whole heaven of cars in flight in all directions, a wall of open sky into which the battered material carcasses in the garage beneath have been translated and transfigured. We never see this mural in its entirety, but only fresh angled shots and ever new figures and details (the human occupants spilling out of a restive convertible, for instance); my own suspicion is that, like the multistaged eponymous being of *Alien*, it never did (does) exist as a completed thing, an object that could be represented. *Diva's* initial movement is, therefore, this one between two far-out living spaces: the somber vacant barn-like studio in which Gorodish ponders his jigsaw puzzle, fanned and swept by the winged rollerskating arabesques of his oriental compan-

ion; and this more cluttered place of Jules, whose spatial depth gets lost and absorbed into the mural, like some brighter colored last judgment on the world before it, the filmic apparatus now challenged to do battle not with its traditional rivals—the theater or the photograph or video—but with the painted image itself, and with the *wall* (a challenged also accepted by Godard, in *Passion* [1982]).

Yet this spatial opposition is also, as we have said, a historical and social one: some post-Sixties multinational modernity versus a traditional French left populism and cult of the common people of Paris that extends back over the Popular Front and the Commune all the way to the Great Revolution of 1789. But these are very precisely the terms of the new Right's *Kulturkampf* today, in the France of François Mitterand, the scenario, framed, in their resourcefulness, by the media intelligentsia of the post- and anti-Marxist *nouvelle philosophie* when they were driven back into an oppositional posture by the victory of the Left in May, 1981. On this view, whatever is associated explicitly or implicitly with "France," with Frenchness, with French traditions, is narrow, parochial, quintessentially bourgeois, and (for a Bernard-Henri Lévi) always secretly or not so secretly anti-semitic; over against those older and now archaic images, a new international (but one might better call it post-international or even "multinational") order has appeared, of which the cultural originality of the United States—primarily of New York City and of California— is the emblem, not because of some superior *national* culture North America might have developed, but rather because this new cultural space expresses the very post-national dynamic of the new media technology and of a whole new post-industrial reproductive machinery and a whole new glittering and synthetic object world. This is to reverse traditional French fears of "Americanization" with a vengeance, and to valorize a process of modernization initiated by Gaullism itself (and rebaptized as the "société de consommation" or consumer society) from a position which is cultural and political all at once. From such a position, "socialism"—not to speak of "French" socialism—whatever rhetoric of change and of the New it may invoke (and a rhetoric of Utopian urbanism, of the creation of new urban space, was a very central component in the electoral vision of the Parti socialiste)—will always be locked into that older French parochial and nationalistic tradition, haunted by Jacobin centralization in the persons of its Communist Party allies, and irremediably marked by the categories of an older French *belles-lettres* (François Mitterand is himself an elegant traditional stylist), indissolubly linked to provinciality (the role of the provincial mayors) and to the *esprit de clocher* (Mitterand periodically returning to his village and donning peasant

garb). (How the New Right's equally strident affirmation of *religion*—Solzhenitsyn, Polish Catholicism, Jewish mysticism—is consistent with a repudiation of an older French social and political dynamic in which religion played a crucial electoral role—now extinct—is no doubt to be explained by the tenacious tradition of anti-clericalism and secularism on the Left, something also today in the process of disappearing.)

This very powerful ideological vision is not without its precedents in France: one thinks irresistibly, for instance, of the Restoration period, in which the new (or "progressive") forces of the industrial bourgeoisie were identified with a by then old-fashioned 18th-century Enlightenment culture, while the landed aristocratic reaction, or at least its intellectual elite, saw themselves as the vanguard of a whole new protomodern cultural movement and style, namely Romanticism. It is a double-bind whose terms the Left would do well to refuse.

Yet it is precisely these terms which are active in *Diva*, where a traditional "France" finds allegorical expression in the figure of Jules and a post-industrial, media, jet-set style is persuasively dramatized by Gorodish. *Diva* is therefore on one of its levels a political allegory, the expression of a collective or political unconscious whose terms are very consonant with those proposed by the Right. Yet it is also clear that these two opposing terms are no longer staged according to the antagonistic scenario of the Right, but evolve a relationship of collaboration and a curious new kind of solidarity, mediated by the theme of technological reproduction on the one hand (the tape itself, the electronic machinery) and by a range of Third World women figures, of which the Diva herself, an American black (played by opera singer Wilhelmenia Fernandez), comes as an ultimate permutation and as something of a new thematic synthesis in her own right ("third world" in the First World, and an interpreter of high Western musical culture who, in the course of the film, consents to the "age of mechanical reproduction").

Yet the way in which *Diva* handles or "manages" the terms of the underlying double-bind or ideological *contradiction* will be less surprising when we consider that one of the more persistent functions of art has been, not to sharpen contradiction or to force a painful self-consciousness about irresolvable conflicts, but rather, very precisely, to evolve "imaginary resolutions of real contradictions," to use Lévi-Strauss's apt formula: non-conceptual "resolutions" in which the very narrative logic itself—like the rebus or the dream—rotates swiftly enough to generate an after-image of appeasement, of harmony, and of conflictual reconciliation, as, most classically, in the wondrous salvational reversals of late Shakespearean comedy. From the per-

spective of a resolutely political aesthetic, such "resolutions" can only seem profoundly aestheticizing in spirit, when not downright conservative; yet it seems at least pertinent to add that *Diva's* solution also implicitly repudiates the right-wing vision of an irreconcilable *conflict* between its ancients and its moderns.

Diva's very images themselves perpetuate this process: their extraordinary luminosity emits, no doubt, a secondary message about technological innovations in film stock and processing. Yet they can also be read as something of a return to the older Bazinian aesthetic, the older conception of a filmic ontology, in which effects are the result of the pre-positioning of objects, the pre-arrangement of the object world, within the shot, rather than as auto-referential exhilaration of a medium taking its contents as some mere pretext for a display of itself and its own unique "linguistic" powers. The great moments here are those of the restitution of a world transformed into images rather than infected and fragmented by them: that of the secret blueness of the Parisian night sky, as in the famous Magritte evening cityscape, or that vision of the lighthouse refuge beyond the world, and the elegant and powerful white Citroen which moves across its causeway in the breathtaking openness of dawn.

Only the primacy of the image itself, the commitment to the consumption of images and to the world's transformation into visual commodities, into a celebration of the scoptic libido, marks some kinship with American postmodernist film, of which De Palma's unaccountably neglected *Blow Out* (1981) is perhaps the most revealing specimen. Yet the latter's virtuoso images consistently and reflexively designate the medium itself and foreground the process of *reproduction* with an insistency which one is tempted to read as a fundamental symptom or secret of postmodernism itself.

The explanatory power of such an interpretation can be tested by its capacity to account for other key, yet seemingly unrelated features of this new cultural style: most notably the disappearance of *affect* in the older sense, the sudden and unexpected absence of *anxiety* as it found its now traditional vehicle in Munch's *Scream*, in Kafka's nightmares or Platonov's, or in classical existentialism. The effacement of such negative impulses is no doubt at one with the critique of the old hermeneutic or depth-psychological models and the waning of the concept of the Unconscious (as, symptomatically, in Michel Foucault's attack on the "repressive model" in his *History of Sexuality*). Yet what results is not merely neutral; the silence of affect in postmodernism is doubled with a new gratification in surfaces and accompanied by a whole new ground tone in which the pathos of high modernism has been inverted into a strange new exhilaration, the high, the

intensité, some euphoric final form of Nietzsche's Dionysian impulse now conveniently breathable at all the interstices of daily life in late capitalist space. The alienated city of the great moderns, with its oppressive streets and its constricting menace, has been unaccountably transformed into the gleaming luxury surfaces of Richard Estes's Manhattan, yielding all the new pleasures of narcissism in ways which remain to be theorized in less moralizing and ideological terms than those of Richard Sennett or Christopher Lasch.

I think that it is instructive to juxtapose these new stimulations (from which the older psychological subject, with its anxieties and its Unconscious, has vanished, along with its unique personal style and its very brushstrokes—the fingerprints of the older ego) with those of an earlier period of modern art, namely the moment of futurism and of an excitement with the streamlined machines—the motorcar, the steamship, the airplane, the turbines and grain elevators and oil refineries of what Reyner Banham has called the "first machine age." In that earlier moment, the energies of a now older capital seemed to have manifested themselves in visible, tangible, emblematic forms of a whole new object world in emergence, a whole new future already in view. Le Corbusier will then, perhaps more dramatically than any of the other high moderns, stake his Utopian transformation of space on the purifying power of such clean and exhilarating new shapes.

Mass production and the shoddy styling changes of consumer society have long since tarnished the pristine energy of those machines, while the emergence of a new structural moment in capital in our own time has been theorized by Ernest Mandel and others as involving a technological revolution in which it is very precisely those older vehicles of production which have been subsumed under the radically different industrial dynamic of the computer, of nuclear energy, and of the media. These new machines can be distinguished from the older futurist icons in two related ways: they are all sources of reproduction rather than "production," and they are no longer sculptural solids in space. The housing of a computer scarcely embodies or manifests its peculiar energies in the same way that a wing shape or a slanted smokestack do: all of which essentially means that the new reproductive technology—being a matter of *processes*— cannot be *represented* in the way in which the older mechanical energies found their representation or figuration.

Yet it is felt to constitute a *system*, a worldwide disembodied yet increasingly total system of relationships and networks hidden beneath the appearance of daily life, whose "logic" is sensed in the process of programing our outer and inner worlds, even to the point of colonizing our former "unconscious." This existential sense of a

total system, unrepresentable and detectable only in its affects like an absent cause, is, of course, itself only an aesthetic intuition of the mode of organization of late capitalism itself (which is not conceptually to be reduced or assimilated to its technologies): it is, however, what feeds postmodernism itself as the latter's fundamental situation as well as its uniquely problematical and unrepresentable content.

In films like *Blow Out*, the very processes of technological reproduction will be mustered to foreground this new systematicity, for which the content of the work is a mere pretext: film, tape, their disjunction as image and sound, open up a dialectic of perception in which the ostensible narrative ceaselessly—yet laterally—sends us back to the reproductive machinery which is its own precondition: smeared light, glass reflexion, all doing second-degree service as the visible stand-ins for the absent camera itself.

Yet as has already been suggested *Diva's* images are of a very different style from these (doubly) "reflexive" American ones: the latter gleam while the former glow. What one would like to say about *Diva* is that here the new-technological content of post-modernism has been recontained, and driven back into the narrative raw material of the work, where it becomes a simple abstract *theme*: the Diva's horror of technological reproduction, along with the incriminating posthumous testimony on the other tape—these have become "meanings" inside the work, where analogous material in *Blow Out* is scarcely meaningful or thematic anymore at all, generating on the contrary a whole celebration and "acting out" of the reproductive process as form and as the production of sounds and images.

Here too, then, as on the level of political allegory, *Diva's* "solutions" are a curious mixture of old and new, a mixture about which it is difficult enough to decide whether it is to be seen as a regressive or conservative recuperation (the newer technologies reabsorbed with an older, more ontological, practice of the image and representation) or on the contrary as a historically original "imaginary solution of a real contradiction," which may be explored for Utopian elements and possibilities, including some whole new aesthetic in emergence. Fortunately the film does not conclude either: the final frightened handclasp, the Diva's surrender to technological reproduction, her consent to Jules's virtually sexless worship of her (and the pardon for his unforgiveable "crime")—all this, freeze-framed for a last instant on the great state, in theatrical space, then rapidly recedes from us, suspended, into a distance which leaves the future wide open.

(1982)

4.

"In the Destructive Element Immerse": Hans-Jürgen Syberberg and Cultural Revolution

Had Syberberg not existed, he would have to have been invented. Perhaps he was. So that "Syberberg" may really be the last of those puppets of mythical German heroes who people his films. Consider this, which has all the predictability of the improbable: during the war a certain stereotype of the German cultural tradition ("teutonic" philosophy; music, especially Wagner) was used by both sides as ammunition in the accompanying ideological conflict; it was also offered as evidence of a German national "character." After the war it became clear that: 1) the history of high culture was not a very reliable guide to German social history generally; 2) the canon of this stereotype excluded much that may be more relevant for us today (e.g., expressionism, Weimar, Brecht); and 3) the Germany of the economic miracle, NATO, and social democracy is a very different place from rural or urban central Europe in the period before Hitler. So people stopped blaming Wagner for Nazism and began a more difficult process of collective self-analysis which culminated in the anti-authoritarian movements of the 1960s and early 1970s. It also generated a renewal of German cultural production, particularly in the area of film.

The space was therefore cleared for a rather perverse counter-position on all these points: on the one hand, the affirmation that Wagner and the other stereotypes of German cultural history are valid representations of Germany after all; and, on the other, that the contemporary criticism of cultural "irrationality" and authoritarianism—itself a shallow, rationalistic, "Enlightenment" enterprise—by repressing the demons of the German psyche, reinforces rather than exorcizes them. The Left is thus blamed for the survival of the Fascist temptation, while Wagner, as the very culmination of German irrationalism, is contested by methods which can only be described as Wagnerian.

As Syberberg undertakes in his films a program for cultural revolu-

tion, he shares some of the values and aims of his enemies on the Left; his aesthetic is a synthesis of Brecht and Wagner (yet another logical permutation which remained to be invented). The Wagnerian persona is indeed uncomfortably, improbably strong in Syberberg; witness the manifestos which affirm film as the true and ultimate form of the Wagnerian ideal of the "music of the future" and of *Gesamtkunstwerk*; poses of heroic isolation from which he lashes out at philistine fellow artists and critics who misunderstand his work (but who are, for him, generally associated with the Left); satiric denunciations in the best tradition of Heine, Marx, and Nietzsche of the anti-cultural *Spiess-bürgers* of the Federal Republic today, complete with a *sottisier* of the most idiotic reviews of his films.[1]

Meanwhile, Syberberg is both predictable and improbable in yet another sense: in a high-technology medium, ever more specialized and self-conscious, in which the most advanced criticism has become forbiddingly technical, he suddenly reinvests the role of the naif or "primitive" artist, organizing his vision of the filmic art of the future not around the virtuoso use of the most advanced techniques (as Coppola or Godard do, though in very different ways), but rather around something like a return to home movies. What he produces is the low-budget look of amateur actors, staged tableaux, and vaudeville-type numbers, essentially static and simply strung together—all of which must initially stun the viewer in search of vanguard of "experimental" novelties.

Though at first astonishing, however, Syberberg's strategy is quite defensible. As in the other arts, the stance of the amateur, the apologia for the homemade which characterized the handicraft ethos, is often a wholesome form of de-reification, a rebuke to the *esprit de sérieux* of an aesthetic or cultural technocracy; it need not be merely machine-wrecking and regressive. Nor is his seemingly anachronistic position regarding the German cultural past without theoretical justification: in the work of Freud, first of all, and the distinction between repression and sublimation which we have come to understand and accept in other areas;[2] in an orthodox criticism of dialectical reversals by which a binary or polar opposite (rationalistic Enlightenment forms of de-mystification) is grasped as merely the mirror replication of what it claims to discredit (German irrationalism), locked within the same *problematic*; in a perfectly proper reading of German history which defines imprisonment in essentially Jacobin, pre-1848 (*Vormärz*) forms of bourgeois ideology critique (for which Marx, Marxism, and the dialectic itself still remained to be invented) as the price which oppositional movements have traditionally had to pay for German political underdevelopment; in a new conception of cultural revolu-

tion, finally, which, drawing its inspiration from Ernst Bloch's aesthetics and his "principle of Hope," his impulse towards a utopian future, is not merely unfamiliar outside of Germany, but has also—under Syberberg's own work—been untested as an aesthetic program for a new art language.

If the films were not worth bothering about, of course, it would be idle to debate these questions. But what would it mean to employ traditional judgments of value for something like the seven-hour *Hitler, A Film from Germany* (1977, titled here *Our Hitler*)? With what would we emerge except formulations such as the "not good but important" of a German newspaper critic ("Kein 'guter' Film, dafür ein wichtiger")? The Wagnerian length involves a process in which one must be willing or unwilling to immerse oneself rather than an object whose structure one can judge, appreciate, or deplore. My own reaction is that, after some three or four hours, it might as well have lasted forever (but that the first hour was simply terrible from all points of view). Perhaps the most honest appraisal is the low-level one which chooses the episodes one likes, complains about what bores or exasperates. The dominant aesthetic of this film, which works to produce an "improvisation effect," seems, at any rate, to block all others.

This improvisation effect is clearly derived from the interview format of cinéma-vérité. Against the composed and representational scenarios of fiction film, ciné-vérité was read as a breakthrough to the freshness and immediacy of daily experience. In the hands of filmmakers such as Syberberg or Godard, however, the illusion of spontaneity is exposed as a construct of preexisting forms. In Godard's films the interview is the moment in which the fictional characters are tormented and put to the ultimate test: full-face, head and shoulders against a dazzling monochrome wall, they reply with hesitant assent or inarticulate half-phrases to the demand that they formulate their experiences, their truth, in words. The truth of the interview, however, lies not in what is said or betrayed, but in the silence, in the fragility of insufficiency of the stammered response, in the massive and overwhelming power of the visual image, and in the lack of neutrality of the badgering, off-screen interviewer. It is in Godard's recent television series, *France/Tour/Détour/Deux/Enfants* (1978), that the tyrannical and manipulative power of this investigative position is most clearly exposed. There the still Maoist interviewer questions school children whose interests, obviously, are radically different from his own. At one point he asks a little girl if she knows what revolution is (she does not). If there is something obscene about exhibiting something—class struggle—to a child who will find out about it in her

own time, there is, no doubt, something equally obscene about the Syberberg child (his daughter) who wanders through the seven hours of *Our Hitler* carrying dolls of the Nazi leaders and other playthings of the German past. These children can, however, no longer be figures of innocence. Rather they mark the future and the possible limits of the political project of these filmmakers, each of whom inscribes his work within a particular conception of cultural revolution. In Syberberg, then, a mythic posterity, some exorcised future Germany, its bloody past reduced to the playroom or the toybox; in Godard, the vanishing "subject of history," the once politicized public that will no longer reply.

Syberberg's documentary and interview techniques are developed in a whole complex preparatory practice which precedes his major films, from an early documentary on Brecht's training methods, through interviews with Fritz Kortner and Romy Schneider (and an imaginary one with Ludwig II's cook, Theodor Hierneis), to a five-hour "study" of Winifred Wagner. The background of a Syberberg interview, characteristically unlike the nonplace of the Godardian wall (with its properly utopian colors, as Stanley Cavell has noted[3]), is generally a house or mansion whose monumental and tiered traces of the past gradually absorb the camera work in such a way that what began as an interview turns into a "guided tour." This unexpected formal emergence is a stunning solution to the dilemma of the essentially narrative apparatus of film as it confronts the absences of the past and the task of "working through" what is already over and done with. So in the Wagner documentary,

> you come to see how the bourgeois utopia of private life turns into idyll, how the whole system breaks down without that music which the master was still able to bully out of himself and life. Without the music of Wagner, Wahnfried [the family estate] was doomed to decline and fall.[4]

The very primacy of the great house, as well as the form of the guided tour, is dictated by Syberberg's material and by the weight of the essentially bourgeois past of German cultural history as he conceives of it—from the nineteenth-century palaces of Ludwig II, or of Wagner, or Karl May's Villa Shatterhand, all the way to Hitler's Reichskanzlei, that is to say, the ultimate destruction of those buildings and the emergence of the misty placelessness (better still, the scenic space) of *Our Hitler*. It is not easy to imagine anything further from the Parisian outer belt of Godard's films, with their shoddy high-rises, noise, and traffic; nor can one imagine Godard filming a documentary on Ver-

sailles, say, or the houses of Monet or Cézanne. Yet this effort of imagination, as we shall see, is the task which Syberberg has set himself, the form of his "estrangement effect": imagine Godard listening to Wagner![5] Or, to turn things around, imagine Syberberg confronting middle-class prostitution, the commodification of sexuality.

Similarly striking is the contrast between Godard's deliberate revelation of his interviewer's manipulations and Syberberg's sense of the *tendresse* and the self-denial demanded of the maker of documentaries and interviews:

> The maker of such films must serve in the archaic, virtually monastic, sense; with all his heightened attention and his superior knowledge of the motifs and the intersections or lateral relationships of what has already been said and what is yet to come, he must remain completely in the background during the process, he must be able to become transparent. . . . You come to understand the grand masters of the medieval unio mystica . . . and maybe that is why we get involved in such a suicidal business. It costs sweat and effort, often more than the kind of excitement one feels in realizing the fantasies of fiction film. You're completely washed out in bed at night, still trembling all over from having had to listen, comprehend, and direct the camera. You are directing from the score of another composer, but in your own rhythm.[6]

Yet it is perhaps this very conception of the self-effacing mission of the documentary artist which underscores the complacencies of *Our Hitler*, the lengthy indulgences which it allows itself. Such complacency is the consequence of a self-serving glorification of the artist in modern, or more specifically, capitalist society. Artists working in a social system which makes an institutional place for cultural production (the role of the bard or tribal storyteller, the icon-painter or producer of ecclesiastical images, even the roles foreseen by aristocratic or court patronage) were thereby freed from the necessity of justifying their works through excessive reflection on the artistic process itself. As the position of the artist becomes jeopardized, reflexivity increases, becomes an indispensable precondition for artistic production, particularly in vanguard or high-cultural works.

The thematics of the artist novel, of art about art, and poetry about poetry, is by now so familiar and, one is tempted to say, so old-fashioned (the generation of fifties aesthetes was perhaps the last to entertain aggressively the notion of a privileged role for the poet) that its operation in mass culture and in other seemingly non-aesthetic discourses passes, oftentimes, unobserved. Yet one of the forms taken by a crisis in a discourse like that of professional philosophy is pre-

cisely the overproduction of fantasy images of the role and necessity of the professional philosopher himself (Althusserianism was only the latest philosophical movement to have felt the need to justify its work in this way, while the Wittgensteinian reduction of philosophical speculation marks a painful and therapeutic awareness of its loss of a social vocation). It was thus predictable that the emergence of that new type of discourse called theory would be accompanied by a number of overweening celebrations of the primacy of this kind of writing. Yet the "alienation" of intellectuals, their "free-floating" lack of social function, is not redeemed by such wish-fulfilling reflexivity. Political commitment, for example the support of working-class parties, is a more concrete and realistic response to this dilemma, which is the result of the dynamics and priorities of the market system itself, its refusal of institutional legitimation to any form of intellectual activity which is not at least mediately involved in the social reproduction of the profit system.

In mass culture, popular music, through its content and its glorification of the musician, provides a most striking example of the workings of this thematics of crisis. The rapidity with which the role of the musician has become mythicized is particularly evident in the instance of rock music: first as a balladeer (Bob Dylan, for example), and then as a Christ figure, through the fantasy of university redemption or individual martyrdom (as in Ken Russell's *Tommy* [1975] or many David Bowie cycles). My objection to the overdetermined content of such works (which, it should be understood, have social and psychic resonance of their own, quite distinct from the supplementary fantasies about their own production) is a reaction to the tiresomeness of their continued and outmoded appeal. Surely the "hero with a thousand faces," let alone the Christ figure, excites no one any longer, is imaginatively irrelevant to the problems of consumer society, and is a sign of intellectual as well as aesthetic bankruptcy.

Yet this is precisely the solution to which Syberberg rather anachronistically returns in *Our Hitler*, spreading a panoply of mythic images before us. His conception of the mythic derives, it is true, more from Wagner than from Joyce, Campbell, or Frye, but it is no less exasperating for all that (even Syberberg's philosophical mentor, Ernst Bloch, has suggested that it would be desirable to substitute a fairy-tale, that is to say a peasant, Wagner for the official epic-aristocratic one). Initially, however, the complacent and auto-referential developments in Syberberg seem to derive from the anti-Wagnerian tradition of Brecht, with whom he also entertains a "mythic" identification: the circus barker of the opening of *Our Hitler* surely has more in common with the streetsinger of *The Threepenny Opera* than with the nine-

teenth-century religion of art. Yet very rapidly the apologia of film as the Wagnerian "music of the future" and the *Gesamtkunstwerk* of our time, the loftiest form of artistic vocation, emerges from the populist framework. A miniature replica of the first movie studio, the little wooden shack which Thomas Edison called the Black Maria and in which he experimented with the "kinetoscope," the ancestor of the movie camera, becomes the Holy Grail. And the quest, then, becomes the yearning for a well-nigh Lukácsian "totality," the impulse towards a Hegelian Absolute Spirit, the self-consciousness of this historical world and the place from which, if anywhere, it might hope to grasp itself through the medium of aesthetic representation.

The problem of totalization is surely a crucial one in a world in which our sense of the unity of capitalism as a global system is structurally blocked by the reification of daily life, as well as by class, racial, national, and cultural differences and by the distinct temporalities by which they are all defined. But the film goes beyond this crucial concern to make an outrageous proposal: we are not merely to accept the filmmaker as supreme prophet and guardian of the Grail, but Hitler as well.

The conjunction of Hitler and film, the interest which he had in the medium is, of course, historically documented. Syberberg provides some of the most interesting specifics: He liked Fred Astaire and John Wayne movies particularly; Goebbels would not let him see Chaplin's *The Great Dictator*, but screened *Gone with the Wind* for him as compensation—which he thoroughly enjoyed; after the first reverses in the East, he began to restrict himself to the viewing of newsreels and documentary footage from the front—to which he occasionally offered editorial suggestions. But by 1944 he had even stopped watching these and reverted to his old Franz Lehar records.

Syberberg, however, proposes that we see Hitler not merely as a film buff, nor even as a film critic, but as a filmmaker in his own right, indeed, the greatest of the twentieth century, the *auteur* of the most spectacular film of all time: World War II. Although interpretations of Hitler as a failed artist have been proposed in the past (and renewed by the memoirs of Albert Speer, himself the prophet of an unrealized architectural "music of the future"), they have generally been diagnostic and debunking, rejoining a whole tradition of analysis of political visionaries, especially revolutionary leaders, as failed intellectuals and bearers of *ressentiment* (thus, even Michelet described the more radical Jacobins as so many *artistes manqués*). There is, indeed, a striking science-fiction idea (not so strikingly realized in its novel form, *The Iron Dream*, by Norman Spinrad) in which, in an alternate world, a sidewalk artist and bohemian named Adolf Hitler emigrates

to the U.S. in 1919 and becomes a writer of science fiction. He incorporates his bloodiest fantasies in his masterpiece, *Lord of the Swastika*, which is reproduced as the text of Spinrad's own novel: "Hitler died in 1953, but the stories and novels he left behind remain as a legacy to all science-fiction enthusiasts."

Syberberg's purpose is, however, a good deal more complicated and sophisticated than this and aims at no less than a Blochian cultural revolution, a psychoanalysis and exorcism of the collective unconscious of Germany. It is this ambition with which we must now come to terms. Bloch's own "method," if we may call it that, consists in detecting the positive impulses at work within the negative ones, in appropriating the motor force of such destructive but collective passions as reactionary religion, nationalism, fascism, and even consumerism.[7] For Bloch, all passions, nihilistic as well as constructive, embody a fundamental drive towards a transfigured future. This Blochian doctrine of hope does not moralize; rather it warns that the first moment of collective consciousness is not a benign phenomenon, that it defines itself, affirms its unity, with incalculable violence against the faceless, threatening mass of Others which surround it. The rhetoric of liberal capitalism has traditionally confronted this violence with the ideal of the "civilizing" power of commerce and of a retreat from the collective (above all, from the dynamics of social class) into the security of private life. Bloch's gamble—and it is the only conceivable solution for a Left whose own revolutions (China, Vietnam, Cambodia) have generated a dismaying nationalist violence in their turn—is that a recuperation of the utopian impulse within these dark powers is possible. His is not a doctrine of self-consciousness of the type with which so many people, grown impatient with its inability to effect any concrete praxis or change, have become dissatisfied. Rather, it urges the program so dramatically expressed by Conrad's character, Stein (in *Lord Jim*): "in the destructive element immerse!" Pass all the way through nihilism so completely that we emerge in the light at its far side. A disturbing program, clearly, as the historical defections from the Left to various forms of fascism and nationalism in modern times must testify.

In accordance with this doctrine, the vision of history which emerges in Syberberg's trilogy[8] is not simply one of the "roads not taken," not simply a Lukácsian project to rescue and reinvent an alternate tradition of German culture. Syberberg's fascination with Wagner's royal patron, Ludwig II of Bavaria, results not from the identification of a moment of cultural choice, a historical turning point which might have changed everything. Although it is that too, of course, and he represents Ludwig as a form of artistic patronage

and cultural development which he systematically juxtaposes with the commercialism of the arts and cultural illiteracy of the middle-class in Germany today. (Indeed, in one of his most interesting proposals, especially in the light of the neglect of his own films within the Federal Republic, Syberberg imagines a "Bayreuth" for the modern film where special state theaters for avant-garde filmmaking would be supported by the various provincial governments.) Even more significant, however, is his representation of Ludwig II as the anti-Bismarck: the tormented and dilettantish unheroic, and often ridiculous symbol of a non-Prussian Germany, of the possibility of a German federation under the leadership of Bavaria rather than the unified state under Brandenburg and the Junkers. Yet Syberberg's treatment of the "virgin king" in Ludwig—*Requiem for a Virgin King* (1972) is no less deliberately ambivalent than his treatment of Hitler, as we shall see.

It is the second film in the trilogy—*Karl May—In Search of Paradise Lost* (1974)—which most faithfully sets out on the Blochian quest for an earthly paradise, the search for utopian impulses within the contingent forms and activities of a fallen social life. The film takes as its theme the popular writer Karl May, who, as a kind of late nineteenth-century German combination of Jules Verne and Nick Carter, made the Western over into an authentically German form that was read by generations of German adolescents, including Hitler himself. The juxtaposition of Wagner's patron and this immensely successful writer of best-sellers is the strategic isolation of a moment of crisis in modern culture, the moment at which culture and emergent mass culture began to split apart from one another and to develop seemingly autonomous structures and languages. This dramatic moment in the development of culture marks a break, a dialectical leap and transformation in capital, just as surely as, on the level of the infrastructure and of institutions, the coming into being of the monopoly form. Syberberg has, it is true, expressed this emergent opposition in what are still essentially unified class terms, for the villa of Karl May and the palaces of Ludwig can still be seen as two variants of a culture of the upper bourgeoisie, or, perhaps, of the high bourgeoisie and the aristocracy, but the only on the condition that Ludwig's "residential" aristocratic style is viewed as already infected with the kitsch of nineteenth-century middle-class taste.

Clearly the film's diagnosis transcends the individual writer and can be extended to all the national variants of the popular literature of nascent imperialism, of the mystery of these last "dark places of the earth" (Conrad) which suddenly become perceptible at the moment of their penetration and abolition—as in the novels of Verne or, in an-

other way, of Rider Haggard (and even of Conrad himself), in which the closing of capitalism's global frontier resonates through the form as its condition of possibility and its outside limit.

> Through its monologue form, the film presents the inner world of "the last great German mystic in the last moment of the decline of the fairy tale," and presents it as a monstrous kind of closet drama, developing according to the laws of some three-hour-long chamber music: "The soul is a vast landscape into which we flee." One can thus seek one's paradise, as the historic Karl May did, in so many trips and voyages to the real sites of his fantasies, thereby knowing ultimate failure as May himself did in his breakdown. . . . Karl May transposed all his problems and his enemies into the figures of his adventures in the wild West and in an orient that extended all the way to China. [In the film] we return them to their origins and see his filmic life as the projected worlds of the inner monologue. A man in search of paradise lost in the typically German misdirection, restlessly seeking his own salvation in an inferno of his own making. Job and Faust, combined, with a Saxon accent, his fanatical longing dramatized in a national hero for poor and rich alike, a hero both for Hitler and for Bloch, and acted out with all the familiar faces and voices of the *UFA* [the major German film company up to 1945], with Stalingrad music at the end which swells relentlessly out of history itself. It may be that other nations can rest at peace in their misery (perhaps also it is not so great as our own), but here we can see it percolating and seeking its own liberation as well as that of others.[9]

Nowhere, then, is the utopian impulse towards the reappropriation of energies so visible as in this attempt to rewrite the fantasies of a nascent mass culture in their authentic form as the unconscious longing of a whole collectivity.

Ludwig, however, presents a more complex and difficult vision, as we may judge from its delirious final image:

> After his resurrection from the scaffold of history. Ludwig throws off his kingly robes and in a Wagnerian finale yodels at the Alps or Himalaya landscape from the roof of the royal palace. . . . Even the bearded child-Ludwig from Erda's grotto is included, with his requiem-smile through the mist. The curse and salvation of the legendary life of the child-king spreads out our own existential dream- and wish-landscape before us in amicable-utopian fashion.[10]

The bliss or *promesse de bonheur* of this kitsch sublime, as glorious as it is, is deeply marked, both in its affect and in its structure as an

image, by its unreality as the self-consciously "imaginary resolution of a real contradiction."

Yet such a moment will perhaps afford us a surer insight into the dynamics of Syberberg's aesthetic, and of his "salvational critique," than the narrative analysis we have hitherto associated with the "method" of Bloch (and in which the very shape of the story or tale, or the narrative form, expresses the movement towards the future). Since Syberberg's are not in that sense storytelling films (although they are films *about* stories of all kinds), a narrative or diachronic analysis does them less justice than the synchronic focus to which we now turn, and by which the movement of filmic images in time is grasped as the "process of production" of relatively static tableaux similar to this one of the Ludwig apotheosis. Such moments, so characteristic of Syberberg's films, can become emblems of the films themselves—as in the widely reproduced logo of *Our Hitler* in which Hitler in a toga is seen rising from the grave of Wagner. Such quintessential images, which share, certainly, in the traditions of symbolism and surrealism, are, as Susan Sontag has pointed out, more accurately understood according to Walter Benjamin's conception of the allegorical emblem.

Yet the originality of Syberberg's images, related as they are to his political project, his attempt at a psychoanalysis and exorcism of the German unconscious, advances beyond these historical references. The surrealist image—"the forcible yoking of two realities as distant and as unrelated as possible"—and the Benjaminial allegory—a discontinuous montage of dead relics—each in its own way underscores the heterogeneity of the Syberberg tableau without accounting for its therapeutic function, since the surrealistic aesthetic aimed at an immediate and apocalyptic liberation from an impoverished and rationalized daily life, and the Benjaminian emblem, while it displayed the remains and traces of "mourning and melancholia," was not an active working through of such material; it was perceived as a symptom or an icon rather than, as in Syberberg, a "spiritual method."

Such a "method" may be characterized as *dereification*: a forcible short-circuiting of all the wires in the political unconscious, an attempt to purge the sedimented contents of collective fantasy and ideological representation by reconnecting its symbolic counters so outrageously that they de-reify themselves. The force of ideological representations (and what we call culture or tradition is little more than an immense and stagnant swamp of such representations) derives from their enforced separation within our minds, their compartmentalization, which, more than any mere double standard, authorizes the multiple standards and diverse operations of that complex

and collective Sartrean *mauvaise foi* called ideology, whose essential function is to prevent totalization.

We have, in American literature, a signal and programmatic enactment of this short-circuiting in Gertrude Stein's neglected *Four in America*, in which Ulysses S. Grant is imagined as a religious leader, the Wright Brothers as painters, Henry James as a general, and George Washington as a novelist.[11] There is but a step from this "exercise" of a reified collective imagination to Syberberg's presentation of Hitler as the greatest filmmaker of the twentieth century. The force of his therapy depends on the truth of his presupposition that the zones of high culture (Wagner, Ludwig's castles), popular and adolescent reading (Karl May), and petty-bourgeois political values and impulses (Hitler, Nazism) are so carefully separated in the collective mind that their conceptual interference, their rewiring in the heterogeneity of the collage, will blow the entire system sky-high. It is according to this therapeutic strategy that those moments in Syberberg which seem closest to a traditional form of debunking, or of an unmasking of false consciousness (as in the reports of Hitler's bourgeois private life) must be read. The point is not to allow one of the poles of the image to settle into the truth of the other which it unmasks (as when our sense of the horror of Nazi violence "demystifies" Hitler's courteous behavior with his staff), but rather to hold them apart as equal and autonomous so that energies can pass back and forth between them. This is the strategy at work in the seemingly banal monologue in which the Hitler puppet answers his accusers and suggests that Auschwitz is not to be judged quite so harshly after Vietnam, Idi Amin, the torture establishments of the Shah and the Latin American dictatorships, Cambodia, and Chile. To imagine Hitler as Nixon and vice versa is not merely to underscore the personal peculiarities they share (odd mannerisms, awkwardness in personal relations, etc.), but also to bring out dramatically the banality, not of evil, but of conservatism and reaction in general, and of their stereotypical ideas of social law and order, which can as easily result in genocide as in Watergate.

It is important at this point to return to the comparison between the different "cultural revolutions" of Syberberg and Godard. Both filmmakers are involved, as we have noted, in attempts to de-reify cultural representations. The essential difference between them, however, is in their relationship to what is called the "truth content" of art, its claim to possess some truth or epistemological value. This is, indeed, the essential difference between post- and classical modernism (as well as Lukács's conception of realism): the latter still lays claim to the place and function vacated by religion, still draws its resonance from a conviction that through the work of art some authen-

tic vision of the work is immanently expressed. Syberberg's films are modernist in this classical, and what may now seem archaic, sense.[12] Godard's are, however, resolutely postmodernist in that they conceive of themselves as sheer text, as a process of production of representations that have no truth content, are, in this sense, sheer surface or superficiality. It is this conviction which accounts for the reflexivity of the Godard film, its resolution to use representation against itself to destroy the binding or absolute status of any representation.

If classical modernism is understood as a secular substitute for religion, it is no longer surprising that its formulation of the problem of representation can borrow from a religious terminology which defines representation as "figuration," a dialectic of the letter and the spirit, a "picture-language" (*Vorstellung*) which embodies, expresses, and transmits other inexpressible truths.[13] For the theological tradition to which this terminology belongs, the problem is one of the "proper" use of figuration and of the danger of its becoming fixed, objectified into an externality where the inner spirit is forgotten or historically lost. The great moments of iconoclasm in Judaism and Islam, as well as in a certain Protestantism, have resulted from the fear that the figures, images, and sacred object of their once vital religious traditions have become mere idols and that they must be destroyed in order that there may be a reinvigoration by and return to the authentic spirit of religious experience. Iconoclasm is, therefore, an early version (in a different mode of production) of the present-day critiques of representation (and as in the latter, the destruction of the dead letter or of the idol is, almost at once, associated with a critique of the institutions—whether the Pharisees and Saducees, the hierarchy of the Roman Catholic Church, or the "whore of Babylon," or modern-day ideological state apparatuses such as the university system—which perpetuate that idolatry for the purposes of domination).

Unlike Hegel—whose conception of the "end of art," that is, the ultimate bankruptcy and transcendence of an immanent and figural language, foresees a final replacement of art by the nonfigural language of philosophy in which truth dispenses with picture-making and becomes transparent to itself—religion and modernism replace dead or false images (systems of representation) with others more lively and authentic. This description of classical modernism as a "religion of art" is justified, in turn, by the aesthetic reception and experience of works themselves. At its most vital, the experience of modernism was not one of a single historical movement or process, but of a "shock of discovery," a commitment and an adherence to its individual forms through a series of "religious conversions." One did not simply read D. H. Lawrence or Rilke, see Jean Renoir or Hitchcock,

or listen to Stravinsky, as distinct manifestations of what we now term modernism. Rather one read all the works of a particular writer, learned a style and a phenomenological world. D. H. Lawrence became an absolute, a complete and systematic world view, to which one converted. This meant, however, that the experience of one form of modernism was incompatible with another, so that one entered one world only at the price of abandoning another (when we tired of Pound, for example, we converted to Faulkner, or when Thomas Mann became predictable, we turned to Proust). The crisis of modernism as such came, then, when suddenly it became clear that "D. H. Lawrence" was not an absolute after all, not the final achieved figuration of the truth of the world, but only one art-language among others, only one shelf of works in a whole dizzying library. Hence the shame and guilt of cultural intellectuals, the renewed appeal of the Hegelian goal, the "end of art," and the abandonment of culture altogether for immediate political activity. Hence, also the appeal of the nonfictive, the cult of the experiential, as the Devil explains to Adrian in a climactic moment of Mann's *Doctor Faustus*:

> The work of art, time, and aesthetic experience [*Schein*] are one, and now fall prey to the critical impulse. The latter no longer tolerates aesthetic play or appearance, fiction, the self-glorifications of a form which censures passions and human suffering, transforms them into so many roles, translates them into images. Only the non-fictive remains valid today, only what is neither played nor played out [*der nicht verspielte*], only the undistorted and unembellished expression of pain in its moment of experience.[14]

In much the same spirit, Sartre remarked that *Nausea* was worthless against the fact of the suffering or death of a single child. Yet pain is a text. The death or suffering of children comes to us only through texts (although the images of network news, for example). The crisis of modernist absolutes results not from the juxtaposition of these fictive works with nonfigurative experiences of pain or suffering, but from their relativization by one another. Bayreuth would have to be built far from everything else, far from the secular babel of the cities with their multiple art languages and forms of post-religious "reterritorialization" or "recording" (Deleuze). Only Wagner could be heard there in order to forestall the disastrous realization that he was "just" a composer and the works "just" operas, in order, in other words, for the Wagnerian sign system or aesthetic language to appear absolute, to impose itself, like a religion, as the dominant code, the hegemonic system of symbols, on an entire collectivity. That this is not a solution

for a pluralistic and secular capitalism is proved by the fate of Bay-
reuth itself, yet directs our attention to the political and social media-
tions which are present in the aesthetic dilemma. The modernist
aesthetic demands an organic community which it cannot, however,
bring into being by itself but can only express. Ludwig II is, then
the name for that fleeting mirage, that optical illusion of a concrete
historical possibility. He is the philosopher-king who, by virtue of a
political power that resulted from a unique and unstable social and
political situation, holds out, for a moment, the promise of an organic
community. Later, Nazism will make this same promise. Of Ludwig
II also, then, it may be said that had he not existed, he would have to
have been invented. For he is the socio-political demiurge, a structural
necessity of the modernist aesthetic which projects him as an image
of its foundation.

What happens, then, when the modernisms begin to look at one
another and to experience their relativity and their cultural guilt,
their own aesthetic nakedness? From this moment of shame and crisis
there comes into being a new, second-degree solution which Barthes
describes in a splendid page so often quoted by me that I may be
excused for doing so again:

> The greatest modernist works linger as long as possible, in a sort of
> miraculous stasis, on the threshold of Literature itself, in an anticipa-
> tory situation in which the density of life is given and developed
> without yet being destroyed by their consecration as an [institution-
> alized] sign system.[15]

Here, in this contemporary reflection on the dialectic of figuration
and iconoclasm, the ultimate reification of the figural system is taken
to be inevitable. Yet that very inevitability at least holds out the
promise of a transitional moment between the destruction of the
older systems of figuration (so many dead letters, empty icons, or old-
fashioned art languages) and the freezing over and institutionalization
of the new one. A rather different Wagnerian solution may be taken
simultaneously as the prototype and the object lesson for this possibil-
ity of an aesthetic authenticity in the provisory. Bayreuth was the
imaginary projection of a social solution to the modernist dilemma:
the Wagnerian leitmotif may now be seen as a far more concrete,
internal response to this dilemma. For the leitmotif is intended, in
principle, to destroy everything that is reifiable in the older musical
tradition, most notably the quotable and excerptable "melodies" of
romantic music, which as Adorno noted, are so readily fetishized by
the contemporary culture industry ("the twenty loveliest melodies of

the great symphonies on a single long-playing record"). The leitmotif is designed, on the one hand, *not* to be singable or fetishizable in that way and, on the other, to prevent the musical text from becoming an object by ceaselessly redissolving it into an endless process of recombination with other leitmotifs. The failure of the attempt, the reconsecration as an institutional sign system, then comes when we hum Wagner after all, when the leitmotifs are themselves reified into so many properly Wagnerian "melodies," of which, as familiar known quantities, one can make a complete list, and which now stand out from the musical flow like so many foreign bodies.

It is not to be thought that a postmodernist aesthetic can escape this particular dilemma either. Even in Godard, the relentless anatomy and dissolution of the reified image does not prevent the latter's ultimate triumph over the aesthetic of the film as sheer process. Godard's structural analysis—by which text demonstration of the structural heterogeneity of such Barthesian "mythologies"—demands in some sense that the film destroy itself in the process, that it use itself up without residue, that it be disposable. Yet the object of this corrosive dissolution is not the image as such, but individual images, mere examples of the general dynamic of the image in media and consumer society, in the society of the spectacle. These examples— represented as impermanent, not only in themselves, but also by virtue of the fact that they could have been substituted by others— then develop an inertia of their own, and, vehicles for the critique of representation, turn into so many representations "characteristic" of the films of Godard. Far from abolishing themselves, the films persist, in film series and film studies programs, as a reified sequence of familiar images which can be screened again and again: the spirit triumphs over the letter, no doubt, but it is the dead letter that remains behind.

Syberberg's "cultural revolution" seems to face quite different problems, for the objects of his critique—the weight of figures like Karl May, Ludwig, or Hitler himself as figures in the collective unconscious—are historical realities and thus no longer mere examples of an abstract process. Late capitalism has elsewhere provided its own method for exorcizing the dead weight of the past: historical amnesia, the waning of historicity, the effortless media-exhaustion of even the immediate past. The France of the consumer society scarcely needs to exorcize De Gaulle when it can simply allow the heroic Gaullist moment of its construction to recede into oblivion at the appropriately dizzying rate. In this respect, it is instructive to juxtapose Syberberg's *Our Hitler* with that other recent New York sensation, Abel Gance's 1927 *Napoléon* (restored by Kevin Brownlow in 1980 and, in the

United States, slightly shortened and presented by Francis Coppola's Zoetrope Studios.) Even if we leave aside the proposed critique of Napoleonic politics in the unfilmed sequels, this representational re-appropriation of the past is only too evidently ideological: the ideal-ization of Napoleonic puritanism and law and order after the excesses of the Revolution and the Directory (read: the great war and the twenties), the projection of a Napoleonic unification of Europe (this will come to sound Hitlerian in the 1930s and early 1940s, liberal once more with the foundation of NATO and the Common Market). These are surely not attempts to settle accounts with the past and with its sedimented collective representations, but only to use its standard images for manipulative purposes.

Syberberg's aesthetic strategy presupposes some fundamental so-cial difference between the Federal Republic of the Restoration and the *Wirtschaftswunder*, of the *Berufsverbot* and the hard currency of the *Deutschmark*, and the other nation states of advanced capitalism with their media dynamics, their culture industries, and their histori-cal amnesia. Whether Germany today is really any different in this respect is what is euphemistically called an empirical question. Sy-berberg's idea is that the German *misère* is somehow distinct and historically unique and can be defended by an account of the peculiar combination of political underdevelopment and leap-frogging "mod-ernization" that characterizes recent German history. Still, there is some nagging doubt as to whether, even in the still relatively conser-vative class cohesiveness of the *Spiessbürger* which dominates West Germany today, the secret of the past may not be that there is no secret any longer, and that the collective representations of Wagner, Karl May, even of Hitler, may not simply be constructions of the media (perpetuated and reinvented by Hans-Jürgen Syberberg, among others).

But this must now be reformulated in terms of Syberberg's filmic system and of what we have described as his political project, his cultural revolution, or collective psycholoanalysis. In order for his method to work, these films must somehow continue to "take" on the real world, and his Hitler puppets and other Nazi motifs must somehow remain "referential," must preserve their links as allusions and designations of the historically real. This is the ultimate guaran-tee of the truth content to which films such as this lay claim. The psychodrama will have no effect if it relaxes back into sheer play and absolute fictionality; it must be understood as therapeutic play with material that resists, that is, with one or the other forms of the real (it being understood that a collective representation of Hitler is as real and has as many practical consequences as the biographical one).

Clearly the nonfictional nature of the subject matter is no guarantee in this respect; nor is this only a reflection of the "textual" nature of history in general, whose facts are never actually present but constructed in historiography, written archives. Aesthetic distance, the very "set" towards fictionality itself, that "suspension of disbelief" which involves an equal suspension of belief, these and other characteristics of aesthetic experience as they have been theorized since Kant also operate very powerfully to turn Hitler into "Hitler," a character in a fiction film, and thus removed from the historical reality which we hope to affect. In the same way, it is notorious that within the work of art in general, the most reprehensible ideologies—Céline's anti-Semitism, for instance—are momentarily rewritten into a thematic system, become a pretext for sheer aesthetic play and are no more offensive than, say, Pynchon's "theme" of paranoia.

Yet this is not simply to be taken as the result of some eternal essence of the work of art and of aesthetic experience: it is a dilemma which must be historicized, as it might be were we to imagine a Lukácsian defense of the proposition that, in their own time, Sir Walter Scott's historical romances were more resonantly referential and come to terms with history more concretely than do these equally historical films of Syberberg. For the imperceptible dissociation, in the modern world, of the public from the private, the privatization of experience, the monadization and the relativization of the individual subject, affect the filmmaker as well, and enforce the almost instantaneous eclipse of that unstable situation, that "miraculous suspension," which Barthes saw as the necessary condition for an even fleeting modernist authenticity. From this perspective, the problem is in understanding Syberberg as the designation of a particular modernist language, a distinctive modernist sign system: to read these films properly is, as I have said, a matter of conversion, a matter of learning the Syberberg world, the themes and obsessions that characterize it, the recurrent symbols and motifs that constitute it as a figural language. The trouble is that at that point, the realities with which Syberberg attempts to grapple, realities marked by the names of such real historical actors as Wagner, Himmler, Hitler, Bismarck, and the like, are at once transformed into so many personal signs in a private language, which becomes public, when the artist is successful, only as an institutionalized sign system.

This is not Syberberg's fault, clearly, but the result of the peculiar status of culture in our world. Nor would I want to be understood as saying that Syberberg's cultural revolution is impossible, and that the unique tension between the referential and aesthetic play which his psychodramas demand can never be maintained. On the contrary.

But when it is, when these films suddenly begin to "mean it" in Erik Erikson's sense,[16] when something fundamental begins to happen to history itself, then the question remains as to which played the more decisive role in the process, the subject or the object, the viewer or the film. Ultimately, it would seem, it is the viewing subject who enjoys the freedom to take such works as political art or as art *tout court*. It is on the viewing subject that the choice falls as to whether these films have a meaning in the strong sense, an authentic resonance, or are perceived simply as texts, as a play of signifiers. It will be observed that we can say the same about all political art, about Brecht himself (who has, in a similar way, become "Brecht," another classic in the canon). Yet Brecht's ideal threater public held out the promise of some collective and collaborative response which seems less possible in the privatized viewing of the movie theater, even in the local Bayreuths for avant-garde film which Syberberg fantasized.

As for the "destructive element," the Anglo-American world has been immersed in it long before Syberberg was ever heard from: beginning with Shirer's book and Trevor-Roper's account of the bunker all the way to Albert Speer, with sales of innumerable Nazi uniforms and souvenirs worn by everybody from youth gangs and punk rock groups to extreme right-wing parties. If it were not so long and so talky, Syberberg's *Our Hitler*—a veritable summa of all these motifs—might well have become a cult film for such enthusiasts, a sad and ambiguous fate for a "redemptive critique." Perhaps, indeed, this is an Imaginary which can be healed only by the desperate attempt to keep the referential alive.

(1981)

5.
Historicism in
The Shining

The most interesting filmmakers today—Robert Altman, Roman Polanski, Nicholas Roeg, Stanley Kubrick—are all in their very different ways practitioners of *genre*, but in some historically new sense. They switch genres the way the classical modernists switched styles. Nor, as with classical modernism itself, is this a matter of individual taste, but rather it is the result of objective constraints in the situation of cultural production today.

T.W. Adorno's account of the fate of "style" in contemporary literature and music proposes the concept of *pastiche* to describe the recourse of Stravinsky, Joyce, or Thomas Mann to dead styles and artistic languages of the past as vehicles for new works. Pastiche, in Adorno's sense, must be radically distinguished from parody, which aims at ridiculing and discrediting styles which are still alive and influential: it involves something of the same distance from a ready-made artistic instrument or technique, but is meant, rather like the copying of old masters or indeed forgery, to display the virtuosity of the practicioner rather than the absurdity of the object (in this sense, late Picasso can be said to constitute so many master forgeries of "Picasso" himself). Pastiche seems to have emerged from a situation of two fundamental determinations: the first is subjectivism, the over-emphasis and over-evaluation of the uniqueness and individuality of style itself—the private mode of expression, the unique "world" of a given artist, the well-nigh incomparable bodily and perceptual sensorium of this or that new claimant for artistic attention. But as individualism begins to atrophy in a post-industrial world, as the sheer difference of increasingly distinct and eccentric individualities turns under its own momentum into repetition and sameness, as the logical permutations of stylistic innovation become exhausted, the quest for a uniquely distinctive style and the very category of "style" come to seem old-fashioned. Meanwhile, the price to be paid for a radically

new aesthetic system in a world in which innovation and fashion-change have become the law (Adorno's example is Schoenberg's twelve-tone machinery)—that price, both for producer and consumer, becomes increasingly onerous. The result, in the area of high culture, was the moment of pastiche in which energetic artists who now lack both forms and content cannibalize the museum and wear the masks of extinct mannerisms.

The moment of genre pastiche in film, however, is distinct from this one in several respects: first, we have to do here not with so-called high culture, but rather with mass culture, which has another dynamic and is much more immediately subject to the determinants of the market. Then too, Adorno was speaking of the waning of a classical moment of modernism proper, while the filmic developments we have in mind here, taking place in the late capitalism or consumer society of the present day, are to be grasped in terms of a very different cultural situation, namely, that of what might be called post-modernism.

The attempts of the greatest of the early filmmakers to make a place for a distinctive individual production—categories of the masterpiece, of individual style, of unified control by a single guiding personality—are quickly blocked by the business system itself, which reduces them to so many tragic ruins and truncated legends (Stroheim, Eisenstein), redirecting these creative energies into Hollywood odd jobs.

The latter are, of course, genre films, yet what is important for us is that with the arrival of media society and television (to which correspond such properly filmic innovations as the arrival of the wide screen) even the possibility of traditional genre film itself breaks down. This end of the golden age of the genre film (musicals, westerns, *film noir*, the classical Hollywood comedy or farce) then predictably coincides with its codification and theorization in so-called *auteur* theory, where the various grade-B or standard productions are now valorized as so many fragments and windows on a whole luminous and distinctive generic world. No one whose life and imagination were marked and burned by the great images of *film noir* or infected by the immemorial gestures of the western can doubt the truth of this for a moment; still, the moment in which the deeper aesthetic vitality of *genre* comes to consciousness and becomes self-conscious may well also be the moment in which *genre* in that older sense is no longer possible.

The end of genre thus opens up a space in which, alongside avant-garde moviemakers who continue their work independent of the market, and alongside a few surviving "stylists" of the older type (Bergman, Kurosawa), blockbuster film productions now become tightly linked to best-sellers and developments in other branches of the cul-

ture industry. The younger filmmakers are thus no longer able to follow the trajectory of a Hitchcock from a craftsman of grade-B thrillers to "the greatest director in the world"; nor even to emulate the way in which Hitchcock enlarges the older generic framework so powerfully, in a film like *Vertigo* (1958), as to approximate an "expressive" masterpiece of the other kind.

Metageneric production becomes, whether consciously or not, the solution to this dilemma: the war movie (Altman's *Mash* [1970], Kubrick's *Paths of Glory* [1957]), the occult (Polanski's *Rosemary's Baby* [1968], Kubrick's *The Shining* [1980], Roeg's *Don't Look Now* [1973], Polanski's *The Fearless Vampire Killers* [1967]), the thriller (Polanski's *Chinatown* [1974], Kubrick's *The Killing* [1956], Roeg's *Performance* [1970]), the western (Altman's *McCabe and Mrs. Miller* [1971] and *Buffalo Bill and the Indians* [1976], Penn's *The Missouri Breaks* [1976]), and science fiction (Kubrick's *2001* [1968] and *Dr. Strangelove* [1964], Roeg's *The Man Who Fell to Earth* [1976], Altman's *Quintet* [1979]), the musical (Altman's *Nashville* [1975]), the "theater of the absurd" (Polanski's *Cul-de-sac* [1966]), the spy movie (Roeg's *Bad Timing* [1980]),—all of these films use the pregiven structure of inherited genres as a pretext for production which is no longer personal or stylistic in the sense of the older modernism. The latter has of course been described in terms of reflexivity, of auto-referentiality and the return of artistic production onto its own processes and techniques. But in that case one would want to designate a rather different type of reflexivity for this new moment—one sometimes termed "intertextuality" (although to my mind the designation most often stands for a problem rather than a solution)—and knowing quite distinct equivalents in post-modernist literary production (Pynchon, Sollers, Ashbery), in conceptual art but also in photorealism, and in that great renewal of rock in the late seventies and early eighties most often blanketed under the term "new wave rock" and saturated with references to the older rock forms at the same time that it is electrifying beyond any sterile exercise in late-show or in-group allusion.

The moment of the metageneric film can also be approached by way of a degraded version which is contemporary with it but can be read as the former's opposite, the expression of the same historical impulse in a non-reflexive form. This is the whole range of contemporary "nostalgia" culture, what the French call *la mode rétro*—pastiche which, in a "category mistake" that confuses content with form, sets down to reinvent the style, not of an art language, but of a whole period (the Thirties in Bertolucci's *Il Conformista* [1970], the Fifties in Lucas's *American Graffiti* [1973]; the American turn-of-the century in a novel like Doctorow's *Ragtime* [1975]). As with the practice of

pastiche that Adorno stigmatized in the work of a Stravinsky, such celebrations of the imaginary style of a real past constitute so many symptoms of the resistance of contemporary raw material to artistic production. Such resistance is generally strengthened by the ideological blinders of contemporary producers but is suggestively broken down when such artists are willing to include a future in their present and to register the nascent pull of science fiction or utopia within the logic of their forms themselves.

What is inauthentic about nostalgia films and texts—though it would have been interesting to see what Altman could have done with *Ragtime*—can best be dramatized in another way by which I will call the cult of the glossy image, as a whole new technology (wide-angle lens, light-sensitive film) has allowed its lavish indulgence in contemporary film. Is it ungrateful to long from time to time for something both more ugly and less proficient or expert, more home-made and awkward, than those breathtaking expanses of sunlit leaf-tracery, those big screen flower-bowls of an unimaginably intense delicacy of hue, that would have caused the Impressionists to shut up their paint boxes in frustration? I hope it is not moralizing to admit that from time to time such sheer beauty can seem obscene, the ultimate form of the consumption of streamlined commodities—a transformation of our senses into the mail-order houses of the spirit, some ultimate packaging of Nature in cellophane of a type that any elegant shop might well wish to carry in its window. The objection is in reality a historical one, for there have certainly been historical moments and situations in which the conquest of beauty has been a wrenching political act: the hallucinatory intensity of smeared color in the grimy numbness of routine, the bitter-sweet taste of the erotic in a world of brutalized and exhausted bodies. Nor was the "sublime" of the sixties, the countercultural rediscovery of the ecstatic necessarily an anti-political thing either, for those intensities, like a stab beyond pain or pleasure, were essentially directed *against* the image. It is the triumph of the image in nostalgia film which ratifies the triumph over it of all the values of contemporary consumer society, of late capitalist consumption.

Think now, on the contrary, of the "beautiful" in Kubrick's work: one still obsessively recalls the sound of "The Beautiful Blue Danube" that spins the slowly rotating space shuttle in *2001* on its way to the Moon, like Musak in a high-class elevator soothing and tranquilizing both the official bureaucratic travellers on the vehicle and ourselves as well, spectators of this technocratic future of our own present beyond all national conflict. The high-culture banality of the waltz thus expresses the banality of this harmonious UN-run global world

as well as the boredom of its depthless inhabitants: it is a text-book example of that signifying mechanism which the Barthes of the Mythologies called "connotation," in which the language and formal categories of the medium are its deepest message, and in which the very quality of the image itself emits a meaning that secretly outdistances the ostensible or immediate purport of its content. Nor is the connotative operation always inauthentic, as it is in Barthes's advertisements or in the ideologeme of Beauty, to which we have referred above: in *Saint Genêt*, for instance, Sartre argued that Genet's practice of the "phony" [*le toc*], his deliberate stylistic projection of the tawdry, of *kitsch*, of the garishly over-written, his willful inclusion of "bad taste" in the connotative messages of his sumptuous sentences, was a proto-political act, the reversal of *ressentiment* in an act of vengeance against his respectable readership (a similar case could be made for Dreiser's junk-style, whose very falsehood expresses the truth of the nascent commodification of his own time). Indeed, the authenticity of Kubrick's use of such high-cultural connotation can be measured against himself, when, in an ideological (and reactionary, anti-political) film like *A Clockwork Orange* (1971), connotation relaxes into overt denotation, and the same high-cultural materials are now used instrumentally to make a didactic point about the boredom and intolerability of an achieved Utopia, in which only violence can bring relief. Such a "statement" about the future must sharply be distinguished from the lateral connotation of the image in *2001*, where the science-fictional content is a vehicle for a message about our own technological present, and about Kubrick's own supreme technological expertise—as sterile and lobotomized as a trip to the moon.

Beauty and boredom: this is then the immediate sense of the monotonous and intolerable opening sequence of *The Shining*, and of the great aerial tracking shot across quintessentially breathtaking and picture-postcard "unspoiled" American natural landscape; as well as of the great hotel, whose old-time turn-of-the-century splendor is undermined by the more meretricious conception of "luxury" entertained by consumer society, and in particular by the manager's modern office space and the inevitable plastic coffee he has his secretary serve. In Hitchcock, such minor figures were still conceived as idiosyncratic, as interesting/amusing (and this not merely because he observed them from an Englishman's distance: the characteristically British humor of the early films is structurally reinvented as a new and authentically American set of attitudes in the Hollywood period): so we have in *Vertigo*, the manager of the San Francisco boarding house who suddenly rears up from behind the apparently empty desk with the excuse that she was "oiling the leaves" of her rubber plant;

or the small-town sheriff, in *Psycho*, who sardonically syllabizes the name of the missing big city detective through his cigar smoke ("Arbo-gast"); or at the end of the same movie, the forensic psychiatrist whose raised index finger pedantically corrects the naive first impressions of his provincial law-enforcement public ("Transvestite? Not exactly!").

Nothing of the sort in Kubrick: these depthless people, whether on their way to the moon, or coming to the end of another season in the great hotel at the end of the world, are standardized and without interest, their rhythmic smiles as habituated as the recurrence of a radio-announcer's drawn breath. If Kubrick amuses himself by organizing a counterpoint between this meaningless and obligatory facial benevolence and the ghastly, indeed quite unspeakable story the manager is finally obliged to disclose, it is a quite impersonal amusement which ultimately benefits no one. Meanwhile, great swathes of Brahms pump all the fresh air out of *The Shining*'s images and enforce the now familiar sense of cultural asphyxiation.

It is possible, of course, that such arid and trivial stretches are essential features of the genre of the horror film itself, which (like pornography) finds itself reduced to the empty alternation of shock and of the latter's absence: I put it in this cumbersome way because the alternating moment—the mere absence of shock—is today divested even of that content and meaning which were inherent in what used to be described as boredom. Think, for example, of the earlier wave of fifties horror and science fiction films, whose "peacetime" or "civilian" context—generally the American small town, in some remote Western landscape—signified a "provinciality" which no longer exists in consumer society today. The Georgetown of Friedkin's *The Exorcist* (1973) is no longer boring in that socially charged sense, but merely trivial, its vacuous daily life the empty background silence against which the ominous wing-flapping in the attic will be perceived. And clearly enough, this very triviality of daily life in late capitalism is itself the desperate situation against which all the formal solutions, the strategies and subterfuges, of high culture as well as of mass culture, emerge: how to project the illusion that things still happen, that events exist, that there are still stories to tell, in a situation in which the uniqueness and the irrevocability of private destinies and of individuality itself seem to have evaporated? This impossibility of realism—and more generally, the impossibility of a living culture which might speak to a unified public about shared experience—determines the metageneric solutions with which we began. It also accounts for the emergence of what might be called false or imitation narrative, for the illusionistic transformation into a seemingly unified

and linear narrative surface of what is in reality a collage of heterogeneous materials and fragments, the most striking of which are kinetic or physiological segments inserted into texts of a rather different order. So into William Carlos Williams's great poem about the impossibility of an American literature or culture, *Paterson*, at the most problematical moments of formal dispersal, blocks of unreduced physical sensation—most notably the waterfall itself—are inserted, as though the body and its meaningless but existent sensations constituted some rock-bottom last court of appeal. In Kubrick also, the emptiness of life in the dead season of the hotel is characteristically punctuated by the favorite sense perceptions of this *auteur*,[1] so that the tireless pedaling of the child on his big wheel throughout the empty corridors is transformed into a veritable Grand Prix, an implacable space probe heading through tunneled matter like an interstellar vehicle with meteorites tumbling past. Such embellishments of the narrative line—micro-practices of the "sublime" in the 18th-century sense, yet also closely related, as formal symptoms, to the bravura sequences in Hitchcock (the parallel swaying, in *The Birds* [1963], of the two lovebirds registering the twists and turns of the highway like a miniature dial)—mark the dissociation of Fancy and Imagination in contemporary cultural production and stand as so many diverse signs of the heterogeneity of the contents into which modern life has been shattered.

As for the child himself, his "story" is not merely the pretext for purer filmic and perceptual exercises of this kind, but in a more general way for a play with generic signals which takes us to the heart of this peculiar form. These initial signals have no doubt already been established by the advertising and the marketing of the film (and the reputation of the best-seller from which it derives): they will be reinforced by initial sequences which confirm and encourage us in the belief that the boy will be the center around which this narrative turns (just as his telepathic powers lend the film its title). We hasten to follow orders and passively/obediently invest these first alarming visions with the appropriate foreboding: the child's powers (and his seeming possession by a preternatural alter ego) augur poorly for a restful winter in the empty months ahead. In any case, we've had enough experience with horrible children (Leroy's *The Bad Seed* [1956], Rilla's *Village of the Damned* [1960]) to be able to identify sheer *evil* when someone rubs our noses in it. Alongside all this, the Jack Nicholson character's fatal weakness is unsuspectingly diagnosed as a more normal and reassuring alcoholism (including whatever other moral instabilities one likes). Such false pretenses are continued at least up to the point at which the old cook, Scatman Crothers, recog-

nizes the boy and explains his powers to him; nor is there time for the theme of telepathy to develop any of its traditional meanings. It has been the subject of grim representations: most notably in Robert Silverberg's 1972 novel, *Dying Inside,* which takes this motif seriously enough to ask—in the midst of a depressingly contemporary Manhattan—what problems such a "gift" would raise for its hapless bearer. Yet on the whole telepathy in recent science fiction has been the occasion for an anticipatory representation of the Utopian community of the future, and of an unimaginable evolutionary mutation in collective relationships (as in Theodore Sturgeon's classic novel *More than Human* [1953]). At best, *The Shining* very faintly recapitulates this Utopian resonance in the protective fellowship between the frightened child and the elderly black chef (and through the latter in the momentary juxtaposition of a ghetto community with the atomized white society of the luxury hotel or the petty bourgeois family unit).

But the main point to be made about telepathy in *The Shining* is that it is a false lead, and it is consistent with the play of generic signals mentioned above that this deliberate confusion should involve the misreading of the film's genre during its first half-hour. The model for this kind of generic substitution is surely Hitchcock's *Psycho* (whose staircase sequence is "quoted" at least twice in *The Shining*), where a banal embezzlement narrative is developed, only to be abruptly extinguished along with its heroine by a very different crime narrative. (In *Psycho,* however, the relationship between the two genres, between the public crime determined by the socially acceptable or "rationale" motive of money and the private or psychotic impulse, is still an arguably meaningful juxtaposition, a message in its own right most openly dramatized in Fritz Lang's *M* [1931].) Here the generic shift seems less coherent and appears to take place within the motif of possession; only it turns out we were looking for it in the wrong place: not the little boy, "possessed" in some ominous way by his phantom playmate, but the alcoholic father whose weakness opens up a vacuum into which all kinds of baleful initially indeterminable impulses seep. Yet this is in itself another kind of generic misreading, which seizes on some of the signals and conventions of the new genre of "occult" film in order to project an anticipation of some properly diabolical possession to come.

The Shining is, however, not an occult film in that sense: I will argue that it marks a return to and a reinvention of a much older sub-genre, with its own specific laws and content, namely, that of the ghost story, one which is for historic reasons less and less practiced today. Yet even the initial generic uncertainty is part of the reflexivity of the metageneric enterprise: Kubrick's freedom to reinvent the various

generic conventions is at one with his distance from all of them, and with their own historic obsolescence in the new world of television, wide screen, and the blockbuster film. It is as though, to recover some of their older powers, classical genres such as this one needed to take us by surprise and to exert their conventions retroactively. Even a relatively straightforward pastiche of an older sub-genre such as *Chinatown* secures its effects ambiguously behind the protective appearance of the nostalgia film.

What is anachronistic about the ghost story is its peculiarly contingent and constitutive dependence of physical place and, in particular, on the material house as such. No doubt, in some pre-capitalist forms, the past manages to cling stubbornly to open spaces, such as a gallows hill or a sacred burial ground; but in the golden age of this genre, the ghost is at one with a building of some antiquity, of which it is the bad dream, and to whose incomprehensible succession of generations of inhabitants it makes allusion as in some return of the repressed of the middle-class mind. Not death as such, then, but the sequence of such "dying generations" is the scandal reawakened by the ghost story for a bourgeois culture which has triumphantly stamped out ancestor worship and the objective memory of the clan or extended family, thereby sentencing itself to the life span of the biological individual. No building more appropriate to express this than the grand hotel itself, with its successive seasons whose vaster rhythms mark the transformation of American leisure classes from the late 19th century down to the vacations of present-day consumer society. The Jack Nicholson of *The Shining* is possessed neither by evil as such nor by the "devil" or some analogous occult force, but rather simply by History, by the American past as it has left its sedimented traces in the corridors and dismembered suites of this monumental rabbit warren, which oddly projects its empty formal after-image in the maze outside (significantly, the maze is Kubrick's own addition). Yet at this level the genre does not yet transmit a coherent ideological message, as Stephen King's mediocre original testifies: Kubrick's adaptation, indeed, transforms this vague and global domination by all the random voices of American history into a specific and articulated historical commentary, as we shall see shortly.

Yet even this undifferentiated sense of the presence and the threat of history and the past as such is enough to reveal the generic kinship between the ghost story and that older genre with which and against which it so often constitutively defines itself, namely, the historical novel. What is the latter, indeed, if not an attempt to raise the dead, to stage a hallucinatory fantasmagoria in which the ghosts of a vanished past once again meet in a costumed revel, surprised by the

mortal eye of the contemporary spectator-voyeur? A novel like H.P.
Lovecraft's *Strange Case of Charles Dexter Ward* can then be read as
forming a "hideous" bridge between the two genres, as furnishing a
disturbing and reflexive commentary on the secret aims and objec-
tives of the narrative historian or historical novelist. So Lovecraft—
as possessed as any historicist by the local and cosmic past of his
mouldering Providence[2]—seems intent on a literal dramatization of
Michelet's classic view of the historian as the custodian and awakener
of the generations of the dead; and the grislier moments of his fable,
as when "world-historical" figures like Benjamin Franklin are raised
up naked from their graves and put to the question by their tormentor,
comment peculiarly on the hybris of the historian and on the latter's
superstitious belief in the possibility of representing the past.

It is no accident, therefore, that alongside the meta-ghost story of
The Shining Kubrick's own work provides one of the most brilliant
(and problematical) contemporary realizations of the representa-
tional ideal of the historical novel proper, in the film *Barry Lyndon*
(1975). The very images of this film seem to draw their mystery as
colored bodies from the privileged effect of powder upon the young
blood of its characters' faces; the simulacrum as a whole stands as a
virtual text-book illustration and validation of Lukács's account of
the archeological novel as a terminal form of the evolution of the
Historical Novel proper: that moment in which this once new genre
begins to lose its social vitality as the living expression of the historicity
of a triumphant and class-conscious bourgeoisie and to survive as a
curiously gratuitous formal shell, whose content is relatively indiffer-
ent. Lukács liked to quote the remark of the great Berlin novelist
Theodor Fontane about the range and the limits within which authentic
historical fiction was alone possible: you can situate your novel, Fon-
tane said, in a period no more remote than that of the life experience of
your own grandparents, by which he seems to have meant to underscore
the constitutive relationship between the historical imagination and
the living presence of those surviving mediators whose anecdotes abut
a determinate past open up a zone of social time henceforth accessible
to fantasy at the same time that it anchors that zone in the referential
constraints of the experience of real individuals. The disappearance of
the grandparents from an atomized suburban culture must then have
a significant effect on the social amnesia, the loss of a sense of the past,
in consumer society and, with it, on the increasingly problematical na-
ture of the historical novel as a form.

The essential precondition of an extended family thus becomes the
symptom and the allegory of the survival of "organic" social relations,
of what Raymond Williams calls the "knowable community"[3]

(whether this takes the form of the village or the classical city, or of the vitality of national groups). In our own theoretical climate, so deeply marked by the revolution of the Symbolic and the discovery of Language, one would surely also want to add the qualification that there must be a continuity of speech from the represented past to the present of the historical novel's readership. Roman empire novels in English, or Lukács's supreme example of the archeological novel, the French-speaking Carthage of Flaubert's *Salammbô*, are thus, even more than curiosities, contradictions in terms. Arguably, *Barry Lyndon's* 18th-century "English" is yet another one of these dead languages.

My point here is not that *Barry Lyndon* is not an artifact of great quality and impressive virtuosity: a great film, why not? a great Kubrick film, certainly. And any number of readings are available to formulate its relevance and its possible claims on us as contemporary spectators: you can take it as a powerful anti-war statement; as a study of power and prostitution, of manipulation, of the pathos of waste, being used and then thrown aside like an old shoe; as some deeper expression, at a psychoanalytic level, of anxieties about mutilation and castration . . . all "major" themes, surely, which a contemporary artist ought to have a perfect right to develop without any further justifications. Yet all these are as it were at a distance from the thing itself, whose very perfection as a pastiche intensifies our nagging doubts as to the gratuitous nature of the whole enterprise. Why this 18th century at all in the midst of a late 20th-century culture industry? Or in that case, why would almost anything else not have done just as well (a Kubrick Elizabethan era, a Kubrick American Revolution, a Kubrick *Ivanhoe*)? The doubt is an insidious one, however, whose contagion threatens to transcend the specialized issue of the content of the historical novel as such and to problematize the raw materials of all contemporary cultural production. Without a past, can we even continue to appeal to a shared present? And as for the choice of a subject, why should a southern small town, a California university, or the Manhattan of the 1970s be any less arbitrary a starting point, in a fragmented multi-national culture, then the London or the German principalities of this 18th century? Indeed, the theory of pastiche with which we began emerged, less from the study of the dilemmas of the historical novel, than from the generalized crisis in cultural production as a whole today.

The Shining may be read as Kubrick's meditation on the issues raised by his previous film and on that very impossibility of historical representation with which the achieved perfection of *Barry Lyndon* so dramatically and paradoxically confronts us. For one thing, the

conventional motifs of the occult or supernatural thriller tends to distract us from the obvious fact that *The Shining*, whatever else it is, is also the story of a failed writer. Stephen King's original was far more openly and conventionally an artist's novel whose hero is already a writer of some minimal achievement and a classical American *poète maudit* whose talent is plagued and stimulated by alcoholism. Kubrick's hero, however, is already a reflexive commentary on this now conventional stereotype (Hemingway, O'Neill, Faulkner, the beats, etc.): his Jack Nicholson is not a writer, not someone who has something to say or likes doing things with words, but rather someone who would like to *be* a writer, who lives a fantasy about what the American writer is, along the lines of James Jones or Jack Kerouac. Yet even that fantasy is anachronistic and nostalgic; all those unexplored interstices of the system, which allowed the lumpens of the fifties to become, in their turn, figures of "the Great American Writer," have long since been absorbed into the sealed and achieved space of consumer society. (Or if you prefer, the as yet unregistered and unexpressed experiences which the beats were able to discover on the margins of the system have themselves—along with the very figure and role of the beat writer as such—become part of the culture and its stereotypes: as with black writing and women's writing, it is what has never been seen which enables the production of a new language—"affirmative culture" then ever more rapidly catches up, assimilates all those things into what everybody knows, maps out the unexplored, turns everything for which you still lacked words into so many consumable images.) The very content of the star system itself, as it inscribes itself in Kubrick's movie, the semiotic content of "Jack Nicholson" as postcontemporary hero, makes the same point by its very distance from the older generation of new rebels (Brando, James Dean, Paul Newman, and even, transitionally, Steve McQueen).

On the other hand, whether the Jack Nicholson character can write or not, he certainly *does* write, as the most electrifying moment of the film testifies; he unquestionably produces "du texte," as the poststructuralists put it (even if you are tempted to recall Truman Capote's comment about *On the Road*—"that's not writing, that's typing!"). The text in question is however very explicitly a text about *work*: it is a kind of zero point around which the film organizes itself, a kind of ultimate and empty auto-referential statement about the impossibility of cultural or literary production.

If you believe that such production must always presuppose the sustaining existence, behind it, of a community (whether identified or not, whether conscious of itself or on the contrary about to achieve such consciousness by means of the very cultural expression which

testifies, ex post facto, to its having been there in the first place), then it is clear why "Jack" has nothing to say: even the family unit of which he is a part has been reduced to a kind of stark isolation, the coexistence of three random individuals who henceforth represent nothing beyond themselves, and those very relations with each other thus called (violently) in question. Meanwhile, whatever possibility this particular family might have had, in the social space of the city, of developing some collective solidarity with other people of similar marginalized circumstances is henceforth itself foreclosed by the absolute isolation of the great hotel in winter. Only the telepathic fellowship of the child, as it strikes a link with the motif of the black community, offers some fantasmatic figure or larger social relationships.

It is however precisely in such a situation that the drive towards community, the longing for collectivity, the *envy* of other, achieved collectivities, emerges with all force of a return of the repressed: and this is finally, I think, what *The Shining* is all about. Where to search for this "knowable community," to which, even excluded, the fantasy of collective relations might attach itself? It is surely not to be found in the managerial bureaucracy of the hotel itself, as multinational and standardized as a bedroom community or a motel chain; nor can it any longer take seriously the departing vacationers of the current holiday season, on their way home to their own privatized dwelling places. It only has one direction to go, into the past; and this is the moment at which Kubrick's rewriting of his novelistic original takes on its power as an articulated and intelligible symbolic act.

For where the novel stages the "past" as a babel of voices and an indistinct blast of dead lives from all the generations of historical inhabitants in the hotel's history, Kubrick's film foregrounds and isolates a single period, multiplying increasingly unified signals: tuxedoes, roadsters, hipflasks, slicked-down hair parted in the middle. . . . The very incoherencies of the film's materials reinforce this coherent and emergent message: thus, in the great hallucination scene, when the ballroom is animated by the merrymakers of another era, among whom Jack Nicholson, unshaven and in his lumberjacket, seems painfully out of place, the long awaited moment of truth takes place, and the film public palpably gasps when the conventions of the ghost story are violated, when the hero physically intersects with his fantasmagoric surroundings and collides with the material body of a waiter whose drink he spills. The audience understands at once that this waiter can only be the one character we have not yet met: the previous nightwatchman whose grisly murder-suicide in an earlier winter has already been revealed. The seeming incoherence is that the night-

watchman—from a recent past, whose psychotic impulses and family violence we tend to imagine along the lines of the Nicholson character's own—can surely whatever he was, not have been anything like this bland and obsequious clean-shaven manservant, whose toneless politeness projects such malevolence through its very inexpressivity. Even the precursor-figure, then, the forerunner of Nicholson's own possession and the ominous shape of this own destiny, has himself been rewritten in terms of some older past, and of the style of some previous generation.

That generation, finally, is the twenties, and it is by the twenties that the hero is haunted and possessed. The twenties were the last moment in which a genuine American leisure class led an aggressive and ostentatious public existence, in which an American ruling class projected a class-conscious and unapologetic image of itself and enjoyed its privileges without guilt, openly and armed with its emblems of top-hat and champagne glass, on the social stage in full view of the other classes. The nostalgia of *The Shining*, the longing for collectivity, takes the peculiar form of an obsession with the last period in which class consciousness is out in the open: even the motif of the manservant or valet expresses the desire for a vanished social heirarchy, which can no longer be gratified in the spurious multinational atmosphere in which Jack Nicholson is hired for a mere odd job by faceless organization men. This is clearly a "return of the repressed" with a vengeance: a Utopian impulse which scarcely lends itself to the usual complacent and edifying celebration, which finds its expression in the very snobbery and class consciousness we naively supposed it to threaten. The lesson of *The Shining*, then, its depth analysis and "working out" of the class fantasies of contemporary American society, is peculiarly disturbing for Left and Right alike. Its generic framework—the ghost story—implacably demystifies the nostalgia film as such, the pastiche, and reveals the latter's concrete social content: the glossy simulacrum of this or that past is here unmasked as possession, as the ideological project to return to the hard certainties of a more visible and rigid class structure; and this is a critical perspective which includes but transcends the more immediate appeal of even those occult films with which *The Shining* might momentarily have been confused. For the former seemed to revive and stage a Manichaean world in which good and evil exist, in which the devil is an active force, in which, with the right kind of attention and the right guides, one could finally sort all this out and determine what was on the side of the Lord and what was not. Such films can be taken as expressions and symptoms: and in a social climate about which we have been told that there is a powerful fundamentalist and religious

revival at work, they might be expected to document a significant development in social consciousness today and to serve an essentially diagnostic function. But there is another possibility: namely, that such films do not so much express belief as they project a longing to believe and the nostalgia for an era when belief seemed possible. Arguably, the golden age of the fifties Science Fiction film, with its pod people and brain-eating monsters, testified to a genuine collective paranoia, that of the fantasies of the Cold War period, fantasies of influence and subversion which reinforce the very ideological climate they reproduce. Such films projected the figure of the "enemy" in the individually monstrous, the collective organization of the latter being at best conceivable as a biological or instinctive sub-human network like the dynamics of an anthill. (The enemy within is then paradoxically marked by non-difference: "communists" are people just like us, save for the emptiness of the eyes and a certain automatism which betrays the appropriation of their bodies by alien forces.)

But today, where information about the planet has become far more widely diffused through the media, and where with the great movement of decolonization of the 1960s the most repressed collectivities have begun to speak in their own voice and to project the demands of properly revolutionary subjects, it is no longer possible to represent Otherness in this way. It is not clear, for instance, that the political unconscious of America today can still conceive of the Russians as evil, in the sense of the alien otherness and facelessness of these earlier fantasies: at best, clumsy and brutal, heavy-handed, as in current evaluations of the invasion of Afghanistan. As for the formerly faceless horde of the Chinese, they are now our loyal ally and have reintegrated the earlier wartime fantasy of the "friendship" between China and America, while our former Vietnamese enemy—no longer, in any case, a global ideological threat—enjoys the grudging prestige of the victor. The Third World, generally, immobilized in a post-revolutionary situation by military dictatorship, corruption, and sheer economic distress, no longer offers adequate materials for the fantasies of a beleaguered Fortress America, submerged by the rising tide of militant underclasses.

This is the situation in which the new wave of occult films (they can be dated from 1973, the year of _Exorcist I_ as well as of the global economic crisis which marked the end of the sixties as such) may rather be seen as expressing the nostalgia for a system in which Good and Evil are absolute black-and-white categories: they do not express a new Cold War psychology as much as they express the longing and the regret for a Cold War period in which things were still simple, not so much belief in Manichaean forces as the nagging suspicion th

everything would be so much easier if we could believe in them. *The Shining*, then, though not an occult film, nonetheless envelops the new ideological genre of the occult of its larger critical perspective, allowing us to reinterpret this still "metaphysical" nostalgia for an absolute Evil in the far more materialistic terms of a yearning for the certainties and satisfactions of a traditional class system.

This is, indeed, the embarrassment *The Shining* has in store for viewers on the Left, who are accustomed to celebrate class consciousness as though its reemergence was everywhere politically positive and did not include the forms of nostalgia for heirarchy and domination allegorized in Jack Nicholson's "possession" by the still Veblenesque social system in the 1920s. Indeed, legitimate and unanswerable questions may well be raised about the "critical"—let alone the outright "political"—status of this ostensible entertainment film and, in particular, about the effectiveness of its demystification of class nostalgia on a general viewing public. Behind such notions of demystification and of the "critical" stand the unexamined models of Freudian psychoanalysis and of a confidence in the power of self-consciousness and reflexivity generally to transform, modify, or even "cure" the ideological tendencies and positions which have thereby been brought up into the light of consciousness. This confidence is at the least unseasonable in an atmosphere where nobody believes in the active capabilities of individual consciousness any more, and in which the very ideologues of "critical theory"—the Frankfurt School—have left behind them, in works like *Negative Dialectics*, testaments of despair about the possibility for "critical theory" in our time to do any more than to keep the negative and the critical (that is, critical theory itself) alive in the mind.

Whatever its critical value, *The Shining* in any case "resolves" its contradictions in a very different spirit. If the possession by the past offers an implicit commentary of Kubrick's historical project in *Barry Lyndon*, the ending of *The Shining*, by a grim quotation, casts new light on *2001*, whose ostensible theme was the evolutionary leap into the future. The manifest contents of this metageneric practice of that rather different thing, the Science Fiction genre, derived, of course, from Arthur C. Clarke, whose Star Child worked yet another variant on the favorite theme of this author, namely, the qualitative mutation in human development and the notion of a kind of "childhood's end" for human history. Even at the time, however, I doubt whether any viewer of what Annette Michelson has significantly called "Man's last motel stop on the journey towards disembodiment and renascence"— the ornate yet anonymous formal bedroom in which the last astronaut runs through the biological cycle from aging and death to cosmic

rebirth—can have received these images with unqualified enthusiasm. The very sterility of the decor and the relentless sloughing off of superimposed moments of the individual's life cycle seemed to provide a grim commentary in images of the film's optimistic ideological message.

The ending of The Shining now makes that commentary explicit, and identifies the operative motif of the Star Child as that of repetition, with all its overtones of traumatic fixation and the death wish. Indeed, the great maze in which the possessed Nicholson is finally trapped, and in which his mortal body is frozen to death, casts a glancing sideblow at the meretricious climax of Stephen King's novel in the destruction by fire of the great hotel itself, but more insistently rewrites the embryonic face of the Star Child about to be born into the immobile open-eyed face of Nicholson frosted in sub-zero weather, for which, at length, a period photograph of his upper-class avatar in the bygone surroundings of a leisure class era is substituted. The anticipatory foreshadowing of an unimaginable future is now openly replaced by the dismal emprisonment in monuments of high culture (the regency room, the maze itself, classical music) which have become the jail cells of repetition and the space of thralldom to the past. It remains to be seen whether The Shining has succeeded in exorcising that past for Kubrick, or for any of the rest of us.

(1981)

6.

Allegorizing Hitchcock

Another case, and just a frequent a one, is that of conceptions of the cinema which aim to be theoretical and general but in fact consist of justifying a given type of film that one has first liked, and rationalising this liking after the event. These "theories" are often author aesthetics (aesthetics of taste); they may contain insights of considerable theoretical importance, but the writer's posture is not theoretical. . . . A simultaneously internal and external love object is constituted, at once comforted by a justificatory theory which only goes beyond it (occasionally even silently ignoring it) the better to surround and protect it, according to the cocoon principle. . . . To adopt the outward marks of theoretical discourse is to occupy a strip of territory *around* the adored film, all that really counts, in order to bar all the roads by which it might be attacked. (Christian Metz, "The Imaginary Signifier")

I

A powerful interpretive act—in this instance, *Hitchcock: The Murderous Gaze*, by William Rothman[1]—is usually understood as telling us something about its subject matter; but it can also be interrogated (as will be the case here) for what it can tell us about *interpretation* as such, the latter's conditions of possibility, what an interpretation has to leave out to include what it finally manages to include, and also what all this has to do with the way in which the interpretive operation constitutes a certain object of study, and a certain (institutionalizable) "field" of study: something I am bound to see a little differently since I am peering over into it from my own (whose "object" is verbal narrative). So I have no vested interest in this particular field, whose products I nonetheless sometimes read with a certain envy, as though it were easier to be a materialist when you had a "really" material object to work with.

On second thought, however, "materiality" is not nearly so useful a way of thinking about film criticism than the concept of *translation* or *transcoding*, as that allows you to measure the relative difference between retelling the story of a novel and writing up the sequence of a film. Explanatory power is then proportional to the distance between the two codes (between the aesthetic "language" and the critical "language"), and much of our time, in literary studies, is spent distancing and "objectifying" our subject of study (turning it, say, into something called "narrative"), so that our critical rewriting will come with certain force or shock.

On the other hand, film criticism ends up reproducing some of our more traditional literary-critical problems, in particular that of the gap between part and whole, presence and totality, style and plot, in short, what Coleridge called fancy and imagination, and what I have preferred (following Deleuze and Guattari) to call molecular and molar. Nothing is quite so disturbing for any organic aesthetics than this "methodological" problem, which also turns out to be a whole historical situation and dilemma. Paradoxically, it is much easier to deal with these distinct "levels" or "dimensions" when they are in contradiction with one another, or are at least doing two very different kinds of things, than when there exists some semblance of harmony between them: Conrad's "impressionism," his production of a certain kind of style, is easier to isolate precisely because it is doing something relatively unrelated to, or disconnected from, his plot construction.[2] Still, inventing ways to bridge this gap (or even worse, to conceal its existence) is one of privileged arenas for interpretation as a bravura gesture (Rothman's interpretive operation will be no exception to this, as will be shown below): and that an equivalent gap confronts the analysis of film can be deduced from the problem of what to do with the individual *frame* (or, somewhat differently, with the individual *shot*). Are these phonemes, the words, or the sentences of "filmic discourse"? And since neither frame nor shot are the categories through which the naive viewer experiences film, what is the epistemological priority of a "semiotic" commitment to the most self-punishing frame-by-frame analysis of a given film (over and beyond the ritual of professionalism involved), as against the suggestion of Stanley Cavell (following Freud on dreams) that the filmic "object" is whatever we *remember* the film to have been (including our mistakes, holes, substitutions), that is to say, its "narrative" appropriated by memory and transformed into an object?

I am, however, anxious to reintroduce History back into this "problem," which is not only methodological (or epistemological), but which reflects an objective development in its object, a widening

structural distance, within all modern cultural languages, between the micro-text and the macro-structure, or between the "molecular" and the "molar." In this form, that "distance" (with all the methodological problems it raises for analysis and for criticism) is to be seen as a historical event: one which I am tempted—very hastily and prematurely, very dogmatically, if your prefer—to see as the scars and marks of social fragmentation and monadization, and of the gradual separation of the public from the private in modern times, as it cannot but exert its force field upon the cultural production of the period. Film, however, imposes such a historical perspective on us in a twofold, doubly complicated way: for besides the internal logic, the internal evolution and development of its own intrinsic languages—from Griffith, say, to Hitchcock and on to Godard and after—it is also itself a historically new cultural apparatus, whose "material" structure may be expected to reflect (and to express), in its very formal structure, a particular moment or stage of capital and of the latter's intensified, yet dialectically original, reification of social relations and processes.

This means that critical or interpretive solutions need always to be retheorized, in a second moment, as indices of a historical situation or contradiction; and it is this second moment which is missing from Rothman's stimulating book (as from how many others?): perhaps what we miss thereby can rapidly be conveyed from two perspectives before we try to do justice to its positive achievements. The question of *genre*, for example, always one of the privileged mediations between the formal and the historical, is relatively neglected here (save for the emergence of "romance"[3]): it being understood that genre criticism does not properly involve classification or typology but rather that very different thing, a reconstruction of the *conditions of possibility* of a given work or formal practice. It is therefore less a question of "deciding" what genre Hitchcock's films belong in, than rather of reconstructing the generic traditions, constraints, and raw materials, out of which alone, at a specific moment of their historical evolution, that unique and "non-generic" thing called a Hitchcock film was able to emerge. Genre functions to prevent embarrassing or unwanted questions from being asked (it is thus like a "frame" with respect to the reader's or spectator's interpretive temptations): the most obvious example of this, in genres clearly related to Hitchcock's work is the "significance" of murder—a theme, problem, or subject which does not (let's be frank) preoccupy us unduly during our normal daily lives. To interest us in this "topic," therefore, requires a certain amount of justification, which is to say, a certain amount of metaphysical rationalization (e.g., "murder is the very metaphor of the human condition," or, "New York is a jungle"). The function of generic fram-

ing, as in the "murder mystery," is to dispense reader and writer alike from the necessary for such rationalization: the generic label says, the centrality of "murder" is pure convention, we will all assume in advance that this topic is "important" and take it from there.

We are then once more reemerging *from* that genre and *from* those conventions when we begin to get nervous about the unjustified (or unjustifiable) function of the theme of murder in art like that of Hitchcock, and now set ourselves the new interpretive task of discovering the "meaning" of this motif ("the connection between murder and marriage is one of Hitchcock's great subjects"—Rothman, p. 53: see below). At that point, however, we would have to distinguish different kinds or even concepts of "meaning" itself: "symbolic" meanings, for instance—where either metaphysics or authorial intention have the power to "impose" a given meaning on what is otherwise a random bit of raw material—ought, one would think, to be radically separated from at least two other types of meaning (which might be coordinated in the present instance): namely the genealogical, in which "murder" as part of Hitchcock's historical and generic raw material is accounted for as an element in his own situation and dilemma with which he must somehow himself deal; and the "enabling" or "conditional" type in which the unique perceptions and "meanings" we do find in Hitchcock are somehow accounted for by the unique peculiarities of his narrative and formal apparatus (including the convention of "murder").

The foregoing can now be somewhat generalized so that the problematization of interpretation it implies becomes a historical dilemma in its own right. At this level of abstraction, we might begin with the fragmentation and privatization of individuals in contemporary society and with the atomization of all hitherto existing forms of community or collective life (including the values and common languages of such groups). Reception of the individual art object thereby becomes rigorously nominalistic, and shared conceptual motifs (symbols, "values") can no longer be assumed or taken for granted. The artist may adapt to this situation by producing the "open work of art," an object that can be used by anybody as they see fit. Such an object does not preselect its public (as only those who share this or that convention of meaning); it is randomly recodable as one likes. Meanwhile, as the artist is equally nominalized (situation-specific, historically and socially bereft of all claims to, or possibilities of, universality) we begin to see the production of private meanings in the work of art. This is the point, paradoxically enough, when film as an emergent cultural language and apparatus of the twentieth century assumes significant historical meaning. For it is, as Metz has in-

structed us, a very peculiar language indeed, a "language without a lexicon" ("this does not mean that filmic expression lacks any kind of predetermined *units*, but such units, where they do exist, are patterns of construction rather than preexisting elements of the sort provided by the dictionary"[4]). This is to say that the kinds of private language (special signifiers functioning as Lacanian "upholstery tacks") we have become accustomed to in high modernist literature are here somehow authorized by the very nature of the cinematographic apparatus itself. All of Hitchcock then becomes one immense private language, on immense chain of "private" signifiers, which has however become public and collectively accessible, (and within which, paradoxically, at some second degree the older modernist "private signifiers" again stand out: Rothman is particularly good on two of these "encodings" in Hitchcock: the strategic use of the overhead shot, and the even more idiosyncratic inscription on the frame of parallel vertical bars of various kinds, to which an auditory equivalent—staccato knocking—is also identified[5]).

The interpretive problem is however that even such private languages are the result of *recoding* preexistent signifiers, and those continue residually to draw a laborious train of inherited (and quasi- or pseudo-universal) meanings behind them which must somehow be "justified" by the critic. It is as though the interpretive process had as its essential function the demonstration that a given spectator-reader need bring no particular form of belief-system dogma along to the reception of this particular aesthetic object; if you have to be Marxist, Freudian, theological, New-Deal liberal, Tory, or whatever, in order to get the point of the film, then there is something "impure" about it: a "pure" filmic language should be conceivable, in other words, which demands no ideological preconditions. But this means, as we shall see later on, that the overwhelming temptation of the interpreter is to turn all remnants of *content* back into sheerly *formal* phenomena or processes, in order to save the work.

But I also mentioned a second possible approach to Hitchcock which I found lacking in Rothman's book, but which will open a useful perspective in which to evaluate it: this has to do with a way of seeing and using Hitchcock's films, which, however inadmissible, has to tell us something about their objective properties, in other words, about their objective capacity of being misinterpreted and misused in this particular way. But in the days I am speaking about there were not yet any "serious" interpretations of Hitchcock: the very first of these, to my knowledge, was the Rohmer-Chabrol hypothesis of 1957, that as Hitchcock was an Anglo-Catholic, his films were about sin and confession along the lines of Graham Greene. To parody the philoso-

phers, then, we might assert that the matter of "interpretation" turns on the meaning and function of this particular word "about," a word that played no particular role in a period when "Hitchcock" simply meant a bag of tricks, such as the tennis court in *Strangers on a Train* (1951; from whose public's obediently swiveling heads the madman's fixed stare emerges like a zoom shot), or (more spuriously perhaps) the Dali sequences in *Spellbound* (1945), such as the moment of the first kiss, behind which an enfilade of doors miraculously swings open. You went to see Hitchcock for those brief embellishments, those episodic bravura moments, just as you searched for further Buñuels, in the hope of finding dream sequences on the order of *Los Olvidados* (1950; the other auteurs of this, the great period of auteurs, were a little less mechanical, although there was always the stunning silent movie sequence of Bergman's *Naked Night* [1953]).

Nothing could have been more distant from the then current New Critical ideals of good reading—namely of responsible and hierarchically unifying or organic interpretation—than this selectivity, which often enough resembled the rifling of a box of chocolates, surreptitiously replacing the unwanted flavors with their undersides perforated for inspection by a thumb. But theoretical intuitions were not wholly absent from such "critical practice": for one thing, we dimly sensed the privileged function of certain formal constraints as the conditions of possibility for these moments of filmic "decoration." Indeed, constraint—as in the unities of French classical tragedy—also seemed to account for the persistence of the thriller form throughout these works, as well as the supplementary games Hitchcock seemed to play with himself (most dramatically in the single continuous tracking shot of *Rope* [1948] or the implacable ephemerality of the fall foliage in *The Trouble with Harry* [1956]).

This perception was not wrong, but needed to be related more dialectically to the matter of fragmentation itself. Indeed, in retrospect one is astonished by the way in which the great foreigners, the great European exiles—Nabokov and Chandler fully as much as Hitchcock himself—work by disassemblage, taking the American misery apart in carefully framed, discontinuous episodes, sometimes as reduced as individual sentences, which then stand as the frame beneath which their aesthetic hobbies are enshrined. It is hard to imagine an American artist greeting the "inexhaustible richness" of American daily life with the same jubilation: on the other hand, it might be argued that the miniaturizing habit of the exiles allowed something to be shown and to be seen about daily life in the United States itself which the immanence of the native, under the rumbling shadow of the el-train, is unable to focus aesthetically. This has some-

thing to do with the invisibility of daily life as such, the way that peculiar object dissolves when you seek to make it the center of your gaze, rather than some peripheral or lateral side effect;' and it is this problem—of the presentation of daily life, and all the more, of American daily life at that—which a remarkable letter of Chandler addresses:

> A long time ago when I was writing for the pulps I put into a story a line like "He got out of the car and walked across the sun-drenched sidewalk until the shadow of the awning over the entrance fell across his face like the touch of cool water." They took it out when they published the story. Their readers didn't appreciate this sort of thing—just held up the action. I set out to prove them wrong. My theory was that the readers just *thought* they cared about nothing but the action; that really, although they didn't know it, the thing they cared about, and that I cared about, was the creation of emotion through dialogue and description.[6]

Adjusting Chandler's language, we can disengage from this reflexion a whole theory—equally illuminating for Hitchcock and Nabokov—about the artistic representation—by indirection and laterally, as it were out of the corner of the eye—of an everyday life, whose condition is the ostensible fixation of the public on the "molar" pretexts of plot, mystery narrative, "suspense," and macro-temporality. The recipe has something in common with Proustian indirection, with the indistinction of the Proustian present, and shares its originating situation in the repression of perceptions and the incapacity to live the daily life of the present itself: this last can then become visible only when the official raised index finger of the artist holds and engages the public's "esprit de sérieux" (even if this last is sheer "diversion" and "entertainment"), so that other, radically different kinds of perceptions become marginally tolerated in the decorative field around the plot or "action" proper.

Since the experience of daily life is arguably related in some fundamental way to the urban (at any rate, it is clear that the *concept* of daily life is very closely related to the concept of the city as it emerges in the late nineteenth century), it may be most appropriate to convey this aesthetic problem by way of our impressions of cities, which, notoriously disunified or random, and spanning a great qualitative range between the personal or the private memory and the public, anonymous, institutional, or stereotypical, are not obviously the most immediately suitable raw materials for a work of art.

To restrict our evocation of a city like San Francisco to its dramatic

landscape is in effect to privilege a type of content or raw material which is little more, essentially, than our experience of picture post-cards or tourist posters; to attempt to locate a personal mediation of such material (or, using a different terminology, to position the individual subject within it) suggests operations as impersonal and anonymous as, say, the technique for parking your car on a steep hill, adjusting the wheel in the direction of the curb depending on which way the automobile is pointed, etc. These are not the most promising subjects for an aesthetic text in whatever medium; nor for they seem to intersect with other features of San Francisco one would want to find evoked here—the two- or three-story wooden house, for example, which gives the visitor so overwhelming an impression of a culture of daily life from which she or he is excluded ("daily life" always being the everyday life of *other* people)—a network of urban routines not less privatized than on the East Coast, but somehow more visible, since we can see into people's kitchens or their upper windows. Sunlight is another distinctive trait one would want a description of San Francisco to do justice to: in some uniquely negative or privative way, in the sense in which it merely marks the absence of Eastern changes of season (and their effects on daily life, as in extreme heat or heavy snowfall) rather than the presence of a distinctive and radically different life in nature, as would be the case for Southern California.

If now we limit ourselves to these already relatively unrelated features (and many more are obvious conceivable), the initial problem they pose is not yet even that of the most appropriate way to *express* such experiences—for that already presupposes that they have been transformed *into* personal experiences, the feelings and perceptions of an individual subject, which might then (disappointingly!) be told in the form of a chance impression accompanied by a "reflexion," as in a diary of some kind. Well before we have reached that point at which such "objective" features of this city seem already to have penetrated personal experience and become assimilated to it, one would have to posit, or to attempt to locate, a space in which all of the distinct features enumerated would be found to intersect: on our account, above, they fell into two distinct groups, have to do on the one had with streets and transportation, and on the other hand with housing.

One "objective" meeting place of these two groups of distinctive traits would then seem to propose itself, namely the *sidewalk*—a kind of liminal area between the public and the private, the space of a transformational or transcoding movement from dwelling to transportation, something felt particularly strongly in San Francisco in the passage from the floors of a house to the steepness of the street outside,

an area which however still remains substantially pedestrian. Here too, however, we should try to resist the immediate temptation of formulating all this in terms of aesthetic *expression*, as though the appropriate combination of perception and verbal talent would suffice to nail down, under this or that *mot juste*, the peculiar leg muscle stress, the warmth of sunlight on the face in spite of the freshness of the air, the commercial level of the cross street before you towards which you seem to descend. But this solution presupposes an aesthetic which is little more than a matter of naming, as though, for this complex combination of sensations, there existed the possibility of some enlarged verbal compound which could stand as something like its noun. It is not clear that such an aesthetic has ever been coherent or of any great practical use: what is at least certain is that it does not correspond at all to the procedures of writers whom one would be tempted to take as models in such a situation. Proust, for example, never "renders" a complex sensation or impression of this kind in a direct, head-on assault; he either describes the metaphorical term of the object in question, or inserts the perception as a break within a continuity of habit, such that the story being told is not that of the perception itself, but rather the break in a very different continuum (as when, coming down the steps of a Manhattan townhouse, an unexpected flow of sea air makes us "think" of San Francisco). Tricks and indirections these—Proust's genius, or better still, his art consisting not in his capacity to "render" such sensations but rather to avoid doing so.

On the other hand, the dilemma of "expression" might just as plausibly (and far more historically) be seen as a symptom of the increasing distance between the subject and the object in modern society, so that one is tempted to abandon the subject to its own devices, and to pursue the object in all its prosaic and mechanical complexity. More precision and more concreteness is for example obtained when we recall that the San Francisco sidewalk is not the exclusive property of the pedestrian either, but is also characteristically the space across which private cars are temporarily parked during the day, so that you have to walk around them, either by going out into the street or negotiating whatever room the tenant or owner has left between the nose of the vehicle and the garage door. What is however unpleasant existentially may be an advantage aesthetically, since this very cramping is a condensation that brings all our themes (the house, the slope, the street with its cars) far more closely in relationship to each other. Why does having to walk around these parked cars in San Francisco make a difference to me that it would not make on a similar occasion in another city or town?

It is not only that what is accidental in another place is customary here, for some reason; it is also that the detour brings me in contact—when I can slip past!—with panels that are at least unconsciously more alarming than the solid masonry of the wall in an ordinary building. One has the impression (are we back to those, then?) that if one of these garage doors began to open for whatever reason, the innocent pedestrian bystander would run some risk of being jammed in between the hood of the car and the lid of its empty garage. In truth, our unconscious is poorly informed on all this, and it seems conceivable that these overhead doors ar tracked so as never to extend into the space above the sidewalk proper: how *that* would be possible is then also (conceivably) explained by the peculiar tracking of the metal arm to which it is attached, one of those engineering mysteries in which pressure in one direction generates the zigzag of a returning leverage in the other, elbow geometries of a type unknown to us. This puzzlement is then contained by the more permissible enigma of the long-distance operating mechanism, whose detached and portable box allows you to switch television channels or turn the whole thing off entirely from your bed. Only the push-button servo-mechanism of the overhead garage door is not only similar, it occupies the same typological slot (only two known exemplars!) in the unconscious as the remote control television channel finder; with this difference that it can also more grandly govern outer space, as when it stages a majestic harmony between the Cadillac turning into the street and the garage door rising slowly in the distance: not so elegant as an ocean liner berthing or the Concorde in flight, but perhaps more deeply characteristic of the Third Machine Age, and even more than that, far more sculptural of urban space, being a matter of relating two gadgets across the latter and thus organizing a multidimensional event, rather than determining the style of a *single* object in motion through the void. This would then be a mode of perceiving the garage-door mechanism via the "sublime," where the pedestrian fear of having it open on you would correspond either to farce or to *film noir*.

I have traced all these connections and followed all these complicated wires in order to affirm a scandalous (or perhaps grotesque) proposition, namely that "daily life in San Francisco" is first and foremost *that*—the overhead garage door opener and the steeply sloping sidewalk, followed by a three-story wooden gentrified house rising vertically and the automotive traffic shooting down and over the hill. It is first of all important to underscore the impersonal or reified zone of what is only in a secondary way a personal experience: just as it is fairly rare to evolve your own unique personal style of dealing with cans or home appliances. On the other hand, until we become angels,

or achieve Utopia, there will necessarily persist this core of purely material and anonymous, I would like to say anti-personal, constraint within our own personal commerce with the urban-industrial landscape.

That the latter can never be *transparent*—after the fashion of private or personal, "psychological" experience (the kind we think of as being "real life")—does not mean, however, that such activities do not vehiculate within themselves a whole cluster or constellation of significant themes, some of which have already been developed here: private versus public and the seams between those realms, a sedimentation of machinery from transportation of a now older variety (the internal combustion engine) to action-at-distance mechanisms, two kinds of space, in which one dwells and in which one travels, "the shout in the street" versus the dim stillness of a furnished interior. . . . Yet the paradox is that the more meaning (allegorical or otherwise) conferred on inert mechanisms, anonymous sidewalks empty of people, blank facades that belong to somebody else, the easier such "symbols" allow themselves to be incorporated into the work of art.

Two distinct problems are therefore posed in the aesthetic appropriation of such material: it must not be impoverished to the point of "meaning something" in a transparent, abstract, or basely symbolic sense; but it must also avoid an aesthetic of personal expression, as when I try to render "my" New York by evoking the smooth rising and dipping of cars sweeping at fixed distances from one another down the great north-south avenues of Manhattan, or "my" Paris as the springy impact of a French vehicle on the cobbled section of a boulevard, the new humming of the tires on its paving stones.

There exist, however, other ways of conveying these materials of daily life of which we have said about that they are something like the "blind spot" at the heart of our own present, of our own experience: an objective reality at which you cannot gaze directly without finding it dissolved into its elements, but which stubbornly reconstitutes itself in the corner of the eye when the latter officially fixes *something else.* The form that this process would take in culture is suggested by Hitchcock's work (but not only that); and I have indulged the San Francisco example at such length because it is precisely this material which is mobilized in his last film, *Family Plot* (1976)—one of the two great Hitchcock evocations of San Francisco (the other is, of course, *Vertigo* [1958]). I am not aware of a Hitchcock film set in Los Angeles (save for the perfunctory opening of *Saboteur* [1942]), but one of the dimensions of his work which is important to me (and omitted almost entirely from Rothman's (1969) book and most others on this director) is the intimate relationship between at least the American films and

place as such or the urban: Quebec City (*I Confess*, 1952), Phoenix (*Psycho*, 1960), Bodega Bay (*The Birds*, 1963), Vermont (*The Trouble with Harry*), Harlem (*Topaz* 1969), let alone the French Riviera (*To Catch a Thief*, 1955), Covent Garden (*Frenzy*, 1972), or the Albert Hall, (*The Man Who Knew Too Much*, 1956), not to speak of fields in the Mid-West (*North by Northwest*, 1959), or in East Germany (*Torn Curtain*, 1966), or the top of Mount Rushmore (*North by Northwest*).

What *Family Plot* allows us to witness, as though in a small-scale laboratory situation, is the mechanism whereby the thriller generates a secondary representation of daily life by absorbing the peculiarities of the overhead garage door into the plot proper, and exploiting the subliminal anxiety aroused by the lack of windows in the door panel by stationing the telepathic heroine outside it in the street, while the strategic space indoors is marked by the hostage in the basement. The chain of associations we have traced in connection with the San Francisco sidewalk and its mechanical adjuncts is thus here transferred to the local (and "degraded") peripeties of the suspense story. The latter clearly do nothing in the way of articulating the meanings of the space of daily life as such; indeed, they would seem to distract us from any form of attention (aesthetic or sociological) to the latter, at least until we recall Chandler's account of a form of representation which operates precisely by way of distraction. Then one comes to admire Hitchcock's eye for the peculiarly invisible yet material nodes in which daily life can be detected: an eye and an immobile gaze that fixes us ever more insistently from out of the extraneous dynamics of the plot in a manner not unlike Bruno's stare from the tennis bleachers, (in *Strangers on a Train*), which might be taken as its allegory.

II

Rothman's approach tends to reify his subject as the level of the "auteur" of genius, so that we do not ever reach the point where genius gets conceived as the capacity to register and process certain kinds of raw material with a rare optical or sonorous range, so that our discussion of the form is then able to pass over without any laborious or clumsy shifting of gears into a discussion of content. The five splendid readings of Hitchcock films which he gives us—and which make one wish for more, perhaps even for some eventual "complete" Hitchcock on the order of Donald Tovey's Beethoven—are of course rigged with a view towards Rothman's own interpretation of Hitchcock as a "serious" artist intent on making philosophical (and psychological) "statements" on evil, statements far more readily authorized by *The Lodger* (1926), *Murder!* (1930), and *Shadow of a Doubt* (1943), than by, say,

North by Northwest or *The Lady Vanishes* (1938). But even before we arrive at the content of those interpretations, some preliminary observation must be made about the way in which the "strategy of containment" that frames all this in terms of Hitchcock's "genius" influences the form of Rothman's essay as well: it is as though the centering of his analyses on what is currently called the phenomenon of "mastery" in Hitchcock results, by way of the mirror drama of criticism itself, in the exercize of an analogous "mastery" in Rothman's own readings—the assumption of an impressive, admirable, often even enviable authority which is also intellectually and theoretically disturbing, and which I want to interrogate here (since it will have become obvious that "responsible" organic interpretations of this kind are going to inspire mixed feelings in someone with a history of picking the raisins out of the texts, and also in someone for whom reification and fragmentation is a real social as well as aesthetic issue.[7])

Rothman's book is, however, more than a collection of analyses: it tells a story and models an evolution or a trajectory from *The Lodger*— taken as a first, already mature statement of Hitchcock's thematics and aesthetics ("not an apprentice work but a thesis, definitively establishing Hitchcock's identity as an artist," p. 17)—all the way to *Psycho*, which marks "the end of the era of film whose achievement *Psycho* also sums up, and the death of the Hitchcock film" (p.255). The choice of crucial exhibits, then stakes out a Hitchcock rather different from that of the adventure thriller (yet the formal contribution of *The 39 Steps* [1935] is strategically recognized in a central analysis here); different also from the psychoanalyzing or depth-psychological Hitchcock, of *Spellbound* or *Marnie* (1964); distinct finally from the self-transcending Hitchcock of *Vertigo* ("Hitchcock's masterpiece to date, and one of the four or five most profound and beautiful films the cinema has yet given us"[8]), or of *The Birds* (whose selection as the ultimate or final "Hitchcock film" would have modified the story Rothman has to tell).

That story can perhaps best be initially approached by way of a rather traditional problem, on whose permutation the theoretical originality of Rothman's book depends: it is that of "identification," whose literary-critical formulation has taken the from of Jamesian "point of view" and of the nature and function of "irony," critical concepts which in the general atmosphere of post-structuralism and post-modernism have rapidly come to be seen as ideological and archaic (reflecting a metaphysics of the individual subject or a whole aesthetics of a now extinct high modernism, respectively).

Leaving aside the *Zeitgeist*, this whole problematic of identification and empathy would seem to run several distinct dangers. If one pulls

it in the direction of verbal narrative and Jamesian point of view in its classical sense, then the question of our "identification" with the character through whose eyes and experience we are made to perceive a set of events becomes a fatally moral or moralizing one. There is, for one thing, the ethical status of the point of view figure, who must not be either too wicked or too preternaturally superior to break off all possibility of identification. Then there is the possibility of an on-going identification which little by little proves to have been developed on the basis of false premises, or else the alternate possibility of a "point of view" held out and offered, which in our own superiority we reject from the outset, all the while still viewing the action through the unsatisfactory medium of limited vision: in these cases the oft-rehearsed phenomenon of irony drearily rises up before us yet one more time.

In film, however, the visual nature of the medium alters the fundamental data of the problem (since "point of view" in the strictest sense of seeing through a character's eyes—as in Delmar Daves's *Dark Passage* [1947] or Robert Montgomery's *The Lady in the Lake* [1946]—has been a very marginal narrative procedure indeed). Now, where it is a matter of *looking at* the body or features of an actor, something like a whole psychology would seem to displace the ethical framework of the more literary version of the problem, and raise (equally false, but different) issues of facial expression, "mirror stages," intersubjectivity, and the like. What is suspicious about both ethical and psychological perspectives is their apparent willingness, "in the last analysis," to ground their analyses on some conception of human nature; hence the usefulness of the new Lacanian permutation on all of this, the concept of "suture," in which "identification" is less the effect of some a priori harmony between my own ego and some external representation of the identity or personality of another, than rather my mesmerization by the empty place of "interpellation," for instance, by the returning gaze, from the open screen, of the shot/reverse shot as that empty place becomes ambiguously associated both with myself as spectator and with the other character/interlocutor.[9] At that point, however, this more rhythmic and formal conception of "identification" as process, by radically dissolving the link to any given protagonist or star, tends to liquidate the problem altogether rather than to solve it.

At first glance, Rothman's staging of the issue of identification would seem to have distanced us fundamentally from the more literary problem of point of view: the mystery of *The Lodger* is no doubt a matter of inside knowledge and privileged information, but it is dramatized in terms of the limits of visual itself, of the necessary and

structural externality of the camera, the fact that a "face" can finally never tell us anything we want to know, nor can it even "confirm" what we have learned of a certainty from some other source. The close-up, in other words, tends by its own logic to strengthen an uncertainty the plot itself may have already attempted to dissolve (as when we learn that neither the "lodger"—Ivor Novello—nor the Cary Grant of *Suspicion* [1941] are really murderers):

> The next sequence beings by fading in on the lodger, who looks right at the camera, a smile on his lips. This shot compels us to recognize that we do not really know who this man is or what he wants. For all we know, the mother's suspicions are accurate and he is a murderer. The shot culminates the film's intimations, to this point, that the lodger is the Avenger, and that he has a bond with the camera. With a knowing look he meets the camera's gaze, as if he penetrated our act of viewing him and were acknowledging complicity with the author of the film. It is as if Hitchcock himself, wearing the mask of Ivor Novello, were meeting our gaze and smiling as recognition dawns on us . . . (pp.29–30)

It is then this "relationship of externality" between the camera and the human face which will then, incidentally, explain the privileged status of Cary Grant as the Hitchcock male star par excellence:

> It is as if Grant has made a pact with the camera: his face may be filmed as long as the camera does not stare long and hard at it or let its focus go soft. And this corresponds to a pact he appears to have made with the world: others may view him as long as they do not display their desire for him; in return, he will not display his feelings. Yet Grant finds himself continually gazed upon in ways that perplex and disturb him. He has a whole repertory of ways of addressing other's uncircumspect looks, and an equal repertory of ways of addressing the camera's gaze . . . (p.122)

This function, however, in which a certain use of the camera meets an actor peculiarly suited to it, will begin to emerge only after *The 39 Steps*, as we shall see in a moment. What must on Rothman's account intervene before this fuller development is now the moment of *Murder!*, in which similar thematics are played out as it were in the "third" rather than the "first" person, or in other words in a film which lacks a protagonist either of the type of *The Lodger* or of that of *The 39 Steps*.

Murder! stages a conventional separation between the inquiring consciousness (the actor-director Sir John, played by Herbert Marshall) and the guilty consciousness (revealed to be the transvestite/

mulatto Handell Fane, played by Esme Percy, whose culpability will pose many of the same problems of judgment as the later, more richly developed "cases" of Uncle Charles (Joseph Cotten in *Shadow of a Doubt*) and Norman Bates (Tony Perkins in *Psycho*). Characteristically (and as he will do with these later Hitchcock figures as well), Rothman takes the sexual ambiguity of this figure as the expression of some more metaphysical (and generalizable)

> vision of nothingness . . . charged with images of death and with signifiers of the realm of human sexuality from which Fane is irrevocably estranged. The vision of nothingness sums up Fane's nature in his own and—as he imagines—in Diana's eyes. It is also Fane's vision of his own death. Death is Fane's mark. In the world, he represents death, and only his own death can release him from his curse. (p.92)

It may be wondered whether any interpretive code—no matter how "ultimate" from any common sense perspective (as that of "death" presumably is)—can be invoked in this unmediated way without dogmatism; in fact, Rothman has several supplementary turns in store for us, including the reading of Fane's suicide that follows immediately on this passage, in which he glosses what has to be one of the most extraordinary moments in all Hitchcock, when the guilty trapeze artist, noose around his neck, executes himself in full public view during a performance in the big tent (dropping however, out of the frame and out of sight of the camera):

> As with all suicides, Fane's suicide is a private act admitting no audience. . . . On the other hand, Fane does perform his suicide in the most theatrical way possible in a public arena before an audience that is hushed, waiting for the death-defying climax of his act. Fane's private act of suicide is also a consummate piece of theater that brings down the house. (pp. 93–94)

At this point, however the thematics of "death" is no longer an "ultimately determining" interpretive code in its own right, but has itself been "reinterpreted" in terms of something which will become far more central to Rothman's analyses in the remainder of the book; and it is perhaps at this point that it might be well to distinguish his readings from those of Chabrol and Rohmer, mentioned above, in which the public immolation of the villain—think also of the raised arms, impaled on a spotlight, at the end of *I Confess*, or the agonizing conclusion of *Saboteur* (later transferred to a very different type of figure)—is taken as the "imitation" of Christ on the cross, and as the

mark of redemption of the sinner (read: the Catholic characters, as opposed to the righteous or "innocent" Protestants who do not even have the merit of knowing what sin is). I believe that theological elements are not absent from Rothman's interpretation, but at this particular step in the interpretation his reading is far more richly mediated than the Anglo-Catholic one.

It also has the merit of explaining why, in spite of Hitchcock's own convictions as to the lack of interest of the whodunit as a form, and his own evident substitution of the adventure-thriller for the detective story as such, *Murder!* should have retained this second formal frame-work, in which Sir John—the official protagonist of the film, unlike the occasional detectives and "explainers" of other Hitchcock works—has the self-appointed function of the investigator of the mystery. Yet we have also observed that Sir John is an actor-director, and must go on to mention the "play within a play" whereby he cinches Fane's guilt.

It is indeed the whole thematic of the theater and of "theatricality" which will provide the key mediation here, and which, as Rothman observes, "plays a role" in the self-definition of contemporary film far beyond the work of Hitchcock alone. But where, e.g., in Bergman's already mentioned *Naked Night* (*Gyclarnas afton*), the explicit and ostensible conflict is between the sophistication of the city actors and the more popular and collective mode of life of the circus troupe, here the circus is assimilated to the theater itself, while the operative distinction is implicit only: that between theatricality (silent movie acting, "expressiveness," rhetorical speeches) and *film-making* proper, for which, in the famous Hitchcock phrase, "actors are cattle," and whose supreme and emblematic figure is not the film "star" but rather the film's director himself. Al of which is strikingly underscored by the climactic suicide of *Murder!*, whose theatrical "untruth" suggests that it is an act for a public, which will have *witnessed* this event, while its filmic "truth" lies in the way in which Fane drops out of the camera's sight and in which his essential mystery is preserved and perpetuated beyond all visibility.

The same evaluative axis explains the peculiar status of Sir John, virtually the only significant Hitchcock character who is the object of *irony* in its old-fashioned New Critical, Jamesian or high-modernist sense.[10] (Indeed, one of the interesting ways of reexamining Hitchcock's evolution would involve the positioning of a "break" here with such now traditional forms of ironic "point of view," and the emergence of a new narrative language "beyond" irony.) Sir John, in other words, imagines that the writing of a "play within a play" constitutes

an index of truth or of correspondence to reality, of truthful "representation," since it in fact solves the mystery; he thereby becomes "guiltier," although in a very different way, than the ostensible villain, Handell Fane, since he now implicitly claims rivalry with Hitchcock himself, as the "Absolute Spirit" or demiurge of the film as a whole. Hence the peculiar and significant framing of a "happy end" on stage rather than in the "reality" of the film itself, as Rothman perceptively demonstrates. There exists therefore a properly theatrical *hybris* in this film: one which takes the form of imagining that it can understand other people (and most notably, "villains" or the guilty), and which thereby rivalizes dangerously with the supreme—but absent—power of the director himself. It is this particular element which is susceptible to a theological reading, as I suggested above: a reading in which Hitchcock is the absent deity of this filmic universe and in which such a play of romantic irony (in the stricter sense, developed by the Schlegels, and also significantly revived in Nabokov) has religious overtones. This possibility of a reappropriation by such a theological reading strikes me as a flaw and an objective weakness in Rothman's work; yet it is of a piece with everything that is perceptive in it as well, and is in any case, if not qualified, then at the least "complexified" by the later chapters, to which we now turn.

The reading of *The 39 Steps*, as I suggested above, will after this particular practice-exercise in "third-person" narrative return us to the mystery—the undecidable question of the possibility or impossibility—of some "first-person" narrative via the close-up of the hero's face. It should be noted in passing, however, that here Rothman also briefly turns to another feature of Hitchcock's work which has been excluded from his own book (owing primarily to his choice of examples), namely the matter of romance, the emergence of the "couple as hero," which he usefully relates to generic developments in Hollywood film at about the same period (pp. 132–34).

The central thesis of Rothman's analysis, however, and the decisive move in the argument his book has slowly been building, has to do with the originality of Robert Donat's acting, or better still, with the originality of his face and person as the support and the medium of the camera's new aesthetic possibilities. These last, however, we are now in a position to understand as constituting themselves *against* theater and theatrical acting, even in the florid silent-movie style of Novello in *The Lodger*, but now in the more positive and "specific sense that we do not admit the possibility that [Donat] is putting on an act for the camera or for himself" (p. 119). Paradoxically, this failure to "stage" one's self with a view towards other people's perception is also the fundamental condition of the movie-goer's *identification* with

Richard Hannay/Donat, so that at this point our earlier problem re-
turns with a vengeance:

> Even in its appropriation of Hannay's point of view the camera
> asserts a separation from him that is, paradoxically, a condition of
> his status as a figure of identification. We cannot understand the
> achievement of *The Thirty-Nine Steps* if we assume that identification
> with a figure on the screen is merely an effect. Our bond with Hannay/
> Donat is no illusion caused by the workings of a mechanism. To
> acknowledge this bond, we must be prepared to address such ques-
> tions as who or what the camera reveals Donat to be, who or what
> Hannay is, what Hannay's world is, and who or what *we* are, that we
> heed the call to imagine Donat in Hannay's place. What imagining
> oneself in another's place comes to and what a figure of identification
> is are questions that underlie *The Thirty-Nine Steps* and all Hitch-
> cock's work. (p. 114)

I have quoted this rather inconclusive passage, both to prepare a more
decisive response to it later on, and to sharpen some of the differences
between Rothman's critical operation in this book and those of a more
"semiotic" or continental criticism, since I assume the unidentified
polemic references to "the working of a mechanism" to be an allusion
to the "suture" debate in which Rothman participated, and which in
turn revolves around the currently fashionable "problem" of the so-
called "death of subject."[11] As this last is generally formulated in a
metaphysical way and as an essentially metaphysical problem (is the
ego or the personality coherent; is personal consciousness something
like a "substance," or on the contrary something more like an "ef-
fect"?), it does not seem very productive to take sides on the matter,
except to observe that the kinds of criticism and interpretation gener-
ated on either side of this divide will be very different from each other.
From the assumption of the stability and coherence of some conscious
subject (in Rothman's book, the place of that supreme coherence will
be called "Hitchcock"), a form of interpretation will result in which
the coherence of a given aesthetic artifact will ultimately be shown
to emit a coherent philosophical message, while interpretation from
the standpoint of the "decentered subject" will tend to register the
work (or the former work, the "text") in terms of what are rather
symptomal or symptomatic "meanings" of various kinds.
 What is interesting is that Rothman's position here moves him in a
historical and sociological direction which he finally does not explore:
The 39 Steps will after all be the last work in this study in which the
problem of identification is rehearsed, not around a putatively guilty
figure (later on: Uncles Charles or Norman Bates), but rather around

an innocent one who is himself the protagonist of the film. "Identifica-
tion" (or "irony") can therefore not be secured by content-markers of
any kind (either Charles's actual guilt, or Sir John's theatrical hybris),
but depends on something else:

> In the figure of Hannay/Donat, Hitchcock creates his first complete
> protagonist and figure of identification, the first of a long line of
> Hitchcock heroes. . . . In this film, Hitchcock makes judgments of his
> human subject and calls for agreement with these judgments. First
> and foremost, he calls upon us to accept his judgment that Hannay/
> Donat is a figure with whom we may identify. Those who accept this
> comprise Hitchcock's audience. . . . *The Thirty-Nine Steps* insists on a
> continuity between its protagonist and the figure of the lodger. Yet
> Hannay/Donat also represents a decisive break with the lodger in the
> fundamental respect that, from the outset, Hitchcock wants us to
> recognize him as innocent, possessed of no dark secret. However,
> while we know everything we need to know about this figure to know
> that he is no mystery to us, we know next to nothing about him as a
> *character*: our faith that we know him and the camera's respect for
> his privacy are intertwined. . . . *Within that unknownness that is
> inseparable from our "knowledge" of a star, Hitchcock discovers a dis-
> turbing mystery.* (p. 113, italics mine)

This emergence of the filmed face as a commodity, along with the
emergence of the star system itself, is, as Edgar Morin and others have
shown us, something like a materialist version of what the movies
substitute for "theatricality" or for what Benjamin called "aura"; and
much of Rothman's analysis could be rewritten or remobilized in
the service of an interpretation of Hitchcock's work as an implicit
commentary on the commodity form itself (and on film as the privi-
leged aesthetic apparatus of a society for which "the image has become
the final form of commodity reification" [Guy Debord]).

Rothman does not, however, pursue this particular direction, and
his alternative is an instructive one indeed. For one thing, we now
achieve something like a definitive formulation of the role and func-
tion of the villain in Hitchcock, in this case, the "Professor," with his
well-known missing finger: "Hannay is oblivious of the Professor's
design, but the Professor is no less oblivious than Hannay of Hitch-
cock's, which mandates Hannay's miraculous escape and the Profes-
sor's final defeat" (p. 143). The Professor is thus clearly a reincarnation
of Sir John, with all of the latter's authorial and theatrical hybris, with
this signal difference that Hitchcock has now been able to abandon the
cumbersome mode of "irony" and to mark the Professor as an official
villain, whole "real" crime is not the incomprehensible conspiracy of

the film but rather the more overweening attempt to usurp the place of God himself (in the filmic situation, of Hitchcock).

As the grand lines of Rothman's interpretation thus begin to emerge, other issues are clarified as well, most notably the until now ill-defined nature of the filmic alternative to "theatricality," or in other words, the originality of screen acting as such, as opposed to the vice of the theatrical, with its perpetual self-consciousness and self-staging:

> But the real author of [the climactic scene, the murder of Mr. Memory by the Professor] can only be Hitchcock. Mr. Memory and the Professor act as they must, given Hitchcock's design. Hannay also plays the role Hitchcock calls upon him to play. Hannay is, as always, free; his act is not dictated by his nature. One last time, he finds himself within a situation he did not create. I have been calling Hannay's acting "improvisation" to register that he acts freely and yet is at every moment framed. What is unprecedented is Hannay's unselfconscious acceptance of this condition, the other face of Robert Donat's graceful acceptance of being filmed. (p. 167)

But at this point and given the terms of this discussion, it becomes clear that we are on the point of leaving the problem of actor and character—and of "identification" as such—behind for a rather different one, that of the presiding intelligence of the film, of its demiurge and of our relationship to *him*, which Rothman will (following the Hegelian tradition) characterize as a matter of *recognition*.

His discussion of *Psycho* is both the climax of this stage of the argument, and its unexpected permutation, so that I move at once to it without consideration of the fine chapter on *Shadow of a Doubt*, which in some ways merely recapitulates the themes already indicated, although it also makes out a provocative case for this film as *the* quintessential Hitchcock film (not, as I've already suggested, the Hitchcock that happens to interest me the most). *Psycho* will, however, recast all this, not merely in the way in which Norman Bates becomes the ultimate bearer of that mystery of otherness whose stages were the Lodger, Fane, the Cary Grant of *Suspicion*, and the Uncle Charles of *Shadow of a Doubt*; but also, and even more significantly, on account of the virtual disappearance of the last "positive" protagonists, the last "trusting" love partners, not to speak of the role of the detective-investigator of the Sir John type. All of which should then logically ensure the primacy of the question of the director, and the displacement of our interest away from "characters" and their more theatrical properties to the supreme mystery of the authorial Consciousness itself.

At this point, however, a dramatic reversal takes place, which should give a certain aid and comfort to the defenders of the "death of the subject" position. For what happens when the hitherto intelligible unities of the characters begin to be questioned is that the "Hitchcock" power behind the camera also loses its anthropomorphic properties. The emergent theme of "filmic knowledge," as distinct from theatrical staging and as we have begun to associate it with the authority of the movie director himself, suddenly becomes radically *impersonal*. The informing power of *Psycho* is no longer a conscious deity with whom one plays Nabokovian games, but rather something very different and far more material, namely the camera apparatus itself.

This is indeed what the single most dramatic analysis in Rothman's book—the lengthy bravura piece on the shower scene (pp. 292–310)—undertakes to demonstrate: "Marion's shower is a love scene, with the shower head her imaginary partner, inhumanly calm and poised, and the shower head is also an eye. Marion's murder is a rape, and it is also a blinding" (p. 292). Yet the shower head is only the initial figure for the camera in this scene, in which a bewildering series of displacements insists over and over again upon the camera's violence. Thus, "Marion's open mouth is also an eye," in the moment of the attack (p. 300), as is, finally and most evidently, the drain down which her blood flows, and which echoes her own dead eye. Meanwhile, the camera's autonomous movements throughout this scene, whose purposeful logic corresponds to no anthropomorphic point of view, also testify to the primacy and independence of this peculiar apparatus, in which machinery and perception are more effectively and symbiotically linked than mind and body.

If this is so, however, and even allowing for the depersonalization of the director, who has here become a mechanical apparatus and a mechanical power, a most peculiar conclusion must be drawn, before which it was Rothman's merit not to have hesitated: namely, that the "author" of this murder is more than analogous, he is virtually at one with, the "author" of the film itself.

Norman, then, *is* Hitchcock, whatever that verb might mean. What we can note is the way in which the most famously "horrific" scene in motion picture history—which has at best been admired for its quasi-pornographic expertise in the manipulation of violence—acquires a *meaning*:

We are not yet prepared to speculate, for example, on whether to regard this monstrous figure as Norman or his mother. But it has to be clear that this figure stands in for Hitchcock. In this theatrical gesture, the camera and the creature that unveils itself by drawing

back the curtain are in complicity. Someone real presents to us the views that constitute *Psycho*, and at this moment that "someone" confronts us with his unfulfilled appetite and his wish to avenge himself on us. (p. 299)

At this point, however, everything falls into place and the various elements of Rothman's preceding analyses are suddenly and unexpectedly, retroactively, unified. In particular the Outsider around whom so many of these films turn—the lodger, Fane, Uncle Charles, Norman himself—proves to have been not merely the expression of a particular theme or obsession of aesthetic interest to Hitchcock, but more than that, the very inscription of Hitchcock himself (and his demiurgic function) *within* the film. "The lodger has assumed a position in the frame that declares his status as a mysterious incarnation of the author's agency and our viewing presence. Staring into the frame, possessing it with his gaze, he is the camera's double as well as its subject" (pp. 45–46). It is as though, in some peculiar "dual inscription," two plots and two whole sets of characters, two distinct and fantasmatic narratives, here momentarily coincided: one set is the official fiction, the story *within* the film—with its victims, detectives, murderers, witnesses, and the like; the other is a quite different dramatic or narrative relationship which involves a creator (Hitchcock), his surrogates and his rivals, and (presumably) his audience. Every so often (or even perhaps throughout?), these two narrative lines share a common occasion, and come to simultaneous expression within a given shot or scene.

Presumably, then "we" are also present somewhere in such a complex and auto-referential apparatus; and indeed, the designation of our own place is not long in coming:

> If this is a demonstration addressed to Marion, it is also a theatrical demonstration addressed to us. Just as we are about to unleash an attack, we are also its victim. The author of *Psycho*, a creature of flesh and blood, stands before us threatening vengeance. . . . In the scene that ensues, we join with Hitchcock in subjecting Marion to a savage assault unprecedented in its violence, while Hitchcock also avenges himself on those who fail to acknowledge him. The author of *Psycho* declares his separateness from us, yet calls upon us to acknowledge that the agency presiding over the camera is within us as well. (p. 301)

Yet all this had been present in *The Lodger* as well, whose lynch-mob scene (in which Hitchcock makes one of his brief signature appearances) equally, according to Rothman, inserts the public into the

spectacle offered it: "The harrowing image of the lodger and the mob is a paradigm, if an enigmatic and paradoxical one, of the relationship between the lodger and the Avenger and the relationship between Hitchcock and us. The relationship of author and viewers, it declares, is at one level a struggle for control" (p. 53). Meanwhile, "if we have faith in Hitchcock, we may assume that our violent struggle with him will be transmuted into a kind of marriage. *The Lodger* in fact establishes marriage as Hitchcock's other key metaphor for the relationship of author and viewers" (p. 53). (This is, incidentally, the explanation for the enigmatic remark about "murder and marriage" quoted above: the two are related, not in and of themselves, but because *both* are *figures* for the relationship of creator and moviegoer.)

We have not yet, however, found our ultimate figural place within this filmic universe. Hitchcock aggresses us, this is some first intuition: that he does so with images seems more complicated to follow, until we realize that the latter are sheer light, and begin to recall the series of displacements in which throughout Hitchcock's work, lights—but especially flashbulbs—are used virtually as guns, most notably at the climax of *Rear Window* (1954) but also in the photography scene in *Shadow of a Doubt*. Now we return to the flashing light at the climax of *Psycho* itself:

> Is it that this flashing only casts a spell in which what is lifeless appears to come alive, in which an illusion of magic is conjured? The following shot, the final one of the sequence, is a reprise of the grinning death's head—but with the frame flashing black and white and divorced from Lila's point of view. . . . In retrospect, our view of the swinging bulb is likewise disclosed as representing the gaze emanating from these empty eye sockets. "Mrs. Bates," like Marion, like Lila, like us, is a viewer, held spellbound as if by a film. Indeed, Mrs. Bates's views are the very views that hold us in thrall. The mummy's private film and the film that casts its spell over us cannot be separated. This withered corpse is one of Hitchcock's definitive representations of his films' viewers. *We* are this mother who commands death in the world of *Psycho* and who is possessed by death. (p. 330)

Meanwhile, it should be added that it is the very explicitness of the representation, the articulation by which the inner plot (the murder) is made to express the outer one (our visit to the movie theater), which accounts for the peculiar status of *Psycho* in Hitchcock's work, as something of a summa and a testament.

III

Now it is time to evaluate this elaborate and ingenious interpretive schema, about which it would be frivolous to "decide" whether it is true or false. What must be said of it first of all is that it is an *allegorical* interpretation, something noted explicitly by Rothman here and there in passing: "*Psycho* is an allegory about the camera's natural appetite" (p. 255); "*The Thirty-Nine Steps* is a fantasy or allegory about the condition of spectatorship" (p. 117). We have already noted some of the advantages of this allegorization of thriller films, which raises them from their seemingly immediate consumption in relief or suspense and promotes them to the more philosophical dignity of *meanings*. On the other hand, it cannot be claimed that the allegorical method has been officially rehabilitated, has regained its medieval dignity, even though in practice it seems everywhere in wider and wider use. We need to know, therefore, why allegorical interpretation should not simply be considered a facile or lazy way of "applying" meanings to a text; and also, in the present context, why, confronted with a host of different types of allegorical meanings or codes, Rothman should have felt himself authorized to select this particular one, which I have described in terms of auto-reflexivity (that is to say, the content of the film is an allegory of the latter's form, or to be more precise, the events within the film are an allegory of the latter's consumption—rather than production, which does not appear to interest Rothman much). The issue is therefore both objective and subjective: there is a historical question about film itself as a medium, and why it should be tempted by such involuted and secondary forms of self-designation which are most commonly associated with high modernism. The other question has to do with the allegorical method itself, and its possible symptomatic value as a replacement and substitution for some other impossible or undesirable practice of the interpretive process.

The possibility of an allegorical reading of film is of course given at once and "objectively" by the dual function of the camera itself, a duality less obvious or at least less easily articulated in other media:

> *Within the real world*, the camera represents the author's act of directing its framings, choosing the views to be presented to us. The camera is the instrument of a real relationship between author and viewer. Following Griffith, movies are designed to arouse the viewer, to make the viewer emotional. The film's author subjects the viewer to his power. *Within the world of film*, the camera has the power to penetrate

its subjects' privacy, without their knowledge or authorization. Furthermore, it represents the author who creates and animates that world and presides over its "accidents," who wields a power of life and death over the camera's subjects. (p. 102)

This duality, this relative separation of functions, is what makes an allegorical reconnection, a punctual linking back up of the two levels or "narratives," possible. Yet, as Rothman goes on to observe, the camera's master "is also impotent. Insofar as his place is behind the camera, he represents only a haunting, ghostly presence within the work it frames. He has no body: no one can meet his gaze . . . " (p. 103). This second specification of the situation will then supply the "motivation" for the plot, give content to the designs the author has on us, the viewers, and finally shape the drama of what Rothman will call the author's quest for *recognition*—something about which , the Hegelian overtones aside, it is hard to see what might be, except for hero-worship and the new star system offered by emergent *auteur* theory.

I think, however, that we must go further into the historical originality and structural peculiarity of the film-viewing process itself than is normally done (particularly in a period for which film-viewing is not "unnatural" at all, but part of a very familiar and ordinary perceptual landscape). This would involve an estrangement of "film-viewing" on the order of what Marshall McLuhan and his school tried to do for the reading of printed books; and it is the great merit of Christian Metz's *Imaginary Signifier* to have at least made a beginning with the description of this odd and specialized human activity:

During the projection, the camera is absent, but it has a representative consisting of another apparatus, called precisely a "projector". An apparatus the spectator has behind him, *at the back of his head*, that is precisely where phantasy locates the "focus" of all vision. All of us have experienced our own look, even outside the darkened theater, as a kind of searchlight turning on the axis of our own necks (like a pan) and shifting when we shift (a tracking show now): as a cone of light . . . [our] identification with the movement of the camera being that of a transcendental, not an empirical subject. [Yet] all vision consists of a double movement: projective (the "sweeping" search light) and introjective: consciousness as a sensitive recording surface (as a screen). I have the impression at once that, to use a common expression, I am "casting" my eyes on things, and that the latter, thus illuminated, come to be deposited within me. . . . The technology of photography carefully conforms to this (banal) phantasy accompanying perception. The camera is "trained" on the object

like a fire-arm (=projection) and the object arrives to make an im-
print, a trace, on the receptive surface of the film-strip (=introjec-
tion). . . . During the performance the spectator is the searchlight I
have described, duplicating the projector, which itself duplicates the
camera, and he is also the sensitive surface duplicating the screen,
which itself duplicates the film-strip. . . . When I say that I "see" the
film, I mean thereby a unique mixture of two contrary currents: the
film is what I receive, and it is also what I release. . . . Releasing it,
I am the projector, receiving it, I am the screen; in both these figures
together, I am the camera, which points and yet which records.[12]

This extraordinary account repositions Rothman's dramatic myth of
recognition (all-powerful yet impotent) within the viewer and within
the machinery of perception itself, while at the same time usefully
insisting by its figures on the historical nature of that machinery
and, as it were, suggesting that the human perceptual machine is
constructed on the basis of its own mechanical products at any given
moment rather than the other way round. However "eternally" true,
in other words, as a matter of psychology may be the interesting
dialectic between passivity and activity within perception itself—
what Metz characterizes as the screen versus the search light, but
what is also easily identifiable as Abrams's romantic "mirror" and
"lamp"—one might just as easily argue for the historical articulation
or actualization of these functions by a "material determinant" such
as the whole apparatus of film: the emblematic new technology would
then have the effect, not necessarily of a cause, but certainly of a
factor capable of exasperating an already latent tension and forcing its
reorganization or rearticulation into a full-blown contradiction. This
is then the sense in which something new and peculiar is being
brought to "human reality" by immobilization within the darkened
movie theater, some heightened coexistence between the now radi-
cally differentiated functions of the passive and the active which,
owing to its very novelty as an experience, tends to convert itself into
a privileged "subject" for the new artistic medium.

But one would also like to add a genealogical perspective in which
the medium (along with its own history, its own technological devel-
opment) is grasped less as a source of innovation in its own right, than
rather as the material reinforcement of an on-going tendency in social
life as a whole. This is Lukács' concept of 'reification' in its broadest
sense of a gradual fragmentation and division of labor within the
psyche, as the latter is retrained and reprogrammed by the reorganiza-
tion of the traditional labor processes and human activities by emer-
gent capital. The sharp structural differentiation of active and passive
within a single mental function—such as this "new" one of filmic

perception—would then be seen as a historic intensification of the reification process, and one which could then go a certain distance in accounting for the privileged status of the new medium, for its gradual supercession of more traditional aesthetic languages. In our present context, however, that of the problems of interpretation, what should be noted about this historical perspective is the way in which, by means of the insertion of the mediatory code of reification and the division of labor, it becomes possible to transform the formalism of an auto-referential interpretation (the film's deepest subject as filmic perception proper) into a more complex historical and social one.

Much the same is true of the other obvious direction in which the thematics of reification leads, namely the fragmentation of the bodily sensorium and the "reification" of sight itself, the new hierarchy of the senses which in very uneven ways begins to emerge from Descartes and Galileo on (the primacy of the "geometrical") until it becomes the dominant vehicle for the "will to power" of mature capitalism itself. The specular as a mode of domination and organization both of the outside world and of other people is a subject which has been richly explored by Sartre, and following him, by Foucault; although the thematics of the visual is probably more familiar in its Freudian form (the primal scene, fantasy as a specular process), particularly in contemporary film criticism. Yet a certain historical (and historicist) enrichment and complexification of the latter might be achieved if the mediation of "reification" were inserted here also, and if the possibility were entertained that the emergence of "seeing" as a social dominant were the necessary precondition for its strategic functions in psychoanalytic models of the unconscious. This historical coordination of the two explanatory codes of the public and the private, of Marxism and Freudianism, is no less urgent when we deal with the contemporary "culture of the image"—most obviously, in the present instance, film itself, but also advertising—where Lacanian analyses still compete strongly with neo-Marxian ones of the Debord type (the *image* itself becoming a form of commodity reification). At any rate, the reintroduction of historical issues about the bodily sensorium and perception itself would seem usefully to "reground" more abstract discussions about the construction of the "subject," since the former are among the privileged instruments whereby that psychic subject is constructed in the first place, and their aesthetic vehicles, including film, are among the principal material agents of the "social reproduction" of such psychic structures.

The perspective I have been outlining is not one of an alternate *interpretation* to that of the type given us by Rothman, but rather a framework of evaluation in which such findings can themselves be

more richly interpreted (and we have already seen this particular film critic approach such a perspective in his assimilation of the mysteries of the close-up to the phenomenon of the star system). Now, however, I want to reverse the problem and make a final—unavoidably dogmatic—reflexion on the interpretive operation we have examined in this interesting book. The observation will be dogmatic because it depends on a presupposition that cannot be defended in advance or a priori, namely that there exists for any given cultural artifact the possibility of something like a "concrete" analysis, or in other words an interpretation which rejoins the historical situation both of the text itself and of its interpreter, in such a way that it is finally capable of grounding or of justifying itself. Such a squaring of the interpretive or hermeneutic circle (sometimes called dialectical criticism) will however necessarily be different on the occasion of every text, so that it is impossible to furnish a model of the operation as can be done for "methods" in general (this is not, in other words, a method).

What I want to use this presupposition to suggest is something I already tried to demonstrate in the concluding section of *The Prison-House of Language,* namely that where for whatever historical or ideological reason such "concrete" criticism was impossible, the resultant formalism would attempt to correct itself by an operation which I described as the projection of form onto content, or better still, the transformation of a formal structure or feature into a type of content in its own right. Nor is it necessary to be particularly moralizing about this type of "idealism," since the very attempt betrays an unconscious need for content proper, and an unconscious awareness that one's reading is a purely formalizing one, a sense of the virtual chemical deficiency, the felt lack or absence of the material ground. At any rate, few examples of this process are quite so striking as *Hitchcock: The Murderous Gaze,* in which an initially inert and "meaningless" content—the elements of the murder plot proper—are allegorized into so many figures for the formal process of the film itself, which then—as the "theme" of the author, his supreme power, and his quest for recognition by the spectator-public—is triumphantly reimported back into the filmic object as its deepest content and meaning.

(1982)

7.
On Magic Realism in Film

The concept of magic realism raises many problems, both theoretical and historical. I first encountered it in the context of North American painting in the mid-1950s; at about the same time, Angel Flores published an influential article (in English) in which the term was applied to the work of Borges;[1] but Alejo Carpentier's conception of the *real maravilloso* at once seemed to offer a related or alternative conception, while his own work and that of Miguel Angel Asturias seemed to demand an enlargement of its application.[2] Finally, with the novels of Gabriel García Márquez in the 1960s, a whole new realm of "magic realism" opened up whose exact relations to preceding theory and novelistic practice remained undetermined. These conceptual problems emerge most clearly when one juxtaposes the notion of "magic realism" with competing or overlapping terms: in the beginning, for instance, it was not clear how it was to be distinguished from that vaster category generally simply called fantastic literature: at this point, what is presumably at issue is a certain type of narrative or representation to be distinguished from "realism." Carpentier, however, explicitly staged his version in a more authentic Latin American realization of what in the more reified European context took the form of surrealism: here the emphasis would seem to have been on a certain poetic transfiguration of the object world itself—not so much a fantastic narrative, then, as a metamorphosis in perception and in things perceived (my own discussion, below, will retain some affiliations with this acceptation). In García Márquez, finally, these two tendencies seemed to achieve a new kind of synthesis—a transfigured object world in which fantastic events are *also* narrated. But at this point, the focus of the conception of "magic realism" would appear to have shifted to what must be called an anthropological perspective: magic realism now comes to be understood as a kind of narrative raw material derived essentially from peasant society, and drawing in sophisti-

cated ways on the world of village or even tribal myth (at which point, the stronger affiliations of the mode would be with texts like those of Tutuola in Nigeria, or the *Macunaíma* of the Brazilian writer Mário de Andrade, 1928). Recent debates, meanwhile, have complicated all this with yet a different kind of issue: namely, the problem of the political or mystificatory value, respectively, of such texts, many of which we owe to overtly left-wing or revolutionary writers (Asturias, Carpentier, García Márquez).[3] In spite of these terminological complexities—which might be grounds for abandoning the concept altogether—it retains a strange seductiveness, which I will try to explore further, adding to the confusion with reference points drawn from Lacan and from Freud's notion of the "uncanny," and compounding it by an argument that "magic realism" (now transferred to the realm of film) is to be grasped as a possible alternative to the narrative logic of contemporary postmodernism.[4]

Indeed, an important new Polish film—(*Fever*, 1981, by Agnuszka Holland)—put me on the track, if not of "magic realism" itself, then at least of the private or personal meaning I must be giving to this term.[5] Poland in general, and the Polish revolutionary movements of 1905 in particular (the subject of the film), seemed an unexpected and peculiar enough reference point, until its affinities with certain Latin American films grew clearer to me: I'm thinking in particular of a recent Venezuelan production called *La Casa de Agua* (*The House of Water*), about a historical figure, Cruz Elías León, a nineteenth-century Venezuelan poet who contracted leprosy; and a Colombian feature called *Condores no entierran todos los dias*,[6] about a turn-of-the-century gangster and political assassin.[7] Both films exhibit political violence—imprisonment, torture, executions, and assassinations—but are exceedingly distinct in tone, the first offering a strange and poetic visual reality, the second an interminable and indeed implacable series of unremittingly violent acts, filmed in rich but conventional technicolor. *Fever*, meanwhile, dwells if anything even more obsessively on violence and in particular on assassination as a political weapon: in the anarchist tradition of "terrorism," or of *propaganda by the deed*, in the spirit of the assassination attempts on the Czars, of the *bande à Bonnot* or the Haymarket, of Conrad's *Secret Agent*, or of the IRA well up into our own time. The film is in fact the story of a bomb, whose intricate itinerary and destiny we witness from its construction by a revolutionary chemist all the way to its final detonation, in a lake, by Czarist explosives specialists. Otherwise, this third exhibit would seem to have little enough in common, either with the lyricism of *La Casa de Agua* or with the tormented, sadistic, yet mindless brutality of *Condores*.

In spite of such stylistic differences, however, I retain a sense of shared features, of which I will here isolate three: these are all *historical* films; the very different *color* of each constitutes a unique supplement, and the source of a peculiar pleasure, or fascination, or *jouissance*, in its own right; in each, finally, the dynamic of *narrative* has somehow been reduced, concentrated, and simplified, by the attention to violence (and, to a lesser degree, sexuality). I want to explain why—in contrast to the more traditional Latin American conception outlined above—these three features strike me as constitutive of a certain magic realism. All of them, in effect, in different ways, enjoin a visual spell, an enthrallment to the image in its present of time, which is quite distinct, either from the subordinate or secondary deployment of the gaze in other narrative systems, or from Bazin's ontological conception of the shot as the deconcealment of Being (something I tend to recognize more pertinently in certain systems of black-and-white photography).

I

I have suggested that as work in the genre of historical film, these works can sharply be distinguished from their analogues in postmodernism, what we have come to term nostalgia films, fully as much as from the aesthetic and the conception of history that characterized an older representation of history linked to the older historical novel, in Lukács's classic sense. I have described nostalgia film elsewhere as something of a substitute for that older system of historical representation, indeed as a virtual symptom-formation, a formal compensation for the enfeeblement of historicity in our own time, and as it were a glossy fetish in the service of that unsatisfied craving.[8] In nostalgia film, the image—the surface sheen of a period fashion reality—is consumed, having been transformed into a visual commodity. Despite the intensely visual pleasure of what I would now call magic realist films, it is not exactly in that way, I think, that the viewing subject engages them.

What is engaged is certainly History, but then in that case history with holes, perforated history, which includes gaps not immediately visible to us, so close is our gaze to its objects of perception. These holes may first of all be characterized as gaps in information, yet in a succession of spatial situations see too intensely for the mind to have the leisure to ask its other questions.

Indeed, for whatever reason, the three films in question seem to presuppose extensive prior knowledge of their historical framework in such a way as to eschew all exposition, and also to preempt the

traditional gesture of the *beginning:* "Towards the twilight of a No-
vember day in the year 1812, following Campostela street towards the
north of the city, there drove a two-wheeled coach drawn by two
mules, one of them bestridden, as was customary in those days, by a
black coachman." I would have suggested, rather, that these newer
films presuppose some already existing *familiarity* with the people
and places passing before our eyes, did I not wish to reserve this
charged term for something rather different. Nor is this at all compa-
rable to the epic *in medias res*, which is even more clearly marked
than the classic novelistic beginning as a set of givens whose origins
and significance may calmly be expected to be divulged at the conven-
tionally appropriate time.

And in general I feel that we must sharpen our consciousness of the
shock of *entry* into narrative, which so often resembles the body's
tentative immersion in an unfamiliar element, with all the subliminal
anxieties of such submersion, the half-articulated fear of what the
surface of the liquid conceals, a sense of our vulnerability along with
an archaic horror of impure contact with the unclean; the anticipation
of fatigue also, of the intellectual effort about to be demanded in
the slow apprenticeship of unknown characters and their elaborate
situations, as though, beneath the surface excitement of adventure
promised, there persisted some deep ambivalence at the dawning
sacrifice of the self to the narrative text. We need a historical phenome-
nology of such entry-points, an inventory of curtains that part in
bravura, or of the various flaps and apertures through which we are
asked to introduce our heads; of the degrees of angle along which we
peer, and the ceiling, or lowered visibility, of this narrative space
we are about to inhabit. Not the least remarkable feature of Zola's
naturalist poetics, for example, is to be confronted in the terrible,
darkened, ominous, as yet ill-defined spaces of the opening pages of
his greatest novels: the pre-dawn jolting darkness of the approach of
the vegetable wagons to Paris in *Le Ventre de Paris*; or yet again, the
room with a view of the railway terminus of the Gare Saint-Lazare in
La Bête humaine, a clear and airy space, high up, and about to be
galvanized by a scene of unspeakable desperation. Yet what is omi-
nous in Zola is still a function of narrative perspective, and an antici-
patory reflex, whereby the novelist confirms in advance the fatal uni-
fication of the chain of events about to unfold.

The entry-point of magic realist films is very different from this,
even though they specifically include flash-forwards of later or even
climactic events: thus in *Fever*, a vertical sheet of water flung upwards
by the ultimate detonation of the bomb is inserted into the initial
opening sequence of its construction by the chemist. Meanwhile, in

La Casa de Agua, the poet's confinement in a deep well is blanched and derealized by shots of the salt flats on which, beneath the look of toiling peasants, a few fleeing but desperately heroic revolutionaries are shot down by the dictator's militia; into later sequences in the fishing village are then also inserted flashes of a funeral procession in mud and rain—the poet's ultimate destiny. Yet such anticipations have little value as narrative signals in a situation in which no promise of narrative unification exists. Rather, these shots enter into peculiar chemical combinations with the image-sequences into which they have been interpolated, as though offering a brutal sample of a range of visual exposures: the bright-dark laboratory of the chemist side by side the gray liquid landscape of the lake in eruption, the moldering green opacity of the stone well side by side with the blinding whiteness of an expanse of salt. Yet for reasons to be suggested later on, such permutations of the gaze, which irritate and intensify it, do not thereby, as in postmodernism and the nostalgia film, transform its objects into images in the stronger sense of that word.[9]

Yet such initial breaks and discontinuities are also sharply to be distinguished from the mysteries of exposition of an older modernism whose enigmas had less to do with the intricacies of its subject matter than with the peremptory and supremely arbitrary decisions of the high modernist demiurge. The opening of *Sanctuary* is in this sense canonical: its characters emerging before us in some strange "always-already" familiarity as though we were already supposed to know who Temple and Popeye and the Virginia gentleman already were—yet here the familiarity is Faulkner's own, and not yet the reader's. He it is who has chosen to withhold the facts of the matter, and the (not terribly complicated) explanation for this prematurely climactic and coincidental confluence of his two narrative strands. Mystery here reinforces the prestige of the *auteur*, and exacts the more personal tribute of a baffled preoccupation with what he may be supposed to have in his mind (or *intend*). It is a structure replicated on the micro-level of style by the notorious "cataphoric" pronoun point-of-view narrative, in which an initial third person or blank "he" or "she" secures our reading identification while obliging us to wait for its proper name and civil status.

Although such categories have been deployed in film theory, particularly for the analysis of traditional or Hollywood narrative, the deeper structure of the medium excludes them for reasons which the evolution of contemporary film (and the appearance of just such films which are under consideration here) makes plain. The unified subject, readily generated by verbal texts, can now be seen to be in question in film as such, despite its ultimate blossoming in the stylistic unifica-

tion of the works of the great high modernist *auteurs*: the camera, the apparatus, the machine, replacing the subject of enunciation, just as the immediacy of sight displaces the subject of reception. Our initial security and confidence in some unified narrative to come has been dispelled without return by the interventions of experimental film: we are no longer necessarily in reliable hands, things may never cohere. And even if they do, a different, another momentum has been conferred on the narrative process. In *Fever*, for instance, it is only well into the second hour that we suddenly grasp the form as I have baldly and dishonestly formulated it above—the bomb as a "unifying device," the events as a kind of *La Ronde* of political assassination in which, rather than the Lacanian phallus, it is the instrument of death which traverses and thus links a series of unrelated destinies (more on that particular disjunction below). Yet, this belated and retroactive discovery of the narrative thread—whose formal ingenuity may be admired on the level of Coleridgean fancy—remains disjointed from the lived experience of the film itself and forever at structural distance from it, such that two distinct visions of *Fever* are retained on the retina of the mind's eye.

Quite another, indeed, is the bomb itself as an object of perception, and it is indeed with this that that film begins: an enormous bewildering close-up of the bristling metal interlarded with human fingertips, gross and clumsy at this degree of magnification, yet perhaps always clumsy with fear, and slightly trembling, at the vicissitudes of contact with an object so delicate and so deadly. The thing itself, not yet identified, is most peculiar indeed: a cylinder, but with intersecting crosshatches, like the barbs of an arrow, or the bare horizontal shafts of some odd tree: these two intersecting sets of rods then presumably being the axes, four and four, to be rotated against each other in order to seal or to open the device, locked by the tube of an end screw inserted as into a torpedo. Yet what is really striking—what makes up the *punctum* of the photograph, in Barthes's sense[10]—is not its appeal to any tactile sense, nor even the matter of color (on which more later on, as promised): but rather the mint newness of this shiny metal object; and not even that, in and of itself, but rather the contradiction between this cleanness of oil on new metal and the old, the very old historical world in which the film is supposed to take place. As though somehow, in that ramshackle world of prerevolutionary Central Europe, you could not have new objects! and certainly not "technology" in some contemporary science-and-industry sense! This confused thought—the attempt to *think* a perception, really— stages and intensifies the structural paradox of the historical novel in general: to read the past through a present of time, to live through a

present marked as the past and the old, the dead and gone. So the film spins an impossible newness back upon us to confront us in bewilderment with the unthinkable conjunction between our own present in time and this ancient history: a point at which, unaccountably, large drops of fresh blood fall slowly upon the cylinder, the camera slowly lifting to disclose the inventor licking a cut finger—not the greater danger of self-destruction, but a lesser one that merely has the ontological priority of being real. The drops of blood conjure a whole beyond of the tactile within the enormous two-dimensional image, transmuting the whorled pudginess of the stained fingers into this new visual realm. What results is not an Image, in the technical sense of derealization, but rather something else, which remains to be described, and which diverts a conventional narrative logic of the unfolding story in some new vertical direction, while working through its elements by way of the mediation of the body itself.

The significance of the title of *La Casa de Agua* (*The House of Water*) is also designated in its opening shot, whose closure transforms it, however, into an allegorical emblem in its own right: a young man, naked, struggling in a darkened shallow pool of water contained by stone walls, as at the bottom of an old well, his desperate efforts to invent a comfortable position (standing, lying, floating, leaning) achieving only, at the end, a mask of anguish tilted backwards, in a silent scream. This will prove later on to have been another flash-forward: since the episode of the solitary confinement in water takes place at the point in the subsequent narrative when the poet is jailed for political reasons, a confinement during which he contracts leprosy. The initial allegorical image thus proves to be a locus of semic transition, indeed, the crucial chiasmus or semic contradiction within this work, whose mystery and horror lie in the superimposed, yet unjustifiable and intolerable, twin destinies visited upon the innocent protagonist: political persecution and torture by the dictator's police (a caricatural species of pig-people, living within the village peasantry of salt miners and fishermen like some grotesque and alien occupying race)—a fate to which another is gratuitously added, as though to prolong that historical suffering into the metaphysical cruelty of Nature itself, the second doom of natural disease, which gradually works this body over according to its own logic, resculpting its classical features into a new mask of welts and excrescences, like a monster from outer space.

At a certain verge of contemporary bourgeois literature, most notably in existentialism, the ideological confusion between Nature and History rises towards the surface of consciousness, in the form of a not yet reflexively articulated contradiction between politics and

metaphysics, between the "nightmare of history"—still attributable to the cruelty of other people—and some more ontological vision of an implacable Nature in which "God is the first criminal, since he created us mortal."[11] Camus's *Plague* offers the most concentrated expression of this slippage, which emerges as a full-blown ideology when the Nazi historical project is represented through the content of that very different thing, a seething bacterial epidemic that intervenes in the web of private human destinies to terminate them in unjustifiable and properly absurd extinction. Indeed, this slippage between two distinct perspectives—the one proposing a political and historical analysis capable of energizing its spectators for change and praxis even in the most desperate historical circumstances; while the other perpetuates some ultimately complacent metaphysical vision of the meaninglessness of organic life, to which the response, at best, can only be some private ethical stoicism of a "myth of Sisyphus"— the contamination of two incompatible languages has increasingly, in our own time, been identified as one dangerous source of depoliti- zation.

In *La Casa de Agua*, however, this very incompatibility has been foregrounded as the subject of the work itself—which dramatizes and articulates it as an unresolvable contradiction in such a way that the ideological inferences and resonances of the older identification are structurally blocked. We will return to this unexpected structure and narrative function later; just as we will also want to ask some more basic questions about the relationship between the ideological theme and the haunting visual surfaces of this magic realist film. Water is at any rate clearly the locus of transformation in which human malignancy is exchanged for the irresistible force of natural and organic disease: a signifier (standing water, muddy and stagnant) developed and articulated, constructed, through oppositions with the signifying poles of the dazzling aridity of the plain of salt, on the one hand, and, on the other, the cleanness of the sea in which the poet's family plies its immemorial trade.

Condores no entierran is on the face of it a more conventional work, whose interest and lessons for us may therefore be easier to tease out. South American films (along with their European pastiche, as in some of those of Werner Herzog) frequently identify themselves by means of an opening "logo" meant to signify the immensity of the continent itself: a high-angle panoramic shot of the enormous sweep of jungle vegetation as it rises and falls into an illimitable horizon. But in *Condores* this now virtually conventional opening is remotivated by point of view, as we come to grasp the origination of the shot in the panoramic gaze of the eponymous predator in full flight. The

landscape is then reduced to the magical domestication of farmland shrouded in light mist, and thence to the farmhouse itself, with two children playing on the front steps in a pastoral idyll not notably distinct from contemporary North American populist films set in an older Middle West. Into this rural peace comes an intrusion that also has its North American analogue: a roadster filled with large clumsy men in uncomfortable suits whose family likeness to American gangster films is unmistakable. What follows, predictably, is the massacre of the family, children included, by tommy gun: the *punctum* of this gratuitous horror then being the very clumsiness of the operation, the stiffness and awkwardness of the gunmen as they slip and clamber about the moist soil of the farmland. This is, one would like to say, something like a constitutional awkwardness and not merely the result of individual ineptness or stupidity or characterological hesitation, as in the terrible scene in *Fever* in which a traitor is badly executed by a militant who has never used a pistol, firing over and over again at parts of the traitor's body, at the dusty ground around him, and into the soft body now prone yet tense with the equally awkward effort to scramble away up a small hill.

In *Condores* we are closest to the stylistic or generic seam that separates magic realism from nostalgia film (there is indeed, as we shall see later, a distant ideological affiliation with Bertolucci's *Il Conformista* [1970], the very prototype of the postmodernist alternative). The mint and shiny antiquity of the gangsters' limousine, for instance, clearly functions as the two-fold and now conventional nostalgia-film signal of a specific historical (or more properly, generational) period and of a specific generic paradigm (in this case, gangster or Mafia film) of which the postmodernist version will stand as a pastiche. Such initial nostalgia-film dynamics will, however, be subverted in various ways as the film develops: this particular element in particular wholly transformed by its recurrence at the end of the movie in which (against all expectation) the Condor is finally killed— an empty small town street at night, an ominously motionless vehicle unaccountably stationed along the more archaic walls and closed wooden double doors, the Condor gunned down as he strides alone through the darkness without bodyguards as is his custom (for reasons of psychology and prestige alike). But this final sequence deploys a language of solids utterly alien to the glossy surfaces of nostalgia film: the touring car occupying a distinct and sculptural volume in the recess of the shot, while the Condor's body stretches foreshortened on the cobblestones with all the inert protrusion of a Mantegna *pietà*.

Here, however, the paradox cleaves to the unaccountable ease with which the monster is destroyed: the title had already designated his

invincibility—"you don't bury condors every day"—thereby foretelling the central episode, in which poisoned fruit is conveyed to the Condor's household and eaten by the assassin and his servant-wife. There follows a leisurely and interminable inspection of their death agonies, the two bodies writhing and distending side by side in the matrimonial bed, their silent sightless spasms juxtaposed as though in ironic commentary on the cohabitation of these two mute and loveless isolated individuals. A middle-class doctor presides over this long night of agony, himself withdrawn and cautious, clearly troubled by his own false situation, which calls upon him professionally to save the life of a powerful being, feared and hated, whom he would surely, like the rest of the village, prefer to let die. Meanwhile, as news of the poisoning reaches the townspeople, an improvised popular fiesta springs up in the nighttime street outside—firecrackers, guitars, heavy drinking, the sheer joy of release from the oppressive existence of the now legendary killer, whose superhuman physical strength, however, brings him safely through the ordeal. The quiet of the following morning is marked by a shot of the ditch alongside a country road in which the dead bodies of the previous night's musicians (themselves unwanted suitors and serenaders of the Condor's daughter) have been unceremoniously dumped. In this episode too, then, volume has been constructed by the stomach cramps and intestinal agony within the bodies of the poisoned victims: misery inside endowing these human shapes with a bulk and dimension that subverts the surface and purely visual logic of nostalgia image.

As it stands now, this argument remains a formal one, seeking to differentiate two distinct filmic modes by which a certain historical content or raw material can achieve representation (I prefer the word "figuration"). Nostalgia film, consistent with postmodernist tendencies generally, seeks to generate images and simulacra of the past, thereby—in a social situation in which genuine historicity or class traditions have become enfeebled—producing something like a pseudo-past for consumption as a compensation and a substitute for, but also a displacement of, that different kind of past which has (along with active visions of the future) been a necessary component for groups of people in other situations in the projection of their praxis and the energizing of their collective project.

The account of some distinct formal alternative to this one, however, remains incomplete, and will be developed throughout the remainder of this essay. But it is important at this point to complete this essentially formalistic description with the more difficult perspective of the relationship of such formal languages with the very structure of the raw materials they appropriate: with what I have elsewhere

called their "logic of content" (Hjemslev's conception of "substance"), or in other words with some sense of dialectical inflection of a formal code by the very structure of the raw material over which it believes itself to exercise a sovereign shaping power or mastery. I have indeed suggested elsewhere that the privileged raw material for nostalgia film seems to be drawn from a more immediate social past, ranging from the Eisenhower era and the American 1950s back to the thirties and twenties. The invisible organizing category of such choices and affinities is therefore essentially a generational one (and the reemergence in the 1960s of the concept or category of the "generation" as a way of narrativizing our lived experience and our broader visions of recent history itself is a very significant symptom indeed).

The raw materials of what I have been calling magic realist film seem to me very different from these (although it is clear that my sample here is statistically inadequate and very much dependent on the accidents of personal viewing). This point is, however, that the more remote historical periods in which these films are set—although they by no means exclude parallels and analogies with the present—resist assimilation to generational thinking and rewriting.[12] Revolutionary activity in 1905 Poland, the prehistory of the Colombian civil war, or a still more archaic nineteenth-century Venezuela—such content also resists appropriation in the service of a more static representation of stable periods and their fashions. We will return to the matter of their unparalleled violence in a different context later on: here it is essential to note that violence functions to make some discontinuous or surcharged reading of the respective historical moment avoidable. I will therefore advance the very provisional hypothesis that the possibility of magic realism as a formal mode is constitutively dependent on a type of historical raw material in which disjunction is structurally present; or, to generalize the hypothesis more starkly, on a content which betrays the overlap or the coexistence of precapitalist and nascent capitalist or technological features. On such a view, then, the organizing category of magic realist film is not the concept of the generation (as in nostalgia film), but rather the very different one of modes of production, and in particular of a mode of production still locked in conflict with traces of the older mode (if not with foreshadowings of the emergence of a future one). This is, I believe, the most adequate way of theorizing the "moment of truth" in the anthropological view of literacy magic realism outlined above, and of accounting for the strategic reformulation of the term by Carpentier in his conception of a "marvelous real," a *real maravilloso*: not a realism to be transfigured by the "supplement" of a magical perspective but a reality which is already in and of itself magical or fantastic. Whence the

insistence of both Carpentier and García Márquez that in the social reality of Latin America, "realism" is already necessarily a "magic realism": "¿qué es la historia de América toda sino una crónica de lo real-maravilloso?"[13] Not the "lost object of desire" of the American 1950s, therefore, but the articulated superposition of whole layers of the past within the present (Indian or pre-Columbian realties, the colonial era, the wars of independence, caudillismo, the period of American domination—as in Asturias's *Weekend in Guatemala*, about the 1954 coup) is the formal precondition for the emergence of this new narrative style.

II

But it is necessary to suspend the question of history temporarily in order to turn to the peculiar and constitutive function of color in these films, particularly since our previous remarks on this subject have not adequately made clear in what way "color" in this new and heightened technical sense is radically incompatible with the logic of the image or the visual simulacrum we have associated with postmodernism—a logic to which the experience of chromatic images would hardly seem alien. Let me try to approach this fundamental distinction by differentiating color from glossiness, which indeed strikes me as the more relevant category for nostalgia film.

As we will understand it there, color separates objects from one another, in some mesmerizing stasis of distinct solids whose unmixed individual hues speak to distinct zones of vibration within the eye, thereby setting each object off as the locus of some unique and incomparable visual gratification. Glossiness, on the other hand, characterizes the print as a whole, smearing its varied contents together in a unified display and transferring, as it were, the elegant gleam of clean glass to the ensemble of jumbled objects—bright flowers, sumptuous interiors, expensively groomed features, period fashions—which are arranged together as a single object of consumption by the camera lens.[14] A remarkable comment of Lacan is apt here (from the very different context of his meditation on the "scopic drive" in the Eleventh Seminar): the example is meant to illustrate what is for him a crucial distinction between the eye and the gaze (*le regard*):

> In the classical tale of Zeuxis and Parrhasius, Zeuxis has the advantage of having made grapes that attracted the birds. The stress is placed not on the fact that these grapes were in any way perfect grapes, but on the fact that even the eye of the birds was taken in by them. This is proved by the fact that his friend Parrhasios triumphs

over him for having painted on the wall a veil, a veil so lifelike that
Zeuxis, turning towards him said, Well, and now show us what you
have painted behind it. By this he showed that what was at issue was
certainly deceiving the eye (*trompe-l'oeil*). A triumph of the gaze over
the eye. . . .

There would have to be something more reduced, something closer
to the sign, in something representing grapes for the birds. But the
opposite example of Parrhasius makes it clear that if one wants to
deceive a man, what one presents to him is the painting of a veil, that
is to say, something that incites him to ask what is behind it.

It is here that this little story becomes useful in showing us why
Plato protests against the illusion of painting. The point is not that
painting gives an illusory equivalence to the object, even if Plato
seems to be saying this. The point is that the *trompe-l'oeil* of painting
pretends to be something other than what it is. . . .

It appears at that moment as something other than it seemed, or
rather it now seems to be that something else. The picture does not
compete with appearance, it competes with what Plato designates
for us beyond appearance as being the Idea. It is because the picture
is the appearance that says it is that which gives the appearance that
Plato attacks painting, as if it were an activity competing with his
own.

This other thing is the *petit a*, around which there revolves a combat
of which *trompe-l'oeil* is the soul.[15]

Lacan's excursus (wrenched from its context, which is that of the
effort to define the Freudian conception of an "instinctual" drive) may
serve as a useful and suggestive point of departure for grasping the
postmodern image as a phenomenon in which the scopic consumption
of the veil has itself become the object of desire: some ultimate surface
which has triumphantly succeeded in drawing that "other thing," that
"something else," the objects behind it, out onto a unified plane such
that they shed their former solidity and depth and become the very
images of themselves, to be consumed now in their own right, as
images rather than as representations of something else.

Lacan is less helpful with the alternative move of his fable, the
status of Zeuxis' legendary grapes (in our rewriting, the locus of magic
realist color and its objects). Let us therefore try a somewhat different
new beginning:

Sabanas was held to be the most cultivated and illustrious region
of the country. Its fields had been planified in harmony with the
unseasonable regularity of the seasons, and according to the colors
of the soil, in a wide and varied register from almost pure white to
jet black. Between these extremes could be found innumerable tones

and hues of brown, rose, purple, yellow, green, gray, red, and blue. People spoke of "weak" gray or "dead" gray, of "languid" or "rich" gray, of brilliant red, of brick red, of flesh red, of purple red, of yellowish red, of drab brownish red, of saffron red, fire red, carmine red, crimson red, scarlet red, burnt red, blood red, or sunset red, and distinguished between "dappled" colors and "veined" colors, between "speckled" and "marbled," and to each one of these they attributed specific qualities for certain crops.[16]

This passage, from the great Cuban magic realist novel *Los Niños se despiden* of Pablo Armando Fernandez, is central to the moment in which Lila, a new demiurge, recreates the world from nothingness (an act of creation which will also end in the vision of absolute nothingness): such a verbal text demonstrates more intensely than any visual one how the step-by-step invention of each distinct color (and its name) corresponds, not merely to some general awakening of the eye itself to the differentiated range of the spectrum as a whole, but rather as it were the calling into being of distinct and innumerable separate senses, each one of which is irritated and stimulated into life by the specific "red" in question. The generic category "red" is thereby virtually exploded as a unity, along with "sight" or the eye itself as some putative central locus for seeing: in this new perceptual heterogeneity seeing "brick red" now involves a sense organ as distinct from that capable of registering "burnt red" as the older general sense of vision was from those of hearing or touch. Meanwhile, something of this new and imperfectly explored multiplicity of perceptual powers now returns back upon the words themselves, to confer on each an unaccustomed magical power, in the incantatory isolation of each distinct act of speech.

Modern linguistic theory, to be sure, has struggled endlessly to rid itself of stubborn old myth of some Adamic nomination—the identification of beings and objects, created creatures, individual flora and fauna, by the isolated and non-syntactical power of the individual noun. From the Saussurean perspective, such myths reinforce an incorrect and mystified notion that meaning first takes place on a one-to-one basis, in the relationship of word to thing and individual signifier to individual signified (rather than, as in the newer linguistics generally, syntactically, in the relationship between signifiers themselves and through their syntactic play and semantic oppositions). Yet perhaps some deeper truth of the Adamic myth reemerges at the "molecular" level (Deleuze), at the level of the individual qualities, in a dimension with which the stigmatized and ideological, unifying categories of "substance" and "object" and "noun" no longer have anything to do:

Fire, fire, fire! Bayamo in flames! The splendor which emanated from the bodies effaced their features and forms. Like a madwoman she cried: Let the first appear. A cloud of red smoke struck her face, and frenetically she cried again: Let the second appear. A yellow colored cloud passed before her without so much as grazing her, and a third orangeish cloud, and a fourth, green a fifth, blue, and a sixth, indigo, and a seventh, violet. Triumphant these lit her eyes up, awakening in her the power of speech, joyous, minute, sweet and gentle . . . [17]

Here the awakening of fresh sight (and voice) result from the wholesale conflagration of the older things; Pablo Armando's little allegory invites us to rethink Zeuxis' grapes in terms of colors so mesmerizing that we gradually forget the objects of which they were supposed to be the properties (while, however we are able to imagine the birds' appetite, no representational identification à la Gombrich can surely be attributed to them).

The prodigious effects of these verbal texts are consistent with what is released by magic realism in its filmic or visual mode. I remember in particular the moment (in *Fever*) of the passing detail of an extraordinary violet apron: a punctual experience of rare intensity comparable only to Baudelaire's "green so delicious it hurts." Such moments suggest that color does not, in these films, function as a homogeneous medium, but rather as some more generalized "libidinal apparatus," which, once set in place, is capable of registering the pulsation of such discontinuous intensities. If so, it becomes tempting to suggest that it secures an antithetical function in nostalgia film, where, in the form of Lacan's "gaze," it governs a homogeneous field from which just such punctual beats of energy are excluded.

When one thinks of the privileged status, in the Saussurean and high structuralist tradition, of the example of systems of color in the various languages (the very prototype of the semantic field of oppositions, it does not seem farfetched to suggest that these seemingly visual experiences know some deeper articulation with a preconscious dimension of language itself (in much the same way that, as Freud and Lacan have both shown, seemingly existential phenomena such as sexual desires and dream narratives can be said to be the effects of the absent cause of linguistic or syntactic variations).

The more immediate theoretical reference, however, must remain Stanley Cavell's remarkable meditation on the nature and significance of color in film generally: a whole Utopian dimension of futurity, as he calls it, involving a "de-psychologizing" and an "un-theatricalizing of their subjects":

> It is not merely that film colors were not accurate transcriptions of natural colors, nor that the stories shot in color were explicitly unrealistic. It was that film color masked the black and white axis of brilliance, and the drama of characters and contexts supported by it, along which our comprehensibility of personality and event were secured.[18]

This constitutive intersection between the experience of filmic color and the opening or foreclosing of certain narrative possibilities will be further explored in the next section. It is, however, important to note that even in a situation in which, since the first publication of Cavell's book, color in film has become the universal norm rather than the exception, his hypothesis retains an ever-scandalous power, suggesting that it is a mistake to imagine the world of our ordinary daily life as a world of colors, and that in that sense it would be more correct to presume that the real world, in which we move, act, and look, is more properly characterized as being "in black-and-white." What the generalization of color film does, however, is to make the foregrounding of this property dependent, not on its opposition with black-and-white film, but rather on oppositions between various systems of color themselves (whence the possibility of distinguishing a magic realist and a postmodern deployment).

Yet another theoretical reference point which must be set in place here is evidently the Freudian conception of the "uncanny,"

> in which a represented event becomes intrinsically marked as the repetition of an older and archaic fantasy of which no independent traces remain in the text. This "return of the repressed" makes itself felt by the garish and technicolor representation of what is given as an essentially black-and-white reality, figures as daubed and rouged as in photorealist painting, objects derealized by the very plenitude of their sensory being, by which the merely perceptual is unmasked as obsession.[19]

Freud's essay proves to be more tightly constrained by its object of study (Hoffmann's tale, "The Sandman") than is often realized: and in particular by a frame narrative from which the subject's past has been excluded (in order to allow it to erupt with a seemingly gratuitous force), and by that strange and non-ironic distancing of the psyche which will finally be dramatized in the ideologeme of "frenzy."[20] These features, which mark the original development of the concept in Freud himself, are less relevant to the films under discussion here, although the role of violence and the depersonaliza-

tion of the subject by the filmic apparatus itself offer distant analogies. What is however to be retained from Freud's canonical demonstration is the way in which narrative elements can be intensified and marked from within by an absent cause undetectable empirically but read off their sheerest formal properties.

Still, these various theoretical possibilities need to be confronted with a different kind of materialist alternative, in which the various symptoms of some new and peculiar filmic use of color are rather simply explained away by technology itself, and in particular by aberrations in film stock and its processing which might better be attributed to the economic situation of the industry in Third World countries than to any more properly aesthetic dynamic. Indeed, far more dramatically than in the sociology of literature, the study of film seems to pose a stark incompatibility between intrinsic and extrinsic analyses, between superstructural and infrastructural codes, between formal readings and just such accounts of the economic and technological determinants of these cultural artifacts—a situation in which the facile appeal to "overdetermination" does not seem intellectually completely satisfying. Yet a certain model of overdetermination is in fact proposed by the theoreticians of Third World cinema—most notably in Cuba itself—where a technical perfection of the image (which one is tempted to identify with the postmodernism of the First World) is explicitly seen as a connotator of advanced capitalist economies, suggesting that an alternative Third World aesthetic politics will wish to transform its own "imperfect cinema" into a strength and a choice, a sign of its own distinct origins and content.[21] Here technology, or its underdevelopment, is then explicitly drawn back inside the aesthetic message in order to function henceforth as an intrinsic meaning, rather than an extrinsic accident or causal determinant.

Meanwhile, this account of color (which we have already associated with phenomena of the body and with new manifestations of volume) needs to be completed by some more general characterization of its consequences for filmic space itself. The strange darkened coloration of *Fever* seems, for example, hard to account for on its own terms, without some consideration of the enclosed and darkened spaces in which the action takes place: even exteriors are here dampened down, either by nighttime sequences or by the omnipresence of driving rain and lowered visibility. There is perhaps at work here a stimulation of the rods and cones within the eye (which, as is well known, modify their relationship with the onset of dusk) such that rarer perceptions (the violet apron!) come to be felt, in the field of nighttime vision, as precious conquests.

In *La Casa de Agua*, by contrast, it is outside air and open space that

predominate: whence one's sense of the virtual transparency of the color of these alternating shots: solid tones diluted with the pure white of the salt flats to the point of euphoria. Even the prison-camp-cum-leper-colony is open to the air, and if the torture well stands as the most concentrated enclosure, the only genuinely interior shots are found in the brief account of the poet's student days, in the luxuriousness of the salons and high-class brothels which are thereby retroactively endowed with something of the value of a lost Utopia of memory—rich, properly nostalgia-film-type images from which the rest of the film will painfully exclude him.

Yet the title has another significance than the one we attributed to it earlier, equally designating the fishing village of his youth and his ultimate destiny: the provisional nature of these wooden shacks, not excluding the headquarters of the dictator's police itself, suggests nothing quite so much as a colonial encampment on the border of the sea, conferring something nomadic on the poverty of the fishermen and the value of a military occupation on the police barracks. This same provisionality marks the protagonist's final dwelling—the shack in which he hides his shame and scatters the sheets of his poems—and grounds the Heideggerian transience of a being-unto-death upon the earth in the more concrete historical situation of colonialism (even though technically the absent pig-dictator himself is simply a local warlord).

In contrast to these two problematic geographies—the ramshackle impermanence of a peasant encampment by the sea, or the Eastern European township with its Russian governor general and its traditional distribution of hospitals and grocery stores, warehouses and townhouses in various states of shabbiness (through which, however, the camera moves with a proximate insistence that excludes all longer perspective)—*Condores* seems established in the more traditional stability of the Latin American small town—no doubt at least partly to underscore the paradox and the horror of a situation in which (as in El Salvador today) the population of an established urban order is killed off day after day, leaving empty houses behind them. Offscreen sound—gunshots in various distances, horses' hooves—probably plays a greater role in sculpting visual space in this film: as in the café sequence—a deep empty tavern room—in which the protagonist has a neighbor's dogs shot out of exasperation with their offscreen barking; or again and always, in the fateful premonitory sound of automobiles arriving and departing.

III

Space is however by no means the most striking feature of *Condores*, whose originality is better grasped by way of its narrative dynamic.

I have already underscored the kinship of this film to the whole genre of gangster or Mafia movies, of which it is less a postmodernist pastiche than a decisive formal permutation. It includes a specifically psychological diagnosis in its insistence on the puritanism of the protagonist: his horror before the nudity of his wife, his own nudity as he bathes standing in an inner courtyard and pouring buckets of icy water over himself. Such a diagnosis is long since conventional (and thereby subject, one would hope, to a certain healthy skepticism), reminiscent as it is of the various pop-psychoanalytic elucidations of militarism or fascism, from Adorno's concept of the "authoritarian personality" all the way to John Huston's *Reflections in a Golden Eye* (1967) or *Il Conformista*, which position the "origins" of reactionary brutality in repressed homosexuality or childhood trauma. The novelty of *Condores*, however (at least from a First World perspective), lies in the fact that the protagonist is *already* political, living out the life of party affiliations and antagonisms (which antedate his own existence, in the form of some eternal rivalry between Liberals and Conservatives, blues and reds, or whatever) in seething resentment. North Americans have also known this permanence of politics in the narrow sense, of party loyalties and hostilities which are lived as a given of daily life with the intensity of clan rivalries, in various places and at various moments (Massachusetts, Louisiana, the great ward systems of the turn of the century, which Max Weber so admired), but our literature has generally transposed such realities into family drama and dynastic saga, even before its more recent full-blown figuration in the Mafia cycle itself. In English, only Conrad's *Nostromo* comes to mind as an attempt to render the Mediterranean realities of the political fact in this sense, yet even in Conrad it is given as background rather than as the stuff of daily life. In *Condores*, however, the political passion is from the outset conjoined to the social resentment of the future protagonist, constrained by his lowly position as an impoverished clerk and the object of frustrating jeers and taunts from wealthier townspeople who belong overwhelmingly to the other political faction. The film then documents an extraordinary transformation of the pretty-bourgeois camp follower into a ferocious and deadly energy, a preternatural force of violence and retribution, thereby offering a chilling representation of the monstre naissant (Racine's description of his own dramatization of the young Nero) which is something other than the passage from private to public, from psychological injury to political vocation (Hitler is the conventional or privileged object of this kind of Western "psychobiography"), since it seeks to project levels of intensity *within* the political itself.

Yet the most interesting originality of the film, what distinguishes

it most sharply from its Mafia- or gangster-film analogues, can be detected in the radical absence, the silence, of any collective framework. Mafia film was constitutively organized around the solidarity between the individual chieftain and the gang, family, or ethnic group from which he will be seen to emerge: the secret glamour of such works can be accounted for by the ways in which they tap unconscious fantasies of community and take the gangster's individual trajectory as a pretext for living the representation of some intense in-group collective life which is wanting in the viewers' own privatized experience.[22] *Condores*, however, dissipates this spurious glamour and refuses such now conventional generic expectations: apart from a few shadowy thugs drifting in his wake and basking in his prestige, this baleful figure moves in stark isolation, with none of the overtones of deviancy or antisociality (a naively psychologizing ideology developed in the earliest of the gangster movies such as Howard Hawks's *Scarface* [1931] or Mervyn LeRoy's *Little Caesar* [1931]). The evolution, the transformation, of *Condores'* hero is, rather, observed without comment, and with something of the glacial realism of the Brecht of *Mann ist Mann*, whose moral was that you could turn people into anything.

Still, none of these observations yet reaches the point at which the problem of the peculiar relationship of narrative dynamic to the visual (and also to a certain new presence to History) becomes visible. Cavell's work on film was informed by the stunning intuition of some deeper historical tendency or break in contemporary film, which he calls "de-theatricalization," but which he does not seem, whether for want of personal sympathy with this historical change, or because he still wishes to think it in analogy with the history of painting, to look for in the right place. I prefer to call this tendency de-narrativization, and I will begin to account for it in terms of a *reduction to the body* and an attendant mobilization of as yet unexploited resources and potentialities of pornography and violence. Such terms are meant to be strictly descriptive and devoid of any moralizing intent: yet the analogies with certain notoriously problematic forms of contemporary high literature are unavoidable. I'm thinking, for instance, of the well-known and widely denounced content of Alain Robbe-Grillet's formalism, whose sadism and violence to women's bodies can scarcely be explained away by the disingenuous suggestion of the novelist himself that his works are to be read as "critiques" of precisely such omnipresent violence and pornography in contemporary culture. Robbe-Grillet's novels, however, suggest the operation of some more general law or dynamic in modernism across the board: the more complex the content, the more simple and simplifiable must be the

form: Proust's great spatial arabesques—the two "ways" of the daily constitutionals, that of Swann and that of the Guermantes, or the stations on the little train—are paradigmatic of such modes of organizing complex content, which Joseph Frank termed "spatial form" (in a rather different sense of the spatial than has been at work in this discussion).[23] By the same token, then, if it is complexity of the form which is wanted, as in Robbe-Grillet's own ingenious fragmentations and recombinations, then the content must be as rudimentary and as easy to reidentify as possible, as it were reified and prepackaged in advance: that physical violence and pornography then become the privileged and final forms of such abbreviated and diminished, yet immediate, raw material.

Such reduction to the body is clearly a function of film as a medium: I am tempted to suggest that in the most authentic literary forms of high modernism the place of the tangible body is occupied by the sentence itself, reified in some new materiality but not yet, as in postmodernism, transformed into its own image. That the tendential autonomy of the sentence strains to divert the energies of an older narrative attention or reading all of *Ulysses* testifies: yet the complex new artificial acts of intellection thereby produced are clearly very different from the effects of the analogous reduction in film, where vision accommodates only too comfortably and passively to the new microscopic or molecular demands made upon it. The new foregrounding, in film, of a properly bodily interest—the agonies of the poisoning sequence in *Condores* or various murders, explosions, executions, along with sexual intercourse itself—solves the problem of narrative in a different way since these things remain events, however minute (on the other hand, is something with a beginning, middle and end—like sexual intercourse—the same as a story?). We need to see this development in its own history, as a moment in the evolution of the philosophical vocation of narrative (before this, generally the novel), which can be described as the foregrounding, exploration, subversion, or modification of the category of the Event in general. Realism, to be sure, has on the whole been understood as a kind of representational work within pregiven or even stereotypical categories of events and actions (and thus, more metaphysically, of reality itself). It is at least clear that the richness of modernism is at one with the crisis of such received categories and with the whole new interrogation—by poesis—of the nature of events themselves, setting out again from Aristotle's dissociation of a biography from a completed action (why are they not the same? or do they only coincide in lives which are "destinies"? or is destiny not itself an ideology and an illusion?). The related but antithetical interrogation leads in the

direction of the minutiae of daily life: when are those brief and incon-sequential segments of time events? And the metaphysical or ideologi-cal charge in such narrative practices comes when the question about the event is tormented to yield a supplementary answer about what living really is, or what reality is in the first (or last) place. Henry James of course remains the most august apologist for this vocation of the novel "experimentally" to construct or to dismantle events in such a way that beyond these empirical happenings the more general philosophical question about the Event itself may rise.

What should now be clear is that an aesthetic of the reduction to the body in film, far from asking these questions and raising the issue of these abstract categories, seeks radically to abandon them as much as possible, to peel them away and discard them from our visual experience, reaching the most elementary forms of bodily experience as its building blocks, about which such questions need not or cannot be raised. A whole range of subtle or complicated forms of narrative attention, which classical film (or, better still: sound film) laboriously acquired and adapted from earlier developments in the novel, are now junked and replaced by the simplest minimal reminders of a plot that turns on immediate violence. Narrative has not here been subverted or abandoned, as in the iconoclasm of experimental film, but rather effectively neutralized, to the benefit of a seeing or a looking in the filmic present. But this development—which has as its histori-cal and sociological precondition the radical fragmentation of modern life and the destruction of older communities and collectivities—is not necessarily an absolute loss or impoverishment, even if it marks the loss of the rich culture of an older modernism.

It may also be understood as the conquest of new kinds of relation-ships with history and with being, as I have argued in the preceding pages. A history-with-holes, for example, is very precisely a kind of bas-relief history in which only bodily manifestations are retained, such that we are ourselves inserted into it without even minimal distance. The waning of larger historical perspectives and narratives, and the neutralization of an older complex of narrative interests and attentions (or forms of temporal consciousness) now release us to a present of uncodified intensities, much as the chemical effect of drugs serves to loosen our temporal pro-tensions and re-tensions in the mesmerizing contemplation of what is now given "hallucinogenically" before us. But the films under discussion here do not, as in some postmodernisms, simply seek to imitate the experience of drugs but to reconquer that experience by other, internally constructed means (much as Freud found himself obliged to abandon the external tech-niques of hypnosis). The mediation of the camera apparatus, the inser-

tion of its technology into our experience, is not external in that sense; or rather the mystery of a technological externality which is now internal and intrinsic is at the heart of the problem of the aesthetics of film, where our historical experience of the decentering of the psychic subject (in Freud and Lacan) meets it and lends it new and no longer accidental significance. But we can only evoke the psychoanalytic exploration of inner and structural psychic distances, along with the Heideggerian conception of an approach to Being, in connection with these films, if we include some new historicism in our account as well, some constitutive and privileged relationship with history grasped and sensed in a new way, radically distinct from the chronologies of the historical novel and the fashion plates of nostalgia film alike.

Such narrative reduction has, for example, very real and practical consequences for ideology and ideological analysis. It is not enough to show a systematic abridgement in the generation and projection of narrative meanings, as though that were only a matter of aesthetic choice; we must try to understand that such eradications also have a political function. We have seen, for example, that the ideological message of *Condores* (if it can be called that) is specifically constructed by narrative reduction, in this case by the deliberate shearing off of the Mafia collectivity which had hitherto been a necessary structural feature of the genre. The full and vivid ugliness of the Condor's deadly *resentment* is conveyed by masking out the libidinal attractions of the family context, and leaving only the protagonist's body in isolation.

Fever is also consistent with this description, even though the circumstances of its production and reception at first confuse the issue, and seem to endow it with a very different ideological message (of an older type). Released immediately before the imposition of martial law in Poland, it was thereafter withdrawn, presumably on account of the sensitivity, under the circumstances, of its representation of a Russian occupying army. (As a consequence, only one copy of the film exists in the United States.) But it would be frivolous to conclude that it is, for that reason, a pro-Solidarity film. The patriotic young fanatics of *Fever* are anarchists and "infantile leftists" of the purest stamp: the framework of some larger underground socialist mass party is invoked, but never represented; and the film explicitly makes the point that its terrorist initiatives are radically disjoined from any such mass political movement, which the viewer assumes to exist somewhere else in the earlier sections of the film, only to have disintegrated in its later stages. The first protagonist (not the least peculiarity of the film being its organization around *two* heroes, whose stories are followed in succession) makes the conventional defense of his

activities as the expression of "solidarity" (a rather different and ironic use of this word) with the masses, to show them that they are not alone in the struggle, and that political efforts continue elsewhere, rather than as a way of achieving any precise political aim.

This is not to say that *Fever* has any comfort for the other side or the non-aligned, who are exclusively represented as police spies, double agents, quislings and lackeys, or else as corrupt members of the bourgeoisie who have accommodated themselves to the system and are terrified at the prospect of resistance. Yet the revolutionaries themselves have our sympathy only "by definition" as it were, ranging characterologically from the naive or the all-too-human to the peculiar pathologies of the heroes themselves, to which we must now turn. These are something like the *dioscuri* of the death wish—the one dark, the other blonde; the one cold and gloomy, the second joyous to the point of the manic—technicians of death whose paths cross only once in the course of the narrative. The dark assassin—intensified by the possession, and then the even more striking absence, of a bushy Slavic mustache—is surrounded by militants of varying degrees of incompetence, and endowed with what one hesitates to call a love relationship; while his blond successor works in complete isolation from comradeship or sex, emerging, not from the world of political militancy, but from the underworld of police spies and double agents, his last act being an attempt to blow himself up with the police headquarters and its unsavory occupants (the bomb, alas, does not go off).

In this woman's film, however, it is clearly the figure of the woman sympathizer who is central to the first narrative, her own peculiar longing for martyrdom (she wants to kill herself along with the governor general at a sumptuous gala reception, to which he fails to come) serving equally to underscore the depersonalization of the terrorist vocation, in which private fantasy and cold political strategy are pathologically dissociated and inextricably intertwined all at once. Two brutal sex scenes make this point dramatically: when, after his escape from prison, the first protagonist screws her like an animal, for "hygienic" reasons, her own ecstasy stands as sufficient comment on the fantasmatic nature of her passion for a figure who, considerably more neutral characterologically than the Condor, is little more than an absence driven and possessed. In the second sequence, she gives herself in *dépit amoureux*, to another militant who is hopelessly in love with her and whose energetic sexual ministrations are received like a rape and literally drive her over the edge into outright catatonia.

Whatever its relevance for contemporary Polish politics, then, *Fever* offers an implacable autopsy of the vocation of anarchist militants, whose dramatic grandeur is conferred upon them by the absolute

hopelessness of their historical situation alone. This ideological demonstration also proceeds, as in *Condores*, by strategic omission—the absence of the masses—and by the disjunction of its constitutive elements—fantasy and strategy, delirious private motivation and ostensible political calculation—which are turned back on one another in arrested contradiction. We have already examined an analogous structure in *La Casa de Agua*, in which the ideologemes of History and Nature are strangely held at a distance from each other by the very narrative which conjoins their nightmarish powers on the body of a common victim.

All this may now seem distant enough from the conception of magic realism with which we began until we grasp the necessary and constitutive relationship between intensities of colors and bodies in these works and their process of de-narrativization which has ultimately been shown to be a process of ideological analysis and deconstruction. In reality these two features—strategic omission or strategic recombination of ideological or conceptual elements and perspectives, and a well-nigh sensory proximity to the bodies and solids of the same history—are but twin faces, absence and presence, of the same aesthetic operation which libidinally intensifies the remnants in the present of what had been surgically excised of its other narrative temporalities.

(1986)

PART TWO

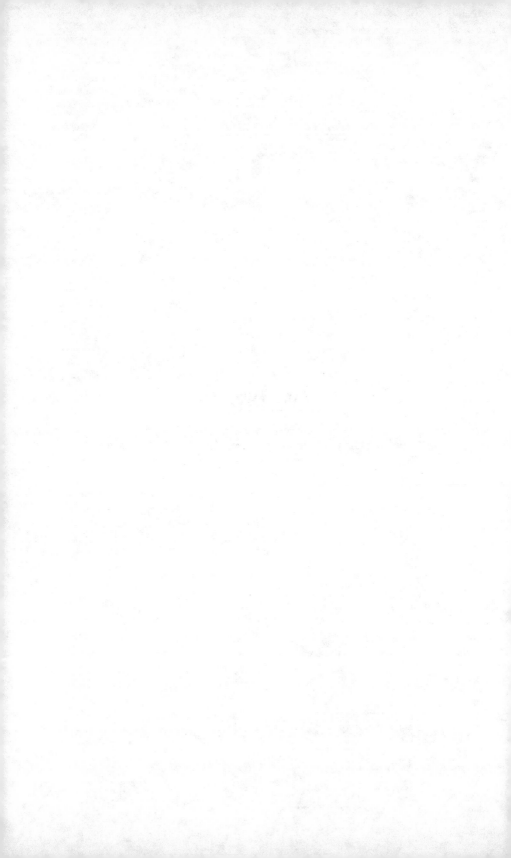

8.

The Existence of Italy

Not Italy is offered, but proof that it exists. (Adorno and Horkheimer)

Film history can be clarified, or at least usefully estranged, by period theory; in other words, by the proposition that its formal and aesthetic tendencies are governed by the historic logic of the three fundamental stages in secular bourgeois or capitalist culture as a whole. These stages, which can be identified as realism, modernism, and postmodernism respectively, are not to be grasped exclusively in terms of the stylistic descriptions from which they have been appropriated; rather, their nomenclature sets us the technical problem of constructing a mediation between a formal or aesthetic concept and a periodizing or historiographic one. Such mediatory operations are not unusual: Spengler's periods are a notorious, and probably unjustly discredited example, while Jurii Lotman's characterization of historical epochs in terms of the patterning of this or that trope (metaphor, metonymy), is clearly a related experiment.[1] But this refunctioning of cultural terminology for historiographic and periodizing purposes runs crucial risks, which may finally be insuperable: in particular, the borrowed aesthetic terms must have the force and willfulness of an estrangement, and not lapse or weaken into yet another form of idealistic history. The cultural component, in other words (borrowed from the Althusserians), must be conceived as a "dominant" but not a "determinant"; it must be grasped, not as a set of stylistic features alone, but as a designation of culture, and its logic as a whole (including the proposition that culture itself and its sphere and social function undergo radical and dialectical modifications from one historical moment to another). Finally, the conception of a period proposed here must include the economic in the largest and most varied senses (the labor process, technology, organization of the firm, social relations of

production and class dynamics, and rate of reification, including money and exchange forms).

That this periodizing operation is not particularly "linear" or even evolutionary will be usefully underscored by its invocation here in the context of film history, whose chronology—virtually coterminous with the 20th century itself—signally fails to coincide with any of the rhythms or coordinates of development in the other arts or media (in literature, for example, the "origins" of realism in the 17th century, the inauguration of "modernity" with Baudelaire or with the *fin de siècle*, the appearance of some properly postmodern cultural logic after World War II, but more particularly from the 1960s onwards) or with the paradigm of the three stages or moments of capitalism which confirm this version of cultural history: namely, a first moment of an essentially national or local capitalism to which the realist dominant roughly corresponds; the break and restructuration of the monopoly period (or "stage of imperialism") which seems to have generated the various modernisms; the multinational era, finally, whose historical originality can alone account for the peculiarities of what has now widely come to be known as postmodernism.[2]

It will nonetheless be argued here that the microchronology of film recapitulates something like a realism/modernism/postmodernism trajectory at a more compressed tempo: a proposition that could also be argued for other semi-autonomous sequences of cultural history such as American Black literature, where Richard Wright, Ralph Ellison, and Ishmael Reed can be taken as emblematic markers; or for the history of rock, where the social moment of Elvis or rhythm-and-blues—and behind that, Black music—unpredictably develops into the "high modernisms" of the Beatles and the Stones, and thereafter into rock postmodernisms of the most appropriately bewildering kinds. These recapitulations become less paradoxical or willful when we distinguish between economic and social levels: from the first, or economic perspective the three moments largely correspond to structural stages. Seen, however, in social terms, the moment of realism can be grasped rather differently as the conquest of a kind of cultural, ideological, and narrative literacy by a new class or group: in that case, there will be formal analogies between such moments, even though they are chronologically distant from each other. Thus, as Colin MacCabe has suggested, one may see "the realist moment of film carrying out some of the same ideological tasks for the 20th century industrial working class that the 19th century realist novel had undertaken for the bourgeoisie."[3] In Black literature, a similar dynamic can be posited for the self-conscious emergence of a specifically Black public later on; while the history of rock charts the emer-

gence of a new youth public. What then needs to be stressed is that the three "stages" are not symmetrical, but dialectical in their relationship to each other: the later two now build on the accumulated cultural capital of the first and no longer "reflect" or "correspond to" a social public with the same immediacy, although clearly the various modernist and postmodernist moments in such a dialectic then reach back to create new publics in their own right. Meanwhile the other theoretical problem raised by this paradigm—whether it does not then follow that "poststructuralism" is simply the same as some increasingly self-conscious and thereby self-referential moment in the history of form—is at least complicated by the inference that then in that case we have to do with two distinct forms of self-consciousness, for which therefore this single term may no longer be satisfactory: namely, the formal self-consciousness of the modern, which draws its abstractions from the content of an older realism, and the allusive "cultural capital" of the postmodern, which ransacks all the preceding cultural moments for its new forms of "cultural credit."

In the case of film, however, this demonstrable pattern—the "realisms" of the Hollywood period, the high modernisms of the great *auteurs*, the innovations of the 1960s and their sequels—is complicated by another and more embarrassing "fact," which I am tempted to dramatize by way of the assertion that there exists, not one, but two distinct film histories, or, if you prefer, that what we loosely call film in fact subsumes two distinct evolutionary species or subspecies—*silent* and *sound*—of which the latter, like the Cromagnons, drove the former out and made it extinct. (The analogy, however, should probably include the proposition that the extinct species was an altogether more intelligent and sophisticated cultural form than its successor.)

This means, in effect, that the two film species—silent and sound— each demand their own separate histories, and that the threefold logic suggested here is observable in both, but in unrelated and dialectically distinct ways. For one thing, silent film was never allowed to develop into its putative "postmodern" version, although it might be interesting to entertain the hypothesis that the independent or experimental film in the post-World War II era (e.g., *Dog Star Man* [1959–64] of Stan Brakhage) developed in the empty space of a silent film postmodernism that never happened; while on the contrary the alternate medium—that of sound film—finds its strongest third-stage evolutionary mutation in the very different postmodernism of *video*.[4]

The development of silent film from some inaugural realism of Griffith into the extraordinary modernisms of Eisenstein and Stroheim, cannot be dealt with further here.

I

"Realism" is, however, a peculiarly unstable concept owing to its simultaneous, yet incompatible, aesthetic and epistemological claims, as the two terms of the slogan, "representation of reality," suggest. These two claims then seem contradictory: the emphasis on this or that type of truth content will clearly be undermined by any intensified awareness of the technical means or representational artifice of the work itself. Meanwhile, the attempt to reinforce and to shore up the epistemological vocation of the work generally involves the suppression of the formal properties of the realistic "text" and promotes an increasingly naive and unmediated or reflective conception of aesthetic construction and reception. Thus, where the epistemological claim succeeds, it fails; and if realism validates its claim to being a correct or true representation of the world, it thereby ceases to be an *aesthetic* mode of representation and falls out of art altogether. If, on the other hand, the artistic devices and technological equipment whereby it captures that truth of the world are explored and stressed and foregrounded, "realism" will stand unmasked as a mere reality- or realism-*effect*, the reality it purported to deconceal falling at once into the sheerest representation and illusion. Yet no viable conception of realism is possible unless both these demands or claims are honored simultaneously, prolonging and preserving—rather than "resolving"—this constitutive tension and incommensurability.

The preliminary question that thereby arises is therefore whether we need a concept of realism at all in the first place. In my own view, it is the very instability of the concept that lends it its historical interest and significance: for no other aesthetic—whatever its manner of justifying the social or psychological function of art—includes the epistemological function in this central fashion (however philosophically incoherent accounts of the vocation of realism may turn out to be). Whatever the truth content, or the "moment of truth," of modernism, or postmodernism, whatever the claims of pre-capitalist moralizing and didactic conceptions of the aesthetic, those versions of aesthetic truth do not, except in very indirect or supplementary or mediated ways, imply the possibility of *knowledge*, as "realism" emphatically does. We may expect, therefore, the moment in which this conviction of the possibility of aesthetic knowledge appears (however we decide to evaluate it) to have something significant and symptomatic to tell us about its own unique historical opening and situation, which is evidently no longer our own.

Yet as a dialectical and polemical fact of life, most anti-realistic or anti-representational positions still do in some sense require a concept

of realism, if only as a empty slot, a vacant preliminary historical "stage," or secondary (but essential) aesthetic counterposition. Only if the conception of modernism itself is promoted to the status of mature secular art as such, as happens in Perry Anderson's brilliant historical excursus on the topic,[5] does it become possible to relegate the various realisms to a lumber room in which various formal oddments are stored, on their way to the ashcan of history: the leftovers of the old hieratic and aristocratic cultural traditions, academic conventions of the type perpetuated in the now bourgeois but still traditional schools of fine arts, and kitsch of all kinds and from all periods. From this rubble (according to Anderson) "genuine art" slowly liberates itself, and with the moderns (Manet, Mahler, Proust, Sullivan) richly and autonomously begins to explore and develop its own full secular potential. In that case, however, what used to be thought of as the "great realists" in Lukács's sense (Balzac, Stendhal, Tolstoy), come logically enough to be annexed to "modernism" in the sense of autonomous or authentic art, and the unusable parts of a former realist tradition fall into the negative receptacle of "tradition" *tout court*, in the privative Weberian sense. Meanwhile, what has been theorized as "classical film,"[6] in other words the Hollywood style or Hollywood narrative (otherwise clearly one candidate for some filmic "realism" to be constructed), can easily be accommodated to Anderson's scheme as that shoddy collection of objects exemplifying academic conventionality and ideological dishonesty all at once, from which some autonomous filmic art (of which we will here specify that it is in fact a specifically *sound-film* modernism) also emerges after World War II.

Anderson's position is a persuasive one, and in fact we probably all do sometimes think this way about the matter, but it is important to realize that it depends absolutely on a valorization of art and of the aesthetic as such which is no longer particularly universal among cultural intellectuals, for whom the concepts of "art" and "greatness" raise as many problems as that of "authenticity" itself. In other words, the "solution" a modernist position allows one to achieve for the false problem of "realism" is itself insensibly undone by a whole range of now *post*modern positions.

What a properly postmodern critique of representation (and of "realism") does is to include and envelop modernism itself within its strictures: something that can be observed in the now classical positions of the *Screen* group, for whom, as Dudley Andrew has observed,[7] the great modernist *auteurs* (Hitchcock, Fellini, Bergman, Kurosawa, *et al.*) are as aesthetically dishonest and ideological as the traditional Hollywood ones. Indeed for *Screen* these "moderns" are if anything

more suspicious than the conventional forms of Hollywood "realism," where the unconscious—Freudian, deconstructive, or even political— can still slip through the cracks in the form, and undo and subvert an iconic surface which the "modernists" are then in their turn concerned to seal and to stamp with the signature of their unique style or "genius."[8] There persists, therefore, in the positions associated with *Screen*, a certain truth claim, but it is no longer the epistemological one of realism as a form of *knowledge*, nor is it that of the modernizing "vision of the world"—the "authentic" expression of the individual subject. Rather, "truth" (or what was formerly called authenticity) is here an iconoclastic and negative or sheerly deconstructive project, identified almost exclusively with experimental film, which undermines all forms of representation and yet thereby in some way requires representation in order to do its work. It seems fair to suppose that this position (which takes a variety of conceptual and philosophical forms) is today still the hegemonic aesthetic. My own discomfort with it springs not merely from the sense that it has become a kind of doxa; nor even from its increasingly evident coincidence with a whole systemic logic of the postmodern (in theoretical discourse fully as much as in aesthetic and cultural practice), which one therefore hesitates to endorse for historical and political reasons; but also because the various formulations of this newer critical aesthetic often seem to include peculiarly modernist values and arguments in a kind of compensatory slippage in which now extinct features such as "irony," the breaking of forms and representations, the valorization of the reflexive, or of self-consciousness, but also the authenticity of the unconscious, and the modernizing dynamic of innovation or of the "make it new"—along with a nostalgia for the vanguard movement— oddly reappear within a postmodernism with which they are distinctly incompatible.[9]

The analysis of semic contradictions of this kind, however, need not imprison us in yet another closed or total system or historical *cul de sac*: something that might appear to be the case if we read this argument as raising a symmetrical question to that raised by realism— namely, whether we need a conception of *postmodernism*, when so many key elements in its aesthetic theorization turn out to be replications of the old-fashioned modern ones themselves? Unfortunately, since other crucial features of the modern position—in particular that of style and of the individual subject, and that of the autonomy of art—are henceforth unavailable, this conclusion would really imply, not that we are still within the modern, but rather that culture as such is over and done with: Hegel's "end of art" with a vengeance.

At this point, one must always affirm a truth which seems to me a͗

obvious as it is axiomatic: that no genuinely or radically different culture can emerge without a radical modification of the social system from which culture itself springs. In a world in which there do exist today, in however embryonic and emergent (or residual) forms, social systems different from our own, this affirmation need not have the bleakness of the earlier kinds of cultural pessimism which the sense of systemic closure seems so frequently to have inspired.

Yet there may also be formal and ideological combinations available *within* the closure of contemporary culture that are still worth exploring. The tension within traditional realism between the epistemological and the aesthetic suggests indeed one such recombination or tendency that has not yet found its name, but which becomes visible when one maps out the ideological space covered by the polemics and the positions that have just been reviewed. The more conventional way of identifying this fourth way or fourth possibility would of course suggest a return in some form or another of conceptions of the "denotive," or of some "literal language"—filmic or other—from which the illusions of the aesthetic have been expunged, so that the vocation of the epistemological or of knowledge cannot be exercised in some pure and unmediated form. This is no longer the "aesthetic" of the various realisms (which still proclaim themselves as art), but it has certainly often been the language of the various theories of *documentary* (including the latter's equivalents in "literature"—such as *proletkult*, notoriously hostile to conventional literary "realism"—and in painting—with its various forms of social *collage*, equally hostile to the painterly modernisms).[10]

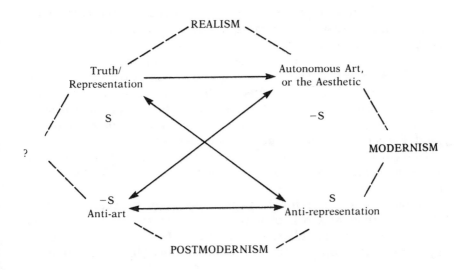

Yet the space of documentary must today, in the age of the signifier, be thought and projected in a new way (see below, Section vii): and the extraordinary revivals of some photo-documentary impulse (in film and video, in the *testimonio* form,[11] and in a host of other less obvious manifestations) are no longer accompanied by the older doctrines of denotative or literal language. Behind all these things, we may speculate, there lies a more fundamental terrain and mystery, namely Barthes's "message without a code,"[12] or in others, *photography* itself, whose formal practice today, no less than its increasing theoretical fascination, signals—in the era of mechanical reproduction and the society of the image or the simulacrum—the place of the *Novum* and sets all the geiger counters of the emergent in desperate activation. Ponge's great question—how to escape from treeness by the means available to trees—which once seemed to us to offer the very formulation of the antinomies of the linguistic, now reimposes itself in a different way with the situation of media society: how to escape from the image by means of the image? It is a question to which photography now promises answers which are no longer those of painting; nor are they immediately filmic ones, since film's relationship to the other medium is no more unmediated than that of any other branch of the "fine arts." Nor will the present essay pursue those answers further, although the presence of the unasked question—and the mystery of photography itself—haunts the following pages with welcome persistence.

II

Returning now to the historical issue of realism itself, the most obvious initial way of estranging and renewing this concept would seem to consist in reversing our conventional stereotype of its relationship to modernism. The latter, indeed, we celebrate as an active aesthetic praxis and invention, whose excitement is demiurgic, along with its liberation from content; while realism is conventionally evoked in terms of passive reflection and copying, subordinate to some external reality, and fully as much a grim duty as a pleasure of any kind. Pleasure is, however, generally in aesthetic experience an exercise of praxis, and even the various aesthetics of play are easily adjusted to forms of production, by way of a notion of freedom as control over one's own destiny.

Something will certainly be gained, therefore, if we can manage to think of realism as a form of demiurgic praxis; if we can restore some active and even playful/experimental impulses to the inertia of its appearance as a copy or representation of things. Meanwhile, modern-

ism may itself be momentarily rethought by experimenting with the provisional hypothesis that—grim duty or not—it is now to be seen as the passive-receptive activity, a discovery procedure like Science, a process of attention no less demanding and disciplined than submission to free association (which will later on, particularly with surrealism, be formally identified with it), a trained faithfulness to whatever, in language, in individual and collective fantasy, fully as much as in social forms, *constrains* the free play of the aesthetic imagination and sets it the rather different tasks of the discovery and the reproduction of these hidden categories which speak to us at the very moment in which we imagine ourselves to be expressing ourselves or our truths. "Je est un autre" can only imply that; while on the level of narrative, Lukács's dialectic of the genres in *Soul and Forms* and *The Theory of the Novel* offers a now distant model of the way in which narrative innovations are *discovered* rather than *created*, since they prove to be the reflexes and the after-images of contradictory social content. This experiment—seeing realism as praxis and modernism as "scientific representation"—at once confronts us with two fundamental methodological problems: what is the nature of the "world" thus produced by realism (it being understood that the very concept of world or worldness is itself a modernist, or phenomenological, one); and how, once we talk ourselves into a positive or productive concept of the realist aesthetic, are we to restore its negative and ideological dimension, its essential falseness and conventionality (as we have learned such structural lessons from the contemporary critique of representation)?

The questions must be conflated, in order to receive a single answer, of any unavoidably dialectical kind: the "world" realism produces in its demiurgic capacity must in other words somehow be grasped as a *false* world, but as one which is objectively false and not some mere appearance or figment (in which case its production by realism would reduce itself to little more than the projection of an illusory idea, a form of false consciousness, an ideology of a purely subjective kind). The crux of the problem—how an objective world can be both real and false all at once—is staged and resolved in the pages of Marx's *Capital*, about which it is therefore enough to add here that the peculiar object of realism (and its situation of production) is therefore the historically specific capitalist mode of production. Earlier forms of some emergent realism—such as the art-novella of the Renaissance—can be genealogically reconceived as corresponding to that enclave stage of "capitalism" within other modes of production generally referred to as commerce, or as merchant activity; while the relationship between objectivity and falsehood constitutive of realism proper is

dialectically transformed and very distinct in the other modes of production, such that this peculiar epistemological aesthetic has no equivalent in them. Nor can we deal here with other crucial preconditions for realistic narrative, such as the emergence of social mobility and the formal effects of a money economy and a market system.

What does need to be theorized about these propositions—that otherwise will seem to lapse at once into the passive correspondence theory of aesthetics which we sought to avoid—is the situation from which "capitalism" and "realism" simultaneously emerge. In a more general way, the relationship between art and its social context can be freed from inert conceptions of reflection by the proposition that the social context (including the history of forms themselves and the condition of the vernacular language) is to be grasped as the *situation*—the problem, the dilemma, the contradiction, the "question"— to which the work of art comes as an imaginary solution, resolution, or "answer."[13] Yet the situation of realism is a historically and dialectically unique one, which demands the clarification of an additional theoretical concept or slogan, namely that of *cultural revolution* in the most general sense.

We will therefore suggest that realism is to be grasped as a component in a vaster historical process that can be identified as none other than the *capitalist* (or the *bourgeois*) cultural revolution itself (whose description and accents will obviously vary according to these two alternative formulas): namely, the moment in which an entire last surviving feudal "world" (power, culture, economic production, space, the psychic subject, the structure of groups, the Imaginary) is systematically dismantled in order for a radically different one to be set in place. The notorious old terms "base" and "superstructure" can still be pressed into service one last time to convey the relationship of cultural revolution to the human subjects who live through it and are in some sense its raw material: for these last survive the extinction of an older physical and social universe with their psychic and practical habits intact. From this perspective, then, the function of any cultural revolution (such as must have accompanied all the great transitions from one mode of production to another) will be to invent the life habits of the new social world, to *de-program* subjects trained in the older one. In the case of the capitalist cultural revolution, for example, I have elsewhere stressed the transformation of space itself[14]: the dissolution of an older uneven or qualitatively heterogeneous space and its reorganization into the grid of homogeneous equivalence and measurability—categories which then know a complex development in their own right in the areas of science and rationalization (and

economics) on the one hand, and in political, juridical, and social categories of "equality" on the other.

The spatial example suggests something of the roles various aesthetic realisms are called upon to play in the cultural-revolutionary process, insofar as the representation of space is a fundamental part of the latter's experience (and is indeed often difficult to distinguish from it). But it is misleading to the degree to which we normally think of space in inert and reified ways; so that such putative spatial "realisms" lapse fatally into static descriptions of rooms or paintings of landscapes in our mind.

We therefore now need to introduce yet another crucial concept, whose signal absence from many contemporary critiques of representation weakens and oversimplifies the theoretical problems at stake here: this is the notion of *narrative* itself, and it has the initial advantage of at once dispelling forever the temptations of the copy theory of art, and of problematizing beyond recognition many of the assumptions implicit in the notion of representation itself. Indeed, the most interesting recent developments in narrative theory and in particular in narrative semiotics[15] are imposed by the gap between the idea of a story or narrative and the idea of a "representation" as such: how the transformational processes of narrative can be thought to *represent* anything, and how such processes in themselves vehiculate those other inert things called "ideas" or "ideology," then become fresh problems that demand new methodologies as well as new solutions. That narrative itself, or storytelling in general, may be ideology, of a hitherto untheorized kind, is a proposition that may ultimately help us to restore the ideological dimensions of realism itself (its negative, as opposed to its positive or productive, demiurgic, moment), but it is a proposition that should be taken to have all the paradoxical force of Althusser's thoughts on ideology in general[16]; namely that this last is not a form of *error* (false consciousness) to be placed by a more appropriate form of truth (or better still, of *science*); but rather that ideology is always with us, that it will be present and necessary in all forms of society, including future and more perfect ones, since it designates that necessary function whereby the biological individual and subject situates himself/herself in relationship to the social totality. Ideology is therefore here a form of social or cognitive mapping, which (as Althusser argued) it would be perverse to imagine doing away with; and I would want to make a similar argument about narrative itself. Under certain circumstances, therefore, it seems clear enough that dominant or daily-life narrative paradigms need therapeutic correction, which may even go so far as to take on the violence

of iconoclasm, as in the *Screen* vision of independent or experimental filmmaking; but then in that case one would want to speculate about the historical situations which require such violence and about their limits in time and in the order of social publics. Robbe-Grillet's argument[17] about the ideological nature of Balzacian "realism"—the way in which Balzacian narrative asserts a form of "reality" which is ideological through and through—is thus perfectly proper; but may not have the same force in a moment in which those older bourgeois narrative paradigms are already broken, and perhaps replaced by newer (postmodern) ones which still remain invisible to us. Meanwhile, the other advantage of the substitution of the problematic of *narrative* for that of *representation* lies in the way in which the former evacuates questions of verisimilitude, "realistic" copying, *identification* of the object in question, which were still implied in the language of the representation debate.

Narrative can be enormously diverse in its ideological forms; but these can also be historically and socially specified by the concomitant notion (in Althusser and elsewhere) of the subject position, provided it is understood that what one wants is not to do away with subject positions altogether, but rather to develop new (and perhaps multiple) ones. We can therefore return at this point to the realism debate, and historicize it by the hypothesis that realism and its specific narrative forms construct their new world by *programming* their readers; by training them in new habits and practices, which amount to whole new subject-positions in a new kind of space[18]; producing new kinds of action, but by way of the production of new categories of the event and of experience, of temporality and of causality, which also preside over what will now come to be thought of as reality. Indeed, such narratives must ultimately produce that very category of Reality itself, of reference and of the referent, of the real, of the "objective" or "external" world, which, itself historical, may undergo decisive modification in other modes of production, if not in later stages of this one. Meanwhile—and this is a decisive feature of all realisms since the emblematic appearance of the *Quijote* itself—realism must also deprogram the illusory narratives and stereotypes of the older mode of production[19]; it must cancel while producing, and at an outer limit, must even seek obsessively to cancel itself as fiction in the first place (the trope of the protestation of non-fictionality has been exhaustively explored).[20] Such cancellation, indeed, seems so fundamental a dimension of realist production that it may be considered a constitutive feature, without which "realism" as such ceases to exist.

The paradigm-cancelling process, however, must also be related to the discovery/invention of new kinds of social material, which have

not yet been named or spoken by the dominant discourse. Stereotypes and dead romantic or "un-realistic" paradigms are thus also at one with silence and exclusion, with the ignoring (in the strong sense) of groups and zones of reality of which the seamlessness of the hegemonic paradigm assures us that they could not possibly exist, since there are no blank spots on the map. On the other hand, everything changes when such areas have been named and spoken, and annexed, however distortedly, by the dominant social cartography, where they simply become stereotypes: any theory of realism, in other words, must also explicitly designate and account for situations in which realism no longer exists, is no longer historically or formally possible; or on the other hand takes on unexpected new and transgressive forms.

III

This description or realism in terms of the un- or not-yet-spoken— a description which includes the social, insofar as it necessarily implies the originating presence of a group whose experience has been thus linguistically "repressed" and "marginalized" (terms not quite appropriate for a kind of experience that never knew expression in the first place)—can perhaps be reformulated and modified and augmented in interesting ways by an analogy with types of language, and in particular with Basil Bernstein's theory of "restricted" and "elaborated" codes.[21] This distinction was meant to convey the structural distance between a situation-specific in-group language, in which the initiates understand each other à demi mot, and that more complicated linguistic structure "elaborated" in history to speak across groups, to conquer a certain measure of what we often call abstraction, and to omit "deictic" relations to an immediate object world as well as to incorporate and disguise by generalizing specific forms of group knowledge or value which would otherwise betray its links to its context and limit its "universality," that is, its claims to legitimacy, to authority and truth. The social as such is evidently inextricably included in this linguistic theory, where the notion of an "elaborated" code is not fully meaningful (as Gouldner has observed[22]) without attention to the agency of its elaboration—namely the emergent intellectuals—and perhaps also to its paradigmatic moment—the emergency of philosophy as such (in ancient Greece). Bernstein's more immediate social references, however, were class ones: since working-class speech omits the elaboration and abstraction systematically fostered and developed by middle-class or bourgeois education, culture, and gentility, respectability, or distinction (depending on how one chooses to identify those values). In a polemic with American

grammarians of "Black English," Bernstein has been accused of a kind of racism, at the least elitism, in his formulation of a type of sociolinguistic difference which seems to condemn lower-class groups to inarticulacy and endow privileged ones with a monopoly on cultural creation[23]; it is an odd reproach, which seems to reflect a bourgeois or assimilationist perspective (the very standpoint of the elaborated code itself), and which fails to appreciate the case that might be made for the power and positive value of situation-specific thinking and speaking, as well as for group coherence (the concept of the elaborated code would, indeed, seem to imply that its group-bearers lacked the social coherence of the groups practicing restricted discourse). For the dialectic, indeed, the narrative content of the Bernstein opposition would seem to articulate itself as follows: the restricted code corresponds to the thought patterns of pre-capitalist formations (and lower or marginal classes under capitalism), the elaborated code to the emergence of the analytic thought of the bourgeoisie; while dialectical thinking and language—or a properly dialectical code as such—projects a synthesis of both, that is to say a thinking which is abstract and situation-specific all at once (or which, to use Marx's far more satisfactory formulation, is capable of "rising from the abstract to the concrete").[24]

At any rate, the interest of an analogy between these codes and the realism/modernism distinction begins with the way in which it underscores the impulse to distance itself from the situation or the context as such which characterized the "elaborated codes" of the various modernisms. The term "abstraction" is pertinent here above all in its philosophical and linguistic sense (rather than its visual or painterly one). But the general problem of "abstraction" thereby produced—linguistic, conceptual, formal, the new autonomy of the sign, the de-naturalization of industrial development and "modernization" as well, and their destruction of the concrete sites and contexts of the older "restricted codes"—surely offers the most promising space in which to rethink the question of "modernism" as such.

When one returns to "realism," however, the sociolinguistic analogy seems to involve us in contradiction, most notably that suggested by the apparently inevitable universalization at work in any artistic language: the "speech art" of a given "restricted" social group may in other words be comprehensible only by its members, but any representation of that group, no matter how rudimentary, would involve a certain aesthetic distance, that is to say, a certain generalization of access and reception. Some forms of pre-capitalist "art," therefore—such as *ritual*—may be thought of as restricted in this sense; but surely not realism itself insofar as it has just been defined as the

deconcealment—within the public sphere—of certain kinds of hith-
erto occluded group reality and experience, of certain forms of linguis-
tic otherness.

We may take Bernstein's formula a step further, on into mystery or
paradox, by suggesting that realism is to be conceived as the moment
in which a "restricted" code manages to become elaborated or univer-
sal: something that only happens to one unique restricted code, and
only for a brief historical period (the forces of the "universal" or
abstraction then dialectically undermining it and giving way to the
modern). This restricted code is evidently the code of a single class,
the bourgeoisie or middle class, when it can still feel itself as a class
or group unity, and when its private class experience is for a time that
of the world itself, or the nascent world of the market and emergent
business space.

It is a proposition that can perhaps be demonstrated negatively by
examining the fate of small group codes in contemporary film, under
the abstractions, no longer even of the modern, but of the new global
system and global space. For the naming and speaking of new forms
of experience is just as surely related to an older realism as it is the
function of group or collective dynamics, albeit now of microgroups
or the so-called "new social movements." Films of this kind, as various
as they may be, are also surely distinct from hegemonic production:
the newer ethnic or post-ethnic film, for example, as in the Stephen
Frears/Hanif Kureishi *My Beautiful Laundrette* (1985); or "punk" film,
such as those of Jim Jarmusch (even though here as well punk seems
to need to touch base with the reality of groups, as the Hungarian-
ethnic motif in *Stranger than Paradise* [1984] suggests); and in wom-
en's film, where different temporalities and instrumentalities—house-
wife's time and space (as in Chantal Akerman's *Jeanne Dielman*
[1977]), or the libidinal investment in endless, aimless conversation
in Marguerite Duras—strike one segment of the audience as stylized
and another as "realistic" or somehow "true to life"—yet in a verisimil-
itude that can never become hegemonic in any Hollywood fashion.
In certain more conventionally storytelling films—one thinks of the
Dutch *A Question of Silence* (Marleen Gorris, 1983) or the more fully
realized *Portrait of Teresa* (1979) of Pastor Vega (but the coherence of
the latter is drawn from its social context—revolutionary Cuba—and
from a collective project of which it is an integral part)—this "quarrel
of interpretations," which divides its spectators and their interpretive
positions against each other, is drawn into the very film itself and
thematized as its content—dramatized, in the first-mentioned of these
films, as scornful laughter, and in the second, as the alternation be-
tween the man's self-defense and the woman's indictment. Normally,

however, the realism of the "restricted code" functions as the taking for granted, in advance, of the familiarity and relevance of the context itself—here and elsewhere, that new thing called "daily life," that new and unfamiliar object of representation which is in one way or another the presupposition of all the newer "restricted" or oppositional realisms. Sartre showed, in *What is Literature?*, the barely perceptible ways in which class positions pre-selected details, and chose their readership in advance by the omission of certain kinds of explanations (only needed by readers with different kinds of class experience); in place of the Utopia of praxis which he projected as the ideal of a classless readership, however, these oppositional realisms turn the tables on hegemonic explanation and omission, and omit the *other* explanations, which the dominant public now needs in its turn, and without which it feels these representations to be alien or boring, stylized or perverse, when it does not simply classify them as "experimental."

Benjamin already characterized the microscopies of the modern in terms of the surgeon's intervention, who "greatly diminishes the distance between himself and the patient by penetrating into the patient's body, and increases it but little by the caution with which his hand moves among the organs."[25] This body, however, with its various organs, is what we have called daily life, and it is into it that the camera surgically penetrates:

> by closeups of the things around us, by focusing on hidden details of familiar objects, by exploring commonplace milieus under the ingenious guidance of the camera, the film, on the one hand, extends our comprehension of the necessities which rule our lives; on the other, it manages to assure us of an immense and unexpected field of action. . . . Evidently a different nature opens itself to the camera than opens to the naked eye—if only because an unconsciously penetrated space is substituted for a space consciously explored by man. Even if one has a general knowledge of the way people walk, one knows nothing of a person's posture during the fractional second of a stride. The act of reaching for a lighter or a spoon is a familiar routine, yet we hardly know what really goes on between hand and metal, not to mention how this fluctuates with our moods.[26]

Benjamin here omits those constitutive links between group experience and knowledge or perception which were among the most remarkable hypotheses of Lukács's *History and Class Consciousness*.[27] The seemingly neutral capacities of camera technology determine in Benjamin a way of framing the problem which might be characterized in terms of the present context thus: is the medical photo—with its

organ enlargements—any less *realistic* than one of the patient's old family snapshots?

Yet the microscopies of contemporary oppositional film are social rather than physical, even where they seem most stubbornly attached to sheerly spatial data. In *News from Home* (1977), for example, Akerman's camera seems to observe without intervention; only its abrupt displacements seem to *probe*, in Benjamin's sense, and they map Manhattan mechanically and as it were non-cognitively, following the city plan square by square, in order, and without any of the imaginary distensions and contractions, without any of the bulging or shriveling spatial projections, of those inner "images of the city" to which Kevin Lynch introduced us.[28] Fixed at the end of an empty street in the warehouse district of lower Manhattan in early morning, the camera receives the few lone vehicles that tentatively negotiate its uneven paving; without transition, it rides the subway north and south, mobile in its immobility, indifferent to the passengers that pass before it; it is then driven back and forth the crosstown streets in midtown, registering the storefronts without interest but without discrimination; now enlarging its rhythmic repertoire by means of the great avenues north and south; and at length, in a concluding flourish, whose aesthetic formality—as a rhythmic or musical segment—is all the more striking for the persistent omission of intention or of style, withdrawing across the bay by boat so that the tiered city at length becomes visible as a glittering image, by nightfall, a totality stubbornly closed to us, about which the preceding two hours of enforced observation will finally have told us nothing. This is very far from being an evocation of *place* in any conventional sense—the sense, for example, in which some early New Wave films have been described as "love letters to Paris" (the letters in Akerman's film—the "news" of the title—come from Europe *to* Manhattan; they detail, in voiceover, the tedious family concerns and routine problems of a provincial home reality). Nor does *News from Home* in any way foreground space itself, in the sense of Nature or ground—like the great cyclically interrogated landscapes of Michael Snow's *La Région centrale* (1971), which causes the "question of Being" to arise from the Arctic tundra.

And this, not merely because the whole organization of the grid—which this film inscribes on us and on our viewing bodies with the wear and furrowing of its traveling shots and even more tangibly by the depth of its immobile positions—finds its historical source in social and political decisions taken by the Commissioners' Report of 1811.[29] Rather, abstraction is here the isolation of one level of social experience rarely separated out from its normal content. The crosscuttings of the modern, indeed, whether in Joyce himself or Dos Passos,

retained the content of their various fragments, and amounted to the montage of distinct segments of the experience of their multiple characters. Here that "experience" has been removed; the anecdotal and its individual subjects have been omitted: returning, however, not merely in the interminable newsy letters from elsewhere—the family topic of growing old, time going by in the family without your realizing it—but also in the viewer, whose own occasional and trivial memories insensibly take the place of the destinator's, of the silent Chantal, about whose life and adventures in Manhattan we learn nothing (save, by ricochet, in the replies from home to her own increasingly intermittent letters, which seem, most often and classically, to ask for money). So it is that strangely, in the urban squalor of the postmodern image, a now distant high Romantic motif seems faintly echoed in the persistence of place and passage of time: *la tristesse d'Olympio*, that same place again, where once, now so long ago . . . Yet now, not the poet but the anonymous spectator supplies this sadness with fitful memories of the city visited over the years, a trip to the theater in the distant past, driving up this same avenue in 1955 and then in 1979, various meetings here and there, buying a newspaper once long ago, an undatable memory of an aimless stroll very early on an empty Sunday morning, or of crowds—at noon, and in late afternoon: this random collection of indifferently significant and insignificant memories, like snapshots in an old shoebox, now separate off from the spatial grid itself—just as the voiceover separates off from the filmic image—a kind of vertical set of discontinuities and levels, in contrast to the horizontal and temporal fragmentation of the postmodern schizophrenic, which shares with this differentiation only the evidence of radical discontinuity itself and of the impossibility of any meaningful reunification of this data, even by aesthetic fiat.

Yet form is present here—and even something like narrative—in the great empty architectonic shifts in which the neighborhoods are laid in place alongside one another like so many bricks, and in the sheer brutality with which the abrupt displacements of the camera position us in successive spaces, like the obligatory segments of a very literal-minded sonata. But this narrative without anecdote is as it were the abstract idea of some grand narrative shorn of all its local language games (to use Lyotard's distinction,[30] to which we will return): Imagination now utterly divested of Fancy, the Idea without any content or subject, become sheer matter, but matter still bearing within itself the armature of its initial historical form. This is now also something like an abstract or even an absolute verisimilitude: everything here is quite ordinary and recognizable—that legendary chicken finally identified by bewildered aboriginals viewing their first

movie is here everywhere available; but then in that case a zero degree of "realism," in which an infinity of subject-position investments is left open, something like a restricted code without a message.

That the relationship between such aleatory messages or content and the empty grid of the code—a function of the new global space of the multinational world system—is however explicitly presupposed by the film's structure: letters from Belgium to a European making films in Manhattan, images seen variously by New Yorkers, who live daily in this space, by Americans who visit Manhattan only occasionally, by tourists, by foreigners, and by people—North Americans or foreigners alike—who have never set foot in the place. In this respect *News from Home* is the very paradigm of the "restricted code" itself: the ground or contingent scene from which a multiplicity of speech acts arise which are untranslatable into each other.

Is the theory of realism always inseparable from political issues and political judgments (unlike the modern, about which one can think politically, but also non-politically, formally, historically, and without the same kinds of passions)? Deleuze and Guattari's theory of the "minor"[31] has the advantage of cutting across some of our stereotypes or doxa about the political as the subversive, the critical, the negative, by restaging an affiliated conception of art in the new forcefield of what can be called the ideology of marginality and difference—perhaps, in our time, the strong form of what used to be populism and what is probably the dominant ideology in the Western left today. For the "minor"—as Deleuze and Guattari codify it out of Kafka—works within the dominant in a somewhat different way, undermining it by adapting it, by appropriating part-structures or hegemonic language (German) and transforming them into a kind of interior dialect (Yiddish), where selective modes of speaking are "intensified" in a very special way, transformed into a private language, hysterical or camp: 1) in which the limits of language (or of representation) are designated by the excess of intensity—which cannot fully say it, raises its voice, mobilizes pitch and intonation; 2) and where the individual subject seems to disappear behind the beleaguered collective which thus speaks all the more resonantly through it (so that all its private utterances are at once political).[32] But this is a very different conception of aesthetic subversion from that of the breaking of forms, and it acknowledges one of the prime features of the postmodern situation which we long mistook to be the death or disappearance of the subject, but which turned out to be intensified collectivization, and the subsumption of all solitary rebels or isolated monads into new forms of group cohesion and affirmation.[33]

Perhaps then the new "oppositional" realisms can better be con-

ceived in this way in general, as the appropriation from within of a representational language long since in place and ossified. But such "minor" aesthetics—such symbolic "restricted codes," now constitutively and by their very structure forfeit any grand progress on towards the status of a new hegemonic discourse; unlike Hollywood style, they can never, by definition, become the dominant of a radically new situation or a radically new cultural sphere.

The inconsistencies and contradictions of these various models of realism—the problem of writing a "realistic" narrative of realism itself—are best used to produce new problems (generally of a historical kind), rather than to stimulate that effort of the will by which we cut through the tangle to some dogmatic solution of "definition." In the present context, we have to distinguish between the realism of other people—something codified from the outside in the handbooks of 19th-century literature (or of early 20th-century film)—and those punctual moments in which—in a generally stylized and modernized cultural climate—we ourselves occasionally learn again, by experience, what genuine realism "really" is.

IV

As for Hollywood "realism," meanwhile, it is also to be grasped, in the same way, as the conquest of new forms of social reality that had not yet come to speech or representation, those very precisely of a properly middle-class construction of reality. This is the sense, for example, in which Edgar Morin, in a once classic work,[34] read the new middle-class domesticity of nascent sound film and of its transformation of the silent-film star system as a symbolic cancellation of the operatic pathos and high tragedy, the gestural expressionism, of the silent era and its distant, glamorous, and legendary idols. Any evocation of some properly Hollywood "bourgeois" cultural revolution would have to begin at this point, where the social transformation of the public in the 1930s decisively modifies the lens and begins to offer viewers glimpses of their own domestic and single-family existence. The negative or ideological moment of this new domestic realism will then become visible when we restore the situation itself, namely the reality of the great Depression, whose collective experience is surely the greatest punctual psychic trauma of U.S. history since the Civil War, in terms of which Hollywood's images of domesticity now suddenly come to be seen, not as "realism," but as compensatory wish-fulfillment and consolation. Conventional notions of mass culture as "distraction" and "entertainment" recover a certain force and content—but also become structurally restricted as to time and place—

when they are historicized to include that from which public needs most urgently to be "distracted."

The most difficult problem confronting any "positive" theory of Hollywood realism as a socio-aesthetic construction of reality involves the other constitutive feature of these films, largely without equivalent in the older literary or pictorial traditions: namely the genre system itself. The rarer explorations of the "truth content" of the various genres, but also the extraordinary research available everywhere today on their various histories,[35] both fail to account for the meaning of the *system* of the genres themselves; while general studies of the Hollywood style or narrative as such—which underscore the ideological implications of categories of narrative continuity and verisimilitude as such, including that of closure and the "happy end"—have not yet reached the point of accounting for the necessary multiplicity or structural diversity of this essential unity, of addressing the question, not merely *why* this style can only manifest itself by way of multiple genres, but how and why the contents of its "constellations" change.

Such historically variable constellations of genres are in fact synchronic genre *systems*; and it is only at the level of such systems that the ultimate relationship between genre and representation (or the illusion of reality) can be grasped. But the description and analysis of a genre system in itself is a difficult and dialectical undertaking which few enough of us have been able to conceive for the traditional literary genres, let alone for film as such.[36] The presupposition is that the ideological conception of "reality" or the "literal," let alone of verisimilitude, is not particularly operative within any of the individual genres taken by itself: there, life tends to imitate art, as with the familiar spectator who emerges from the theater imitating Bogart's gait or Belmondo's imitation of it. That narrative conventions are in any particular genre mistaken for "life" or reality is a category mistake no doubt uniquely reinforced by Hollywood; but history and styling changes can be allowed to correct it; and the prodigious extension and development of a historical film culture to be expected from the spread of the VCR and the rental library will include a much keener sense of the relativity of film styles (something no doubt already at work in the culture of the postmodern).

What the project of a genre system for film implies is rather that the reality socially constructed by Hollywood "realism" is a map whose coordinates are parcelled out among the specific genres, to whose distinct registers are then assigned its various dimensions or specialized segments. The "world" is then not what is represented in the romantic comedy or in *film noir*: but it is what is somehow gov-

erned by all of them together—the musical, the gangster cycles, "screwball comedy," melodrama, that "populist" genre sometimes called social realism, the Western, romance, and the *noir* (but the enumeration must be closely and empirically linked to a specific historical moment)—and governed also, something more difficult to think, by their implicit generic relationships to each other. The unreal—the not-said, the repressed—is then what falls outside of the system as a whole and finds no place in it (or else—in this moment of a 20th-century mass-cultural "realism"—finds its place in the accompanying "high art" or modernism of the period[37]).

But at this point a further unexpected moment may be foreseen: that in which the individual text (like Leibniz's monad) suddenly proves oddly again to expand and to reveal traces of the entire genre system within itself as in the peculiarly distorting registration of a specific generic microcosm, and according to its own structural priorities, its own characteristic dominants and subordinate. In *After the Thin Man* (1936), for example, virtually all the other genres copresent in the specific genre system of that period stage at least a fleeting appearance: the musical for instance, in the scenes of the nightclub and the torch singer, and of ballroom dancing; motifs which however also betoken the ever more distant symbolic presence of the Western, with its feminine-specular space of the tavern, and in the role of the villainous nightclub owner (Joseph Callea, whose villainy plays no role in this mystery but is functional only in the other, absent genre); the gangster film as well, here "degraded" to the level of the stock comic lowlife figures and specimens of stereotypical underground life who are the vestiges of William Powell's earlier or "other" life as a detective); drawing room and aristocratic family farce meanwhile add in the dimension of the rich and of "high life"; while various pairs, including Nick and Nora themselves, project a range of potential love comedies and romances; the whole being then reanchored in the expressionism of *film noir* by the murder sequence in the fog and the final evocation of mental unbalance. But this now omnibus text—which parades the various genres before us as in a variety show or music hall (see Section xi)—has nothing to do in its structure with that *transcendence* of genre we will observe in nascent sound-film modernism; rather, it remains a specifically generic text, which in the process reinforces the genre system as a whole, as though the formal commitment to any specific genre finally obligated the filmic text to touch bases with all of them, in something like an inversion of what will later be called *auteur* theory. There the *auteur* broke through genre to *style* by practicing all the different genres in turn—here the

systemic genre text combines them all within a single production, dismissing its "auteur" (W. S. Van Dyke II) into anonymity. Yet the dissolution of filmic realism, the "end" of genre or of Hollywood, is already implicit in the tense and historically and structurally unstable constitutive relationship between genre and its conventions, or, what is another way of saying the same thing, between the individual genre and the system as such. The convention of resolution or the "happy end," for example (which in various genres obviously does not require the survival of the protagonist and can often wear a properly "tragic" appearance), is best evaluated against the Frankfurt School discussions of commodification in 19th-century literature, where success—still minimally tolerable or "authentic" in the Balzacian world of the emergent market—becomes unavoidably unauthentic as the century draws on. The successful hero—now always a male and generally a businessman—the Octave of *Au bonheur des dames*, the protagonist of *Bel Ami*—can only confirm his "happy end" by way of money, and thereby falls out of "high literature" altogether, announcing the wish-fulfilling structure of the bestseller and of a later mass culture. The opposite of success alone then offers authentic literary material, insofar as—from the woman's novel and the tragedy of adultery all the way to the "existentialist" anti-hero—it resists commodification. The becoming conventional and thus inauthentic of the Hollywood happy ending signals an analogous moment, after World War II, when a new extension of commodity culture, along with the waning of the memory of the Depression, drain the wish-fulfillment of its Utopian force and render it meretricious.

The other feature of the end of Hollywood implicit in this description (or rather, now, of the supercession of filmic realism by modernism as such) can be formulated as the repudiation of the genre system itself, something which happens in the other arts and literature at an earlier moment when the conception of some *Gesamtkunstwerk*, Book of the World, or ultimate autonomous aesthetic practice, comes to replace the professional production of one book or novel after another. The introduction of the "wide screen" in 1952, with its overdetermined technological and economic situation (end of the studio system, introduction of television), is also emblematic of this mutation in aesthetics itself, which renders the modest on-going practice of the traditional genres somehow uncomfortable, if not intolerable.

V

The introduction of the technological fact—along with technological explanation and technological determinism—into theoretical dis-

course creates peculiar linguistic formations which are rather different from the transcoding operations characteristic of "theory," in which multiple but purely theoretical discourses are somehow combined. But the new formation, the new hybrid discourse, in which theory attempts to assimilate technology, is not strictly comparable to those works of art which seek in one way or another to absorb, or at least to incorporate, to register, the brute fact of contingency, the meaninglessness of matter and being as such; for technology is not in that sense contingent or meaningless, and its "absorption" or incorporation would present greater analogies to those visual works of art to which, in one way or another, a living machine has been attached. The machine is far from being meaningless, but it is of a radically different order of meaning than the aesthetic object; and some of the oddness comes from the jumps the mind is forced to make between those orders or dimensions.

I am tempted to say that all technological explanation has, as its strong function or "proper use," demystification, generally in the service of a materialist philosophical position: de-idealization, then, despiritualization in whatever sense or context, provided it is understood that this is in fact *not* a position but rather an operation, and *intervention*, whose aims and effects depend on what is being demystified, generally the innate tendency of literary or cultural critics to an idealism of meaning or interpretation. Thus, in an initial move, technological criticism—exegesis in terms of the introduction of the wide screen, or the dialectic of sound film (return to the studio, new lighting problems, the capacities of existent film stock)—comes as the therapeutic revelation of an *outside* of the work itself; these "determinants" are thus *extrinsic* (to use the old Wellek-and-Warren term) in a new and positive sense, for they suddenly show up the poverties and the shabby idealistic pretenses of an older intrinsic criticism: details that had been read as features of an aesthetic intention and as components of a "meaning" now prove to have been "merely" what was required technically, the way the particular shot had to be managed within the technical limits of the period, or obvious second-best makeshift solutions dictated by the obligatory indoor shooting or the deficiencies of the stock. That such external necessities have then been *on reception* (by the public or by later ingenious critics) drawn inside the text and endowed with meaning of a more properly aesthetic kind now—after the intervention of this technological explanation—strikes us as pitiful and humiliating; chastened, interpretation packs its bags and vows to have nothing more to do with Janus-faced objects of this kind, which, approached as works of art, suddenly turn into machinery before your very eyes, and can best be abandoned to some

second shift of engineering historians who take the seats vacated by the aesthetes. Unfortunately all cultural objects are ultimately dual in this sense; nor is the engineers' new mode of formal decipherment in any way an adequate *substitute* for interpretation, since it is not exactly reading at all, but something closer to symptomatology. Now, however, insofar as cultural texts continue to be read or viewed, culture itself enters the agonizing aporias of the mind-body problem at the very moment in which the philosophers had decided to leave it behind them for good.

But technological explanation does not stop at this moment of demystification and intervention; it leads on into a new kind of discourse in its own right (which can be called technological determinism for shorthand purposes). Two stages in this new discourse need to be distinguished. First, the technological "fact" in question now immediately demands to be inserted in a historical *series*. The "wide screen"—now no longer grasped in relationship to this specific aesthetic work, such as John Boorman's *Point Blank* (1967), where the viewer is virtually spilled out of this window or balcony onto the wide-screen pavement below—demands on the contrary that it be set in relation to "facts" commensurable with it: the aspect ratio of earlier screens and earlier experiments in this mode, the dimension of the future (including television and video ratios), a more distant prehistoric past in the shape of the history of the dimensions of easel painting and even window design), etc. A new history now opens up, which is, like all such series, an infinitely regressive one, entailing what Hegel calls "the usual infinite progress from condition to condition."[38] But this historiography will now begin to reproduce all the dilemmas generated by the history of forms, and very specifically that of the opposition between the intrinsic and the extrinsic, by virtue of the choice of the particular theme or feature (the determinant), of which the history is to be written and in terms of which other historical facts become by definition external (manufacture, for example, the history of the factories in which such screens are physically produced). The reemergence of such problems within the new field which was inaugurated by the very act of discrediting them elsewhere may encourage the suspicion that there is finally something "idealistic" about the establishment of any historical continuum or "narrative"; and that once the materialist and demystificatory gesture becomes incorporated into a historical narrative in its own right it reestablishes an idealism of its own, which no protestations of materialism can effectively dispel for long (there are also, as Sartre once said, *idealistic* materialisms).

But this is by no means the conclusion of our methodological narrative, for the new materialist and technological histories, in something

like a second stage, have further weapons at their disposal to maintain their original authenticity. That lay in the intervention of one order of things into another. Now these various and multiple historical series can begin to intervene in each other, reciprocally, and the tendential idealization of one kind of factor can be subverted by the introduction of a radically different one; this last, then, as it tends in its turn towards the monism of an "ultimately determining instance," destined to be put in its place by the disclosure of a determinant realm hitherto ignored (for surprise is a constitutive feature of the operation of demystification; the new factor must virtually by definition be something that had somehow not occurred to us). Thus, in a striking essay, Peter Wollen undertakes to rebuke and complexify the nascent doxa of a materialist history based on the camera and perspectival technology by introducing the very different technology of film stock and *its* specific history, something which now serves as the brutal recall of a new kind of *outside* (one neglected, forgotten, not taken into account, repressed) to that earlier materialist historiography (which had its origins in the psychoanalytic theory of subject-positions). Wollen ingeniously seeks to secure the "heterogeneity" of his own new position by setting up a triadic system, or an interplay of three distinct sets of technological series: "recording, processing, and projecting or exhibiting."[39] But even the multiple combinations of this triad are in principle predictable; while the whole point of a commitment to heterogeneity is the consent, by definition and in advance, to the emergence of new factors not encompassed by thought ahead of time. The process of materialist demystification, or the overthrow of thought by "heterogeneity," is therefore also a properly infinite or interminable one, but now something like a horizontal infinity as opposed to the vertical infinity of the historical series: rather, a contamination by adjacent planes or fields. For "materialism" need not only be a matter of various material machineries: in Marx and later on in Gramsci and Sartre it is also a materialism of social praxis and of institutions, the last now intervening to de-idealize a *mechanical* materialism and to introduce a whole new range of "factors" that include the studio system, production decisions, marketing, the organization of the concern or business or trust, thereby ejecting us from the narrower technology of the wide screen or of film stock into the social history of invention, bureaucracy, the monopolization of outlets and theaters ... in patient anticipation of a fresh reversal which will "materialistically" seek to reground all those factors in their turn in the mechanics of capitalism and *its* technologies. These avatars of the original—punctual—technological explanation expand

to the point at which they once again intersect with the plane of interpretation proper (the formerly intrinsic reading of the text, and commitment to the history of aesthetic form): for much the same dialectic can be observed at work within "intrinsic" criticism. They will therefore not offer reassuring solutions to what we have called the mind-body problem of the cultural text; yet one can at least identify two general programs for the inevitable attempt to reconnect the technological and the interpretive dimensions of the work whose geological separation we have here observed.

One such general direction can be described as the internalization or the re-internalization of the whole dialectic of technological analysis outlined above. This is the "solution" most dramatically projected by Adorno in his *Aesthetic Theory*, where technology and what he (consonant with his privileged illustrations, which are taken from music) most often calls technique are now powerfully drawn back *inside* the work of art itself, or the aesthetic *monad*, there to become its deepest content.[40] Characteristically, then, on this view, it is then very precisely the "idealism" of the various meanings and interpretations which becomes somehow external or extrinsic, and even a new kind of "factor" in its own right (in the sense in which one evokes the historicity of the former "content" of the work—its types of affect, conceptuality, ideology, message, and the like). A weaker version of this strategy is then to be found in a whole range of contemporary interpretive practice which posits the auto-referentiality of the work's detail, so that its former content on inspection proves to be the way in which the work itself comments on its newfound camera mobility, or speaks of its wide screen by way of new forms of landscape (a contemporary variant on the Russian Formalist doctrine of the "motivation of the device," of which my Boorman example above was something of a parody).

A second, or inverse, move, however, tends to dissolve the former work into history and periodization itself, to the point at which its aesthetic features begin to coincide with the descriptions of the objects of other forms of historiography (including the technological ones). From this vantage point, the two kinds of phenomena—the work's "meaning" and the new technology—gradually come to be grasped as two distinct symptoms of the same historical moment, now reconceptualized in an exceedingly "complex and overdetermined" way. This is of course what is here being proposed by the hypothesis that the "end" of genre and of Hollywood, the emergence of new kinds of films both modern and postmodern, is somehow at one with all the new sixties technologies—television and the other media fully as much as

182 / The Existence of Italy

wide screen—in the unity of a single historical process, whose parts condition each other reciprocally, but also "reflect" each other in curious and aleatory parallel spirals.

But this second conclusion must be earned, as a final "moment," by a systematic working through of all the earlier positions and interventions just outlined, and is not available as a static model somehow given in advance. Hegel is at least good for something here, in the way in which he systematically warns against trying to conflate these methodological moments or imagining that the dilemmas and antinomies of any one of them can be "solved" (even from the standpoint of the last moment in the process). This insistence of the irreducibility of methodological stages has often strangely been thought of as Hegel's "master narrative" (it can certainly be reified, via shorthand, into such a narrative), when it in fact commits us, with a desperate lack of perspective, to the local work at hand.

VI

The end of genre, however, is also something like a "legitimation crisis" in the Hollywood aesthetic: a crisis which, as Pierre Bourdieu has taught us[41] is one of the self-justification of aesthetic activity and consumption, of the latter's rationalization, fully as much as a breakdown in practice. For Bourdieu, the exercise of the aesthetic is indeed always a matter of class privilege and of the compensation for social contradictions, so that, as a matter of Sartrean bad faith and class guilt, it always requires some supplementary theoretical alibi: the various aesthetic doctrines then emerge to justify the unjustifiable, and to offer plausible reasons for cultural activities whose deeper socially symbolic meaning lies elsewhere, in areas about which one does not care to think ("distinction"—the various cultural practices which signify class "cultivation"—is a specifically French mode of mobilizing culture for class purposes to which Bourdieu has devoted a number of his works). This view implies, of course, that the new aesthetic of an emergent modernism (such as *auteur* theory in film, as we shall see in a moment), is no less spurious than those of the older realisms; yet the possibility of such new forms of aesthetic rationalization of self-justification is of course a historical one, and demands a return to modifications in the situation itself. The waning of the realistic moment, therefore, constitutes a historical crisis in which the consumption of genre films becomes increasingly a matter of guilt, and in which some new legitimation must be sought for movie-going, a legitimation which will be constructed from out of the arsenal of

the now traditional ways in which high modernism in the other arts dealt with analogous situations in an older cultural past.

Yet at this point the chronological gap between the historical emergence of the first late 19th-century modernisms and this belated sound-filmic one in the late 1950s obliges us to complicate our schema, since from a global perspective the filmic "realisms" against which the moment of *auteur* modernism emerges were themselves, in a different sense, part of a worldwide *modern* style proper. To grasp this, we have to reposition the emergence of a bourgeois or domestic Hollywood sound-realism (and the loss of the great silent forms) within a context in which other national developments reveal their family likeness with it: most notably, socialist realism in the Soviet Union, and so-called "fascist" art in Central Europe—both of which, of course, mark a return to "representation" with a vengeance, but have most frequently been grasped as breaks or brutal ruptures in a more generally international style, and as the effect of arbitrary forms of state intervention, rather than as being themselves effects and manifestations of some more properly global stylistic transition or mutation.[42]

Even in anecdotal terms, for instance, Irving Thalberg's relationship to Stroheim offers interesting parallels with Boris Shumyatsky's vendetta against Eisenstein, while the repudiation of the latter's "intellectual cinema" might just as plausibly be grasped as part of a worldwide reaction against silent-filmic modernism and a return to "entertainment" in the form of the theatrical. If this historical narrative is more complicated than that, it is because the stylistic dominant of this new sound "realism" incorporates features of the modern which have been "popularized" (or "degraded," as the Frankfurt School might put it), and which now, in the form of the concept and the ideology of the *streamlined*, may be said to constitute something like the secret modernism or subordinated formalism of a whole new global "realism," whose stylization now also emits the period connotation of the "new machine" as well (ocean liners, limousines, wing spans against the sky).[43] The now conventional term for this particular period style—*art deco*—may therefore be generalized across the whole international spectrum of representationality in the 1930s, particularly when we grasp the way in which this vision of the new machine is peculiarly mediatory, and available to Left, or populist or progressive, appropriations, fully as much as to Right aristocratic messages about private and public elegance. Eva Weber[44] has indeed shown very strikingly how WPA art and the left-documentary photographs of Lewis Hine are fully as much manifestations of a general *art deco* spirit as the decorative furniture and fashions that more immediately spring to mind.

It is indeed no accident that a certain technology (embodied in the visible machine as it radiates speed and energy through its forms at rest) stands as the common ideological and stylistic denominator of Hollywood and Soviet socialist realism alike, when these are read together as moments of some vaster global *art deco* transition. For Stalinism, no less than Nazism, is itself a function of the emergence of the whole range of new technologies that mark the second stage of capitalism (electricity, the combustion engine, the tungsten filament, and the vacuum tube): but it is deployed within the lag between those technologies and the new social fact of mass "democratization" (literacy, information, the emergence of a new post-feudal public that needs to be taken into account as a political reality). The most persuasive accounts of the Stalinist turn in the Bolshevik Revolution,[45] insist on the twofold lag between a small party of revolutionary intellectuals and the requirements of an enormous range of managerial and bureaucratic functions, on the one hand, and that between a small industrial working class and the overwhelming demographics of an older peasantry on the other. Historically unique new forms of personal power and arbitrariness then emerge at once in the space between the new technological capacities and the underdevelopment of an as yet very incompletely "bourgeoisified" public (or public-*sphere*, to mark the difference between this analysis and the conventional and purely "political" terms of the presence or absence of a Western paraliamentary system). But this situation is by no means unique to the vicissitudes of the Soviet Revolution: it also characterized Hitlerian fascism, which has most recently been described as Germany's "bourgeois revolution" in which Hitler finally destroyed the German *ancien régime* and at the same time was the agent of "modernization" in both its technological and communicational senses.[46] Now that the neoclassical monumentality of Nazi art (and that of Italian fascism) is in the process of being assimilated, by way of pastiche, to contemporary postmodernism, it should no longer be so difficult to grasp its stylistic affinities with *art deco* generally, including the latter's North American variants.

For such developments also characterize the United States of the 1930s, where Hollywood and WPA art are only two features of a vaster period development that also significantly includes figures like Walt Disney or Robert Moses—both of whom embody unique one-time economic and political possibilities conjoined with stylistic invention and an influence that ranged across all of the then nascent "leisure culture" of the period. That Moses in particular was personally as ruthless as Stalin and as omnipotent (within the rather different constraints and limits of North American legality) will be driven home

to any reader of Robert Caro's extraordinary biography of him.[47] Yet it is only when we consider him primarily as a cultural producer and innovator that the global specificity of the *art deco* moment again reemerges—that conjuncture of new technological institutions which endow a few individuals with a momentary and historically unique type of personal power, at the same time that they generate a new cultural language that can variously be described either as democratic and representational, or as degraded and manipulative, in very much the dialectic of realism and ideology that has been proposed above. Yet the stress on the historical situation from which this *art deco* representationality emerged and to which it was a reaction should also make it easier to understand how "realism" in this sense is a historical phenomenon, rather than an eternal formal possibility, and has it in it to come to an end, as well as to emerge.

VII

The preceding discussion did not touch on the most remarkable (if not the most influential) theory of filmic realism, namely that associated with the name of André Bazin, or Kracauer's related conception of the filmic "redemption of physical reality."[48] Kracauer's splendidly corrective term stages a fundamental distance between this conception and any stereotype involving the passive "reflection" of reality, while at the same time introducing a religious—or better still, ontological—resonance which demands explanation. (Bazin's ideological positioning was also "religious" in the most general sense, since he emerged from the *Esprit* movement and the very active left Catholicism of the immediate postwar period.)

It is however clear that neither of these conceptions of "realism" involves narrative as such in any constitutive way; or rather, that for both, narrative temporality as such is reduced to the situation and the pretext in which truth appears not as knowledge but as Event. Kracauer's stress on "physical reality" can only misleadingly be assimilated to materialism; but it is at least as non- or anti-idealist as the various Christian conceptions of carnality or incarnation (such as Auerbach's notion of the "creaturely"—the constitutive limits of the body and of finitude).[49]

This realism is therefore not exactly a "naturalism" either: even though the second climax—the second achievement of linguistic reality, after the moment of Dante—in Auerbach's *Mimesis* significantly coincides with the work of Zola; and even though a certain ideology of naturalism in filmmaking—a naturalism assimilated, in Jean Renoir for example, to a kind of populism and vitalism—seems particu-

larly propitious for the deployment of the reality-effects sought for and prized by these film theorists. Whence the aptness of the word "ontological" as a way of cutting across the opposition between materialism and idealism, and of stressing—particularly in Heidegger— the radical distinction between the merely physical (the ontic), and that moment or Event in which the physical world momentarily and fitfully coincides with Being itself: the deep shot, grainy with the plaster of the retaining walls and the stones of the courtyard, streaked (as so often in such filmic moments) by rain, revealing the French countryside, not merely in Being, but in historical time as well, as a specific moment of the social past "incarnated" in the matter of things and dwellings; and of landscape as well: the peculiar poignant historicity of that river water which for Deleuze makes the very element of the French school in cinema,[50] and of the willow, or of the empty roadways flanked by elms, indeed of empty fields not merely somehow "French"—because shot by Renoir—but French of a certain epoch, now long since vanished, and even, as in La Règle du jeu (1939), French of a certain social class.

What is this to say but that the Bazinian conception of filmic realism (along with that of Kracauer) projects an ideal of film whose secret truth is no longer film, but rather photography itself, and black-and-white photography at that, as we shall see in a moment. But this photographic impulse or libido, so to speak, must be very carefully distinguished from the tableau-formations or visual signifiers of filmic modernism (although there are historical and structural relationships between the two) and even more sharply differentiated from the glossy images of postmodern film.

If film is better equipped (under certain circumstances) to register the truth of photography than is photography itself, this can only be accounted for in terms of the supreme category of the Event that has already been touched on. Meanwhile, the temptation of Heideggerian language in this context can be explained by its unique combination of the ontological impulse with the categories of happening in time: Being is in Heidegger neither a thing nor a dimension of things, nor is it an idea or concept, but rather an Event, which it would be better to call "the deconcealment of Being." Photography as such—and even documentary film, which one might have expected to be central to these theories of realism, but whose claims are paradoxically resisted in the name of fiction film—both offer occasions for reification and, one would like to say, for ontic misreading, insofar as they are preeminently susceptible to reappropriation by an aesthetic of inert reflection, and tend to omit (or to allow us to ignore or to forget) the dual structure of eventfulness constitutive of such photographic realism—

the event on the side of the subject as well as that on the side of the object, the happening of the act of registration as well as the instant of history uniquely "registered" upon the bodies of the photographic "subjects."

Contemporary documentary film, to be sure (I'm even tempted to call it *postmodern* documentary or material documentary), includes and foregrounds this dual presence of the event far more self-consciously than the classics of the genre seem to have done (or at least seem to *us* to have done). What is both postmodern and "materialist" about the newer documentaries—and what makes them truer, but very distantly related and unexpected heirs to a Bazinian ideal which, after the end of black-and-white film, becomes something of a historical curiosity—is their participation in that general repudiation of, and even loathing and revulsion for, the fictive as such which seems to characterize our own time: some new and intensified form of cultural guilt, perhaps, but even more surely the new logic of material signifiers which comes to characterize the moment called postmodernism. Paradoxically the concept of the "fictive" is itself a theoretical casualty of this situation, along with the now false problems it traditionally posed for aesthetic theory: the "fictive" (along with its conceptual partner "literary language") can no longer serve to demarcate the autonomy of culture in the conditions of image or spectacle society and in a conceptual atmosphere where the notions of "text," "discourse," or better still, "narrative," already themselves obliterate this classical distinction. The non-fictive—whether it be the "non-fiction novel" of a few years ago in the U.S., or the *testimonio* everywhere in Third World literature today—no longer falls out of culture; while the "imperfect cinema" of Godard's handheld camera certainly captures the "real" Champs Elysées of a given year and date,[51] whatever the ostensible fiction this "location" stages.

In what can therefore be considered one of the paradigmatic "ends" of high modernism, Thomas Mann's Devil, in *Doctor Faustus*, had already prophetically warned of this particular "end of art" in guilt and delegitimation:

The work of art, time, and aesthetic appearance [*Schein*] are one, and now fall prey to the critical impulse. The latter no longer tolerates aesthetic play or appearance, fiction, the self-glorifications of a form which censures passions and human suffering, transforms them into so many roles, translates them into images. Only the non-fictive remains valid today, only what is neither played nor played out [*der nicht verspielte*], only the undistorted and unembellished expression of pain in its moment of experience.[52]

Adorno's related formulation—how there could be poetry after Ausch-witz?—is misleading to the degree to which it assigns the failure of culture to a single specialized nightmare of the instrumental rather than to logic and possibilities of late capitalism itself as a whole, which unexpectedly realizes Hegel's "end of art" by turning the former images into the very realities of business itself.

Nor is this revulsion with culture only to be found in non-literary and non-fictive forms: in Borges himself—in any case one of the canonical predecessors of the postmodern and a writer whose alternative culture was resolutely anti-modernist and bricolated from non-canonical and residual works like those of Chesterton or R. L. Stevenson—what might have been called auto-referential in modernist works also takes what can only be called a materialist turn: not the Book-of-the-World, but the missing volume, the library, the manuscript or the copy, the textual variant—all inscribe within this particular fantastic a material book, the stray volume of an imaginary encyclopedia, which may not be "real" (nor is it "this one" we are reading, as in many modernisms), but which marks the text with the longing and the nostalgia for the physical thing.

What better characterized the possibilities of the contemporary documentary film (or video) today is the presence of the production process in a form to which literature and the other arts can scarcely approximate, although the theories of those arts were already fascinated by the concept of production itself as early as the 1960s. Indeed, if commodity fetishism can in one way be usefully characterized as "the effacement of the traces of production from the object," then aesthetic dereification will naturally enough be identified as the will to deconceal those traces: yet the book or the painting remains produced, no matter how insistently it tries to unravel itself; and even the films of Godard in hindsight seem susceptible to a kind of retroactive canonization-reification in which ostentatious marks of improvisation or editing interventions are frozen over after the fact (and by the sheer familiarity of numerous rescreenings) into the timeless features of the "masterwork."

But process and production take on a rather different meaning when the very object of the documentary is itself in perpetual change and when, as in some unexpected new form of the Heisenberg principle, the very operation of recording and representing it intervenes to change the outcome before our very eyes. So it was that an enterprising West German production team sought (in a film called *Torre Bella*, after the name of the latifundia in question)[53] to seize the Portuguese revolution of 1974 *sur le vif*: arriving in time to witness the first tentative moment of agrarian self-determination in which the peas-

ants piously continue to stand guard over the mansion from which their lords have fled, tilling the fields in the old way, in stewardship, against the day on which reckoning will be demanded. The great house, meanwhile, scrupulously cleaned and respected, is filled with the trophies and mementos of a virtually *ancien-régime* aristocracy of pre-World-War-I style: photos of hunts in Poland, souvenirs of English manors and French estates, and the armorial and genealogical inter-marriages of a still pan-European dynastic culture. We are therefore also able to witness the moment in which the bewildered peasants—whose lords have unaccountably still not returned—consult the revolutionary military councils these last fled from in the first place, only to receive the even more bewildering doctrine of a "higher law" of the people and of production, and the advice to seize the lands and work them for themselves.

At this point, we are told, the crew began to follow the revolutionary process with a vengeance, screening the rushes once a week so that the peasants could themselves observe their own praxis and comment on it, as well as on its representation. What happened was that, with such exposure, the "peasants" now became recognizable individuals, whom the camera began to follow selectively lingering on the more dramatic or the more photogenic, and also on the more articulate—now thereby lifted up formally to the status of "spokespeople" and ideologues. The peasants' self-consciousness of this process took, how-ever, an unexpected turn; and the filming itself becomes an exemplary fable at the point in which the participant-viewers became aware that their documentary had already acquired a "star" (and their revolution its "ideologue" and "leader") in the person of a young and handsome city lumpen, distantly related to one of the families on the estate, who, returning to the land during the upheaval, imperceptibly came to exercise authority by virtue of the camera alone. His subsequent ex-pulsion, which marks a significant new moment in collective praxis and self-consciousness, would also have been a more interesting story than anything the final version of the film actually told: but a story that now transforms an objective documentary into a dialectical one and a whole new conception of documentary form.

Something like that new form was in fact realized, against an un-imaginably broader time scale, in a recent Brazilian documentary—*Cabra Marcado para morrer* (*Twenty Years Later*).[54] Genre is here ex-ploded by the sheer accident that scars this film and writes it into history with all the unrepeatability and irrevocable contingency of human biological life. Neither the optionality of literary (or psychoan-alytic) memory, nor the mute evidence of the photographic past, can match the resources of these images, which began as a movie version

of the life of the agrarian organizer Joao Pedro Teixeira, who was assassinated in 1962. The organizer's wife played herself in the film, whose camera and storytelling techniques fully as much as the hair styles and automobiles have all of the flavor of a period piece, intimately related to the Hollywood of the forties and early fifties. It is worth pausing a moment on this particular "authenticity," since it is a matter which will return very centrally in our discussion of nostalgia film, whose mise en scène also demands the most lovingly authentic reconstruction. Here, however, it is what is most "fictive" and authentically Hollywood which is authentic in a different sense: the representation is itself as historical and as "dated" as a photograph, no matter what its objects, betraying its pastness by the very style of representation along with the state of its technology and the quality of its film stock.

In that sense, of course, any old movie can be said to be historical, and even documentary to the degree to which it is itself a "document"; but this one was never finished. For shortly after the beginning of production, there took place in Brazil the military coup which brought Goulart's left-populist government to a violent end and ushered in a long dictatorship that ended only yesterday—which was precisely the moment, indeed, in which the production of this unusual "film" resumed. For all of the participants in the earlier project having dispersed, in danger for their lives—the "leftist" film crew fully as much as the family of the dead leader and his co-workers—what the camera now reveals, in the process of rediscovering the participants one by one, is that the widow went into hiding under a false name, while her children were scattered and brought up in other provinces with relatives, most of them unaware of each other's existence let alone that of the mother, long assumed to be dead. The physical ravages of these people—like all the powdered hair and aging facial makeup of the once familiar characters in Proust's last volume—are, one wants to say, the least operative sign of historicity, which is not in that more limited sense a question of the body or of matter itself, than rather of the Event, something marked by the active intervention of the film-production-process in its object, which it alters historically. Materialism—or the material signifier—is in such films therefore not a function of some historical "truth," which might be set in opposition to the fictive; nor even of an event whose representation we passively contemplate; but lies rather in the way in which the production process becomes an event in its own right and comes to include our own reception of it. The peculiar present tense of such an Event seems to transcend the traditional philosophical (or phenomenological) issues of the relationship of our present to a former present in the past.

Modernism also aspired to some perpetual present, but it was the present of the New and of innovation[55]; this one of neo-documentary, however, seems to spring from the conjoining of praxis or production with those mysteries of photographic "presence" which we will return to in a moment. Something of this falling away of representational distance of this reinvention of an act (rather than its "reproduction"), can also be sensed in our relationship to the great *mots* and historical utterances of the classical memoirs: Barthes liked to refer, for example, to the words "When I *was* king," spoken by Louis XIV on his deathbed. In these too, a kind of verbal praxis, still fresh with immediacy, awaits and demands a kind of reenactment, just as it has been said, of the sentences of Pirandello's plays, that he was able to write the voice and the intonation into them syntactically, like a hidden score the actor must rediscover.

VIII

Still photography remains, however, the archetypal embodiment of this process and of its paradoxes: in it even "fiction photography" (19th-century *mise en scène* and costumed poses) ultimately becomes "realistic," insofar as it remains a historical fact that 19th-century bourgeois people did put on costumes to pose for such tableaux. On the other hand, one is also tempted to say that in another sense there is no photographic *realism* as such—all photography is already "modernist" insofar as it necessarily draws attention (by way of framing and composition) to the act by which its contents are "endowed with form," as we used to say in the modernist period. "Realism," on this view, would simply consist in the space of the family photograph and the "likeness" of some sheerly personal association and recognition[56]; while the emergence of formal autonomy in the non-family-album image explains the paradoxes we have found ourselves involved in an earlier section, such as the assertion that Lewis Hines's social-realistic photographs of the 1930s are also to be seen as examples of *art deco*, that is to say, of a kind of popularized modernism.

The event registered by the camera includes history in the form of death (or the passage of time): photography is thus already a philosophically "existentialist" medium, in which history is subject to a confusion with finitude and with individual biological time; and whose costume dramas and historical records are therefore always close to the borderline between historicity and nostalgia. As for the event of the camera's registration, however, it leaves its traces not merely in the formal and compositional properties mentioned above (where it is not the content of any particular form which counts, so

much as the admirable violence of the momentary achievement of that particular set of formal relationships in the first place)—but also and above all in the black-and-white process as such, so unmistakably a *translation* of light into a specific language: that "unbroken sequence of infinitely subtle gradations from black to white" which Edward Weston celebrated.[57] Color stock is clearly no less a translation, no less a registering and an inscription in another medium: but it does not tend to foreground itself as a representational system, or to draw attention to its distance from "reality" the way the black-and-white system does. We forget the differences between the various color systems when we are within any one of them; and lose ourselves in the multiple oppositions between the individual colors, something that saps our attention from the strangeness of representationality itself, an attention retained by the black-and-white glossy print as an object in the world, both *like* this last and distinct and stylized from it. Color thus spells the end of filmic and photographic realism *and* modernism alike, as we shall see below.

Why for both Bazin and Kracauer this essential ontological truth of the still photograph demanded fulfillment, but not in that medium (and most often in fiction film), strikes one as being very closely related to the problems of temporality, reification, and the "existential" as they menace the photographic print as such, which the movement of film dissolves back into an irrevocable passage of time. No consumable image—of the type of the still photograph—survives this process as an object: and the great moments of some Bazinian "epiphany" are not salvageable as simple "freeze-frames" reproduced from the negative.[58] They cannot, in other words, be *translated* back into photography, but constitutively presuppose the inevitability of time and change and loss as the price they must pay to become events rather than things. In such moments perception can only persist as the promise of memory, and then as memory itself: in film, therefore, the realities of the "existential"—time and death, the very death of the image in question—are drawn back into the formal process, so that they do not have to be added in as content and as message, in that slippage from history to finitude (from the political to the existential-metaphysical) which we have observed at work in the interpretation of still photography. The very movement of film, therefore, makes the existential component of still photography concrete and experiential, thus liberating the contents of the image itself for a more historical and social intuition of Being. Renoir's characters and Stroheim's—or Renoir's and Stroheim's *actors*—are not the long deceased human beings of the photography albums of the same period: they are active components of a set of social relations which may have vanished, but

which comes before us with the lively energy of radical difference, rather than with the melancholy of mortality. The deconcealment of Being in the filmic image is therefore historical rather than existential.

But it is equally important to differentiate the pain and the stasis of these passing moments of the "redemption" of visible reality in film from what has often been theorized as non-narrative or lyric, which also suspends the storytelling attention in which it is sometimes embedded to deflect perception in some other vertical or suspended direction. The aesthetics of Bazin or of Kracauer are indeed as hostile to the purely lyric as such, as they are to documentary (or at least to the claim of documentary to the status of the dominant form within this conception of realism): twin specifications or limitations which suggest that this particular, seemingly static, transfiguration of photography within "realist" film entertains more complicated relations with the value and the structure of narrative than we have yet allowed for.

If we are so often tempted to describe these moments of the deconcealment of Being in terms of place or landscape, the temptation can now be explained by the additional proviso that such places or landscapes are now reorganized around the category of the scene as such.[59] Benjamin has indeed famously remarked, of Atget's "photographs of deserted Paris streets," that "he photographed them like scenes of crime. The scene of a crime, too, is deserted; it is photographed for the purpose of establishing evidence. With Atget, photographs become standard evidence for historical occurrences, and acquire a hidden political significance."[60] But one is tempted to wonder whether in that sense everything that comes before us as a scene is not, in some way, the deserted "scene of a crime," where the scandal and the violence, the punctuality and irrevocability of "crime" is simply shorthand for the unexpected emergence of the Event as such. The category of the "scene," of space organized scenically, is the correlative of the category of the Event: the former causes the latter to emerge in expectation or in memory, just as the latter powerfully reorganizes the inertia of space into a place of ritual and a kind of momentarily deserted center. It is this new form, the radically ephemeral appearance of the scene as such within a different type of space, that Heidegger calls the "clearing" (or *Lichtung*) of Being. What causes it to come into visibility, however, can only be narrative itself, which, a little more than the mere *pretext* for such "lyric" moments (although it is easy to see why we tend to think in those terms), sharpens our attention to events and cause us to read spatial settings in ways that predispose us for this momentary vision.

The theories of Bazin and of Kracauer—which one normally thinks

of either as a normative aesthetics or as a set of expressions of taste and of opinions on this or that film (in either case unacceptable to-day)—can, from this Heideggerian perspective, be rewritten as programs for the structural analysis of certain types of film, most notably those *auteurs*—Renoir, Welles, Rossellini—which were central for both. But it was inevitable that a self-conscious film should itself finally take as its content this whole process, and stage the emergence of the ontological scene as its overt theme and subject-matter. Such a film does not thereby inaugurate a richer and more intense development of the "realist" mode, but stands in effect as its codification and what definitively marks the end of the particular historical opening and possibility, of which we have also observed that it is incompatible with the color process.

Blow-Up (1966) is indeed also, although in color, Antonioni's own meditation on the black-and-white process so recently abandoned by him; finally, by fulfilling the realist ontology—that is, by revealing Bazinian realism openly as ontology (and as metaphysics)—it can be seen as the inauguration of all those non-ontological impulses which will take its place and which we loosely term postmodern, something usefully dramatized by the appearance of two interesting postmodern pastiches or sequels to this work: Coppola's *The Conversation* (1974) and De Palma's even more explicit *Blow Out* (1981) in both of which the ontological medium of sight is strategically replaced by the "textuality" of sound.

What *Blow-Up* offers us is a chance to interrogate directly the conditions of possibility of the experience of the Heideggerian "clearing" which it causes to rise up from the vacant grassy expanse of Maryon Park as from the very ground of Being itself. Such preconditions are of varied kinds, sexual as well as social, cultural as well as formal. The transfer of Antonioni's thematics from Italy to an England in the first flush of the Beatles and Carnaby St. counterculture determines, for example, a kind of muting or even transformation of the earlier thematics of alienation, which Antonioni had previously dramatized in the twin but incommensurable materials of sexual impotence and spatial abstraction (the E.U.R. district of Rome, in *Eclipse* [1962]).[61] The spatial dimension of the earlier films persists here, but in the weakened form of the theme of the destruction of an older London (the antique shop sequence): it is however clearly this persistence of spatial attention and interrogation that opens up the very different perception of the park itself. As for the interpersonal thematics, the David Hemmings character is obviously a very different kind of personality than any of the earlier heroes: nonetheless, certain crucial analogies remain, in particular the unfulfilled promise of a "relation-

ship" with the mystery woman (Vanessa Redgrave), about whom it therefore seems crucial to assert that the hero does *not* make love to her. It is in the context of the overt misogyny of the protagonist—his exasperation with and loathing for the models with whom he works—and also the odd detail of his homophobia (the "poofs" who are invading the quarter with their poodles are doubled—almost at the moment of the "vision" itself—by another strange vision of a matronly woman in man's uniform, stepping across a tiny bit of metal *fence*—see below—as she spears stray papers and detritus at the entrance to the fateful park)—these gender anxieties and confusions stage the very different kind of interest he shows the Redgrave figure, who is in any case only interested in using him for her own purposes. The matter of sex is important, because the physical encounter with the two girls punctuates the development and "blowing up" of the images. Before that episode, the protagonist thinks he has prevented a murder; after satiety, the well-known link between sex and death causes him to look more closely, and to discover the traces of the corpse. Of the various obvious "flaws" in this still very fresh and vital film (one sees why Antonioni thought he needed the mimes and made-up demonstrators, but that part doesn't wear well), the principal formal doubt, of a more metaphysical nature, if I may put it that way, ataches to this corpse: should it really have been seen? Should the existence of the *referent* finally have been documented in this "realistic" or representational way? The corpse is however waxen, and far and away the most unreal object shown in the film—a dead body already on its way to image- or simulacrum-status: the thought, indeed, crosses one's mind that its features are exceptionally Italianate for this "English" film, and not without some distant fleeting resemblance to Antonioni's own. . . .

The "clearing" is in any case here very specifically the "scene of a crime": and it is through this empty attention or "set" toward that "event" and its specific information traces that the other experience of the "ground" is able to pass. There is a crucial structure of laterality at work here (demonstrable elsewhere in contemporary literature), by which perception or experience requires a kind of partial distraction, a lateral engagement or secondary, peripheral focus, in order to come into being in the first place.[62] The empty common is therefore not an image in any of the full or even postmodern senses of the word (although arguably it becomes one when, in the playing field at the end of the film, Heidegger is rewritten as Schiller and the question of Being attenuated into the more ethical one of Play). Indeed, in these supreme moments the screen defeats the Gestalt structure of normal perception, since it offers a ground without a figure, forcing the eye to scan this grassy surface aimlessly yet purposefully in a spatial

exploration that is transformed into time itself: there is nothing to be seen, and yet we are, for one long lost instant, looking at it, or at least trying to.

But even this strange form of vision has formal and historical preconditions; it demands, for example, a certain physical framing, not unrelated to the mind-set of the protagonist, who unites in his work social realism—the flophouse pictures for his book—and the fashion-model photography by which he makes his living. In the park he finds "something" that escapes both these stylistic categories; but its constitutive elements have already been prepared in Antonioni's earlier work, most notably *Eclipse*, whose notorious ten-minute closing sequence may be read as an inversion of the spatial experience of *Blow-Up*. In the earlier film, the empty street corner (in the E.U.R. district) waited in vain for the lovers throughout the long hours of late afternoon and first dark; the camera idly but anxiously scanning the length of the avenues and finding only (to us) anonymous pedestrians, people waiting for buses, uneventful routine events (most wondrously, the horse and horse cart out for their evening—we have already seen their morning—canter). The crossing is marked with the conventional (but very large) white zebra lines ("I'll kiss you when we come to the end of it"), and on the far side, the remnants of some *locus amoenus* within the alienated landscape of Mussolini's modernism: a sacred pool (but it is nothing but a rainbarrel in which a piece of paper idly dropped by one of the lovers still insistently floats), a sacred wood—but it is nothing but masses of foliage in the wind—and, finally, a white picket fence. Yet the masses of foliage are a word, a signifier: Antonioni inserts them earlier in the film in a gratuitous visual observation that only this return now motivates. But the fascination with leaves and their relationship to motion seems to have marked photography (and film) from their beginnings—"leaves [that] ripple and glitter in the rays of the sun" (Cook and Bonelli, 1860); the Lumière brothers' first highly praised shorts of "the ripple of leaves stirred by the wind"; D. W. Griffith's 1947 denunciation of the degradation of Hollywood, its loss of interest in "the beauty of moving wind in the trees."[63] Philosophically, when the crucial issue of movement appears within the ontological meditations of Sartre's *Nausea* it is in the form of wind moving in the leaves and moving them. The massy foliage of *Eclipse* is nothing but an episode: in *Blow-Up*, however, the great trees of Maryon Park are shaken with wind as though by a kind of permanent violence, day or night never at rest; it is as though in this place above the city the god of wind reigned in perpetuity. So crucial is this sound that in the most remarkable moment of the film, as David Hemmings grimly contemplates his ultimate motionless

blow-up, the wind returns in the soundtrack as though to certify its authenticity.

But the picket fence is no less essential; and the standardized wooden slats of *Eclipse* here return in a unique and hand-hewn form. This fence, which now encloses the grassy expanse, the empty scene, becomes a formal object in its own right, according to which we measure the muting of the "reality" of filmic color into the (bluish) photographic medium of black-and-white. It is as though, using the language of Gestalt psychology, the figures—the foliage and fence— had been drawn back into the frame, thereby assimilated to a kind of "ground," which opens the possibility for the ground itself to become a kind of figure. But it is also suggestive to articulate this process in terms of Roland Barthes's rather different opposition between the *studium* of the photograph (its official topic or subject matter) and its *punctum*—or in other words that scandalous and contingent (scandalously contingent) detail that arrests the attention and nails the image to historical time. Yet the studium is not exactly the ground, nor is the punctum necessarily the figure. Indeed, in the most Bazinian of the Barthes readings (in *Camera Lucida*), it is very precisely the ground itself which becomes a punctum—in Kertesz's picture of a blind violinist, led by a child: "what I see, through this 'eye that thinks' and that makes me add something to the photograph, is the unpaved road, whose very grain and trampled earth make me *certain* of Central Europe . . . I recognize, with my whole body, villages I passed through in trips to Hungary and Romania long ago."[64]

Antonioni's ground without a figure also wishes to be this ground which is a *punctum*: through it now pass, purified, abstracted, the neorealist impulses of his earlier films, now reified into the photographic stills that were their deeper truth, only to find these now collectable objects literally confiscated in their turn. With their disappearance, the "realist" vocation of Bazin and Kracauer, the mission of film to redeem physical reality, or rather to reinvent the photographic libido that was its lost origin and starting point, its nostalgia and its secret death wish or eros all at once, comes to an end; and something else (which is no longer modernism either) takes its place.

IX

What has been absent from these alternate accounts of realism— the experimental-oppositional, Hollywood, documentary, and photographic-ontological—is any trace of the older valorization of a realistic "work" within a dominant stylistic or narrative paradigm (as for example when *The Grapes of Wrath* [1940] is singled out from other

Hollywood films of the period as a sterling example of "social realism"). In a period intensely conscious of the mediations of the representational apparatus itself, it seems preferable to characterize such internal variants as ideological ones; and then in that case what used to be described as social realism will now be identified as "populism"[65] and analyzed as such. Meanwhile, although I don't want to give the impression that I think these four alternatives exhaust the matter, they are not random surmises either but seem to be subtended by a kind of system in their own right:

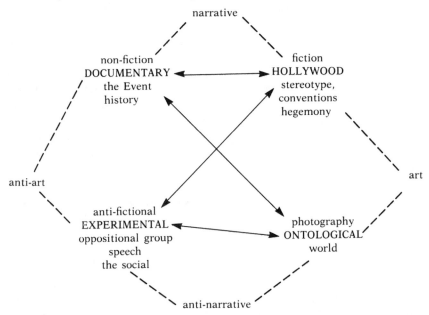

What should now be observed, as we retrace our steps to say something about filmic modernism, is that this last will in no way be homologous to realism, either by way of its structures or by way of its theoretical problems. The relationship between the two moments is a dialectical one, that is to say, it involves an utter transmutation of the structure and contents in question (always assuming one even wants to retain those terms to subsume both discussions). It will be remembered, indeed, that realism uniquely posed epistemological questions and claimed a truth status quite unique in the history of aesthetics: to say, now, that modernism is somehow more "formalistic," or no longer poses those claims or raises those questions, is clearly insufficient. Modernism, indeed, does something else, for which the discussion of realism has not prepared us at all.

It will seem appropriate to characterize the moment of modernism

as the moment of emergence of the great *auteurs*: Hitchcock, Bergman, Fellini, Kurosawa, Renoir, Welles, Wajda, Antonioni, Satyajit Ray, etc. But the formulation is intended to historicize this issue by way of a willful paradox, since this is not at all the way the term "auteur" has in fact been meant in that period of film criticism in which it was at first proposed and introduced.

Cahiers du cinéma (to speak of it like an *auteur* in its own right) proposed the *auteur* concept in order—as against what they saw as the provincial, technically boring, "literary" and sentimentalist tradition of French cinema—commercial and "art" film alike—to restore a certain conception of the more *advanced* Hollywood product and also to validate the latter's dignity as an object of critical and theoretical study. They did not, of course, as their own subsequent films amply demonstrate, mean to imitate that product in some new international professionalism, but rather to appropriate it and to allude to it, to incorporate it into new, post-Hollywood forms. The key problem in this intellectual operation was multiplicity of a two-fold kind: the multiple determinants of the studio system (reediting by management, as well as the combined work of a variety of experts in various technical fields); and also the jack-of-all-trades assignments of the best directors, who pass "effortlessly" from Westerns to Westchester comedies, from thrillers to war movies. The concept of the *auteur* is then a heuristic concept or methodological fiction, which proposes that we treat collective texts (in spite of their commercial contamination) as though they were the work of single "artist," and also that we surcharge generic difference with stylistic unity, and treat the multiple productions of a single signature as though those were so many distinct expressions of a single style, a single set of thematic preoccupations, and a single "world" (in the loose phenomenological sense in which this term passed over into a modernizing literary criticism).

This operation—a reconstitution of the object of study of a new film theory or criticism—seems perfectly proper and has been validated by any number of interesting and fruitful studies. The methodological hypothesis also seems true in some other sense: that is, John Ford's work does seem to have at least the unity of Faulkner's or Dreiser's. Yet I think it will be more interesting to suspend those truth claims, and to see the *auteur* hypothesis in a historicist way, as the projection back over a body of texts originally produced and received within a different *episteme*, of the new historical *episteme* of high modernism as it began to be theorized in this later period by literary critics who codified the practices of an earlier high literary modernism, *and also* as it began to be practiced by a new kind of high modernist filmmaker

in roughly the same period (the 1950s). The moviemakers of the thirties and forties, in other words, can come to be thought of as *auteurs* because now, "for the first time," *auteurs* really exist and operate in ways utterly unlike those of the older period. What is suggested here is a related, but as it were semi-autonomous set of historical symptoms: which, with a certain lag in Europe, and specifically in France's attempt to reflect on American movie production, produces a specific *theory* there—at largely the same time that that production is itself slowly being modified in the United States, in *practice*. The appearance of French auteur theory therefore—in *theory*—is the emergence of a method whereby the former genre films are now rewritten in terms of the new reorganization of the category of the auteur; while in "reality" the very production of genre films is giving way to a new specifically auteur type of production. But the French are not reflecting on that new production (in which they will shortly themselves as filmmakers participate); rather this whole historical transformation expresses itself in their work in the new theory, while "independently," elsewhere, in practice, it is simultaneously expressing itself in a new formal dynamic.

For one thing, the new *auteurs* validate the working hypothesis of a stylistic unity of production by actively attempting themselves to secure that unity of production in their own hands—*Citizen Kane* (1941) is here again the supreme success story, against which Welles's subsequent failures can be read alternatively as tragic or as suicidal; while Hitchcock largely enjoyed a comparable, if not absolute power,[66] and non-Hollywood *auteurs* have often been able momentarily to usurp analogous authority. The codification of the concept, then, follows the emergence of new formal realities which it projects backwards onto the past, rewriting it in order to bring out objective features (or real potentialities) of that past which could not have been visible until the new situation foregrounded just such new categories.

Such is the justification for considering that the art-film or foreign-movie period (the early 1950s to the early 1960s) is the full form or embodiment of that *auteur* category apparently developed (at the same time) to organize new views of the preceding one. Why *auteurs* in this sense are to be considered part and parcel of the practice of high modernism, and indeed, what relevance this aesthetic and periodizing category (whose key dates are at best the 1910s and 1920s) has for filmic production in the 1950s, must now be explained. (Amateurs of chronology will, however, want to register the existence of something like a literary "second Modernism" in the immediate post-World-War II period, of which the American works of Nabokov, and

early Beckett, along with abstract expressionism and residual twelve-tone musical composition, are some of the markers.)

Many of the now conventional descriptive features of modernism—such as style, plotlessness, irony, and subjectivity—can be productively rewritten or defamiliarized by rethinking them in terms of the problematic of artistic or aesthetic *autonomy*, provided this last is suitably enlarged. For one thing, it is a paradoxical feature of the concept of autonomy that it almost always turns out really to mean *semi*-autonomy (in the Althusserian sense): that is to say, the independence and self-sufficient internal coherence of the object or field in question is generally understood dialectically to be relative to some greater totality (in relation to which alone it makes sense to assert that it is autonomous in the first place). In other words, only Spinoza's "God or Nature" can be thought to be autonomous in the strict sense of this notion; what it normally designates consisting in a becoming relatively *more* independent of the organ, or the zone, or the part, or the function.

The theme and problem of aesthetic "autonomy" has been central in contemporary German debates, particularly in Adorno's aesthetic writings, and, more recently, in the work of Peter Bürger.[67] The development of mass culture here, the attention to its theorization, along with the populist spirit of the 1960s, have endowed the topic for us with an elitist taint, obscuring its importance (even for the study of mass culture) and depriving us of a useful conceptual problem and an alternative way of framing the problematic of culture. Yet the word is also a mediatory concept, whose richness derives from the coexistence within it of several related yet relatively distinct objects, which must be disentangled at the outset, even if we mean to go on to reestablish their deeper interrelationships.[68]

For everything changes, depending on whether what is meant is the autonomy of aesthetic experience, as that has traditionally been distinguished, since Kant, from practical or instrumental, "worldly" activities, or, on the other hand, from abstract thinking and knowledge; or whether the relevant topic is rather the autonomy of culture itself, within a secular and increasingly differentiated society; or finally, the autonomy of the individual work of art as some self-enclosed monadic world without boundaries.

The first two of these three possible meanings—the autonomy of aesthetic experience and the autonomy of culture—have generally tended to reinforce each other, discussions of the one passing over imperceptibly into discussions of the other at a point it is sometimes difficult to determine. It is because we leave so much existential

baggage at the door of the movie theater—not to speak of the gates of Bayreuth or the chair of the reading room (our tendency to think *spatially* about the autonomy of aesthetic experience is not its least interesting feature)—that we seem to have to go on to deal with the matter of the specialization of artistic and cultural practices, the matter of the difference between culture and the other components of our social system. (The very slippage from the topic of *art* to that of *culture* is itself another sign of this—productive—tendency to adjust an existential focus into a societal one.) Yet precisely that conception of the autonomy of the cultural sphere—which intersects suggestively with the whole problematic of the "public sphere" as it has been developed by Jürgen Habermas and after him by Negt and Kluge[69]— seems initially relevant today above all by virtue of the *eclipse* of what it meant to designate. Not the least paradox of extreme societal differentiation in late capitalism is the volatilization of those separate compartments and their unexpected diffusion throughout social space as a whole. This is the spirit, at least, in which one wishes to affirm a prodigious expansion of the cultural field itself today to include and subsume all those other zones or "levels" of the economic, the political, or the psychoanalytic, which may once, at the emergence of secular society, have been relatively independent of it and of each other. Theories of spectacle society, philosophies of the media and the informatic, diagnoses of the colonization of the Unconscious by commodity reification, consumerism and advertising, all converge tendentially on this situation, which is now also widely known as "postmodernism."[70]

The concept of the autonomy of culture, therefore, allows us to witness with greater precision its historical dissolution, and at the same time to register the paradox of a thing that disappears by becoming universal, rather than by extinction. This historicization of the concept then inevitably begins to produce its deeper, its true problem, namely that of its own historical emergence, along with the phenomenon it claims to think and to designate: the construction of some heightened space wrested from a social itself in the process of being industrialized and organized bureaucratically. What is meant by the related conception of some historically provisional "autonomy of the sign" is then that staking out and roping off of an area of henceforth "literary" language (or of the languages of painting or music) so that its perception as an object is felt to be distinct from the speech—and sounds and colors—of everyday life, at the same time that its hitherto conventional referential content is suspended and at length problematized. The very emergence of the term language in this sense—the "language" of film, say—is itself symptomatic of the way in which a

dwelling in that new autonomous aesthetic space and an attention to the material qualities and properties of its specific "language" now begin to peel the sign from off the referent and to reorganize the former into an object in its own right—that is to say, into something possessing "autonomy." What is absolutely presupposed here is the identity between this historical process and what we call high modernism itself, which will be understood, not as the designation of specific artistic movements, nor first and foremost as a matter of style, but rather as the cultural dominant of a specific mode of production (or rather, of a specific stage or moment of such a mode of production: since I argue elsewhere[71] that "modernism" characterizes the second stage of capitalism—its monopoly stage or the so-called "age of imperialism"). Among other things, such a formulation dispels the twin misconceptions about such periodization: that it implies some massive homogeneity about a given period (a "dominant," rather, governs a great many other heterogeneous tendencies), or that rigid chronological breaks are foreseen and desired (most often the new "dominant"— a former "secondary" or "subordinate" feature—is the end result of a slow process of restructuration whose novel effect is suddenly discovered after the fact and as it were genealogically).

This is why the experience of *modernist* autonomy and of its cultural sphere projects a very different historical stereotype on the mind's eye than that litter of *postmodernist* cultural artifacts which one thinks of rather like a great junk pile of videocassettes, or those older "pictures" or "representations" of reality of the *realist* moment either, which may sometimes be likened to some enormous mesmerizing enlargement of a Griffith face in close-up, all grain and pores, and tacked up on your bedroom wall. Yet this "autonomy" of high modernism is in reality, as we have warned, more strictly speaking a semiautonomy, culture herein taking on the appearance of Hegel's "inverted world,"[72] which floats above this one and reflects it upside down—a space in which the Utopian negation by art of this world and of the socially and materially existent can equally well be seen as the futile and idealistic caricature of a complacent bourgeois aesthetic resigned to its constitutive exclusion from praxis and worldly action (as well as from epistemological authority). Herbert Marcuse's great essay on "the affirmative character of culture"[73] is the classic exploration of this particular dialectic, about which we need to add that it is also the precondition for the foundation of philosophical aesthetics as such, whose German traditions reach their posthumous climax and summation in Adorno's *Aesthetic Theory*. But we also need to add what Adorno knows (at least in the form of a tragic consciousness) and what is absent from Marcuse's critical formulation here (and also from his

own late aesthetic), namely that "culture" here means the modern and that this particular problematic or dialectic is modified when the latter touches its end.

It is, however, with the modern that we still have to do here; and more specifically at this point with the relationship of these first two faces of the topic—the autonomy of aesthetic experience and that of culture—with its third avatar, namely the autonomy of the work itself. What seems to happen is that the individual work comes, in the modernist period, as it were to act out symbolically the autonomous vocation of culture as a whole; above and beyond its own specific content, to "reflect" and connote this last as well, but on the mode of shamanistic mimicry and of producing itself as the symbolic surrogate, the substitute or replacement part-object: the cultural part now offering itself as the allegory of the new historical whole of autonomous culture. The Book of the World wants to be a good deal more than one mere book among others *in* the world: this new allegorical vocation springing, as Jonathan Arac puts it, "from its synecdochic relation to the institution of autonomous culture itself."[74]

Thus, what has already been described as the anti-generic thrust of the various modernisms, their refusal to stay put in modest generic categories as commodities and products of a professional's expertise (if not a craftsman's)—their newly discovered vocation to be the Book of the World—can also be interpreted as the effort, within the dynamic of a secular and differentiated culture, with its babel of codes and fragmented or multiple publics, to reinvent a single central "sacred text," which—*Finnegans Wake*, Mallarmé's *Livre*, Bayreuth, or the Radiant City—could concretely "fulfill" the secular autonomy of culture by abolishing it and endowing it with a new scripture, whose exegesis and interpretation is at one and the same time a shared commentary on the Real itself. The formal point to be made about the various modernisms is that the failed Absolutes of the works just enumerated are reflected and projected at greater distance, and more weakly, in the transformation of what one hesitates to call the lesser moderns into *auteurs*. The phenomenological approach to modernist works, in other words, which sees the various texts of a single author or creator as so many fragments of a "world," so many emanations of a unique and specific "style," offers the crucial rewriting technique whereby collections of separate art-objects or "texts" can be converted into something resembling the supreme modernist *Livre*.

This rewriting process will naturally be accompanied by the construction of new kinds of meaning-effects: the modernist works will project metaphysical and existential, often aesthetically auto-referential resonances which would have been structurally unrealizable in

the realist period, and old-fashioned or undesirable in the postmodern one. The structure of such meaning-effects—their condition of possibility in general—is more interesting than the content of the various interpretations proposed, which range from the psychoanalytic—the reading of Hitchcock in terms of sin and guilt, sacrifice and punishment, on the strength of his Anglo-Catholic upbringing[75]—to the aesthetic-ideological—the analysis of his films as so many rigorous meditations on the very possibility of filmmaking itself and its "ethics."[76] The structure of the modernist work includes and demands the interpretive moment and offers an exegetical blank check with the one requirement that you cannot propose nothing (unless "nothingness" is your interpretation).

X

The preceding account is, however, less a theory of modernism that a prolegomenon to one: such a theory (which will not be more than sketched in here) begins with drawing the formal consequences of the situation just described, and in particular the way in which the various kinds of "autonomy" now inscribe themselves in the very structure of the individual works. What we now want to identify therefore are the traces of "autonomy" within the structural processes, something it seems best to mark with the violence of neologism, as *autonomization*—thereby also drawing a conceptual line between the historical situation and preconditions of high modernism and an analysis of its formal structures. Autonomization can now be initially observed on two levels of the modernist work in general, or, if you prefer, from two distinct standpoints, two positions unequally distant from the work as a whole. One of these distances—the longer one—discloses the process at work in the becoming autonomous of the episodes; while the more proximate one tracks it down into the very dynamic of the individual sentences themselves (or the equivalent ultimate "autonomous" unit of formal syntax).

There, however, is less often a tension or an incompatibility between these two levels than one might imagine: the programming of the reading mind to an episodic logic adjusts to the occasional exaggeration of the episodic or autonomous sentence itself, as when Nabokov writes of Humbert Humbert's refrigerator: "it roared at me viciously while I removed the ice from its heart."[77] But in the long run an allegorical price tends to be extracted for these indulgences, unless as in Mallarmé's "Un coup de dés," the autonomous sentence becomes coterminus with the entire work itself. The danger is not so much that of the sheer collection, despite the invitation of the narrator of Gide's

sotie, as an afterthought at the end of that work, to make a list of our "favorite sentences from *Paludes*": for when the sentence or the material signifier has won genuine autonomy over and against the semi-autonomies of the modernist work, then we are already in full postmodernism. Yet those semi-autonomous sentences tendentially come to provoke their own mini-interpretations, if only to document their right and their capacity to exist all by themselves in the void to begin with. What happens then is that the sentence resolves itself into the purity of a non-event: "Zwei Wochen später war Bonadea schon seit vierzehn Tagen seine Geliebte"[78]; or else, as with the modernist visual emblem in film, the part will come to replace the whole as the latter's shorthand, colophon, or signature.

There are, of course, "sentences" of all these kinds in modernist film, from Eisenstein (the swinging trays of *Potemkin* [1925]) to Hitchcock: and they are somehow, very much in Barthes's sense, *scriptible*, defying the critic to invent the appropriate verbal equivalent, for example, for the dead weight of a slack male hand attempting to accompany its handcuffed female partner with all decent passivity as the latter clumsily unsheathes a silk stocking from that strange third member, a rain-soaked woman's leg. Like Buñuel's dream sequences, such gratuitious sentences—the fateful and eponymous rope, glimpsed between apogee and perigee of a swinging kitchen door—once seemed (like metaphor for Proust and Aristotle) the hallmark of Hitchcock's "genius," as well as the pleasure for which all the rest was little more than pretext.

But these gags, whose "autonomy" is given in their very structure itself, are neither the black-and-white glimpses of Being of Bazinian realism, nor are they the glossy "images" of the postmodern. Their relationship to the larger whole—not the overall form of the work itself, but rather now the episode—is that of degree rather than of kind, since, like some of the verbal sentences already quoted, they can be seen as miniature episodizations in their own right. A somewhat different completion of this impulse, which, unlike these Hitchcok miniatures, does seem to produce a picture, can be found in what might be called the modernist emblem, as in the Dance of Death at the end of Bergman's *Seventh Seal* (1957). In movement still this last, more properly a vision than an image, it nonetheless—far from punctuating the work, or unexpectedly and gratutiously embroidering it— resumes the narrative's essentials with a flourish, as though the film had been made in order to end up as this future still or clip: something caricatured by the Last Supper of Buñuel's *Viridiana* (1962). It is certain that overfamiliarity with books of motion picture illustrations makes it difficult to tell whether such "famous moments" are gener-

ated from inside the form, or externally, by sheer force of repetition. Nonetheless, this menace of reification and of the visual (thematized *within* Hitchcock as content in the matter of voyeurism) is at one with modernism itself, whose homeopathic strategy pits reification against itself, reproducing a social process in its specialized formal languages by way of self-defense; but it is a menace that cannot be fulfilled without destroying the very structure of the modernist work. Or rather, to say it the other way round, we can decide to rewrite these books as postmodern texts by heightening the silences around their sentences (as in Flaubert); and can even attempt, more violently, to misremember modernist films by jumping from "image" or frame to the next in a properly discontinuous or heterogeneous fashion. The modernist version of the image, however, which we have called the visual emblem, on the whole reawakens all the suspicions of postmodernists intent on denouncing the "organic" work of art, since it seems to preserve a relative consonance with that larger form of which—as a kind of "sentence"—it is itself a part, namely the episode.

This (postmodern) polemic conception of the "organic work," however, is generally as misplaced as the equally conventional and related denunciations of so-called "linear history," particularly insofar as the very language of the organic explicitly designated functional differentiation, the specialization of radically different organs within a life-totality distinct from all of them, and implying something very different from any formal homogeneity. This is the sense in which *Ulysses* designates each of its chapters with the sign of a different organ of the human body; Joyce's conception of the chapter as a formal unit is, indeed, one of the supreme philosophical achievements of the modern movement, comparable (as Proust once said about Flaubert's use of the preterit tense, or *passé simple*) to Kant's invention of the Categories. Its genealogy can be constructed around the principles of the chapter in Flaubert (beginning with *L'Éducation sentimentale*, and codified in a rather bureaucratic way by Zola), and reflects the increasing gap between abstract categories of the Event or the Life and the concrete or microscopic experience of existential time (the notion of the "single day"). At any rate the Joycean chapter is virtually the archetypal emblem of the process of episodization in modernism ("A new style per chapter not required!," advised Pound in exasperation on first reading the "Sirens" section; the enormity of this misunderstanding—and from this particular reader!—remains fresh and scandalous to the present day).

There is here, however, a constitutive tension between the episode and the totality not necessarily present on the level of the sentence itself (which could, as we saw in the case of Mallarmé's poem, *become*

the totality in a way in which the episode, virtually by definition, cannot). It is this tension, or even contradiction, which probably accounts for the tenacious stereotype of the "plotlessness" of the modernist novel: as though there were any non-narrative moments in *Ulysses* (or in Virginia Woolf, for that matter)! But their narrativity is that of the episode and not of the work "as a whole," by which we probably mean the *idea* of the work, its "concept," what the single-word title of Joyce's book is supposed, for example, to convey. Autonomy—or, if you like, semi-autonomy—reemerges with a vengeance here, where the chapters run with their pretext, each setting its own rules in a certain dialectical independence, which is itself then authorized and reconfirmed by the perfunctory allusion of the chapter as a whole to some corresponding section of the *Odyssey*. In my view, this tension corresponds to the distinction, prophetically theorized by Coleridge, in his own embattled resistance to 18th-century allegory, as that between Fancy and Imagination, and also to that theorized by Deleuze, in his very different coordinates, as that between the molecular and the molar. Its analysis is necessarily central to any theory of modernism as such, since when these two poles split definitively asunder (when semi-autonomy, in other words, breaks up into autonomy *tout court*, and a sheerly random play of heterogeneities), we are in the postmodern, which can accommodate the molecular fancy of isolated difference with genuine and visceral sympathy and delight. How postmodernism might equally well be hospitable to the "molar," to the Imagination, to the "concept" of totality in a void, without content—this symmetrical operation may seem more enigmatic, until we recall, not merely those imaginary books projected by Borges which have been referred to already, but above all Stanislaw Lem's exploitation of this vein, in the form of volume upon volume of book reviews of non-existent works of all kinds,[79] in which it is clearly the idea of the work which is called into play, independent of any need for its realization. If we continue a little further in this direction, indeed, we may be tempted to see the "idea" of any work—that of *Madame Bovary*, for instance—in this light, and not much further on to come to the conclusion that literary criticism as such—itself coterminous with the modern movement—is that molar satellite wrenched from the episodic work in its moment of emergence and accompanying it at a distance as its absent, unrealizable principle or *Begriff*.

The dynamic of episodization in film has been noted by Kracauer,[80] without of course connecting it to a conception of modernism in any case alien to him, but who specifically underscores the affinity between certain genres and filmic content and the development of the

new formal principle. Hitchcock's possibilities are for example clearly dependent on the episodic spaces left open by the thriller as such, where even the false trail and the wrong scent can serve as pretexts for the virtually autonomous release and expression of psychic energies that seem to have little or nothing to do with the content. Whence, for example, the *melancholy* of terror in Hitchcock: the deserted cobblestones of an empty lane, an unpeopled backwater within the metropolis of London itself, between whose garden walls the James Stewart character anxiously stalks his only lead (an individual named Ambrose Chapel), with a physical vulnerability suggesting that he is the victim rather than the hunter (and reminiscent of the fearful shrinking of Ingrid Bergman's whole body before the camera-revolver of the conclusion to *Spellbound* [1945]—genuine filmic "sentences" these physical gestualities, whose syntax can thus be echoed or rhymed from film to film). The spaces of such melancholy are, however, in Hitchcock *historical*: *Frenzy* (1972) replicates this residual London of the second version of *The Man Who Knew Too Much* (1956) within the center city itself, in the deserted street on which the office of the protagonist's ex-wife is fatefully located (but here what is evoked to explain the absence of pedestrians is the lunch hour—an only too meaningful moment of day in this particular film!); while the American setting of *Psycho* (1960) requires a supplement of Gothic imagery and architecture—a kind of melodramatic *amplificatio*—to unwedge the equivalent of such antiquated space within the American landscape. Traditional sections of London in these films therefore mark, not historical memory, but *repetition* itself: nor is Bernard Herrmann's extraordinary music some merely external decoration of the visual content, inasmuch as it also tells us of the dread inevitability of the return of terror, of the sharp pang of *ennui* that death and horror here also hold, of the archaic inflection of the word "sad" (as T. S. Eliot charged it, in *The Waste Land*, with all the mustiness of dead violence and forgotten history). Movie music in any case, and not only in Hitchcock, acquires its own autonomy within the modernist loosening of forms, and often develops a formal power not inferior to the visual image itself.

Kracauer, indeed, astutely notes a more global relationship between melancholy and the visual, which he explains in terms of the Benjaminian *Trauerspiel* and the Benjaminian *flâneur*:

It is certainly not by accident that Newhall in his *History of Photography* mentions, on two different occasions, melancholy in connection with pictorial work in a photographic spirit. He remarks that Marville's pictures of the Paris streets and houses doomed under Napo-

leon III have the "melancholy beauty of a vanished past"; and he says
of Atget's Paris street scenes that they are impregnated with the
"melancholy that a good photograph can so powerfully evoke." Now
melancholy as an inner disposition not only makes elegiac objects
seem attractive but carries still another important implication: it
favors self-estrangement, which on its part entails identification with
all kinds of objects. The dejected individual is likely to lose himself
in the incidental configurations of his environment, absorbing them
with a disinterested intensity no longer determined by his previous
preferences. His is a kind of receptivity which resembles that of
Proust's photographer [the reference is to a passage of *The Guer-
mantes Way*] cast in the role of a stranger. Filmmakers often exploited
this intimate relationship between melancholy and the photographic
approach in an attempt to render visible such a state of mind. A
recurrent film sequence runs as follows: the melancholy character is
seen strolling about aimlessly: as he proceeds, his changing surround-
ings take shape in the form of numerous juxtaposed shots of house
facades, neon lights, stray passers-by, and the like. It is inevitable that
the audience should trace their seemingly unmotivated emergence to
his dejection and the alienation in its wake.[81]

We will return to this relationship between melancholy and the image
in our discussion of its postmodern variant.
 In Hitchcock's films, however, the ideologeme of melancholy seems
to do more than to motivate and rationalize the visual, although it
unquestionably does that as well: it comments, one would like to say,
on the formulaic genre itself from which the episode derived and of
which its "modernism" is the transmutation: that generic repetition
of the "same," which causes the viewers of horror films to scream at
the first unsullied glimpse of the empty street or the empty house, is
here the deeper boredom or fatality of the form itself, which cannot
but deliver the goods and supply the corpse—yet it makes of this
necessity a historically and aesthetically original virtue by draining
off the generic sign system itself and transforming the latter's signifi-
ers into some new autonomy of the sign in its own right. Even the
jokes are thereby chilled in the process: the comedy of errors in the
taxidermist's shop—in *The Man Who Knew Too Much*—becoming a
ballet of predatory animals (that then, again immobilized, pass onto
the walls of the motel in *Psycho*), while the organizing datum or gag
of the sequence is spatial. That "Ambrose Chapel" in particular is not
a *man* (who in the mysteries of the sexual subculture wonders whether
the Stewart character has it in mind to accost or to blackmail him)
but rather a *place*—the visual and architectural content of this "melan-
choly" might have warned us in the first place. The joke has no direct

equivalent in the earlier version of *The Man Who Knew Too Much*, at least in part because the episodes of the 1934 film were not yet so independent of one another as to require this kind of linkage by way of the permutations of the signifier: "Chapel, Ambrose," versus "Ambrose Chapel." The chapel itself, however, when it comes into view in its turn, is equally deserted and melancholy: solitude proves just as easily mobilizable for London's dreary streets, as though the only crowds England can marshal in response to the teeming markets of Marrakech are those who buy their tickets in orderly fashion for the Albert Hall ("Hall, Albert").

In fact, however, the content of the affective charge of the episode is less significant than the liberation—and autonomization—of affect itself. As the technical use of the word "gag" suggests, the comic or farce—in their very structure discontinuous—lend themselves as well or better to the process than do their various tonal opposites, to the point where one can affirm some deeper affinity between the operations of the comic and the episodizing logic of the various modernisms, provided the former is grasped in an appropriately non-humanist or even non-human way as an impersonal process (Homeric laughter, the grinning teeth of Wyndham Lewis's *Tyros*). In Hitchcock, for example, the extraordinary translation of English human into a very different American type (complete with a whole new character system) suggests the operative presence, during the American period (which is also that of the "modernist" films), of something like Bakhtin-Voloshinov's *alien speech*, a foreign language at work behind the ostensible surface language and lending it a peculiar opacity and density,[82] as in Milton or Nabokov, Conrad or Raymond Chandler. At any rate a kind of impersonal farce or humor—whether in Joyce or Musil, Baudelaire or Kafka—whose historical originality has often been confused by the development of the concept and value of "irony" as such—is often enough the sign of the completion of the process of autonomization and the hardening of modernist language into a reified condition.

In film, the prodigious fact of Chaplin is enough to document this deeper "preestablished harmony" between modernism and farce: something then reconfirmed by Keaton (as a kind of anti-Chaplin) and later on by the films of Jacques Tati. But at this point other mediations become visible, in particular the vaudeville or music-hall format from which the visual gags themselves derive: not the meaning of laughter then, not some "comic spirit" or world-view, but rather the discontinuous structure of the variety show accounts for the formal affinity in question here (just as it was the behavior of the melancholiac or the *flâneur* that accounted for the formal links between melancholy and

the episodic, and not some deeper pessimism or nihilism in the modern *Zeitgeist*).

XI

The variety show in fact allows us to make some ultimate historical and anecdotal connection between the autonomization process in modernism and the inaugural conception of "montage" by way of the practice and the theory of S. M. Eisenstein: since this last very specifically emerges from the experience of the music hall and was first theorized, not in the technical language of shots and editing, but as a "montage of attractions,"[83] very much along the lines of some sheerly formal alternation, in which the radical difference of a given content from what precedes and follows it is more important than the nature of the content itself. ("Something to eat and drink on every page," Flaubert described this dynamic, which a contemporary television-sensitized audience might be tempted to think in terms of rapid cutting and increasingly limited attention spans.)

Eisenstein's theory—which proposed something like a "calculus of juxtapostions" in very much this spirit—allows us to pursue the process of autonomization or episodization, as it were, from its other end, at the moment of emergence. His conception of "montage" will thus first require the reduction of each shot to its greatest tonal intensity in order to heighten the language of contrast and the shock of its conflict with the following one. What is most interesting in this process is however the way in which what began as a juxtapostion between *two* shots now tends to become a single autonomous segment (montage proper) in its own right: it is as though the fact of sheer relationship, or the mental act of perceiving binary juxtaposition and difference, were expansive, and tended to grow into a new and larger form, not reducible to any of its primitive components. That this process does not stop there, however, Eisenstein's later work continues to testify: for in his a posteriori account of one of the sequences in *Alexander Nevsky* (1938),[84] that gap or tension between the two shots which hitherto constituted montage now opens up and takes on the status of an image in its own right, a third entity which comes into being to bridge the other two, and whose content in this case is not indifferent, for it is characterized as hushed silence or the "dawn of anxious waiting" (the Russian forces awaiting the appearance of the Teutonic Knights). Montage thus assumes the existence of the time between the shots, the process of waiting itself, as it reaches back and encompasses the two poles of its former dynamic, thereby embodying

itself as emptiness made visible—the line of Russian warriors in the distance, or even more climactically, the empty horizon of ice on which the Teutonic Knights, not yet present, impend.

The paradox confronted here, and the structural instability of the modernist moment generally, returns us to the issue of the semi-autonomy that presides over autonomization, and of the tenuous but ineradicable link to something greater that marks the episode as part of something else even at its fullest moment of independent development. It is a phenomenon sometimes obscured by the oversimplifications of a characteristically modernist hermeneutic, in which "meaning" becomes translatable back into conventional abstract language. Eisenstein's so-called "intellectual cinema," for example, is often staged by its inventor as the mere translation into images of abstract thoughts which can be unproblematically formulated in a conventional verbal expression, such as the "anxious waiting" referred to above, or the "fateful midnight hour" of Maupassant's *Bel Ami*.[85] Eliot's "objective correlative" and Freud's straightforward mode of formulating the "dream thoughts" in terms of wish-fulfillments of a relatively prosaic nature—even Joyce's schematic *resumés* of his separate chapters in *Ulysses*—all of these share with Eisenstein's descriptions a tendency to reduce the new material to a preexistent and recognizable, when not stereotypical, "thought" or meaning, rather than to project it in the direction of the Utopian production of a language that does not yet exist, or of a content which awaits its names. Meanwhile, the formulation of a linguistic meaning in common language tends to overemphasize and reify the independence of the aesthetic sign, its "autonomy" in the strictest and most absolute sense, in a way in which the stress on rhythmic alternation does not. When, for example, movement and turbulent motion are contrasted, in sharp montage, with the long-drawn-out stasis of an empty landscape, then what emerges is less the realistic sense of an action or an event, in its various parts or components, than a new kind of perceptual abstraction, the perception of a new kind of tonal opposition between agitation and privation. This is not, despite Eisenstein's intellectualizing language, a new kind of *abstract* thinking, but rather a *perceptual* thinking which has some affinities with Lévi-Strauss's *pensée sauvage* (including the flexing of non-conceptual semic oppositions) and many more with that "qualitative progression" in terms of which Yvor Winters prophetically characterized the very logic of literary modernism itself.[86] Such descriptions lend a somewhat different meaning to Eisenstein's alternate account of this process of abstraction as a "liberation of the whole action from the definition of

time and space," and make it increasingly compatible with the analysis of modernism proposed here, namely as the process of autonomization of the sign (and of culture itself).

The differential logic of the various modernisms, however, is structurally distinctive only when it is coordinated by some totalizing principle, or if you like, by the mere idea of a monumental work or totality, the principle of an absent totality, never concretely realized in any achieved synthesis, yet detectable in its deformation of the episodes and their content like the operations of some heavenly satellite or gravity mass hidden below the horizon and invisible to the naked eye. The way in which this strange slot (I am tempted to call it an "ultimately determining instance" in the realm of form) can be secured is not given in advance, and varies with the enormous variety of the modernisms themselves: Eliot's theory of the modern use of myth is one stab at a formulation, but genre or formulaic logic provides a very different principle of unification, as in the Hitchcock thriller. I am tempted, however, to suggest a third, perhaps more psychological, form of this principle in order to give a more varied sense of its operations, as well as a kind of parable of its function.

I'm thinking, for instance, of a remarkable early novel of Marguerite Duras, called *Le Marin de Gibraltar* (*The Sailor from Gibraltar*, 1952) in which something like the principle of formal totality is transformed into the content of the work, and rewritten in terms of the psychology of the love passion. The story begins with a French government functionary on vacation, and dissatisfied with his life generally, who meets a rich American woman sailing the world on her private yacht. As they join forces, it transpires that she has a mission: to find somewhere, in this or that part of the globe, a sailor she once met in Gibraltar and for whom she felt the ultimate passion, the unmistakable; the protagonist then abandons his job and his past to accompany her on her quest. At length we are given to understand this: that, if we insist on using that word, "love" is what the hero and the heiress experience for each other as they travel the world in search of the sailor from Gibraltar. On the other hand, should *they* ever happen to use the word, the thing would vanish without a trace (in a kind of grim parodic reversal of Stendhal's well-known formula: but Marguerite Duras's work is in any case suffused with a mistrust and a suspicion of language). The protagonists everywhere have to believe that transcendent love, or the real thing, exists, but exists *somewhere else* (in the woman's obsession with the sailor). Their own experience must remain contingent in order to retain its vitality: it needs distraction and laterality to persevere in being, unable to bear the weight of absolutes or of the frontal gaze, the couple staring at one another. They must

face outward, as it were holding hands: the novel is not so much a cautionary fable about the dangers of self-consciousness, as it is a parable of modernist form (Proust's equally psychologized notion of the incompletion of experience in the present has analogous form-motivating results—an allegory of the longing within content, not for form, but for the idea of form). In a similar way, Duras's novel stages one of the "great ideas" for a novel, which cannot by definition be realized since nothing of any consequence (except for love itself) can happen during the quest.

Hitchcock's romances serve a similar function, so that it is inaccurate to restrict the totalizing principle in his films to the generic dynamic of the thriller alone: the chase is for the most part the experience of a partnership, yet with this qualification the "thriller-romance" may stand, along with the variety show and the quirks of the melancholy *flâneur*, as a third kind of determinant for the autonomization of episodes. For, as in Duras's fable, the function of the partnership is not to experience the love passion as such, but rather to traverse, survive and navigate, the adventures of the episodic narrative: something often underscored by the initial repugnance and distrust the future heroine feels for the already threatened hero (she denounces him, in *The 39 Steps*, and merely dislikes him, in *The Lady Vanishes* [1938]; she seems to betray him, in *Notorious* [1946] and *North by Northwest* [1959]; and is incompatible with him in *Rear Window* [1954]; while finally in *The Birds* [1963] virtually all these things obtain). The official plots of these films encourage us in the belief that the reversal of this initial relationship involves the heroine's dawning conviction that the hero is innocent; but it would be difficult enough to prove which comes first. Nor does it seem correct to suggest that the hero's interest is only aroused at the moment in which the heroine becomes a scopophilic object[87]: that is, the moment in *Rear Window* when Grace Kelly enters the apartment across the courtyard and for the first time becomes visible within the Stewart character's zoom lens: surely she has on the contrary at that moment entered the partnership as such, something about which this particular film is for once quite explicit. The demonstration can also be made a contrario, by way of the failure of the partnership in *Vertigo* (1958): here the Barbara Bel Geddes character offers an alliance of the classic Hitchcock type which sexual obsession forbids. In *Psycho*, the possibility of partnership is displaced onto the two surviving minor characters, heroes of a traditional Hitchcock film but no longer of this one; while the whole sadistic fury of *The Birds* is marshalled to recreate the partnership situation by way of victimization and cosmic upheaval. None of which is meant to deny the presence in Hitchcock of the

scopophilic or fetishistic impulse as well, for which women are visual objects; but they are certainly subjects in their other role and status in what we have called the partnership. In fact this alternation between subject and object status is not one of psychological states (of the male on-looker, for example) but of formal levels, and is best grasped in terms of the modernist dialectic outlined here: namely the opposition and the tension between the principle of totality (the partnership) and the content of the episodes themselves, where fetishism and voyeurism then concretely come into play.

Indeed, this very dialectic between visual obsession and partnership is specifically articulated in one of Hitchcock's most unjustly neglected films, *Stage Fright* (1950), where, very much as in Marguerite Duras's novel, what might be called a "daily" or contingent love affair between the heroine and her policeman companion comes into being under the overarching framework of her "absolute" or romantic passion for the Richard Todd character. (It is indeed doubled or preceded by a trial run of the partnership situation between the heroine and her father [Alastair Sim]: an unusual moment in a filmmaker more often preoccupied with tyrannical mothers, when not busy tormenting his own actress-daughter in more awkward and painful roles in his own films.) This dual structure is then replayed in the mirror of the male protagonist's situation, where Richard Todd's sexual obsession with Marlene Dietrich leaves no space for the partnership arrangement merely simulated with the official heroine herself [Jane Wyman]. Visual obsession is thus central in Hitchcock, and open to the most suspicious and extensive degrees of libidinal investment: but it must be read against its structural other pole. In the obsessional moment, as it were, the man stares at the woman (or vice versa, for it is important to stress the implications of Hitchcock's fascination with fire-and-ice, or Grace Kelly-eroticism, where it is the woman who shows desire and stares at the man). In the partnership situation, however, both man and woman gaze out together at the episode: something again wondrously enacted in *Stage Fright* in the love scene in the taxi between "Jane Wyman" and Ordinary Smith, where languid fascination steals through an increasingly distracted and faltering conversation about the facts of the case.

In Hitchcock's modernism, to put all this another way, specular obsession still needs to be motivated by the "theme" of voyeurism: we watch Jimmy Stewart watching, we are not yet plunged into the image itself as such. The scopophilic impulse is not merely contained by the concept of a psychic subject; it is also drawn within the episode and its formal logic, where it becomes what allows a narrative to segment into the distinct or semi-autonomous events of this or that

viewing. When the psychic subject disappears altogether, however, and along with it, the process by which looking is specifically foregrounded as a privileged element and a psychological motive *within* modernist film, we are no longer in this last any more, but in full postmodernism, at which point the analysis of scopophilia as a symptom and even an ideological stance becomes pointless. Postmodern specularity needs no motivation since it has become its own reason for being: a subject obsessed with looking does not have to be "constructed" since there are no longer any centered subjects of that sort in the first place: looking is everywhere and nowhere in the "society of the spectacle," and a completely new relationship to the filmic image thereby appears in which the spectator simply rips it off and cannibalizes a "work of art" designed for that very purpose in a random—but highly visual—appropriation of its various "bonuses of pleasure." In retrospect, therefore, Hitchcock's thematization of scopophilia may strike us as exceedingly self-conscious: in an image culture, the specialized obsession with the image no longer has any clinical interest, just as the kinds of linguistic and stylistic experiments of the modern period lose their point under the universal dominant of Language or the text.

XII

On the other hand, all of this can be said in another way, in which we celebrate the return of Benjaminian aura to the movie screen, where looking retrieves a kind of splendor and authenticity from the perceptual habits of video and television: the "good print" then becomes something like an "original" again. In photography, however, as Susan Sontag has pointed out, things are somewhat different, the marks of aging—fading, yellowing, and the like—increase the value of a black-and-white print and heighten its interest as an object for us.[88] Color prints, however, merely deteriorate with age: only mint color has value, so that in some sense the capacity of the photograph metonymically as well as representationally to serve as a marker for the past is in the case of the various color systems lost and forgotten— whence the affinities between color reproduction and the perpetual present of the postmodern.[89] The distinction is strikingly dramatized in the Cuban film, *The Opportunist* (*Un Hombre de exito*, Humberto Solas, 1986), which begins with streaked and faded black-and-white (fictional) newsreel footage of the return of the police chief figure to La Havana in 1932, wondrously transmuted into color while the camera pauses on the monumental interior of the palace; this very effective mechanical trick signifies the eclipse of historical distance, the new

immediacy of some mint present into which we are at once projected. This is, rightly or wrongly, the stereotype with which we approach all historical representations at least since the emergence of the historical novel as such in the early 19th century: as *The Opportunist* also constitutes the first Cuban "nostalgia film"—of a properly postmodern type—it will offer a useful opportunity for weighing postmodernizing historical representations against the powers and limits of older, most frequently "realist" ones.

The logical sequel to our description of modernism, however—an account of the breakdown in the links between the episodes, and a becoming fully autonomous of the hitherto merely semi-autonomous components of the work, all the way down to sentences and signifiers themselves—involves the analysis of independent film and experimental video, subjects I have touched on in part in another place.[90]

In this respect, however, what has perhaps been insufficiently stressed in discussions of nostalgia film is itself precisely this dialectical relationship of its specific idiom with an opposing and contrasted aesthetic: the relationship can indeed be grasped as an antagonistic dialogue in which the symbolic meaning of each position cannot fully be read except as a repudiation of its opposite number. So it is that the reification of the image in high postmodernism—the gloss and mint brilliance of its filmic but also its televised languages (particularly in the new wave of nostalgia detective series—*Crime Story*, the ill-fated *Private Eye*—that restore the polish of *Miami Vice* to its proper historicist setting in the forties and fifties)—develops side by side with an equally flourishing alternate language of grade-B forms, punk films, and conspiratorial or paranoid artifacts, whole willful choices of sleaze and imperfection, of junk and garbage landscapes, and of deliberately shoddy or garish color when not outright black-and-white stock, mark the will to inauthenticity as the sign of a now socially marginalized Real and as the only true space of authenticity in a spurious image culture dominated by a hegemonic postmodernism.

This opposition—which will be our final topic—therefore cuts more deeply than sheer style, although style has traditionally offered the most convenient language and categories to discuss it in, as most notably in those Third World theories of so-called "imperfect cinema" (Julio Garcia Espinosa),[91] which staked out a new position for revolutionary art in the 1960s, one quite distinct from older left theories, whether of socialist realism or of other radical traditions, at the same time that it in effect codified the practice of Italian neorealism (so influential in world cinema generally), and echoed the contemporaneous practices of First World oppositional filmmakers like Godard, with their use of handheld cameras, their deliberately sloppy and

foregrounded editing, and their ostentatious valorization of home movies in place of Hollywood (but also as a substitute *for* it). The aesthetic of imperfect cinema is thus an allegorical one, in which the form is called on to convey specific stances toward the content and as it were to connote its essential features: thus, if technical perfection connotes advanced capitalism—its values of profit-maximizing efficiency fully as much as its technologies and the labor processes generated by such technology and such values—then "imperfection" can be expected, like a vow of poverty, to connote, not merely the inert necessities of an underdevelopment that has been imposed and "developed" by force, but also the willingness to renounce the surpluses of socialist development in solidarity with other Third World countries (as an aesthetic, it thereby corresponds to Che's global political ethic as expressed in the Tricontinental speech). Yet with the end of that transitional period which was the 1960s, cultural and technological space is no longer quite the same: the uneven qualities of film stock and the resultant stylistic consequences have meaning only as constraint and the experience of Necessity. In fact, as we have already seen, Cuba itself now makes nostalgia films (in addition to *Un Hombre de exito*, the Soviet-Cuban co-production of *Capablanca* should be mentioned); while Godard has described an unexpected but exemplary trajectory from true imperfection all the way to the most advanced film-and-video laboratory. Indeed, it is in one sense video itself that inherits the virtues attributed to a formerly imperfect cinema: triumphantly retaining its status as the latter's poor cousin, while ambiguously connoting "advanced technique" and "trash" all at once. But films which choose the styles and trappings of imperfection in an optional situation, in the attempt to retain their social content (rich versus poor, monopolies versus oppositional individuals or groups), where they do not lapse into complacency or self-indulgence, very precisely adopt the panoply of grade-B signifiers that have already been enumerated for what we will call "conspiracy film" and reinteriorize the political oppositions in some new but non-political way.

Meanwhile, the Arriflex—whatever it may have connoted about the filmmaker's economic possibilities—is also a new form of technology in its own right (and not a return to cumbersome or archaic equipment). In fact, it is as though the First World took up the allegorical gauntlet thrown down by the Cuban theorists: for it is simply a mistake to assume that the technological "perfection" of the new nostalgia glossy-film product involves anything like a concealment or repression of its own production, and an "effacement of the latter's traces." On the contrary the very elegance of such films—and it is clearly a commodified elegance, that we consume as such, and that makes up

much of our "bonus of pleasure"—is first and foremost an index of the production process itself: through the features of such images, we simultaneously consume the most streamlined features of the new technologies, latest-model state-of-the-art, computerization, mixing systems, complex banks of counters and dials (which specifically include the human expertise of their inventors if not their tenders)—this whole machinery of reproduction which is itself meant to be consumed like a commodity (whose end-product—the art image, the filmic object—is also its wrapper). At this ultimate stage in the production of commodities by commodities, the distinction between means and ends is abolished, allowing us to consume the idea of the Polaroid itself along with the "idea" of its latest snapshot, and by means of it. Color is also clearly the sign of this dialectic, as a "supplement," a bonus of pleasure that adds nothing to its own content, and yet a "nothing" which—as the sign of new systems of reproduction—opens up new and equally "supplementary" spaces for libidinal investment.

Nostalgia film therefore contains the production process and signifies and connotes it fully as much as do its opposite numbers in "imperfect cinema" or grade-B conspiracy or punk film. What one can argue, however, is that its evident formal and socio-economic difference from them derives rather from its commodification of labor and its organization and institutionalization of the human beings involved in its production: something not yet present in imperfect cinema, which remains a collective act; and something from which the content of conspiracy film also seeks explicitly to distance itself, by the representation of amateurish or pre-capitalist "enterprises" (the making of pornographic movies in *Videodrome* [David Cronenberg, 1983] for example), a situation which may not correspond to the actual production of this grade-B film itself, but which at least suggests a certain incompleteness in the commodification process. In German idealism, the word "play" still tried to designate something of the spirit of collective activity untouched or incompletely organized by the new system: its contemporary forms—such as the laborious and awkward improvisations of Duras or Wenders—are far from being diversions or even from offering the commodity-pleasures of what they at enormous effort and cost react against: in such works the existence of a social collective is perhaps a surer sign of non-commodification than the playfulness of the object. In any case, today, "conspiracy" is fully enough the symbol and paranoid substitute for such collective activity as play (except in the forced example of Antonioni's mimes in *Blow-Up*); while pleasure has become increasingly associated and ideologically "discredited," if I may put it that way, by its annexation by the capitalist image and image-production as such.

This is to say that if the "truth" sought by various kinds of left and radical cultural production in recent times has always turned around production, the dominant of nostalgia film is rather reception and consumption.

What is received is however far from being straightforward: nostalgia film may for example—along with a number of other postmodernisms, such as what is variously called neo-expressionism or the new figuration—involve a return to storytelling, after what are sometimes inaccurately thought of as the "abstractions" of the modern. As its name suggests, it also seems to involve a new kind of return to History, but then in that case its affinities are probably to be found in the various eclectic historicisms of the other postmodernisms, and not in some renewed or original historicity itself.

What is in any case demonstrable is that these two tendencies interfere with and often short-circuit one another and problematize what at first looks like a return to the historical pageant or the "epic" film—Bertolucci's *Conformist* (1970), for example, arguably the inaugural film of a new genre (although *Lacombe, Lucien* and *The Night Porter*, both from 1974, signal the appearance of the equivalent term— "la mode rétro," in France), spans the period from the early thirties to the fall of Mussolini's regime; *The Godfather* (1972, 1974) covers a linear period from the end of World War II to the early 1960s, with, however, flashbacks to the turn of the century and the Sicilian thirties; *Un hombre de exito*, finally, begins in the Machado period and ends with the Revolution—some seventeen years of chronological history. Such epic durations mean in any case that only sample probes of the various historical moments they include can be given, and that great gaps and leaps will necessarily be negotiated by our own historical stereotypes.

The matter of prior knowledge in fact offers at least one useful way of distinguishing between older historical representations (such as the historical novel, as Lukács studied it) and this newer type. Lukács posited a kind of *Bildungsroman*, in which an "average hero" (like Waverley) gradually approached, glimpsed, and briefly confronted a *world-historical figure*, of whom the reader might be expected to have knowledge in rumor and tradition as well as in the history books.[92] "Experiencing history" in these novels was therefore a kind of thirst for presence and perception, ultimately gratified by the view of what such a renowned personage "really was like." That this form presupposes History to be the history of "great men" is evident; but the names of the great are also markers for the dates and differences of the distinct historical landscapes. Nonetheless a historiography centered on the category of the "character" probably lends itself to

narrative, or to storytelling, more immediately than a historical travelogue organized around history's distinct chronological landscapes.
Yet it is something like this last that we witness in nostalgia film, where the "world-historical figures" have ceased to be narrative characters and have been transformed into the various generations or historical periods themselves. Their "names" now join the various other objects and bric-a-brac whose presence is characteristic of a given period as its celebrity-logoes, and on a par with the three other crucial types of time-markers or period features which are: hair and fashion styles, automobiles, and music (including dance crazes). In Doctorow's Ragtime, for example, "Houdini," "Henry Ford," "J. P. Morgan," are just that (among other things): the fashionable names and the public sphere of that particular period. Yet the types of objects enumerated already begin to suggest serious limitations on the time-content of these newer representations: styles of coaches, for example, cannot function for us in the same way that even the most archaic automobile does, as the index of a specific period (see Ragtime again). Nor are we aware of, say, the waltz as a history-specific and even a history-laden event in the emergence of musical fashion (the end of the Napoleonic wars, the birth of a new kind of physicality and perhaps even a new temporality and spatial experience) in the same way as the tango. Nor are hair and clothing styles specific variants of our own present beyond a certain "point in time": the slicked-down, sharply parted men's hair styling of the 1920s comments pointedly on us in a way that romantic heads of hair—let alone the violent political and ideological struggles over 18th-century power and the wig—no longer can. The meaning of those styles of a more distant past are to be sure accessible to a political hermeneutic; but they do not seem to be available for us in the new historicist art language of the nostalgia film, a limit which will offer significant clues as to its ultimate message.

Meanwhile, we witness the transformation of the narrative content of such works from representation to something like a reading, a deciphering of historical indices and signs, an inspection of the fashion-plate and an appreciation of what is less a new standard of historical accuracy (although one is willing to believe in a certain gain in historiographic sophistication) than a wholly new form of visual "verisimilitude" (Ridley Scott's construction of the narrative of The Duellists [1977] as a series of simulacra of romantic paintings of the period is an instructive and emblematic gesture).[93] Such modification in the reception of the raw material of nostalgia film will have significant consequences for the status of character within the texts who must now, like the viewers themselves, come to entertain a relatively

more contemplative relationship to the events and actions in question, when they are not called on merely to illustrate and exemplify some stereotypical preexistent "knowledge" about the period (unlike ourselves, people in the twenties acted like this or that: because if they were indistinguishable from us, and did not foreground Difference rather than Identity, did not manifest or embody this or that "historical" feature of a specific generation of the past, the claims of the representation itself would begin to unravel).

Whence a certain passivity even in the protagonists of nostalgia film, which, taken together with some of the other modifications just mentioned, goes a certain distance towards accounting for what seems to be our inevitable disappointment with the narratives of these expensive and visually exciting productions: the narrative must always somehow give us to *recognize* our already existing stereotypical knowledge which it is called on somehow—but no doubt as subtly as possible—to *confirm*. The compositional problem posed by the protagonists is therefore as obvious as it is acute: although they must somehow centrally initiate the action of such films, their personalities and their very style of action must also reconfirm our prior knowledge and therefore be typical or characteristic, in a way rather different then what Lukács famously had in mind: above all, no interesting spontaneity or arbitrariness in the gestures and decisions, nothing "personal," so to speak, to mar the representativity of the series of events. (The weakness of nostalgia film generally then lies in this eschewal of the "grand narrative," now relegated to what we already know in advance, which no multiplicity of tiny speech acts, anecdotes, lies, and micronarratives comes to replace or displace).

Scott's "average heroes" were no doubt also passive: but it is a passivity recontained by the fact of youth itself and by the emergent conventions of Bildungsroman as form.[94] In nostalgia film, however, the formal requirement determines a return of that *melancholy* we have touched on in earlier contexts in what is here a historically original form: the Trintignant character in *The Conformist*, most dramatically the whole mood of *The Godfather* as it seems to derive from Michael's [Al Pacino] dilemma; even the passivity of the Solas protagonist is tinged with this peculiar *Stimmung*, which can of course easily disguise itself as an elegiac relationship to the past and to the passage of time. Moravia's 1951 *Conformist*, however, published so soon after the war, in full industrial reconstruction, explicitly raises the not yet "historical" question of the causes and origins of fascism itself, a question to which its title—and the psychology of its protagonist—explicitly replies, in the form of the then popular existential doctrine of the "flight from freedom," the longing to shelter one's

individual anxieties within the conformities of a large group. ("Here was one single, complete thing he had in common with the society and the people among whom he found himself living. He was not a solitary, an abnormal person, a madman, he was one of them, a brother, a fellow-citizen, a comrade."[95])

Moravia's hero is therefore a faceless and anonymous figure without any intrinsic interest, save that of an interesting psychological case: scarcely a starring role at any event. Bertolucci's character, quite the opposite of this, is driven by fatality: when Trintignant's active reactions to things and events and people begin to clash with and formally contradict Moravia's arrangements, the gaps are concealed by "interesting" silences of a melancholy nature. In the novelist's notoriously heavy-handed psychological evocations, the childhood sadism and the "murder" constitute the situation of difference which Clerici must flee into the comfortable identify of the group; in Bertolucci's more characteristically sixties psychologizing, Clerici's "sadism" (and probably some "latent homosexuality") is itself the unconscious motivation for his fascist commitment. In any case, Moravia's psychologizing motivation (in this novel) lends itself poorly to cinematographic adaptation insofar as it determines an absence and a privation rather than visually interesting behavior (what we see in Bertolucci is rather Trintignant *acting* this incomprehensible privation and passivity *out*).

The melancholy of these films and their protagonists seems to express, seems also to convey *meanings*: but it is in reality what the Russian Formalists called the "motivation of the device," the way of making a virtue of a plot necessity, and endowing formal constraint with an appearance of content in its own right. Thus, the mood of *The Godfather seems* to convey Michael's unhappy choice, and his unwanted family obligation to violence (and big business ruthlessness): in reality, however, it is designed to place us in that "nostalgic" frame of mind in which we are most receptive to the inspection of old photos and the aesthetically distant contemplation of bygone fashions and scenes from the past.

Yet, as we have suggested, only strategic segments of the past are open to such representation, whose limits are thus fixed both chronologically and semiotically. Nineteenth-century content, for example (as in *Heaven's Gate* [1980]), is either generically determined and fixed in time by way of the language of the Western and the facts of the frontier; or else it expresses a very general 1960s significance by way of the bagginess of the women's clothing and a vestimentary populism that still bears traces of the politics of communes and the return to nature of that period. Such signs otherwise fail visually to specify any

particular decade in this pre-industrial American past, while it is precisely on such visual specification of a well-nigh generational precision, that nostalgia film formally depends.

XIII

In fact, the privileged historical content of such films seems very largely to be constituted by the 1920s and the 1930s, as decades which entertain a kind of semiotic binary opposition in our stereotypes of American history: the first offering a wealth of images of the modish, of high styles and fashions, nightclubs, dance music, roadsters, and art deco; while the second conventionally connotes the seamy side of the real, in the form of the Great Depression and of gangsters and their saga and characteristic raw material.[96] But this opposition owes its articulation to the "peculiarities" of U.S. history: since what either Italy or Cuba shows us is the coexistence of both sets of signs throughout the whole length of the interwar period—signs which taken together form a coherent dichotomous class system, high versus low, privileged versus labor, culture versus violence.[97] The second level or language of this articulated system—what we have associated with the 1930s and "social reality"—can slide chronologically with a certain limited freedom in either direction: furnishing the "ethnic" content of pre-World-War I representations, just as it can prolong the thirties themselves to a certain point beyond World War II. The upper-class component of the system is, however, far more rigidly fixed in time and associated with the interwar years. It therefore stages a genuine nostalgia and longing for class content and class privileges and elegance; where the thirties material largely feeds the "new historicism" of the various contemporary ethnic revivals and simulations of ethnic identity. Both parts of the system, however, express a nostalgia for class struggle and class difference and for the resultant historical and political dynamisms, which it is contemporary doxa to believe absent from late or multinational capitalism. But they do so by way of an aesthetic or stylistic mediation of a structurally unique type, on which we have touched already in an earlier context: namely art deco itself, as the formal expression of a certain synthesis between *modernization* (and the streamlined machine) and *modernism* (and stylized forms), which can be inflected, as we have seen, in either a stylish (or "1920s") or a populist (or "1930s") direction. What we have been calling nostalgia film, therefore, might better have been termed nostalgia-deco film, to underscore its dependency on the earlier cultural language, through which it exercises its own specific historical and political Imaginary.

In fact, the peculiar ideological "fit" between these stereotypes of the twenties and the thirties suggests that, however they are reappropriated, they may also carry some more deeply coded narrative within them, which adds its overtone to their resonance in specific situations. For the various ideologemes of elegance and leisure-class privilege which are coordinated in the general seme or signifier of the first of those two decades are from the European perspective scarcely bourgeois at all, but remind us, following Arno Mayer's fundamental book, *The Persistence of the Old Regime*,[98] that "culture" there was in general marked as the legacy and the continuing presence of the older aristocracies, offering its costumes and decorative trappings for the ludic exercises of new power (it is not only, in other words, the revolutionary movements that, fearing the demands of the radically new, "drape themselves in the costumes of the past"). If then the thirties, with their violence and labor unrest, their social "realism," as opposed to the Hollywood-generic frivolity of twenties languages, stand for capitalism itself as a new industrial system, then the message vehiculated by these twin period-signs, side by side, becomes a diachronic and a narrative one: the passage from aristocratic culture to the capitalist "base" or "infrastructure," or in other words that mythic moment most often designated in Marxist research as the "transition" from feudalism to capitalism: mythic origins, the emergence of History itself.

Ours is a moment whose suspicion of "master narratives" has been most paradigmatically voiced by J.-F. Lyotard (in an opposition between grand narratives and speech acts that Jonathan Arac has pointedly retranslated into "tall tales" versus "white lies"[99]). Since the liberal or bourgeois narrative of progress, which stands, in Lyotard, as the only other illustration of the master narrative, is extinct, this formal category would seem to be designed principally to subsume the case of Marxism and its "philosophy" or "vision" of history. I have come to feel that the Marxian sequence of modes of production is not a narrative of that kind, nor even a narrative at all; on the other hand, I have also come to feel that some deeper unconscious narrative does subtend a great many Marxian histories and discussions, and not only Marxian ones. But then in that case that master narrative is not exactly the triumph of socialism or the liberation of human beings, about which no one is clear, "inevitable" or not "inevitable," exactly what form that would take; but rather another triumph and another transition altogether.

This is, I believe, the transition from feudalism to capitalism, a story that often bears the name "modernity" in the bourgeois disciplines. Indeed, I think I would go so far as to add the speculation that this

particular story is what is being secretly (or more deeply) told in most contemporary historiography, whatever its ostensible content. Such a proposition evidently implies that history-writing also knows a political unconscious, and that its surface or manifest topics also symbolically act out deeper perplexities and attempt to resolve contradictions that often have little enough to do with the official subject matter at hand. This is, in other words, to transfer the spirit of Lévi-Strauss's analysis of myths and tribal stories—already imported into the study of high literature and mass culture alike—across into what used to be thought of as a realm of empirical facts, if not science itself. Yet it is the presence of narrative that authorizes the transfer, and, in a period in which historians have become keenly (or uncomfortably) conscious of their fundamental narrativity, allows us to hypothesize a libidinal economy such that the storytelling form itself carries a freight of meaning and tells a supplementary story in addition to its immediate or local historiographic reference. One thereby imagines the archivist of Ragusa, or of the agricultural system of the Pampas, consciously working away at solving the evidentiary problems at hand, while the narrative system itself dreams on independently of the aporias of social contradiction, which it unconsciously works up into symbolic resolutions or harmonizations.

But a second proposition is also being suggested here: namely that in that case the contradiction which symbolically preoccupies much of modern historiography is the whole matter of *transition*, the emergence of the modern world or capitalism, the miraculous birth of modernity or of a secular market system, the end of "traditional" society in all its forms.[100] If this is something like the primal mystery, however, or the unthinkable, it becomes clear that none of these descriptions can be neutral or innocent, since all pass through our ideological attempts to think what remains for us (in the collective unconscious) the only true Event of history. "Modernization" is one word for that event, a word filtered through a certain kind of contemporary (and even technocratic) bourgeois ideology at a late stage in industrialization. Marx himself famously characterized this same aporia for the early bourgeois political economists and theorists of the market: "They believe that there once was history [e.g., in traditional societies being supplanted by commerce and capitalism], but there isn't any anymore." Meanwhile, although the Marxists pinpoint this "event" under the problem-slogan, "the transition from feudalism to capitalism," it is a story which they have any number of ways of telling.

This is not to imply that this second or unconscious narrative is always structured in the same way: what is "the same," one wants

to suggest, is the Event itself, which however, following a kind of ideological Heisenberg principle, can never be present to the mind or the naked eye, always retreats, and is detectable only in the terms of this or that provisional solution, as though, unconsciously obsessed with some primal event to which they return again and again after the fashion of Freudian repetition and the trauma, without being able to explain it to themselves or to liquidate their obsession, the storytellers told their tale again and again, reiterating the cataclysmic nature of the Event itself. Meanwhile, the very term "origins" seems a misnomer for this particular obsession, which does not model its object as an absolute beginning or an emergence *ex nihilo*, but very specifically seeks to grasp the mystery of the before and the after, and very much posits an antecedent state or condition to which the change somehow happens. The weaker Freudian version of this critique of origins—to rewrite all this in terms of the Oedipal triangle and the relationship of sons to fathers (or more recently, of daughters to fathers)—has the advantage of acknowledging some form of an "antecedent state or condition." But the Freudian "ultimately determining instance" may no longer seem particularly plausible in a situation in which the nuclear family is itself everywhere in decay, and opened up to the social in a variety of untheorized contaminations. One might just as easily suggest that what gives the Freudian paradigm its continuing strength and explanatory power is very precisely the way in which it has itself been symbolically invested by the deeper mystery of the historical *factum* and of a somehow absolute moment of historical transformation.

But no particular psychological explanation need be adduced for the investment of all kinds of historiography with this deeper symbolic narrative significance. The phenomenon is very much, one would think, a formal one, and is enabled by the very constitution of the historical object of inquiry, by a specialized focus which excludes other topics in order to fasten exclusively to this particular content, which thereby becomes something like a formal *now*, a reconstructed presence to this particular phenomenon in time which opens up that "libidinal investment" proper. If this is, as the form assures us, for the moment the only topic in the world, then it must necessarily be called upon to include all those other repressed obsessions and interests within itself: the official subject matter thereby begins to act out the "subject of desire" as well, and to offer a privileged occasion for the restaging of the historical trauma.

This hypothesis—which clearly demands "verification" by way of a very great range of historiographic materials—may seem at least minimally plausible for cultural texts. In particular (now to restrict

it even further) it has been our argument that the stylistic unit of "art deco" includes some deeper symbolic articulation of an opposition between the twenties and the thirties which demands interpretation in its turn, and which has seemed symbolically to act out that vaster historical transition between the feudal and the bourgeois period, under the guise of a twenties "aristocratic" high life and a thirties amalgam of labor, money, and violence. Such an interpretation has however immediate and contemporary implications: for, as we have seen, the paradigm of art deco is by no means a closed historical issue, but has returned in force in what we now call the postmodern. Is this then to say that even within the extraordinary eclipse of historicity in the postmodern period some deeper memory of history still faintly stirs? Or does this persistence—nostalgia for that ultimate moment of historical time in which difference was still present—rather betoken the incompleteness of the postmodern process, the survival within it of remnants of the past, which have not yet, as in some unimaginable fully realized postmodernism, been dissolved without a trace?

(1988)

Notes

Introduction

1. "A popular tradition warns against recounting dreams on an empty stomach. In this state, though awake, one remains under the sway of the dream." Walter Benjamin, "One-Way Street", in *One-Way Street and Other Writings* (London, 1979), p. 45.

2. In *The Pleasure of the Text* (Paris, 1973).

3. See the wonderful remarks on orchestral coloration in chapter five of Adorno's *Versuch über Wagner* (Frankfurt, 1952).

4. "I began to reflect on contingency on the occasion of a film. I saw films in which there was no contingency, and when I went outside, it was there. It was thus the presence of necessity in films that made me feel how none existed in the street outside the theater." "Conversations with Jean-Paul Sartre", in Simone de Beauvoir, *La Cérémonie des adieux* (Paris, 1981), p. 181.

Chapter One

1. See for the theoretical sources of this opposition my essay on Max Weber, "The Vanishing Mediator," in *The Ideologies of Theory*, Vol. II (Minnesota: University of Minnesota Press, 1988), pp. 3–34.

2. The classical study remains that of J.-P. Vernant; see his "Travail et nature dans la Grece ancienne" and "Aspects psychologiques du travail," in *Mythe et pensée chez les grecs* (Paris: Maspéro, 1965).

3. Besides Marx, see Georg Simmel, *Philosophy of Money* (London: Routledge, 1978) and also his classic "Metropolis and Mental Life," translated in Simmel, *On Individuality and Social Forms* (Chicago: University of Chicago Press, 1971), pp. 324–39.

4. "[Bourgeois city-dwellers] wander through the woods as through the moist tender soil of the child they once were; they stare at the poplars and plane trees planted along the road, they have nothing to say about them because they are doing nothing with them, and they marvel at the wondrous quality of this silence," etc. J.-P. Sartre, *Saint Genêt* (Paris: Gallimard, 1952), pp. 249–250.

231

5. Guy Debord, *The Society of the Spectacle* (Detroit: Black and Red Press, 1973).

6. Reification by way of the *tableau* was already an eighteenth-century theatrical device (reproduced in Buñuel's *Viridiana*), but the significance of the book illustration was anticipated by Sartre's description of "perfect moments" and "privileged situations" in *Nausea* (the illustrations in Annie's childhood edition of Michelet's *History of France*).

7. In my opinion, this "feeling tone" (or secondary libidinal investment) is essentially an invention of Zola and part of the new technology of the naturalist novel (one of the most successful French exports of its period).

8. Written in 1976. A passage like this one cannot be properly evaluated unless it is understood that they were written before the elaboration of a theory of what we now call the postmodern (whose emergence can also be observed in these essays).

9. See Jacques Scherer, *Le "Livre" de Mallarmé* (Paris: Gallimard, 1957).

10. My own fieldwork has thus been seriously impeded by the demise some years ago of both car radios: so much the greater is my amazement when rental cars today (which are probably not time machines) fill up with exactly the same hit songs I used to listen to in the early seventies, repeated over and over again!

11. Written before a preliminary attempt to do so in *The Political Unconscious* (Ithaca: Cornell University Press, 1981); see in particular chapter three, "Realism and Desire."

12. Up to but not including: see Stephen Heath, "*Jaws:* Ideology and Film Theory," in *Framework*, volume 4 (1976), pp. 25–27. Still, Heath's plea to study the filmic effect rather than the content does leave the "shark-effect" itself open to interpretation. It is meanwhile also worth mentioning the interpretation attributed to Fidel, in which the beleaguered island stands for Cuba and the shark for Northamerican imperialism: an interpretation that will be less astonishing for U.S. readers who know this Latin American political iconography. This image of the U.S. probably predates the classic "Fable of the Shark and the Sardines," published by the former Guatemalan President Juan Jose Arevolo in 1956, after the American intervention, and is still current, as witness Ruben Bladés's recent ballad.

13. See Adorno's thoughts on the "resistance" of chronology in a letter to Thomas Mann, quoted in *Marxism and Form* (Princeton: Princeton University Press, 1971), pp. 234–350.

14. See my review of Wright, in *Theory and Society* Volume 4 (1977), pp. 543–559.

Chapter Two

1. See, for a useful survey of the newspaper coverage of the Wojtowicz robbery, Eric Holm, "Dog Day Aftertaste," in *Jump Cut*, No. 10–11 (June, 1976), pp. 3–4.

2. Stanley Aronowitz, *False Promises* (New York: McGraw-Hill, 1973), p. 383.

3. Ralf Dahrendorf, *Class and Class Conflict in Industrial Society* (Stanford: Stanford University Press, 1959), pp. 280–289.

4. See Richard J. Barnet and Ronald E. Muller, *Global Reach* (New York: Simon and Schuster, 1974), p. 68.

5. Jean-Paul Sartre, *The Psychology of Imagination* (New York: Washington Square Press, 1968), pp. 21–71, where analogon is translated as "the analogue."

6. See my *Postmodernism, or, The Cultural Logic of Late Capitalism* (Durham: Duke University Press, 1991), particularly the first and last chapters.

Chapter Four

1. See in particular Syberberg's two books *Hilter, ein Film aus Deutschland* (Hamburg: Rowohlt, 1978); and *Syberbergs Filmbuch*, Frankfurt: Fischer, 1979).

2. "Syberberg repeatedly says his film is addressed to the German 'inability to mourn,' that it undertakes the 'work of mourning' *(Trauerarbeit)*. These phrases recall the famous essay Freud wrote during World War I, 'Mourning and Melancholia,' which connects melancholy and the inability to work through grief; and the application of this formula in an influential psychoanalytic study of postwar Germany by Alexander and Margarete Mitscherlich, *The Inability to Mourn*, published in Germany in 1967, which diagnoses the Germans as afflicted by mass melancholia, the result of the continuing denial of their collective responsibility for the Nazi past and their persistent refusal to mourn" (Susan Sontag, "Eye of the Storm," *The New York Review of Books*, XXVII, 2 [Feb. 21, 1980], 40). The trauma of loss does not, however, seem a very apt way to characterize present-day Germany's relationship to Hitler; Syberberg's operative analogy here is rather with the requiem as an art form, in which grief is redemptively transmuted into jubilation.

3. In Stanley Cavell, *The World Viewed: Reflections on the Ontology of Film* (New York: Viking, 1971).

4. Syberberg, *Filmbuch*, pp. 81–82.

5. We do not, in fact, have to imagine Godard listening to other kinds of "classical music," since this last is omnipresent in his recent films. "Music is my Antigone," he declares in the extraordinary *Scénario du film "Passion"* (1982), a videotext not merely of great interest on what is surely his finest later film to date (*Passion*, 1982), but which may stand as an apotheosis of the visionary and prophetic vocation of the artist equal to anything in Syberberg (and rather tending to confirm J.-F. Lyotard's idea that the "modern"—in this case a more traditional glorification of the aesthetic—comes *after* the "postmodern"—or in other words the Godard of the 1960s and early 1970s).

6. Syberberg, *Filmbuch*, pp. 85–86.

7. See the chapter on Bloch in my *Marxism and Form* (Princeton: Princeton University Press, 1970). In a seminal essay, whose diffusion in Germany was surely not without effect either on Syberberg's own aesthetic or on the reception of his films, Jürgen Habermas attributes a similar method to Walter Benjamin; see "Consciousness-Raising or Redemptive Criticism—The Contemporaneity of Walter Benjamin," *New German Critique*, no. 17 (Spring 1979), 30–59.

8. The trilogy consists of: *Ludwig—Requiem for a Virgin King* (1972), *Karl May—In Search of Paradise Lost* (1974), and *Hitler, A Film from Germany/Our Hitler* (1977).

9. Syberberg, *Filmbuch*, pp. 39, 45–46.

10. *Ibid.*, p. 90.

11. Gertrude Stein, *Four in America* (New Haven: Yale University Press, 1947).

12. This is, I take it, what Sontag means to stress in her characterization of Syberberg's essentially symbolist aesthetic.

13. See the chapter on religion in Hegel's *Phenomenology of Spirit;* Rudolf Bultmann's work is the most influential modern treatment of the problem of figuration in theology.

14. Thomas Mann, *Doktor Faustus* (Frankfurt: Fischer, 1951), p. 361.

15. Roland Barthes, *Writing Degree Zero* (London: Cape, 1967), p. 39.

16. Erik Erikson, *Young Man Luther* (New York: Norton, 1958).

Chapter Five

1. See Annette Michelson, "Bodies in Space: Film as 'Carnal Knowledge,' " *Artforum* (February 1969).

2. For a socialist interpretation of Lovecraft, see Paul Buhle, "Dystopia as Utopia: Howard Phillips Lovecraft and the Unknown Content of American Horror Literature," *Minnesota Review*, no. 6 (Spring 1976).

Chapter Six

1. William Rothman, *Hitchcock: The Murderous Gaze* (Cambridge: Harvard University Press, 1982); page references included within the text.

2. See my *The Political Unconscious: Narrative as a Socially Symbolic Act* (Ithaca: Cornell University Press, 1981), chap. 5.

3. See Rothman, *Hitchcock* pp. 133–34.

4. Christian Metz, *The Imaginary Signifier: Psychoanalysis and the Cinema*, trans. Britton, Linda Williams, Ben Brewster, and Guzzetti (Bloomington: Indiana University Press, 1982), p. 212.

5. See Rothman, *Hitchcock*, pp. 27, 317; and pp. 33 and 353 n. 3.

6. Raymond Chandler, *Selected Letters*, ed. Frank MacShane (New York: Columbia University Press, 1981), p. 115.

7. Raymond Durgnat's *The Strange Case of Alfred Hitchcock; or, The Plain Man's Hitchcock* (Cambridge: MIT Press, 1974), to my mind the only other book of comparable quality to this one (if one does not count Raymond Bellour's important articles on the subject), is a useful corrective to Rothman in many ways: first, for Durgnat's skepticism about Hitchcock's profundity ("Potemkin submarines—a fleet of periscopes without hulls"); second, for his (pre-structuralist) willingness to entertain the idea that Hitchcock's work, rather than "expressing" a single coherent ideology or philosophy, might in fact be a "space" in which a host of incompatible, inconsistent, sometimes even contradictory ideologies move; and third, for his sensitivity to something about which Rothman (and many other comparable American intellectuals and critics) is almost wholly color-blind, namely social class. For a single striking instance, one's whole reading of *The Lodger* is transformed by a fact never mentioned in Rothman's elaborate analysis, namely that the "lodger" is an upper-class visitor to Daisy's milieu, and that their romance is an inter-class "fraternization." It is true that Durgnat is one of the rare Englishmen to have written about Hitchcock and might thus be expected, a priori, to sense the class vibrations in the latter's work more alertly than American or French viewers might: but this is in itself an interesting lesson, as though in cultural importation and transplantation, in the translation of cultural artifacts to other or alien national situations, what travels the least

well, what evaporates or becomes invisible more rapidly than any other code or connotation, is that of social class.

8. Robin Wood, *Hitchcock's Films* (New York: Castle Books, 1969), p. 71. Wood's judgments and reactions are probably, of all the Hitchcock's criticism I have read, the closest to my own personal ones.

9. See Stephen Heath, "On Suture," in his *Questions of Cinema* (London: MacMillan, 1981), as well as the texts of J.-A. Miller and Jean-Pierre Oudart in *Screen*, vol. 18, no. 4 (Winter 1977/78), and those of Daniel Dayan and Rothman himself in Bill Nichols, *Movies and Methods*, vol. 1 (Berkeley: University of California Press, 1976).

10. With the signal exception of the same James Stewart figure in *Rear Window*. But here I find David Spoto's argument most persuasive and illuminating that the four Stewart films are to be taken as a totality and show the "logical and clear development of a single character": in *Rope* (1948),

> he is the dubious Cadell, a man whose weak leg and slight limp manifest an inner moral weakness, In *Rear Window* (1954), Cadell's limp becomes Jeffries' broken leg, and the period of recuperation reveals a pathetically vulnerable and morally suspect view of life and relationships. In *The Man Who Knew Too Much* (1956), he portrays Ben McKenna, a domineering husband who knows too much for his own and his family's good. And in *Vertigo* (1958), he is Scottie Ferguson, forced to retire from detective work because of an acrophobia that points to more serious spiritual problems.

Donald Spoto, *The Art of Alfred Hitchcock* (New York: Hopkinson and Blake, 1976). In the present context, I would want to use this idea to argue that the "ironic" (or high-modernist) positioning of the Stewart figure of *Rear Window* is also dissolved by the evolution of Hitchcock's form over the four Stewart films.

11. See above, note 9. In the context of Rothman's Hitchcock book, however, the debate needs to be prolonged on the other side by a discussion of Stanley Cavell's notion of "theatricalization" (on this, see Chapter Seven below in particular note 18), especially, for the matter of the actors' faces and expressions. On this matter, see, too, Michael Fried, *Absorption and Theatricality: Painting and Beholder in the Age of Diderot* (Berkeley: University of California Press, 1980).

12. Metz, *The Imaginery Signifier*, pp. 49–51.

Chapter Seven

1. See Angel Flores, "Magical Realism in Spanish American Fiction," *Hispania* 38 (May 1955): 187–92.

2. See Alejo Carpentier, "Prólogo" to his novel *El Reino de este mundo* (Santiago, 1971); the most useful survey of the debate remains Roberto Gonzalez Echeverria, "Carpentier y el realismo magico," in *Otros Mundos, otros fuegos*, ed. Donald Yates, Congreso Internacional de Literatura Iberoamericana 16 (East Lansing, Mich., 1975), pp. 221–31.

3. See Angel Rama, *La Novela en America Latina* (Bogota, 1982), and especially Carlos Blanco Aguinaga, *De Mitólogos y novelistas* (Madrid, 1975), in particular the discussions of Gabriel García Márquez and Alejo Carpentier.

4. My own general frame of reference for "postmodernism" is outlined in my *Postmodernism; or, The Cultural Logic of Late Capitalism*, (Durham: Duke Univ. Press, 1990).

5. For further specifics, see *Variety*, 25 Feb. 1981.

6. *La Casa de Agua*, written by Tomás Eloy Martínez and directed by the Venezuelan painter and film critic Jacobo Penzo in 1984 (for further specifics, see *Variety*, 29 Aug. 1984); *Condores no entierran todos los dias*, directed by Francisco Norden, from a novel by Gustavo Alvarez Gardearzabel, 1984 (for further specifics, see *Variety*, 16 May 1984). I was fortunate in being able to see these films at the Sixth Annual Festival of Latin American Cinema in La Habana, December 1984. May the present article serve as a modest token of thanks to my hosts; it is dedicated to the Cuban Revolution.

7. I leave this formulation intact as a faithful reflection of my reactions and impressions; in fact, the action takes place in 1948. I am indebted to Ambrosio Fornet for the interesting suggestion that the absent subtext of the events in this film may well be the so-called Bogotazo of 9 April 1948, in which the populist leader, Jorge Eliécer Gaitán, was assassinated by right-wing fanatics of the Condor's type (see Arturo Alape, *El Bogotazo: Memorias del olvido* [La Habana, 1983]).

8. See note 4, above.

9. See, for a theory of the image as the "derealization" of the world, Jean-Paul Sartre's *L'Imaginaire* and *Saint Genêt*.

10. "A Latin word exists to designate this wound, this prick, this mark made by a pointed instrument: the word suits me all the better in that it also refers to the notion of punctuation, and because the photographs I am speaking of are in effect punctuated, sometimes even speckled with these sensitive points; precisely, these marks, these wounds are so many *points*. This second element which will disturb the *studium* I shall therefore call *punctum*. . . . A *punctum* is that accident which pricks me (but also bruises me, is poignant to me)" (Roland Barthes, *Camera Lucida*, trans. Richard Howard [New York: Hill and Wang, 1981], pp. 26–27). Barthes's analytic concept is a necessary starting point, but only that; it stands, for the investigation of the photographic image, at about the level of the New Critical concept of "paradox" for that of poetic language some thirty years ago.

11. See Jean-Paul Sartre, *"The Flies" ("Les Mouches")* and *"In Camera" ("Huis Clos")*, trans. Stuart Gilbert (London, 1946), p. 71.

12. Even so, it is always worth retaining Theodor Fontane's idea (often referred to by Georg Lukács) that one could not successfully stage a historical novel much before the chronological period to which one's own grandparents belonged.

13. Carpentier, "Prólogo," *El Reino de este mundo*, p. 16.

14. The allegorical emblem of such an aesthetic might then well be revealed—in its limits as well as its power—in the assassination scene of *Il Conformista*, in that rolled-up window of the locked car door from behind which the protagonist observes the pleading outraged desperation of his lover even as she pounds against it.

15. Jacques Lacan, *The Four Fundamental Concepts of Psychoanalysis*, trans. Alan Sheridan (New York, 1978), pp. 103, 111–12.

16. "Considerábase a Sabanas como la región más culta e ilustrada del país. Por país entendíase a todo el territorio de Sabanas y a la serie de tierras circundantes, cuya extensión nadie se atrevía a conjeturar, pero que se extinguía al precipitarse

en el mar. La siembra se planificó de acuerdo con las estaciones, de intempestiva regularidad, y según los colores del suelo, de amplia y variada gama, extendiéndose desde el blanco casi puro hasta el negro azabache. Entre estos extremos, se encontraban numerosos tonos y matices del pardo, rosado, púrpura, amarillo, verde, gris, rojo y azul. Se hablaba del gris "débil" o "muerto" y del gris "lánguido" o "rico", del rojo brillante, rojo ladrillo, rojo encarnado, rojo purpúreo, rojo amarillento, rojo pardusco, rojo gualda, rojo fuego, rojo carmin, rojo carmesí, rojo escarlata, rojo quemado, rojo sangre y rojo atardecer, y se distinguían los colores "moteados" de los "veteados", y los "manchados" de los "jaspeados", y a cada uno de ellos se le atribuían cualidades específicas para ciertos cultivos." Pablo Armando Fernandez, *Los Niños se despiden* (La Habana, 1968), p. 118; my translation.

17. "¡Fuego, fuego, fuego! ¡Bayamo en llamas! El resplandor que emanaba de los cuerpos borró sus rotros, sus formas. Enloquecida gritó: que comparezca el primero. Una nube de humo rojo le golpeó el rostro, y ella, frenética, volvió a gritar: que comparezca el segundo. Una nube color amarillo, sin siquiera rozarla pasó frente a ella, y una tercera anaranjada, y una cuarta, verde, y una quinta, azul, y un sexta, índigo, y una séptima, violeta. Triunfante, se le iluminaron los ojos animándole la voz, alegre, fina, dulcísima." Fernandez, *Los Niñas se despiden*, pp. 160–61; my translation.

18. Stanley Cavell, *The World Viewed: Reflections on the Ontology of Film*, enl. ed. (Cambridge, Mass.: Harvard University Press, 1979), pp. 89, 91. He concludes his argument thus:

> When dramatic explanations cease to be our natural mode of understanding one another's behavior—whether because we tell ourselves that human behavior is inexplicable, or that only salvation (now political) will save us, or that the human personality must be sought more deeply than dramatic religions or sociologies or psychologies or histories or ideologies are prepared for—black and white ceases to be the mode in which our lives are convincingly portrayed. But since this until yesterday dramatic modeling was the mode in which the human appeared, and its tensions and resolutions were those in terms of which our human understanding of humanity was completely satisfied, its surcease must seem to us the vanishing of the human as such. Painting and sculpture found ways to cede human portrayal in favor of the unappeasable human wish for presentness and beauty—by, for example, finding ways to make paintings without value contrast among their hues. But movies cannot cede human figuration or reference (though they can fragment it, or can animate something else). Movies in color cede our recently natural (dramatic) grasp of those figures, not by denying so much as by neutralizing our connection with the world so filmed. But since it is after all our world that is presented to us, and since those figures presented to us do after all resemble us, but since nevertheless they are no longer psychically present to us, we read them as de-psychologized, which, for us, means un-theatricalized. And from there it is only logical to project them as inhabiting the future, a mutation away from the past we know (as we know it). (p. 94)

For a remarkable discussion of color in the European *nouvelle vague* generally, see Marie-Claire Ropars, "La couleur dans le cinéma contemporain," in *L'Ecran*

de la mémoire, ed. Ropars (Paris, 1970), pp. 160–73. Her reminder of Sergei Eisenstein's reflections on color may serve generally as a motto for this section of the present essay:

> the sense of color as a process, developing as independently as music and in much the same way accompanying the whole movement of the work. . . . Just as the sound of leather cracking must be detached from the boot that makes it in order to become an element of expression in its own right, so the concept of orangish red must be detached from the hue of the tangerine in order for color to be inserted into a consciously directed system of expression and action. (Eisenstein, quoted in Ropars, "La Couleur," p. 173)

Finally, one is tempted to return again to the suggestive chapter "Color and Meaning" in Eisenstein, *The Film Sense,* trans. and ed. Jay Leyda (New York: Harcourt, Brace, and World, 1957), pp. 113–53.

19. Fredric Jameson, *Fables of Aggression: Wyndham Lewis, the Modernist as Fascist* (Berkley and Los Angeles, 1979), pp. 57–58.

20. See the longer version of my "Ideology of the Text," in *The Ideologies of Theory,* Vol. 1 (Minnesota; University of Minnesota Press, 1988) pp. 17–71.

21. See, in particular, Julio Garcia Espinosa, *Una Imagen recorre el mundo* (Mexico, 1982) and Tomás Gutiérrez Alea, *Dialectica del espectador* (La Habana, 1982).

22. See Chapter 1, above.

23. "Spatiality" as Joseph Frank uses it in his famous essay is closer to a synchronic arrangement for mnemonic purposes (comparable to Frances Yates's equally well-known *Art of Memory*) than to phenomenological, structural, or dialectical accounts of space from Gaston Bachelard to Henri Lefebvre.

Chapter Eight

1. See for example Jurii Mikhailovich Lotman, *The Semiotics of Russian Culture* ([Ithaca: Cornell University Press, 1985]). Spengler's program can be commemorated in his own words:

> I have not hitherto found one [contemporary historian] who has carefully considered the morphological relationship that inwardly binds together the expression-forms of all branches of a culture, who has gone beyond politics to grasp the ultimate and fundamental ideas of Greeks, Arabians, Indians and Westerners in mathematics, the meaning of their early ornamentation, the basic forms of their architecture, philosophies, dramas and lyrics, their choice and development of great arts, the detail of their craftsmanship and choice of materials—let alone appreciated the decisive importance of these matters for the form-problems of history. Who amongst them realizes that between the differential calculus and the dynastic principle of politics in the age of Louis XIV, between the space-perspective of Western oil-painting and the conquest of space by railroad, telephone and long-range weapon, between contrapuntal music and credit economics, there are deep uniformities? Yet, viewed from this morphological standpoint, even the humdrum facts of politics assume a symbolic and even a metaphysical character, and—what has

perhaps been impossible hitherto—things such as the Egyptian administrative system, the classical coinage, analytical geometry, the cheque, the Suez Canal, the bookprinting of the Chinese, the Prussian Army, and the Roman road-engineering can, as symbols, be made uniformly understandable and appreciable.

Oswald Spengler, *The Decline of the West* (New York: Knopf, 1939), pp. 6–7. Franco Moretti suggests that period-stylistic operations of this (or any other) type are methodologically incompatible with what may be called historical-generic criticism of the type boldly developed by Lukács in *Soul and Forms* and *The Theory of the Novel*, and of which Moretti is himself the most brilliant contemporary practitioner (see *Signs Taken for Wonders* [London: Verso, 1983] and *The Way of the World* [London: Verso, 1987]). This latter operation can be described as a reconstruction of the ways in which the structure of a particular concrete historical situation (and the logic of its content) open the way to the development of certain genres and close off the possibility of others. (Moretti has himself recently stressed the relationship of this approach to contemporary evolutionism, which returns to the much maligned and distorted original method of Darwin himself.) In what follows, the cultural "dominant" of a period is grasped as the reaction to the concrete structural modifications of the economic system: but I agree that, save perhaps for the shifting constellations of the various *media*, generic dynamics are largely unregistered here. Speculation on the "current tasks of contemporary criticism and theory" might well wish to inscribe this (to me) very interesting problem on the agenda.

2. See my *Postmodernism, Or, The Cultural Logic of Late Capitalism*, (Durham: Duke University Press, 1991), for a fuller theoretical statement of these hypotheses, and also for preliminary remarks on the question of "nostalgia film," to which I return at the end of the present essay.

3. In correspondence.

4. See for preliminary thoughts on this new medium my "Surrealism without the Unconscious," in *Postmodernism*) (cit. note 2 above).

5. P. Anderson, "Modernism and Revolution," *New Left Review*, no. 144 (March–April 1984), pp. 95–113. Often in Adorno also, the realist and postmodernist moments fall away, leaving art (in the capitalist period) to coincide with modernism in its very essence.

6. Above all, in David Bordwell, Janet Staiger, and Kristin Thompson, *The Classical Hollywood Cinema* (New York: Columbia University Press, 1985).

7. Dudley Andrew, *Concepts in Film Theory* (Oxford: Oxford U. Press, 1984), pp. 119–127. Thomas Elsaesser has recently suggested a parallel with Kracauer's evaluation of expressionism (in *From Caligari to Hitler*), which would then similarly spring from a judgment on the ideology of ("elitist") form rather than from any immediate political evaluation: "Kracauer's antipathy to Weimar films was ultimately due more to their gentrification of the cinema than to any anticipation of the course of history in narrative and fictional form." "Cinema—the Irresponsible Signifier or The Gamble with History," in *New German Critique*, no. 40 (Winter 1987), p. 84.

8. The now classical model for such analyses is the analysis of "John Ford's *Young Mr. Lincoln*" by the editors of *Cahiers du cinéma (1970)*, translated in Bill Nichols,

ed., *Movies and Methods*, Vol. I. (Berkeley: University of California Press, 1976), pp. 493–529.

9. The same is true of philosophical and literacy "deconstruction," as in Paul de Man's concept of irony.

10. Benjamin H. D. Buchloh has written authoritatively about such oppositional forms, e.g., in "From Faktura to Factography," in Annette Michelson, *et al.*, eds., *October: The First Decade* (Cambridge: MIT Press, 1987), pp. 77–113. See also, for a pathbreaking account of some literary equivalents, Barbara Foley, *Telling the Truth* (Ithaca: Cornell University Press, 1986).

11. See for example, "Anatomia del testimonio," in John Beverley, *Del Lazarillo al Sandinismo* (Minneapolis: *Ideologies and Literature*, 1987), pp. 153–168.

12. Roland Barthes, "Rhetoric of the Image," *Working Papers in Cultural Studies*, University of Birmingham, Center for Cultural Studies (Spring, 1971), p. 41.

13. The concept of the "situation" is clearly Sartrean, but the idea that form itself might be a response to the psychoanalytic as well as the social contradictions of a given personal "situation" only emerges fully, I think, in *Search for a Method* (New York: Vintage, 1968). The way in which a period ideology and a period style might be grasped as a response to a collective *class* situation is then explored in *L'Idiot de la famille*, Vol. III (Paris: Gallimard, 1972). Lukács's rather different and more Hegelian model also seems to me to be suggestive; after an explicit attack on reflection and correspondence theories (which later caused him no little political grief), he observes:

> Thought and existence are not identical in the sense that they "correspond" to each other, or "reflect" each other, that they "run parallel" to each other or "coincide" with each other (all expressions that conceal a rigid duality). Their identity is that they are aspects of one and the same real historical and dialectical process. ("Reification and the Consciousness of the Proletariat," in *History and Class Consciousness* [Cambridge: MIT Press, 1971], p. 204)

The model here is one of distinct, semi-autonomous loops in which subject and object develop without "representing" each other in any way, and yet continue to be related (Lukács still uses the word "identity" in the Hegelian sense of the "identity of identity and non-identity") by their participation in the social totality, or, what is the same thing, their co-participation in the *present* of History, their actuality (see pp. 157–159). Something like this second model will be implicit when we come to the problem of technology (see below, section V).

14. See, for example, "The Realist Floor-Plan," in Marshall Blonsky, ed., *On Signs* (Baltimore: Johns Hopkins University Press, 1985), pp. 373–383. The philosophical basis for a new approach to the analysis of space was laid by Henri Lefebvre, in *La Production de l'espace* (Paris: Anthropos, 1974).

15. For my assessment of some of those developments, see the "Foreward" to A. J. Greimas, *On Meaning* (Minneapolis: University of Minnesota Press, 1987), pp. vi–xxii; and for examples of my own practice on narrative analysis see "The Vanishing Mediator," in *Ideologies of Theory*, Vol. II (Minneapolis: U. of Minnesota Press, 1988), pp. 3–34; and also *Fables of Aggression* (Berkeley: University of California Press, 1979).

16. See "Ideological State Apparatuses," in *Lenin and Philosophy*, (New York: Monthly Review, 1971), pp. 127–186.

17. See Alain Robbe-Grillet, *For a New Novel* (New York: Grove Press, 1966).

18. Space seems to me the most suggestive recent category whereby to transcend the very rich contemporary work on "subject-positions" (much of it in film theory), which may now be touching its limit. See for example Pierre Bourdieu's study of the Kabyl village (segmented and distributed as an ongoing example throughout his *Outline of a Theory of Practice* [Cambridge: Cambridge University Press, 1977]), for a suggestive demonstration of a methodological leap beyond the traditional antitheses between the social-scientific and the psychoanalytic, and also beyond those which one currently senses between the static findings of subject-position analysis and the dynamics of narrative analysis.

19. This canonical gesture of the *Quijote* is classically theorized by Roman Jakobson in "On Realism in Art" (L. Matejkaand and K. Promorska, eds., *Readings in Russian Poetics* [Cambridge: MIT Press, 1971], pp. 38–46; and also developed in detail in Harry Levin, *The Gates of Horn* (New York: Oxford University Press, 1966).

20. See for example Michael McKeon, *The Origins of the English Novel* (Baltimore: Johns Hopkins University Press, 1987), chapter 1; which might "estrangefully" be juxtaposed with Jane Feuer's arresting work on defamiliarization devices in the musical film, *The Hollywood Musical* (Bloomington: Indiana University Press, 1982).

21. "Social Class, Language, and Socialization," in Basil Bernstein, *Class, Codes and Control*, Vol. I (London: Routledge and Kegan Paul, 1971), pp. 170–189. But see also Elaine Showalter, "Feminist Criticism in the Wilderness" (E. Showalter, ed., *The New Feminist Criticism* [New York: Pantheon, 1985]), esp. pp. 259–266 for a different discussion of what she calls "the wild zone" of language outside hegemonic space.

22. In Alvin W. Gouldner, *The Dialectic of Ideology and Technology* (New York: Seabury, 1976), pp. 58–66.

23. William Labov, *Language in the Inner City* (Philadelphia: U. of Pennsylvania Press, 1972), esp. chapter 5.

24. Karl Marx, 1857 Introduction to the *Grundrisse*, trans. M. Nicolaus (Harmondsworth: Penguin, 1973), p. 101. And see also Sartre's stimulating discussion of the relationship between modes of production and modes of thought in *Anti-semite and Jew* (New York: Schocken, 1948), pp. 34–43.

25. Walter Benjamin, *Illuminations*, trans. H. Zohn (New York: Schocken, 1969), p. 233.

26. *Ibid.*, pp. 236–237.

27. See my "History and Class Consciousness as an 'Unfinished Project,' " in *Rethinking Marxism*, Vol. I, no. 1 (Spring 1988), pp. 49–72.

28. *The Image of the City* (Cambridge: MIT Press, 1960).

29. Rem Kohlhaas, *Delirious New York* (New York: Oxford University Press, 1978), pp. 13–16.

30. J.-F. Lyotard, *The Postmodern Condition* (Minneapolis: University of Minnesota Press, 1984), pp. 18–23, 31–37, 64–67. It is however worth noting that the distinction between grand narratives and micronarratives, which evidently corresponds

to a theoretical and cultural need and which has met with extraordinary success, is not present in Lyotard in this form. He opposes "grand narratives" to "speech acts," and although the concept of the latter emerges within a general philosophical valorization of narratives as such, the choice of this second term reinflects its objects in a new non-narrative direction, towards the paralogism and the "interruption."

31. Gilles Deleuze and Félix Guattari, *Kafka: Pour une littérature mineure* (Paris: Minuit, 1975).

32. I have argued for the structural politicality of Third World literature from a different perspective in "Third World Literature in the Era of Multinational Capitalism," *Social Text*, no. 15 (Fall 1986), pp. 65–88.

33. I discuss this further in the conclusions to my *Postmodernism* book, op. cit.

34. Edgar Morin, *Les Stars* (Paris: Seuil, 1972), pp. 20ff.

35. As for example, variously in Jane Feuer, *The Hollywood Musical*, op. cit., Stanley Cavell, *Pursuits of Happiness* (Cambridge: Harvard University Press, 1981), or Will Wright, *Sixguns and Society* (Berkeley: University of California Press, 1975).

36. But see Claudio Guillén, *Literature as System* (Princeton: Princeton University Press, 1971), and Northrop Frye's *Anatomy of Criticism* (Princeton: Princeton University Press, 1957); as well as my "Magical Narratives," in *The Political Unconscious* (Ithaca: Cornell University Press, 103–150).

37. It is worth noting that the model of a genre system called for here is not exactly satisfied by the combinational scheme devised by Gilles Deleuze (in his remarkable two-volume *Cinéma*) for what we here call narrative realism, or what is elsewhere called classical film (it being understood that fantasy, dream sequences, filmic expressionism, and the like, are perfectly consistent with a dominant realistic paradigm). Deleuze grasps the national traditions contemporaneous with Hollywood as variations on a more general Leibnizian structure in which a monad links the particular—the image or shot, the present of the work— with its totality or world by way of a unique stylistic solution. Thus to the North American or Hollywood "organic form" replies the Soviet "dialectical form"; while to the French impressionistic tradition of the quantitative (flowing water, a gamut of greys, the "mathematical sublime") replies the German expressionistic tradition of the intensive (the "non-organic life of things," Kant's "dynamic sublime"). The second pair of oppositions relates to the first by the way in which in impressionism the particulars add up to the totality in a new way (which is neither organic nor dialectical, but rather mechanical), while in expressionism the totality somehow attempts to submerge the particulars in the formless intensifications of light and shadow. (Gilles Deleuze, "Montage," *Cinéma* I, *L'Image-mouvement* [Paris: Minuit, 1983], chapter 3; or, [Minneapolis: U. of Minnesota Press, 1986], pp. 29–55.) Karatani Kojin has observed that Deleuze's return to Leibniz and to the model of a simultaneity of monads reflects the ideological needs of the older nation-states as they confront the imminence of the transnational post-1992 European superstate.

38. G. W. F. Hegel, *Science of Logic*, trans. A. V. Miller (New York: Humanities, 1969), p. 474. "As for windows, one ought minimally to register the Euclidean axioms of a certain Wolf, in whose 'First Principles of Architecture' the Eighth Theorem runs: A window must be wide enough for two persons to be able to look out side-by-side in comfort. Proof: It is quite usual for a person to be at the window with another person and to look out. Now since it is the duty of the architect to satisfy

in every respect the main intentions of his principle (section I)," etc., etc. (Hegel, *Science of Logic*, op. cit., p. 816, note 1). However, unhelpful this may be for architectural rationality, it does begin to resound peculiarly when we think of Caspar David Friedrich's paintings.

39. Peter Wollen, "Cinema and Technology: A Historical Overview, in Teresa de Lauretis and Stephen Heath, eds., *The Cinematic Apparatus* (New York: St. Martin's, 1980), pp. 14–22, reprinted in his own *Readings and Writings* (London: Verso, 1982), pp. 169–177. The three levels or dimensions bear some family likeness to Deleuze and Guattari's three moments of production, registration, and consumption (in the *Anti-Oedipus*).

40. These propositions are scattered through Adorno's *Aesthetic Theory;* I have tried to reassemble them in a more programmatic way in *Late Marxism: Adorno, or, the Persistence of the Dialectic* (London: Verso, 1990).

41. See especially his book on photography, *Un art moyen* (Paris: Minuit, 1965).

42. In fact, the decision about breaks and continuities in historiography is not a matter of empirical evidence at all, but as it were a methodological choice that precedes the organization of the data, which will themselves look very different depending on whether they are read as repetition and continuation (e.g., modernism as a continuation of some earlier romanticism) or as absolute break and rupture, as innovation (the modern, and modernity, as an absolute repudiation of a past which *included* romanticism). Such an inaugural choice—the absolute presupposition either of Identity or of Difference—can therefore not be argued or proven from the "facts" whose very interpretation depends on that choice in advance; nor is such a methodological decision made innocently or randomly: it is an ideological choice one makes for extra-historiographic reasons—in this case, out of conviction that history proceeds by discontinuities, rather than in some idealistic continuum. If it is then objected that the belief in discontinuity is a feature of the whole contemporary poststructural *Weltanschauung* or *Zeitgeist*, then so be it—provided one is aware of that and takes one's stand consciously on it.

43. See in particular Gert Kahler, *Architektur als Symbolverfall: Das Dampfermotif in der Baukunst* (Braunschweig, 1981).

44. Eva Weber, *Art Deco* (New York: Exeter, 1985), p. 45. See also Bevis Hillier, *Art Deco of the Twenties and Thirties* (London: Studio Vista, 1968); B. Hillier, "Introduction," to *Art Deco* (Minneapolis: Minneapolis Institute of the Arts, 1971), pp. 13–48; Reyner Banham, *Theory and Design in the First Machine Age* (London: Architectural Press, 1960); and also, Alexander Cockburn, "Assault on Miami's Virtues," in *Corruptions of Empire* (London: Verso, 1987), pp. 136–141.

45. Charles Bettelheim, *Class Struggle in the Soviet Union 1917–1923* (New York: Monthly Review, 1976); and Alexander Rabinowitch, *The Bolsheviks Come to Power* (New York: Norton, 1976).

46. See Geoffrey Barraclough, "The Great Disturbing Element," *New York Review of Books*, Oct. 24, 1968, pp. 14–16; and David Schoenbaum, *Hitler's Social Revolution* (New York: Doubleday, 1966).

47. *The Power Broker* (New York: Vintage, 1975).

48. The subtitle of Siegfried Kracauer, *Theory of Film* (New York: Oxford University Press, 1965). See also the two translated volumes of André Bazin, *What is Cinema?* (Berkeley: University of California Press, 1967, 1972).

49. See in particular Erich Auerbach, "Figura," in *Scenes from the Drama of European Literature* (Minneapolis: University of Minnesota Press, 1984), pp. 11–76; and also *Mimesis* (Princeton: University of Princeton Press, 1953).

50. Gilles Deleuze, *Cinéma I, L'Image-mouvement*, op. cit., pp. 111–116.

51. The state visit of Eisenhower to Paris on August 27, 1959, in *A bout de souffle.*

52. Thomas Mann, *Doctor Faustus* (New York: Knopf, 1945), p. 40, translation modified.

53. *Torre Bella* (1977), directed by Thomas Harlan. I am indebted to Jim Kavanagh for drawing my attention to this film, as well as for recounting the director's own testimony about its production recounted further on in the text. A similar story is told in Marvin Surkin and Dan Georgakis, *Detroit I Do Mind Dying* (New York: St. Martins, 1975).

54. *Twenty Years Later* (1984), directed by Eduardo Coutinho. For further specifics see *Variety*, Jan. 9, 1984, pp. 317–318, and J. Hoberman, "Once More with Feeling," *The Village Voice*, May 14, 1985, p. 60. I am indebted to the organizers of the Sixth International Film Festival in Havana for the opportunity of seeing this film; and to Robert Stam for further information about it.

55. See Paul de Man, *Blindness & Insight* (New York: Oxford University Press, 1976) pp. 142–165; Adorno's *Aesthetic Theory* (London: Routledge and Kegan Paul, 1984), passim.; and also for further comments on this last, my forthcoming study of Adorno's aesthetics (note 40, above).

56. See Pierre Bourdieu, *Un art mineur*, op. cit.: it is precisely *against* the family photograph that Bourdieu's various *amateurs* react and against which their various "styles" and "aesthetics" have socially symbolic meaning.

57. Kracauer, *Theory of Film*, op. cit., p. 8.

58. Here and in the preceding reference (to the way in which canonized texts, such as Godard's "classics," become reified), the very possibility of reification is grounded on that dual property of language, theorized by Humboldt, as *ergon* (finished product) and *energeia* (process) alike.

59. The reference is to Kenneth Burke's "dramatistic" category in *A Grammar of Motives* (Berkeley: U. of California Press, 1969).

60. *Illuminations*, op. cit., p. 226.

61. The so-called "Esposizione universale romana" was built by Mussolini in 1942 for his aborted World's Fair.

62. See my remarks on Hitchcock elsewhere in this volume (chapter 6) as well as my essay "On Raymond Chandler," *Southern Review*, 6 (1970), pp. 624–650.

63. Kracauer, *Theory of Film*, op. cit., pp. 27, 31, 60.

64. Roland Barthes, *La chambre claire* (Paris: Gallimard, 1980), p. 77.

65. The crucial problem of the relationship between populism as an "ideology" and Marxism as a "science" has been centrally raised by Ernesto Laclau, *Politics and Ideology in Marxist Theory* (London: New Left Review, 1977). The significance of Laclau's intervention for aesthetics lies in the way in which he dissociates a kind of narrative ("social realism," "socialist realism") from the Marxist theory or "science" which has so often been thought to be inseparable from it. What you have consistently mistaken for a *Marxian* art, he says in effect, is in reality the art and aesthetic of a populist *ideology*, which is not theoretically implicit in

Marxism although it has occasionally and in specific historical situations coexisted with it. But perhaps that very coexistence testifies to some structural weakness in Marxism which can then not produce its own ideologies from within itself but needs the compensation of these extraneous ones? These doubts then modify the direction of Laclau's own book, which, beginning as a critique of *populism*, ends up as a critique of Marxism itself and with its stigmatization, as a theory incapable of generating those active dimensions required for political praxis, which are ideology and aesthetics or cultural production. Laclau's later work (*Hegemony & Socialist Strategy*, with Chantal Mouffe [London: Verso, 1985]), which explores the political potential of the "new social movements," may then in this sense be seen as a return to the lessons of the very populism criticized in the first book, and an application of those lessons to our (very different) postmodern situation. That under certain circumstances, the ideologies of marginality and difference (and of the "new social movements" or of micropolitics) have some deeper structural affinity with the older populisms is surely a hypothesis with many consequences, and which merits debate and reflection.

66. This is the concrete basis for arguing that Hitchcock is to be considered among the "high modernists," something that will be presupposed hereafter. Simon Frith's account of rock stardom presents interesting analogies with directorial *auteurdom:* the new system allows much greater control by rock star or director— "The star system lay behind the rise of 'musician power,' . . . it was as they became superstars that rock artists were able to define the commercial terms of music-making." But stardom also is at one with commodification: "stars make record promotion easy. . . . The importance of stars for *all* sales means that papers will publicize them as much as they can, radio stations play their latest records as soon and as often as possible, magazines litter their pages with their pictures." *Sound Effects* (New York: Pantheon, 1981), p. 135. One may hazard the speculation that in this sense the great silent and sound film stars are the precursor of the directorial "star" in the later period (the former's prestige waning as the latter grows).

67. Peter Bürger, *Theory of the Avant-Garde* (Minneapolis: U. of Minnesota Press, 1984), and *Zur Kritik der idealistischen Aesthetik* (Frankfurt: Suhrkamp, 1983). Adorno's lifelong meditation on aesthetics is summed up in his posthumous *Aesthetic Theory* (op. cit.).

68. In this Germanic context I cannot resist the temptation to quote Hegel on the subject: "In this respect [substantives], German has many advantages over other modern languages; some of its words even possess the further peculiarity of having not only different but opposing meanings so that one cannot fail to recognize a speculative spirit of the language in them: it can delight a thinker to come across such words and to find the union of opposites naively shown in the dictionary as one word with opposite meanings, although this result of speculative thinking is nonsensical to the understanding [Verstand]." G. W. F. Hegel, *Science of Logic*, op. cit., p. 32 ("Preface to the Second Edition").

69. Jürgen Habermas, *Strukturwandel der öffentlichkeit* (Neuwied: Luchterhand, 1952); Oskar Negt and Alexander Kluge, *Offentlichkeit und Erfahrung* (Frankfurt: Suhrkamp, 1972); and *Geschichte und Eigensinn* (Frankfurt: Zweitausendeins, 1981): on this last, see my "On Negt and Kluge," in *October*, no 46 (Fall 1988), pp. 151–177.

70. See my *Postmodernism, Or, The Cultural Logic of Late Capitalism*, and also "Periodizing the Sixties," in *The Ideologies of Theory*, op. cit.

71. *Postmodernism*, op cit.

72. See his readings of "force and understanding" in *The Phenomenology of Mind*, trans. A. V. Miller (Oxford, 1977), Section A III, pp. 79–105; and in *The Science of Logic*, trans. Miller (op. cit.), Vol. II, Section Two, Chapter 3, pp. 512–528.

73. In *Negations* (Boston: Beacon, 1968), pp. 88–133.

74. Private communication.

75. The allusion is to Claude Chabrol and Eric Rohmer's study, *Hitchcock: The First Forty-four Films* (1957; New York: Unger, 1979).

76. The allusion is to William Rothman's *Hitchcock: The Murderous Gaze* (Cambridge: Harvard U. Press, 1982), discussed in chapter 6 of the present book.

77. Vladimir Nabokov, *Lolita* (New York: Putnam, 1955), p. 98.

78. Robert Musil, *Der Mann ohne Eigenschaften*, Vol. I (Hamburg: Rowohlt, 1952), p. 30: "Two weeks later, Bonadea had already been his mistress for fourteen days."

79. See *A Perfect Vacuum, Imaginary Magnitude, One Human Minute* (New York: Harcourt Brace Janovich, 1979, 1984, and 1986, respectively).

80. Kracauer, *Redemption*, pp. 251ff.

81. *Ibid.* pp. 16–17.

82. V. N. Voloshinov, *Marxism and the Philosophy of Language* (Cambridge: Harvard University Press, 1986), pp. 71–77.

83. Cf. the unpublished 1924 article of that title, in Jay Leyda and Zina Voynow, *Eisenstein at Work* (New York: Pantheon, 1982), pp. 17–20. The time "of the music hall is by definition interrupted; it is immediate time. And this is precisely the meaning of the *variety* show: for scenic time to be exact, real, cosmic, the time of the thing itself and not of its pre-vision (tragedy) or revision (epic). The advantage of this literal time lies in the way in which it foregrounds gesture, for it is clear that gesture can exist as spectacle only when time is broken up . . . to exhaust gesture as spectacle and not as meaning: such is the original aesthetic of the music hall." (Roland Barthes, "Au Music-hall," *Mythologies* [Paris: Seuil, 1957], p. 199). Barthes's brilliant sketch (not translated in the English version) goes on to link gesture to human labor; it may be instructively juxtaposed with T. S. Eliot's national-populist (and explicitly anti-filmic) evocation of "Marie Lloyd," in *Selected Essays* (New York: Harcourt Brace, 1950), pp. 405–408.

84. S. M. Eisenstein, *The Film Sense* (New York: Meridian, 1957), pp. 175–216.

85. *Ibid.*, p. 21.

86. Yvor Winters, "The Experimental School in American Poetry," in *Defense of Reason* (Chicago, University of Chicago Press, 1947), pp. 30–47.

87. The reference, here and in what follows, is to Laura Mulvey's classic 1975 essay, "Visual Pleasure and Narrative Cinema," reprinted in Philip Rosen, ed., *Narrative, Apparatus, Ideology* (New York: Columbia U. Press, 1986), pp. 198–209.

88. Susan Sontag, *On Photography* (New York: Farrar Strauss and Giroux, 1977), pp. 140–141.

89. Tinting would, however, appear to be the exception to this rule; some of the oldest extant photographs are selectively color-tinted and thereby betray a peculiar capacity to suggest the mysteries of the past which is foreclosed to systems of color reproduction as such; but it bears uncanny intimations of an emergent

Utopian photography today (see the relevant chapter in *Postmodernism* (op. cit., note 2, above).

90. See note 4, above.

91. Julio Garcia Espinosa, *Una Imagen recorre el mundo* (La Habana: Filmoteca de la Unam, 1982), and in particular "Por un cine imperfecto," pp. 30–42, which dates from 1969.

92. Georg Lukács, *The Historical Novel* (Lincoln: University of Nebraska Press 1983).

93. The masterpiece of Godard's late period, *Passion* (1982) can be thought of as the coming to self-consciousness of this formal feature of the postmodern pastiche or allusion, for it turns on the project of a television crew to film simulacra, staged by real actors, of the great "masterworks" of Western painting, from Rembrandt to Manet, from Rubens to Ingres.

94. See Franco Moretti, *The Way of the World*, op. cit.

95. "The Conformist," in Alberto Moravia, *Three Novels* (New York: New American Library, 1961), p. 63.

96. The reading of *The Shining* reprinted in the present volume (chapter 5) has an obvious bearing on this history and its imaginary functions.

97. Unlike North American violence of the period, which separates itself off from daily life, business, and politics as an autonomous space (a space which is then available for symbolic investment as the *equivalent* of a repressed politics and capitalism), other countries have lived such "thirties" content as the very stuff of politics and daily life itself. In Cuba, for example, politics, and very specifically student politics, were already at one with a Chicago-type gangland atmosphere, where everyone carried guns. This is how Fidel himself described the period:

> The political atmosphere in the University of Havana had been contaminated by the national disorder. My impetuosity, my desire to excel fed and inspired the character of my struggle. My straightforward character made me enter rapidly into conflict with the *milieu*, the venal authorities, the corruption and the gang-ridden system which dominated the university atmosphere. The pressure groups of corrupt politicians made the gangs threaten me and led to a prohibition on my entering the University. This was a great moment of decision. The conflict struck my personality like a cyclone. Alone, on the beach, facing the sea, I examined the situation. Personal danger, personal risk made my return to the University an act of unheard-of temerity. But not to return would be to give in to threats, to give in before bullies, to abandon my own ideals and aspirations. I decided to go back and I went back . . . *with arms in my hand*. . . . Naturally I did not find myself fully prepared to understand exactly the roots of the profound crisis which disfigured the country. This resulted in my resistance being centered on the idea of personal valour.

Quoted in Hugh Thomas, *Cuba: or, the Pursuit of Freedom* (London: Eyre and Spottiswoode, 1971), pp. 810–811.

98. New York: Pantheon, 1981.

99. See Jonathan Arac, *Critical Genealogies* (New York: Columbia U. Press, 1987), p. 286.

100. It is a proposition that I have argued in more restricted fashion for Max Weber in "The Vanishing Mediator," note 15, above. I can here only give two more random examples, both chosen from the history of technology: thus, Elizabeth Eisenstein's *The Printing Press as an Agent of Change* (Cambridge: 1979), suggests according to the classical Weberian "dialectic" that in a first moment the printing press does not bring enlightenment, but reinforces superstition (because a host of popular occult manuals are not printed up and diffused for the first time). In a similar move, in the article cited above (note 39), Peter Wollen also grasps change first as a kind of regress, before it overleaps itself in a dialectical progression (whose story need not be told, since it took place during the intervening period). Thus, the development of color stock is read as "a breakthrough which proved to be a set-back," but which then as it were laterally generates the more tangible "progress" of experimental film as such: "the entire new field of independent film has begun to appear between home movies and the industry." More recently I find much that clarifies my own reactions to Hitchcock in Pascal Bonitzer's *Le champ aveugle* (Paris: Gallimard, 1982), as well as in Tania Modleski's remarkable *The Women Who Knew Too Much* (N.Y.: Methuen, 1988), and also in the admirably suggestive Lacanian commentaries of Slavoj Žižek and his collaborators, in *Tout ce que vous avez toujours voulu savoir sur Lacan sans jamais oser le demander à Hitchcock* (Paris: Navarin, 1988).

Index

249